W9-BEE-098

LAND OF RIVERS

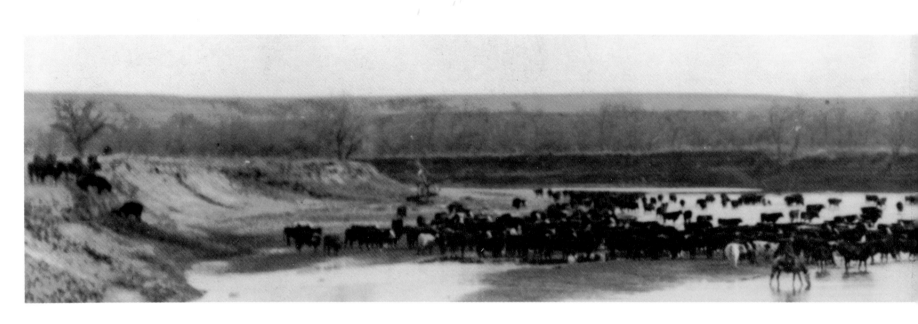

AMERICA IN WORD AND IMAGE

Land of Rivers

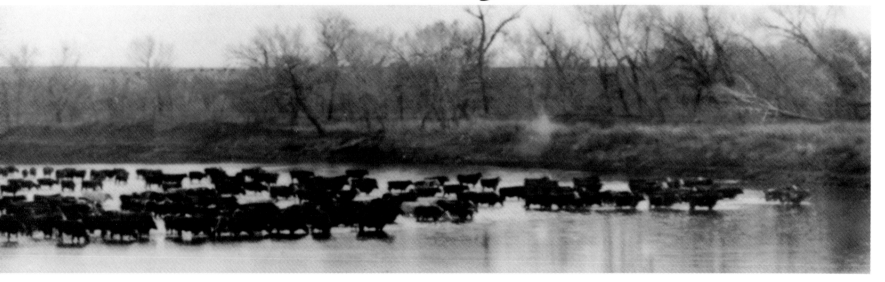

Edited by Peter C. Mancall

Foreword by Edward Hoagland

CORNELL UNIVERSITY PRESS ITHACA AND LONDON

© 1996 by Cornell University

PRODUCTION AND MANUFACTURING by Wilsted & Taylor Publishing Services, with COPYEDITING by Nancy Evans, DESIGN by Christine Taylor, and PRINTING through OverSeas Printing Corporation

Printed in Hong Kong

♾ The paper used in this book meets the minimum requirements of the American National Standard for Information Sciences—Permanence of Paper for Printed Library Materials, ANSI Z39.48-1984.

LIBRARY OF CONGRESS CATALOGING-IN-PUBLICATION DATA

Land of rivers : America in word and image / edited by Peter C. Mancall ;
 foreword by Edward Hoagland.
 p. cm.
 Includes bibliographical references.
 ISBN 0-8014-3105-0 (cloth : alk. paper)
 1. United States—Description and travel. 2. Rivers—United States.
 I. Mancall, Peter C.
E161.5.L36 1996
973—dc20 96-19079

TITLE PAGE: River scene on the Big V Ranch, near Ponca City, Oklahoma, c. 1910. Kansas Collection, University of Kansas Libraries.

This anthology is based on the publication *Roll On, River*, an anthology published in 1990 for reading and discussion groups by The National Council on the Aging, Inc., and supported by the National Endowment for the Humanities. For information contact: NCOA, Humanities Program, 409 Third Street SW, Washington, DC 20024. A different version of the Introduction was published in pamphlet form as "Rivers and the Making of a Nation" (Marshall, Minnesota, 1995).

Texts Permissions. Ella Clark, excerpts from *Indian Legends of the Pacific Northwest*, pp. 86–95, 107–8, 116–17. Copyright © 1953 The Regents of the University of California; © renewed 1981 Ella E. Clark. Reprinted by permission. Richard Hakluyt the Elder, excerpt from "Inducements to the Liking of the Voyage Intended towards Virginia in 40 and 42 Degrees of Latitude," in *The Elizabethan's America*, edited by Louis B. Wright. © 1965 Harvard University Press. Reprinted by permission. Alexander Whitaker, excerpt from "Good News from Virginia," in *The Elizabethan's America*, edited by Louis B. Wright. © 1965 Harvard University Press. Reprinted by permission. Correspondence of Benjamin Franklin and Mary Stevenson, excerpted from *The Papers of Benjamin Franklin, Volume 9*, pp. 195, 213–16, 247–50, 296, edited by Leonard Labaree. © 1966 Yale University Press. Reprinted by permission. Peter Kalm, excerpt from *Travels in North America*, vol. 1, pp. 349–54. © 1964 Dover Publications, Inc. Reprinted by permission. William Bartram, excerpt from *The Travels of William Bartram*, edited by Francis Harper. © 1958 Yale Uni-versity Press. Reprinted by permission. Tench Coxe, excerpt from *A View of the United States of America*. Augustus M. Kelley, Publishers. Reprinted by permission. Edgar Allan Poe, "Morning on the Wissahiccon." Reprinted by permission of the publishers from *The Collected Works of Edgar Allan Poe: Tales and Sketches, 1843–1849*, vol. 3, edited by Thomas Olive Mabbott, Cambridge, Mass.: Harvard University Press. Copyright © 1978 by the President and Fellows of Harvard College. Nathaniel Hawthorne, "My Visit to Niagara," excerpted from *The Snow-Image and Uncollected Tales*, vol. 11 of the Centenary Edition of the Works of Nathaniel Hawthorne. © 1974 by the Ohio State University Press. Reprinted by permission. John Wesley Powell, excerpt from *The Exploration of the Colorado River and Its Canyons*. © 1961 Dover Publications, Inc. Reprinted by permission. Langston Hughes, "The Negro Speaks of Rivers," from *Selected Poems* by Langston Hughes. © 1926 by Alfred A. Knopf, Inc., and renewed 1954 by Langston Hughes. Reprinted by permission of the publisher. Written by Jerome Kern and Oscar Hammerstein II, "Ol' Man River." Lyrics © 1927 by PolyGram International Publishing, Inc. Copyright renewed. Used by permission. All rights reserved. Robert Frost, "West-running Brook," from *The Poetry of Robert Frost*, edited by Edward Connery Lathem. © 1956 by Robert Frost. Copyright 1928, © 1969 by Henry Holt and Company, Inc. Reprinted by permission of Henry Holt and Company, Inc. Helge Instad, excerpt from *The Land of Feast and Famine*, pp. 271–75. © 1992 by McGill-Queen's University Press. Reprinted by permission. David E. Lilienthal, excerpt from *TVA: Democracy on the March*, by David E. Lilienthal. Copyright © 1944 by David E. Lilienthal. Copyright renewed 1971 by David E. Lilienthal. Reprinted by permission of HarperCollins, Publishers, Inc. George Webb, excerpt from *A Pima Remembers*, University of Arizona Press, 1959. John Graves, excerpt from *Goodbye to a River* by John Graves. Copyright © 1959 by the Curtis Publishing Co. Copyright © 1960 by John Graves. Reprinted by permission of Alfred A. Knopf, Inc. Rachel Carson, excerpt from *Silent Spring* by Rachel Carson. Copyright © 1962 by Rachel L. Carson, renewed 1990 by Roger Christie. Reprinted by permission of Houghton Mifflin Co. All rights reserved. Woody Guthrie, "Roll On, Columbia." Words by Woody Guthrie, music based on "Goodnight Irene," by Huddie Ledbetter and John A. Lomax. TRO Copyright © 1936 (renewed), 1957 (renewed), and 1963 (renewed), Ludlow Music, Inc., New York, N.Y. Used by permission. Edward Abbey, excerpt from *Desert Solitaire*, McGraw-Hill, 1968. Copyright © 1968 by Edward Abbey, renewed 1996 by Clarke Abbey. Reprinted by permission of Don Congdon Associates, Inc. Wallace Stegner, excerpt from *The Sound of Mountain Water* by Wallace Stegner. Copyright © 1969 by Wallace Stegner. Used by permission of Doubleday, a division of Bantam Doubleday Dell Publishing Group, Inc. Randy Newman, "Burn On." Copyright © 1972 UniChappell Music, Inc. All rights reserved. Used by permission. Annie Dillard, excerpt of pages 19–21 from *Pilgrim at Tinker Creek* by Annie Dillard. Copyright © 1974 by Annie Dillard. Reprinted by permission of HarperCollins, Publishers, Inc. Ann H. Zwinger, excerpts from *Run, River, Run* by Ann H. Zwinger, University of Arizona Press, 1975, 1984. Copyright © 1975 by Ann H. Zwinger. Reprinted by permission of Frances Collin, Literary Agent. Norman Maclean, excerpts from *A River Runs through It* by Norman Maclean. Copyright © 1976. Reprinted by permission of the University of Chicago Press. Barry Lopez, "Drought," excerpt from *River Notes: The Dance of Herons*, by Barry Lopez. Used by permission of Andrews and McMeel. All rights reserved. William Least Heat Moon, excerpt from *Blue Highways: A Journey into America*, by William Least Heat Moon. Copyright © 1982 by William Least Heat Moon. By permission of Little, Brown and Company. Donald Worster, excerpts from *Rivers of Empire: Water, Aridity, and the Growth of the American West*, Pantheon Books, 1985, pp. 3–7. Copyright © 1985 by Donald Worster. Reprinted by permission of the author. William deBuys and Alex Harris, excerpt from *River of Traps*, University of New Mexico Press, pp. 194–200. Copyright © 1990. Reprinted by permission of University of New Mexico Press.

Continued on page 208, which constitutes an extension of this copyright page.

For Bertha and Jacqueline,
and for Nicholas

All rivers flow into the sea,
Yet the sea is never full;
To the place from which they flow,
The rivers flow back again.

—Ecclesiastes 1:7

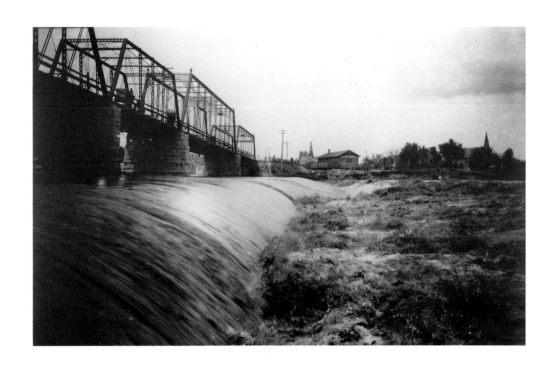

Kansas River dam and bridge in high water, n.d.
Kansas Collection, University of Kansas Libraries.

We have an unknown distance yet to run;
an unknown river yet to explore.
—John Wesley Powell, 1869

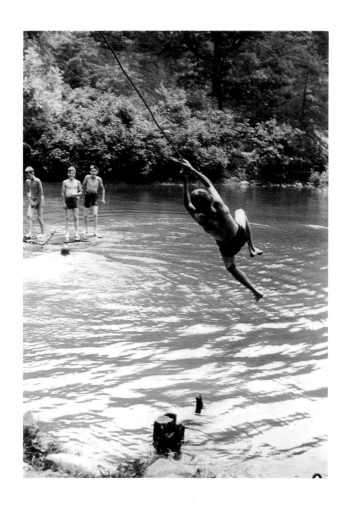

Swimming hole at Pine Grove Mills, Pennsylvania, July 1941.
Library of Congress, Geography and Map Division.

Contents

Water is our birthplace. We need and love it. In a bathtub (knees drawn up a little fetally), or by a lake or river, or at the sea, we go to it for rest and refreshment or solace. "I'm going to the water," city people say when August comes and they crave a break. The sea is a democracy, so big it's free of access, often a bus or subway ride away, a meritocracy, sink or swim, and yet a swallower of grief because of its boundless scale: beyond the horizon, the home of icebergs, islands, whales. Even our tears are a mysterious, magisterial solvent that bring a smile, a softening of hard thoughts, and lend us a merciful and inexpensive respite, like half an hour at the beach. In any landscape a pond or creek, amber or pewter-colored, catches and centers our attention as magnetically as if it were, in Thoreau's phrase, "earth's eye." And from there rivers run, sometimes placid, often not, to where the ocean thumps and crashes.

I live in Vermont, and my pond is a gentle spot fed by three springs in the woods, each a shallow sink in the ground that is perpetually filling. If you carefully lift away the bottom covering of waterlogged leaves, you see the penny-sized or pencil-point sources of crystalline water welling up, where it all begins—the brook, the pond, the stream, the lake, the river, and finally the ocean, till rain brings it back again. My pond feeds Wheeler Brook, which empties into Crystal Lake, and then the Barton River, then Lake Memphremagog, which straddles the Canadian border northward into Quebec, and the Magog River, and the St. Francis River, flowing into the vast St. Lawrence. (Some of Rogers' Rangers, in the French and Indian War, fled past my stream in 1759 after their devastating raid against the St. Francis Indians.) But if I walk about a mile through the woods, I'll reach a spring that is the headwaters of another brook that feeds into the Sutton River, and then the Passumpsic River, and the Connecticut River, and winds up way south in Long Island Sound.

Rivers were thoroughfares until rather recently. Audubon, Lewis and Clark, Peter Kalm, William Bartram, Johnny Appleseed, and the young Abe Lincoln of course used them, as did anybody who was anybody on the Hudson, the Mississippi, and half a hundred other regions. "The *Ohio* is the most beautiful region on earth," Thomas Jefferson once wrote. Alligators, alligator snapping turtles, sturgeons or garfish, "white bears" or black bears, pelicans, storks, cranes, swans, herons—all the panoply of nature might be present in the beginning. Logjams and sandbars, cutbanks and oxbows, dolphins, seals, moose swimming, salmon and eagles, quite

like an Alaskan river nowadays, and a riveting definition of the New World.

Rivers have carved the world, and, because they never stop moving—gray, brown, blue, black, or green on a single day—they seem infinitely reassuring. On bridges all over, people stand mooning over them. They can capture a culture, set it in relief, or embody the imagery of exoticism. The Thames, the Seine, the Rhine, the Tiber, the Volga, the Danube, the Ganges, the Yangtze, the Amazon, the Congo, the Niger. I've been to the official start of the Nile at Jinja, at 3,740 feet on Lake Victoria in Uganda (though the actual headwaters include such fractured places as Burundi and Ethiopia), and have driven northward to Nimule, where it crosses the Sudanese border, and to Juba, Malakal, Kosti, and Khartoum, in the Sudan, and have seen it also at Cairo and Alexandria in Egypt, 4,100 river miles away. Hippos and crocodiles swim in it, lions and elephants drink from it (the Siberian tiger was sometimes called the *Amur* tiger, after the great wild Asian river, 2,700 miles long, which the big cat roamed); and the Nile between Lake Albert and Lake No runs through the battleground of Africa's senior civil war, dating from 1955 until today, with two million dead. Much of the Nile is still primeval. But think of the art galleries in Europe from whose windows you can look out and—no coincidence—see running water.

My own brook and pond are a drinking fountain for scurrying raccoons and mincing deer, for a couple of bears, a lone bobcat, and a coyote family. A silent blue heron, as tall as a Christmas tree, and a castanet-rattling kingfisher—a faster flyer and a brighter blue—come fishing for frogs and tadpoles. Garter snakes also will grab a frog if they can, to upgrade their mostly nightcrawler diet. (I have two three-foot matriarchs living under my house who between them produce about fifty babies a year.) And a red-tailed hawk, cruising by, will sometimes swoop to seize a snake or frog, while the bobcat waits for a rabbit where the brook purls slow. Lately a bull moose has begun to use the pond as a hot-weather wallow, soaking for half an hour, mouthing algae, munching sedges, and browsing on the willows that lean from the bank. A

beaver cut down some poplars to gnaw and stitch into a dam that would create the proper depth and flow for wintering, but decided that the depth remained insufficient to withstand our Vermont temperatures and retreated downstream to a larger pond. In summertime, the trees hang over my swimming hole nearby, with a dovish sky showing beyond the canopy of leaves like a hugely enlarged swimming hole, as I watch the swallows and dragonflies hawk after midges, until I feel I was born floating both in the air and water. It's a beguiling hammock, and all the more so because if you relax too much while floating and swimming and let yourself sink, you could conceivably drown—the sky turning bruise-colored as autumn approaches.

"Religion is what the individual does with his own solitariness. . . . Thus religion is solitariness; and if you are never solitary, you are never religious," the philosopher Alfred North Whitehead wrote. That's what rivers give us—and the sheen of rainwater on a bare field in March, the crump of surf combed by the wind, foaming and glistening. One doesn't have to be in remote places. I lived beside the Hudson in downtown Manhattan for twenty years, and never failed to grin, in any weather, every morning when I stepped outside. A river is a solitary experience, and grinning sometimes a religion. In a lifetime I have been privileged to visit the Mississippi at Winona, Minnesota, and Venice, Louisiana; to swim in the Rio Grande and the Iowa River; to barge on the Hudson, Yukon, and Stikine rivers. The Tanana, the Taku, the Skeena, the Omineca, the Kuskokwim, the Koyukuk, the Copper, the Colville, and the Susitna rivers are some of the wilderness corridors that I've seen. And this is not boasting, this is a matter of priorities; you can go to all of them with a pack, on a shoestring.

Rivers are hopeful, rivers move: "the river of life," as we sometimes say, not "the mountain of life." Nor do you stand in the flow of a mountain and cast for fish. Rivers debouch out of somewhere beyond you, seamlessly replenished from a million sources, yet sliding toward a larger scheme. Rustling, rattling, peremptorily elbowing a roomy bed for themselves out of any sort of terrain—though often looking as sleek as taffeta even in a savage flood—

rivers represent large-scale order and small-scale chaos, whereas civilization is frequently the reverse: cities that have traffic lights but are disintegrating. Unfortunately, no program of restoration can re-establish that true primitive river clogged with hidden underwater tree-trunk snags, with deadwood driftpiles bristling just above the surface, and "sweepers," half-uprooted but still living trees overhanging the fast currents where the bank is newly cut away. Beavers inhabit the currents on the slow side, otters swim and dive about, arrowy ducks and V's of geese cross and recross the sky, and other birds land or else rise in clouds. This is a virgin river, with interminable mucky sloughs and swamps, churning eddies, shifting channels, ice jams, quicksand, whirling stretches, jagged rapids, abrupt falls, the water brown and chalk-colored in regular stripes where different tributaries join. We cannot "clean up" a contemporary river, remove the pollutants, restock it with hatchery fish, and have it be the same.

Rivers used to personify religion and God: perpetually replenished, untidy, changeable, limber, and strong. It must have been unimaginable, except supernaturally, to earlier peoples, how the water got back from the ocean so that the river still flowed. Coyote, Raven, or perhaps Eagle did it.

Peter Mancall's *Land of Rivers* begins with several such legends ("How Coyote Made the Columbia River"). And then Samuel de Champlain, on the Kennebec in 1605, weighs in. And William Penn, Benjamin Franklin, Thomas Jefferson. And John James Audubon at a log drive: the benign men and oxen, but the ferocity of the busted logjam. Hawthorne awed and savoring Niagara. Thoreau's paean to his Concord River, "probably as old as the Nile or Euphrates." Phoebe Judson's Big Blue River. Isaac Cowie's Ten Shilling Creek and Steel River. John Wesley Powell's breathless first raft reconnaissance of the Colorado. Horace Bixby matchlessly tutoring Sam Clemens in reading the Mississippi from the *Paul Jones*. John G. Neihardt—who loved the Missouri as much as Twain relished the Mississippi—condescending to the Nile as a mere "mummy" by comparison. And Robert Frost's "West-running Brook." And Langston Hughes's line, "My soul has grown deep like the rivers." And "Ol' Man River" and "Flat River Girl." And Helge Instad's Snowdrift River: "The Snowdrift is the most turbulent river east of Slave Lake." Proprietary like Neihardt and Thoreau.

Wallace Stegner's remembered glee as a boy on Henry's Fork of the Snake River, in *The Sound of Mountain Water*, John Graves's elegiac *Goodbye to a River*, memorializing Possum Kingdom and the Palo Pinto country on the Brazos River, and Norman Maclean's haunting rhapsodies on the subject of flyfishing the Big Blackfoot River represent a trio of masterly writers born near the beginning of this century, who could remember a more pristine wilderness, but witnessed its destruction. Lovers of wild, wild places like Jefferson, Audubon, Bartram, and Kalm, they passed the torch to younger writers like the naturalist Ann Zwinger, who is wonderfully lush yet precise at the headwaters of Wyoming's Green River, and Annie Dillard, in Virginia on Tinker Creek, watching water turtles "smooth as beans" and weightless as men bounding on the moon. And of course the seriocomic warhorse, Edward Abbey, the dean of late-twentieth-century nature writers.

But for an elegy, let's give the last word to Norman Maclean:

"Eventually all things merge into one, and a river runs through it. The river was cut by the world's great flood and runs over rocks from the basement of time. . . . I am haunted by waters."

EDWARD HOAGLAND

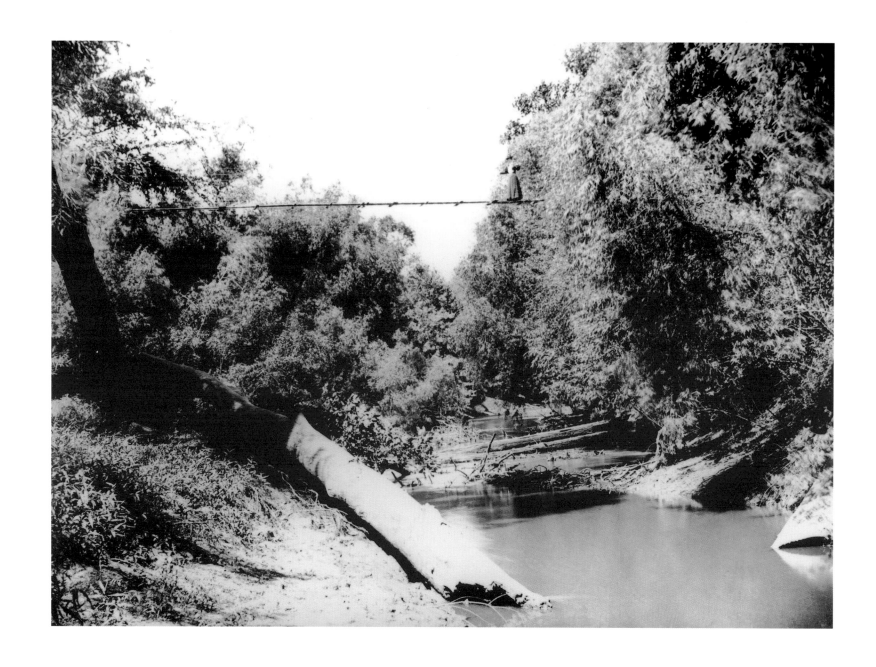

Woman on a suspension bridge over the Wakarusa River, late nineteenth century.
Kansas Collection, University of Kansas Libraries.

Preface

*P*inewa Creek, obscure even to most residents here on the eastern edge of the plains, runs through the southeast portion of my family's land in rural Douglas County, Kansas. This is not much of a waterway. For most of the year it is a creek in name only; muddy bottomland would be a more apt description. But during spring runoff, and after particularly violent storms during the rest of the year, Pinewa Creek carries water toward its juncture with the Wakarusa River, a tributary of the Kansas River. Once that water reaches the Kaw, as the Kansas River is known locally, it traverses Kansas until it drains into the Missouri River, and thence into the Mississippi. Hard as it is for me to believe, the water that my kids and dog are always eager to jump into will, some day, reach the greatest river that flows through the heart of the United States.

Many Americans, perhaps most, could make similar statements. With the exception of people who grew up in parts of the American West, most Americans, past and present, have lived near rivers. To be sure, many urban dwellers may pay little attention to the nearness of the Hudson, Potomac, Delaware, Charles, Chicago, or Mississippi, but they would not live where they do if it were not for those rivers. We dwell in a land of rivers. Perhaps this collection of prose and poetry, of paintings, drawings, photographs, and prints, will remind readers of that fact.

AN EARLIER VERSION of this book, *Roll On, River: Rivers in the Lives of the American People* (Washington, D.C., 1990), came about through the generosity of the National Endowment for the Humanities and its Discovery Through the Humanities Project. My involvement in the project began when the National Council on Aging (NCOA), a nonprofit group based in Washington, D.C., asked me to edit an anthology on rivers in America to be used in discussion classes for senior citizens around the country. Since the time of that invitation in 1989, I have been collecting stories and illustrations documenting Americans' views of the rivers that slice across the landscape. I therefore eagerly take the opportunity to thank the NCOA, especially Sylvia Liroff, for having faith that a historian of one eighteenth-century river valley might be able to put together a collection that reflected four centuries of American river culture.

Many people have, over the years, contributed to this project. Most important is Donald Worster, colleague and friend, who first suggested that the NCOA ask me to edit the collection, and who has given guidance throughout its existence. Along with the advisory committee for the NCOA volume, which also included Patricia Nelson Limerick, Ken Olsen, William H. Truettner, and the late Astere Claeyssens, Don shared his abundant knowledge of

American rivers. Others have also contributed, especially by making suggestions about the contents of the volume. I particularly want to single out Philip Barnard, Roy Goodman, David Katzman, Cheryl Lester, Lou Masur, Adam Rome, Joshua Rosenbloom, Mary Rosenbloom, Beth Schultz, Robin Schultze, and Cindy Taft. I received great help in the selection of illustrations from Mary Panzer of the National Portrait Gallery; several people at the Spencer Museum of Art at the University of Kansas, notably John Pultz and Steve Goddard; and the staff of the Kansas Collection, in the Spencer Research Library at the University of Kansas. Steve Jaffe, now at the South Street Seaport Museum in New York City, provided expert advice on illustrations for New York; Amy Flemming did the same for illustrations of the Wissahickon in the collections of the Library Company of Philadelphia. Terri Rockhold and Lisa Steffen helped me with the seemingly endless task of clearing permissions. The Word Processing Center at Kansas ably transcribed the texts. I thank as well the audiences at the "Worcester: Headwaters of the Blackstone River" conference in Worcester, Massachusetts, in 1992 and the "Flood of '93" conference in Marshall, Minnesota, in 1995 for their comments on an address that became the introduction for this volume. I am particularly grateful to Joe Amato for the invitation to deliver the keynote address to the Minnesota conference, and for his consistent support.

Several people went well out of their way to provide assistance. Peter Agree, my editor, early on recognized potential in this anthology and guided it through its acceptance, expansion, and publication with Cornell. Beth LaDow and Joshua Alper provided suggestion after suggestion, constantly offering advice and support. Lou Masur paid enormous attention to the introduction, giving it a clarity that it would otherwise have lacked, and sharing with me his enormous knowledge of visual images. And Lisa Bitel, as ever, has kept me going along with this project; her comments on every draft improved the book.

Punctuation and spelling have been silently corrected in places to make quotations more readily understandable. Whenever it has been possible to do so I have left quotations in their original form.

I dedicate this book to my grandmother, to my mother, and to my son. Families are not rivers, but they too nurture and sustain.

P.C.M.
Lawrence, Kansas

OPPOSITE: Alvin Langdon Coburn, *Brooklyn Bridge*, 1910. Spencer Museum of Art/University of Kansas.

LAND OF RIVERS

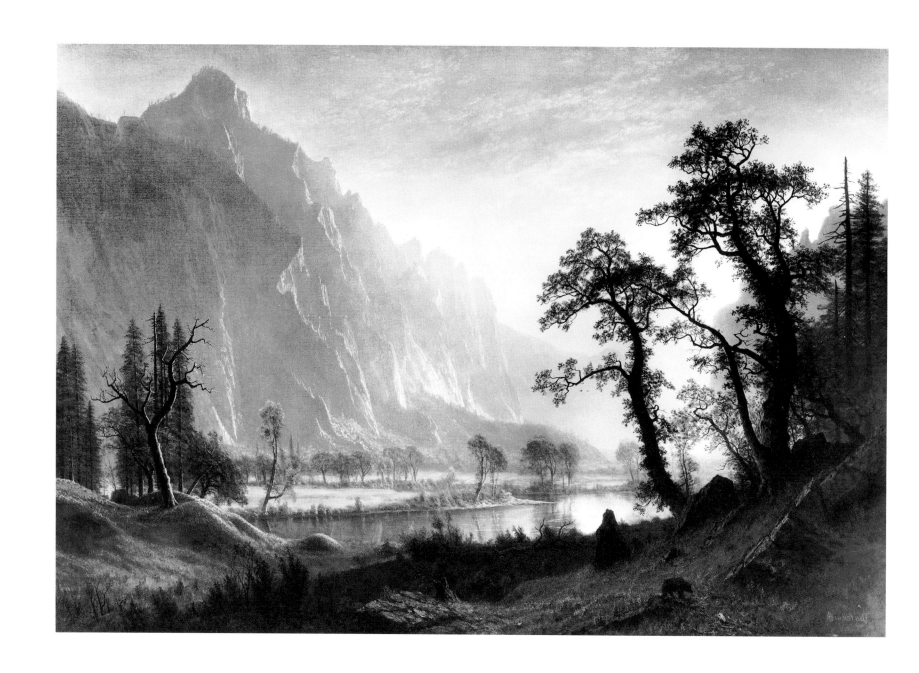

Albert Bierstadt, *Sunrise, Yosemite Valley,* c. 1870.
Amon Carter Museum, Fort Worth, Texas.

River Cultures of North America

*A*merica has always been a land of rivers. Many of its greatest writers have described the rivers of the United States and Canada, and painters, printmakers, and photographers have added to the riparian canon. Rivers are ubiquitous in our culture. As the late Norman Maclean wrote: "Eventually, all things merge into one, and a river runs through it."[1]

Over the past four centuries, rivers have figured prominently in the dreams of Americans. These visions—whether embodied in Indian myths of origin, the journals of explorers and pioneers, the detailed prospectuses of would-be developers and structural engineers, or evocative literary works—survive, and we can use them to reconstruct, at least in part, the ways disparate groups of Americans understood the natural world they inhabited. Some, whether they aimed at improving human living conditions or at economic gain, transformed their dreams into reality by harnessing the power of rivers. Others, often in response to economic development, celebrated the natural state of American waterways, some romanticizing a pristine condition in retrospect, still others arguing for present and future preservation measures.

From the rivers draining into Chesapeake Bay in the east to the Columbia in the northwest, and from the often barely detectable Rio Trampas of the southwest to the ice-laden currents ripping through the northeast and into Canada, rivers throughout America have evoked a gamut of emotions, and writers and artists have left us images of the entire spectrum. Some of the most famous works—Mark Twain's writings about the Mississippi, the landscape paintings of Albert Bierstadt and Frederic Church—are conceived on a grand scale and evoke an awed response. Renderings of more intimate landscapes, such as those by Wallace Stegner and Edgar Allan Poe, move the reader in more subtle ways. And who among us can look at depictions of the Johnstown Flood and not tremble at the destruction that such torrents can unleash?

To grasp the history of American rivers, we need to remember that modern industrial developers were not the first to look at these watercourses and see profits. It is no coincidence that the beginnings of Western civilization developed in ancient Mesopotamia between the Tigris and the Euphrates, and that all the major cities of the ancient world grew along the banks of rivers. People have always built their largest population centers near rivers or other major bodies of water. Cairo has the Nile, Paris the Seine, London the Thames, Rome the Tiber, Budapest the Danube, and

Moscow the Moskva. The European settlement of North America followed the same pattern. The important colonial and antebellum centers—Montreal, Quebec, Boston, New York, Philadelphia, Washington, Charleston—all had rivers flowing nearby or through them, and smaller communities, especially the village-like Chesapeake tobacco plantations, formed on or near rivers as well. Later urban centers, notably Pittsburgh, Cincinnati, New Orleans, St. Louis, and Kansas City, grew up by the great rivers—the Ohio, the Mississippi, and the Missouri—that cut across the continent.

Long before, American Indians had also created their most important settlements in river valleys, though many, particularly in the northeast, did not remain there throughout the year. Eastern woodlands Indians knew well the seasons of the year when anadromous fish made their annual migrations, when thousands of salmon ventured upstream to spawn, and they incorporated these fish runs into their seasonal rounds, camping near particularly rich rivers and streams. Further, Indians knew early on that river valley land was the most fertile. Though they also knew that rapids, shallows, and falls could be dangerous, many groups relied on rivers as a source of water and a means of transportation, and rivers also figured in healing rituals. Given the centrality of rivers in their lives, it is not surprising that some Indians incorporated them into the most intimate and vital aspects of their cultural and religious beliefs and told stories that recounted the supernatural origins of particular rivers.

But it was not the stories told by Indians that led Europeans to cross the Atlantic and settle along the banks of American rivers. Instead, the colonists acted on time-tested principles deeply enshrined in their own histories and cultures. In the early sixteenth century Thomas More had informed his English readers that the residents of Amaurotum, capital city of Utopia, appreciated the advantages of the river Anydrus. Though the city suffered from the backwash of saltwater from the ocean—a situation identical to that in London—the location also conferred a great advantage: the river brought ocean-going ships directly to the city's port. (Besides, the Utopians of the capital could always get drinking water from another nearby river, from which they had built "conduits . . . of baked clay" to transport water into various parts of the town.[2]) Writings other than political philosophy also attested to the significance of rivers. The epic poem *Poly-Albion* by Michael Drayton, for example, published in London in 1613, contained within its five hundred–plus pages numerous references to the rivers of the realm and their importance.

Potential colonists also read the works of those who promoted overseas settlement. In the decades leading up to the founding of Jamestown, skillful promoters portrayed America's rivers as avenues to almost unimaginable prosperity. Richard Hakluyt the Elder, an eager advocate of American colonization in the late sixteenth century, was unequivocal: "The great broad rivers of that main that we are to enter into," he wrote in 1585, ". . . do seem to promise all things that the life of man doth require and whatsoever men may wish." American rivers, Hakluyt argued, could be used to transport goods from the interior to the coast and from the ocean to inland settlements, and they could be significant in the defense of settlements. Furthermore, he wrote, the "known abundance of fresh fish in the rivers, and the known plenty of fish on the seacoast there, may assure us of sufficient victual in spite of the people, if we will use salt and industry." No wonder that he thought that these "rivers so great and deep" would be the key to creating successful colonies in America.[3]

A similar entrepreneurial spirit appeared in the work of Alexander Whitaker, who delivered a sermon in Virginia in 1613, subsequently published in London under the title "Good News from Virginia." Whitaker believed that the natural advantages of America had one ultimate source. "Wherefore," he wrote, "since God hath filled the elements of earth, air, and waters with His creatures, good for our food and nourishment, let not the fear of starving hereafter, or of any great want, dishearten your valiant minds from coming to a place of so great plenty."[4] Whitaker's was a vision of a great network of rivers linking settlements on or near Chesapeake Bay with the untold riches of the interior.

Other colonizers, not all of them English, honored these notions through their actions. They set out to explore with the idea that one river would lead them to the mythic Northwest Passage, that

water route to the Pacific Ocean and the great Asian market on the other side of their world. The earliest European maps of North America crystallized these longings into seemingly undeniable geographic fact: rivers reached from the Atlantic deep into the interior, their tributaries stretching like veins toward otherwise inaccessible places.

Over the course of the colonial period, the settlers and their heirs, like the Indians before them, learned that achieving prosperity beside a great river was not always easy. Many rivers flooded during the spring, washing away the dwelling of any newcomer improvident or foolish enough to have built too close to their banks. In Jamestown and elsewhere, rivers that ran fresh during spring turned into virtual pits of disease and filth during the summer when runoff slackened and rainfall could be rare. Residents contracted salt poisoning, typhoid, and dysentery from the stagnant James River, both the source of their drinking water and the ultimate deposit of their fecal refuse.[5] Elsewhere along the east coast mosquitoes carried yellow fever and malaria to the unfortunates who lived in low-lying areas, particularly near rivers; on occasion, as at Philadelphia in 1793, yellow fever epidemics killed thousands of residents, many of them the poor who were unable to flee the scourge. Rivers, early Americans learned, brought opportunity, but they could also bring death.

Still, the promise of prosperity dominated the colonial vision of rivers, and that vision survived beyond the Revolution. Thomas Jefferson's *Notes on the State of Virginia* (1787) included a chapter on rivers, and waterways figured prominently in numerous plans for expansion and economic development in the early republic.[6] The idea of transforming rivers into natural engines to drive the machines of the industrial world gathered headway gradually in the late eighteenth century and soon became reality in the work of technological innovators such as Samuel Slater, whose textile mills reshaped the Blackstone River.[7]

The early desire to harness river power was most clearly expressed by Tench Coxe, an assistant in the Treasury Department under Secretary Alexander Hamilton, himself a great promoter of American economic development. Coxe's vision for American

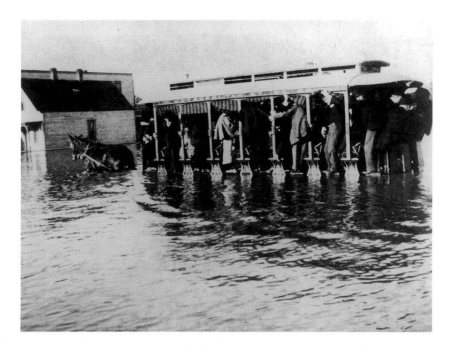

Osage Avenue, Armourdale, Kansas City, Kansas, during the flood of 1892.
Kansas Collection, University of Kansas Libraries.

rivers, like that of many who preceded him, stemmed from his assessment of contemporary political issues and their impact on commercial prospects in the newly independent United States. Writing in the mid-1790s, when the French Revolution threatened the peace of much of Europe and jeopardized the transatlantic trade in manufactured goods, Coxe argued that Americans above all needed to develop inland towns and take advantage of the continent's many rivers.

He illustrated his point by envisioning a town that he believed should be created in the hinterland of central Pennsylvania, along the banks of the Susquehanna River. The settlers of Coxe's town would be able to take advantage of the river to drive mills for processing hemp, flax, paper, and other goods. These industries would require other institutions and artisans to support them: distilleries, schools, blacksmiths, boat-builders. Coxe expected the new town to become, as he wrote, an "*auxilliary* to Philadelphia, as Manchester, Leeds, Birmingham, and Sheffield, &c. are to the sea-ports of Great-Britain." Thus roads would be needed to connect the town to turnpikes and to other developing cities. Once the roads were cut, Coxe argued, the town would prosper. "Thus circumstanced," he wrote, "and with the supplies of wood-fuel, coal, bark, grain, cattle, hemp, flax, wool, timber, iron, stone, lime, forage, &c. which those roads, and the Susquehannah and its branches, would certainly and permanently afford, this place could not fail to become of very great profit to the subscribers or prize holders, or the state, and to the landed interest, both tenants and owners." Coxe castigated Americans who had built inland towns "without due attention to the powers of water, the advantages of interior navigation, and a copious and certain supply of other fuel, when wood shall become scarce and dear."[8]

Coxe here demonstrated an awareness of one of the most enduring aspects of rivers: unlike forests, whose economic value was exhausted once they had been cut down, rivers held a power that had no conceivable end. They were the ideal source of energy for the machines of the American industrial revolution. Coxe's imaginary town on the Susquehanna soon became a reality with the growth of Williamsport, Binghamton, Wilkes-Barre, and Scranton. What Coxe did not foresee any more than his forebears at Jamestown were the problems to which harnessing rivers gave rise. Dams needed to regulate the flow of water to drive mills flooded farmers' fields upstream and prevented the movement of anadromous fish. As a result farmers lost their crops and many hinterland residents felt deprived of their customary fishing rights. From the late eighteenth century into the nineteenth, courts adjudicating individual cases generally ruled in favor of what they held to be the public good. Thus in Rhode Island the courts sided with mill owners whose dams cut off the supply of migrating fish and in doing so helped to solidify an emerging legal tradition that diminished customary rights deemed threatening to economic development. The right to fish, it should be noted, was not some recreational innovation claimed by self-serving farmers who liked to go fishing occasionally. It was, instead, an ancient right, declared in the Magna Charta and upheld for centuries in medieval and early modern England. When farmers in Rhode Island petitioned to maintain their right to fish they drew on long-standing, legally codified opposition to dam-builders.[9] Jurists who supported economic development in spite of the costs to other valley residents were deciding more than disputes over specific resources. They were also determining which resources would survive in an increasingly industrialized world.[10]

By the time textile developers were building their mills, Americans had, by and large, accepted the legitimacy of altering the natural world and its watercourses to serve their economic demands. Farmers and fish, it turned out, had little clout in the contest to control the rivers of an industrializing America, a fact sadly familiar to Henry David Thoreau. "Salmon, Shad, and Alewives, were formerly abundant here," he wrote in *A Week on the Concord and Merrimack Rivers* (1849), "and taken in weirs by the Indians, who taught this method to the whites, by whom they were used as food and as manure, until the dam, and afterward the canal at Billerica, and the factories at Lowell, put an end to their migrations hitherward." Thoreau thought that the fishes' fate was permanent,

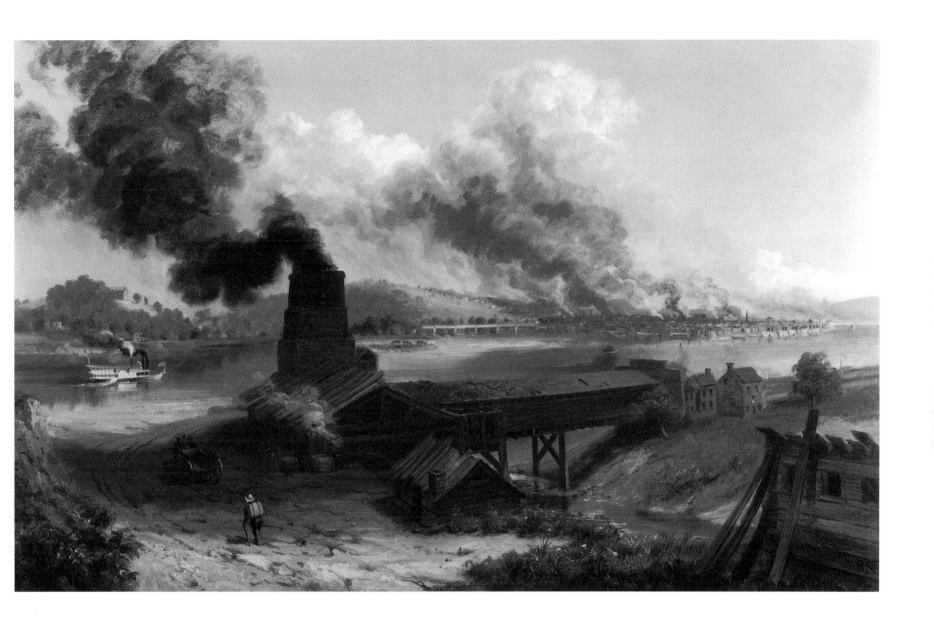

Russell Smith, *Pittsburgh Fifty Years Ago from the Salt Works on Saw Mill Run*, 1884.
The Carnegie Museum of Art, Pittsburgh, Museum purchase, gift of Howard Heinz endowment.

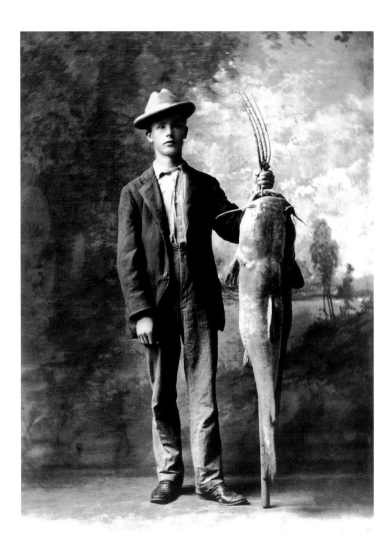

John Welsh and catfish, n.d.
Joseph J. Pennell Collection, Kansas Collection, University of Kansas Libraries.

though he held out a small hope for their return: "Perchance, after a few thousand of years, if the fishes will be patient, and pass their summers elsewhere, meanwhile, nature will have levelled the Billerica dam, and the Lowell factories, and the Grass-ground River run clear again, to be explored by new migratory shoals, even as far as the Hopkinton pond and Westborough swamp."[11]

Throughout the nineteenth and into the twentieth century Americans continued to look to rivers for their economic potential. In the nineteenth-century West, farmers, especially those who hoped to grow crops in areas that received little annual rainfall, wanted land near rivers. Irrigation, claimed William Smythe, the leading advocate of the practice in late-nineteenth-century America, would spread democracy, lead to widespread economic improvement, and advance the cause of agricultural science. Reading his great work, *The Conquest of Arid America*, first published in 1899, we sense that for Smythe, as for Coxe, the greatest advantage of rivers lay in their utility: their potential to be manipulated by men and women with the knowledge necessary to develop ever further the resources of the nation and advance a democratic society. "The conditions which prevail where irrigation is not necessary—large farms, hired labor, a strong tendency to the single crop—are here reversed," he wrote. "Intensive cultivation and diversified production are inseparably related to irrigation. These constitute a system of industry the fruit of which is a class of small landed proprietors resting upon a foundation of economic independence." "This," he stressed, "is the miracle of irrigation on its industrial side."

Smythe envisioned a new relation of city and country. "The great cities of the western valleys will not be cities in the old sense," he noted, "but a long series of beautiful villages, connected by lines of electric motors, which will move their products and people from place to place. In this scene of intensely cultivated land, rich with its bloom and fruitage, with its spires and roofs, and with its carpets of green and gold stretching away to the mountains, it will be difficult for the beholder to say where the town ends and the country begins. This is the miracle of irrigation upon its social side." Furthermore, irrigation made it possible to grow a wide

variety of useful plants, a development Smythe predictably termed "the miracle of irrigation upon its scientific side."[12]

Smythe seems, in retrospect, almost naive in his sense that scientific progress would lead to human progress, that the "miracle" of irrigation could solve the agricultural problems facing western Americans without creating new problems. Yet that same faith in the power of rivers continued to drive the American quest for economic development, with results both beneficial and harmful. One of the most spectacular and far-reaching was the building of dams to create hydroelectric energy in the twentieth century.

David Lilienthal, chairman of the Tennessee Valley Authority (TVA) in the early 1940s, was a firm believer in the benefits of this process. To read his remarkable book, *TVA: Democracy on the March* (1944), now is to be transported to an age little different from Smythe's, but far from ours. Lilienthal placed the utmost trust in the government to develop natural resources wisely, and, in those last years before the birth of the atomic age, he unquestioningly believed that science would lead people to a better world. The dams built on the five rivers in the TVA system had numerous benefits, not least the expediting of barge traffic and the gains in flood control. But the electric power the rivers generated was the project's greatest contribution. "No major river in the world is so fully controlled as the Tennessee," Lilienthal declared, "no other river works so hard for the people, for the force that used to spend itself so violently is today turning giant water-wheels. The turbines and generators in the TVA powerhouses have transformed it into electric energy. And this is the river's greatest yield."[13]

Here, in its most unambiguous form, was the modern American creed, developed over three centuries as Americans sought prosperity by putting nature to work, controlling it, and reaping great rewards. Why, after all, should rivers flow in their natural courses when their power could be harnessed for human advancement, their dangers reduced? In this scheme of things, rivers were no different from any other commodity and thus could be fitted to serve specific economic purposes. To deal with them otherwise, Lilienthal and others presumably believed, would be to violate the command God had given to Adam and Eve: "Be fertile and increase, fill the earth and master it; and rule the fish of the sea, the birds of the sky, and all the living things that creep on earth" (Genesis 1:28). Wedded to the American conviction that economic development aided the cause of democracy by spreading the benefits of commerce and industry to an ever-widening circle of people, the biblical sanctification of human control over nature provided even further justification for the attempt to take from the environment whatever was necessary to make a profit.

OTHER AMERICANS THOUGHT about rivers very differently and valued them for reasons that had nothing to do with profit. Even in the colonial period not every observer looked to rivers for economic gain. Samuel Sewall's ode to the Merrimack was not a Puritan plan for development but a celebration of nature's (and thus God's) great works. Benjamin Franklin's scientific musings about rivers and tides were not composed in the service of economics but instead sought to explain and thus promote a fuller appreciation of the natural world.

The industrial revolution itself, as its canals and dams transformed the flow of rivers and the movements of people and goods during the nineteenth century, provoked an openly romantic celebration of rivers, evident in prose, poetry, and the visual arts, particularly landscape painting. When Nathaniel Hawthorne wrote about his visit to Niagara Falls (1835); when Harriet Beecher Stowe, in the middle of the century, sent Eliza across the ice in *Uncle Tom's Cabin* (1851); and when Frederic Church (in, for example, his *Twilight, "Short Arbiter 'Twixt Day and Night"* of 1850) and Albert Bierstadt (in *Platte River, Nebraska* of 1863 or *Sunrise, Yosemite Valley* of 1870) depicted rivers flowing across their epic and myth-strewn western American landscapes, rivers took on a primal force that they lacked in the developers' imaginings. Similar themes also dominated the paintings of the Hudson River School (such as Thomas Cole's *The Oxbow on the Connecticut River* of 1836), though often on a somewhat smaller scale than in western landscapes. Rivers might be altered by people, these artists recognized, but they still inspired

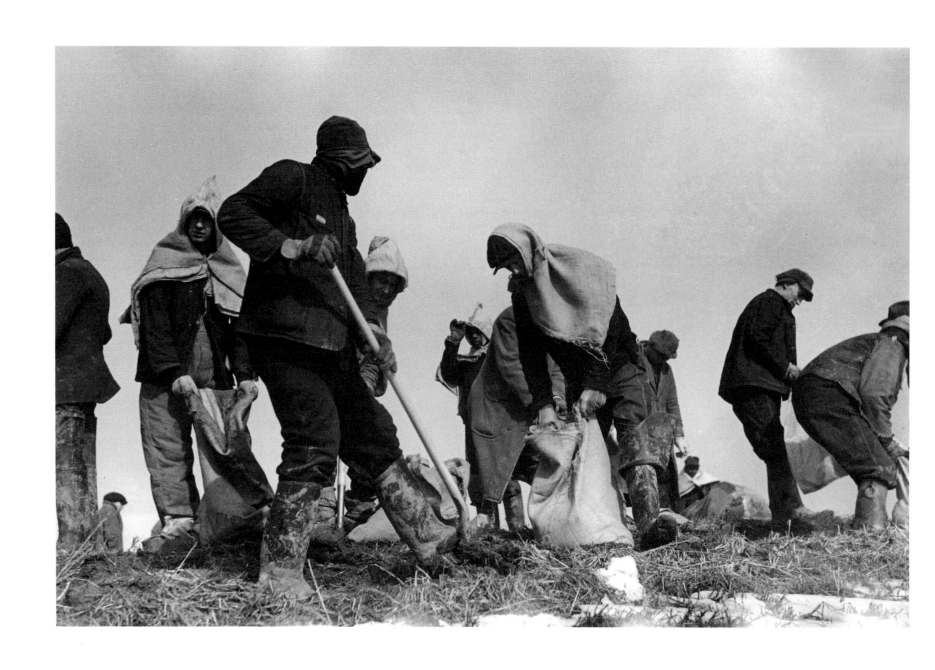

Working the levee during the height of the flood, near Bird's Point, Missouri, January 1937.
Library of Congress.

wonder and had the ability to dwarf the individuals who tried to master them. And rivers remained potent symbols, carriers of emotional and spiritual significance. Perhaps the most famous of all American paintings is Emanuel Leutze's depiction of one of our founding myths, *Washington Crossing the Delaware* (1851). Rivers obviously also bore religious meaning for the many people who incorporated them into the ritual of baptism.[14]

Rivers as symbols of primal nature—the natural world's and our own—resonate in twentieth-century art as well, especially in works of fiction. When floodwaters engulf convicts in William Faulkner's "Old Man" (1939) or when, in Eudora Welty's "The Wide Net," a husband rounds up friends to go fishing for his wife who has reportedly jumped into a river, the authors are describing people at risk in a natural world beyond human control. And, like Ernest Hemingway in "Big Two-Hearted River," writers on fishing (those American heirs to Izaak Walton) describe rivers in which fish still abound—rivers, that is, whose original diversity survives. Perhaps Wallace Stegner put it best when he recalled his experiences along a mountain stream. "Watch its racing current, its steady renewal of force: it is transient and eternal," he wrote in *The Sound of Mountain Water* in 1969. "And listen again to its sounds: get far enough away so that the noise of falling tons of water does not stun the ears, and hear how much is going on underneath—a whole symphony of smaller sounds, hiss and splash and gurgle, the small talk of side channels, the whisper of blown and scattered spray gathering itself and beginning to flow again, secret and irresistible, among the wet rocks." The vision is powerful, and rendered so clearly in Stegner's prose that we share his belief that "by such a river it is impossible to believe that one will ever be tired or old."[15]

THE ATTITUDES UNDERLYING THE PROSE and paintings of many nineteenth-century Americans and some of their twentieth-century heirs constitute one kind of protest against the unfettered pursuit of profit that drove the building of dams and canals regardless of the ecological, and often social and spiritual costs. By the late twentieth century, however, American writers, often gather-

ing evidence from photographers who bore witness to the ravages inflicted on American rivers, shifted the direction of protest. Though they continued to evoke nature and its splendors, they did so while describing the human and environmental costs of unrestrained development, often with the explicit goal of stimulating a demand for changes in federal policy. Threats to the nation's rivers and the protests the threats engendered constituted defining moments in the origins and growth of the conservation movement in America.[16]

Late-twentieth-century conservationists, of course, were not the first to have qualms about the development of the environment. More than a hundred years earlier, George Perkins Marsh, along with Thoreau, had called attention to the far-reaching ecological changes brought about by massive human alteration of the natural world.[17] And by the end of the nineteenth century, Americans motivated by a variety of concerns had become uneasy with the long-term deterioration of the environment and were seeking ways to preserve it, or at least to manage economic development so as to prevent an impact as deleterious as those of earlier efforts dominated by the relentless pursuit of profit. Some wanted resources managed more efficiently; others wished to ensure that the benefits of developing resources would be equally distributed; still others found that preservation had its own aesthetic benefits. But whatever their motives, they were only partially successful in stemming environmental decline and making conservation a valued pursuit. Significantly, these writers and planners still retained a faith that government could, if properly directed, work to preserve the environment.[18]

By the post–World War II period many Americans demonstrated greater skepticism, and environmentalists sought to undermine the ideological premises that had long supported American economic development. These activists took their message directly to their audiences in unambiguous prose: no longer should Americans sacrifice the environment for the sake of progress. Consider, for a moment, the views of John Graves. He resented the damming of parts of the Brazos River in Texas, a stream he had fished early

in his life. Upon hearing that the river would soon be forever changed, Graves returned to travel it one more time, "to float my piece of the river again," as he put it in his moving book *Goodbye to a River* (1960).[19] Rather than simply and privately mourn the changes in the river, he went public with his qualms and pointed out that development of rivers was in some ways destroying them.

Others were more bitter, especially those who lived in or traveled through the American West, where the construction of dams and irrigation systems shocked many people. Edward Abbey skewered the working premises of the United States Bureau of Reclamation—the "beavers," he termed them—who made the decision to flood Glen Canyon, one of the most beautiful canyons in the American West. Abbey had traveled the river before the dams, and he believed that he was lucky to have seen it all. "In fact I saw only a part of it but enough to realize that here was an Eden," he wrote in *Desert Solitaire* in 1968, "a portion of the earth's original paradise. To grasp the nature of the crime that was committed imagine the Taj Mahal or Chartres Cathedral buried in mud until only the spires remain visible. With this difference: those manmade celebrations of human aspiration could conceivably be reconstructed while Glen Canyon was a living thing, irreplaceable, which can never be recovered through any human agency." "The love of wilderness," Abbey told his readers, "is more than a hunger for what is always beyond reach; it is also an expression of loyalty to the earth, the earth which bore us and sustains us, the only home we shall ever know, the only paradise we ever need—if only we had the eyes to see. Original sin, the true original sin, is the blind destruction for the sake of greed of this natural paradise which lies all around us—if only we were worthy of it."[20] Why did such destruction occur? Because, as the environmental historian Donald Worster has argued, the "hydraulic society" we inhabit is based on the constant appropriation and channeling of river water for economic ends.[21]

More powerful than Graves or Abbey, whom the advocates of economic development could dismiss as idealistic romantics, was the growing body of evidence that American rivers were becoming increasingly polluted. Rachel Carson's *Silent Spring*, published first in *The New Yorker* and then in book form in 1962, brought the effects of such degradation eloquently to the attention of the public. Most of America's largest rivers, Carson argued, were transporting pesticides from farms and forests; these pesticides were killing waterborne insects and the fish that fed on them and the animals and birds that fed on the fish. Rivers, the necessary conduits for the movement of the life-sustaining elements of the world, had become what Carson aptly termed "rivers of death." Though her campaign against DDT proved successful, later reports about other toxins in rivers, and in harbors containing the residue of decades of waste transported downstream, demonstrate that her vision of a "silent spring" may yet be realized.

How had it happened? How did rivers, for centuries vital to American life, become carriers of death-dealing toxins? At what point did industrial development so denigrate the natural world that efforts to control and exploit nature became forms of social and economic suicide? Why had we allowed such destruction to take place?

It is difficult even in hindsight to point to the moment or moments when the industrial uses of rivers began to undermine the environment. Human beings, after all, always modify the natural world. Perhaps the vision of Tench Coxe and Samuel Slater was benign; they, after all, wanted only to extract the power of rivers, though the declining fish yields that followed seemed to signal the ecological costs of their efforts. Perhaps the early advances in the American economy and the production of textiles were worth those declines. Perhaps Smythe's ideas were equally benign. After all, irrigation did lead to massive agricultural expansion, especially in the West, although it is also true that such expansion has only intensified, not reduced, the concentration of farmland in the hands of a small number of agribusinessmen.[22] And Lilienthal and others who celebrated dam-building cannot be faulted for their earnest desire to spread electricity to people who did not have it and to facilitate the movement of goods throughout the country.

At some point, however, perhaps as early as the late eighteenth century, Americans became enthralled with the alleged benefits of industrialism and the consumer revolution that it spawned. At that moment, our desire to use rivers became inexorably transformed into our inability to stop abusing them. Rivers are, as the environmental historian Richard White has written, "organic machines" flowing through our midst, tempting us to use their raw energy to serve our needs.[23] We have for so long conjoined our belief in progress to our need to develop rivers that we have been unable to see the long-range consequences of our actions for the rivers themselves. In this we are not alone. Only a few years ago a Japanese government official, in response to environmentalists' efforts to stop the development of the last free-flowing river in Japan, scolded: "It is just emotional sentimentalism to want a river to remain just as it is." "Such thinking," he concluded, "has no place in modern society."[24]

In the United States we have begun to realize that at least some rivers need to survive in their natural state if Americans are to maintain a world that we can both appreciate and continue to depend upon for our survival. That was the premise of Public Law 90-542, the Wild and Scenic Rivers Act, passed by Congress in 1968. The passage of that act signaled a historic change in America: the codification of the belief that, in the future, some rivers must be protected from economic exploitation. Such a notion would have shocked Tench Coxe and William Smythe and others who made the development of American rivers the central component of their plans for economic and national success.

But these free-flowing rivers are not common, and the act came too late to prevent, or sensibly manage, industrial encroachment, particularly on rivers in the eastern United States. The transformation of New England waterways into dynamos to drive the mills of the industrial revolution represented only the first stage in the course of American economic history. Other rivers too became integrated into commercial plans, from those on which logs were floated downstream in Maine and Pennsylvania (the sites of early lumbering booms) to others diverted for irrigation in the West, with far-reaching ecological effects. Contrary to the hopes of many conservationists at the beginning of the twentieth century, the fruits of such economic expansion have not led to any significant redistribution of wealth, nor have they in any way enhanced the splendor of American valleys.[25] And the movement of ever-larger numbers of people into the relatively arid lands of the southwest continues to damage the rivers, especially the Colorado, siphoned off to meet a demand for water to sprout lawns in the desert.[26]

The market-oriented ideology that initially inspired the development of rivers has survived largely intact. Little else explains our grotesque indifference to the pollution of rivers and the bodies of water, such as Boston Harbor or Chesapeake Bay, into which rivers relentlessly dump the industrial effluvia of our society. Centuries of tradition, no matter how distasteful, are difficult to overcome. Those who wish to exploit American rivers probably feel that they have a customary right to pursue their vision of prosperity with little interference from regulatory agencies and environmentalists; that is the lesson *they* derive from American river culture. In difficult economic times, some developers still deliberately pollute rivers, claiming that their actions are intended to save jobs.[27]

The future ecological vitality of American rivers is very much in doubt, and will remain so as long as our dominant economic sensibilities value profit and production for the market over preservation of the environment. Perhaps some greater consideration of the importance of rivers in American life will contribute to a redefinition of priorities. Maybe someday Americans will learn how to restrain our inherited desire to develop, in Hakluyt's phrase, the "rivers so great and deep" flowing so temptingly before our eyes.

Notes

1. Norman Maclean, *A River Runs through It and Other Stories* (Chicago, 1976), 104.

2. Thomas More, *The Best State of a Commonwealth and the New Island of Utopia* (orig. Louvain, 1516), in Edward Surtz and J. H. Hexter, eds., *The Complete Works of St. Thomas More*, 15 vols. to date (New Haven, Conn., 1965), 4:117–19.

3. Richard Hakluyt the Elder, "Inducements to the Liking of the

Voyage Intended towards Virginia in 40 and 42 Degrees of Latitude," in Louis B. Wright, ed., *The Elizabethans' America* (Cambridge, Mass., 1965), 28–29.

4. Alexander Whitaker, "Good News from Virginia," in Wright, ed., *Elizabethans' America*, 222.

5. Carville Earle, "Environment, Disease, and Mortality in Early Virginia," in Thad W. Tate and David L. Ammerman, eds., *The Chesapeake in the Seventeenth Century: Essays on Anglo-American Society and Politics* (Chapel Hill, N.C., 1979), 96–125.

6. Thomas Jefferson, *Notes on the State of Virginia*, ed. William Peden (Chapel Hill, N.C., 1955), 5–16; John Seelye, *Beautiful Machine: Rivers and the Republican Plan, 1755–1825* (New York, 1991), passim.

7. Gary Kulik, "Textile-Mill Labor in the Blackstone Valley: Work and Protest in the Nineteenth Century," in Douglas M. Reynolds and Marjory Myers, eds., *Working in the Blackstone River Valley: Exploring the Heritage of Industrialization* (Woonsocket, R.I., 1990), 109.

8. Tench Coxe, *A View of the United States of America* (Philadelphia, 1794; rpt. New York, 1965), 380–93.

9. Gary Kulik, "Dams, Fish, and Farmers: Defense of Public Rights in Eighteenth-Century Rhode Island," in Steven Hahn and Jonathan Prude, eds., *The Countryside in the Age of Capitalist Transformation* (Chapel Hill, N.C., 1985), 25–50.

10. See Morton Horwitz, *The Transformation of American Law, 1780–1860* (Cambridge, Mass., 1977), chap. 2; and Peter C. Mancall, *Valley of Opportunity: Economic Culture along the Upper Susquehanna, 1700–1800* (Ithaca, N.Y., 1991), 209–13.

11. Henry David Thoreau, *A Week on the Concord and Merrimack Rivers*, ed. Carl F. Hovde (1849; Princeton, N.J., 1980), 33–34.

12. William E. Smythe, *The Conquest of Arid America* (New York, 1899), 44, 46–47, 48.

13. David E. Lilienthal, *TVA: Democracy on the March* (New York, 1944), 16.

14. For a remarkable modern account of the importance of a river in baptism see Flannery O'Connor's "The River," in O'Connor, *The Complete Stories* (New York, 1977), 157–74.

15. Wallace Stegner, "Overture," from *The Sound of Mountain Water* (New York, 1969).

16. Tim Palmer, *Endangered Rivers and the Conservation Movement* (Berkeley, Calif., 1986).

17. George Perkins Marsh, *Man and Nature: Or, Physical Geography as Modified by Human Action*, David Lowenthal, ed. (1864; Cambridge, Mass., 1965).

18. Clayton R. Koppes, "Efficiency, Equity, Esthetics: Shifting Themes in American Conservation," in Donald Worster, ed., *The Ends of the Earth: Perspectives on Modern Environmental History* (New York, 1988), 230–34, 241–43.

19. John Graves, *Goodbye to a River* (New York, 1960), 9.

20. Edward Abbey, "Down the River," from *Desert Solitaire: A Season in the Wilderness* (New York, 1968), 152, 167.

21. See Donald Worster, *Rivers of Empire: Water, Aridity, and the Growth of the American West* (New York, 1985).

22. Worster, *Rivers of Empire*.

23. Although White was writing particularly about the Columbia River, his points have more general applicability. See Richard White, *The Organic Machine: The Making of the Columbia River* (New York, 1995).

24. Quoted in Colin Nickerson, "Japan to Still Its Last Wild Waters," *Boston Globe*, April 15, 1992.

25. See Theodore Steinberg, *Nature Incorporated: Industrialization and the Waters of New England* (New York, 1991), and Worster, *Rivers of Empire*.

26. See Gary D. Weatherford and F. Lee Brown, eds., *New Courses for the Colorado River: Major Issues for the Next Century* (Albuquerque, N.M., 1986).

27. See Michael deCourcy Hinds, "Coal Mine Sends Polluted Water into Ohio Creeks," *New York Times* (National Edition), August 20, 1993.

OPPOSITE: Thedor de Bry, *Their manner of fishynge in Virginia*, detail. Library of Congress, Geography and Map Division.

The Sixteenth and
Seventeenth Centuries

EXCERPTS *from*

Indian Legends of the Pacific Northwest

Compiled by Ella E. Clark

For centuries, American Indians have kept their history and culture alive through oral histories passed down from generation to generation. Among the tales maintained in this way are countless accounts of the origin of the world and of the divine creation of various natural resources.

Many of these tales, including the selections here from the Pacific Northwest gathered by the folklorist and professor of English Ella Clark and published in the 1950s, offer explanations for the creation of particular rivers.

WHY RIVERS FLOW BUT ONE WAY

First Story. Long ago, before the world changed, all the animal people came together for a big meeting. Eagle was the headman of the gathering. He lived up high, in the top of a tall tree. Whenever the people wanted to decide anything important, they called up to him as he sat in the tree, and he gave them his opinion.

Each of the animal people at the meeting had a chance to say what he thought. Even Raven and Mink, who were slaves, told the others what they believed should be done. Raven's opinion was so good that he became known as a wise man.

For a long time the people argued about the direction in which the rivers should flow. Should they flow up or down, or both up

and down? All but Raven thought that one side of all rivers should run up the mountains and the other side should run down. All the rivers should go up as far as the falls, they said, and then should turn round and come back.

"What do you think of our plan?" they called up to Eagle.

"I agree with you," answered Eagle. "If the rivers go both ways, the new people who are to come will have an easy time. It will not be hard to go upstream, and it will not be hard to go downstream. What does Raven think?"

"I don't agree with you," replied Raven. "If the rivers turn round at the falls, salmon will have no chance to stop. They will go up as far as the falls, and then they will come right back again. Where will they spawn? And how will the new people catch them? I think that all rivers should flow but one way."

"Raven is right," agreed Mink. "The people will have a very hard time catching salmon if the rivers run both ways."

"I think the rivers should go but one way," repeated Raven. "And I think that at all the bends in the streams there should be little eddies. They will make the salmon go slower. The people can fish there, too."

"Raven's reasons seem very good," said Eagle in the tree.

"Raven's reasons seem very good," repeated the people on the ground. So they followed his plan.

That is why all rivers now run but one way. That is why the salmon go all the way up their home river to spawn.

Second Story. Near the beginning of the world, Eagle suggested that Lake Quinault should be a prairie with the Quinault River running through the middle of it.

But Raven replied, "No, that would be too easy for the people. They must work for what they want. If they want camas roots, they should have to go through the woods and find the prairies that are farther away. They should have to carry the camas from the prairies to the river."

And so Lake Quinault has always been a lake. Raven would

have it that way. The Quinault River flows into it from the mountains and out of it into the ocean.

Then Eagle said to Raven, "I think one side of a river should flow upstream and one should flow down."

"No," replied Raven, "that would be too easy for the people. When they want to go upstream, they should have to pole up. We can leave some eddies along the banks."

That is why all rivers flow down. Raven would have them that way. The eddies are the only results of Eagle's wishes.

Then Eagle said, "The milt in the male salmon ought to be fat so that the people can use it to cook the fish in."

"No," said Raven, "the fish would be too good for the people if the milt is fat. It should be worthless as food."

Not long afterward, Eagle's child died. In his grief, Eagle went to Raven and said, "It would be better if the people who died should come to life again."

"No," answered Raven, "it is better that they remain dead. They should not come back to the earth."

And that was arranged as Raven wanted it. Eagle's child and the people who died later never came back to the earth world.

HOW COYOTE MADE
THE COLUMBIA RIVER

Long ago, when Coyote was the big man on the earth, this valley was covered by a big lake. At that time there was no Columbia River. West of us, between the lake and the ocean, was a long ridge of mountains. But the Columbia River did not go through it. Indians today believe that.

Coyote was smart enough to see that salmon would come up from the ocean to be food for his people here if he would make a hole through the mountains. So he went down to a place near where Portland is now, and with his powers he dug a hole through

the mountains there. The water went through the hole and on to the ocean.

The water in the big lake up here was drained, and the water flowing out of it made the Columbia River. Coyote got the Columbia to flow through that hole, the way it does today. Then the salmon came up the river to this part of the country. His people after that had plenty to eat.

When he dug that hole through the mountains, Coyote made a kind of bridge. You have heard about it—a broad rock bridge that went across the river. People could walk from one side of the Columbia to the other. A long time afterward, an earthquake broke the bridge down. The rocks that fell into the water formed the Cascades of the Columbia. They made it hard for boats to go up and down the river there.

COYOTE AND THE
MONSTER OF THE COLUMBIA

One time on his travels, Coyote learned that a monster was killing the animal people as they traveled up and down Big River in their canoes. So many had been killed that some of the animal people were afraid to go down to the water, even to catch salmon.

"I will help you," promised Coyote. "I will stop this monster from killing people."

But what could he do? He had no idea. So he asked his three sisters who lived in his stomach in the form of huckleberries. They were very wise. They knew everything. They would tell him what to do.

At first his sisters refused to tell Coyote what to do.

"If we tell you," they said, "you will say that that was your plan all the time."

"If you do not tell me," said Coyote sternly, "I will send rain and hail down upon you."

Of course the berries did not like rain and hail.

"Do not send rain," they begged. "Do not send rain or hail. We will tell you what to do. Take with you plenty of dry wood and plenty of pitch, so that you can make a fire. And take also five sharp knives. It is Nashlah at Wishram that is killing all the people. He is swallowing the people as they pass in their canoes. You must let him swallow you."

"Yes, my sisters, that is what I thought," replied Coyote. "That was my plan all the time."

Coyote followed his sisters' advice. He gathered together some dry wood and pitch, sharpened his five knives, and went to the deep pool where Nashlah lived. The monster saw Coyote but did not swallow him, for he knew that Coyote was a great chief.

Coyote knew that he could make Nashlah angry by teasing him. So he called out all kinds of mean names. At last the monster was so angry that he took a big breath and sucked Coyote in with his breath. Just before entering his mouth, Coyote grabbed a big armful of sagebrush and took it in also.

Inside the monster, Coyote found many animal people. All were cold and hungry. Some were almost dead from hunger, and some were almost dead from cold.

"I will build a fire in here for you," said Coyote. "And I will cook some food for you. While you get warm and while you eat, I will kill Nashlah. I have come to help you, my people. You will join your friends soon."

With the sagebrush and the pitch, Coyote made a big fire under the heart of the monster. The shivering people gathered around it to get warm. Then with one of his sharp knives Coyote cut pieces from the monster's heart and roasted them.

While the people ate, Coyote began to cut the cord that fastened the monster's heart to his body. He broke the first knife, but he kept cutting. He broke the second knife, but he kept cutting. He broke his third and his fourth knives. With his fifth knife he cut the last thread, and the monster's heart fell into the fire.

Just as the monster died, he gave one big cough and coughed all the animal people out on the land.

"I told you I would save you," said Coyote, as the animal people

gathered around him on the shore of the river. "You will live a long time, and I will give you names."

Coyote went among them and gave each creature a name.

"*You* will be Eagle, the best and the bravest bird. *You* will be Bear, the strongest animal. *You* will be Owl, the big medicine man, with special powers. *You* will be Sturgeon, the largest fish in the rivers. *You* will be Salmon, the best of all fish for eating."

In the same way Coyote named Beaver, Cougar, Deer, Woodpecker, Blue Jay, and all the other animals and birds. Then he named himself. "I am Coyote," he told them. "I am the wisest and smartest of all the animals."

Then he turned to the monster and gave him a new law. "You can no longer kill people as you have been doing. A new race of people are coming, and they will pass up and down the river. You must not kill all of them. You may kill one now and then. You may shake the canoes if they pass over you. For this reason most of the canoes will go round your pool and not pass over where you live. You will kill very few of the new people. This is to be the law always. You are no longer the big man you used to be."

The law that Coyote made still stands. The monster does not swallow people as he did before Coyote took away his big power. Sometimes he draws a canoe under and swallows the people in it. But not often. Usually the Indians take their canoes out of the water and carry them round the place where the monster lives. They do not pass over his house. He still lives deep under the water, but he is no longer powerful.

T HE FIRST STEAMBOAT the white people brought up the river was stopped by Nashlah. The Indians told the white men to throw food into the river and then they could go. They did so. They threw overboard sugar, flour, rice, and other things. Then Nashlah let the boat loose.

WHY COYOTE CHANGED THE COURSE OF THE COLUMBIA RIVER

Coyote had a tepee near the Sanpoil River. Kingfisher had a tepee there too. Four brothers, the Wolves, had a tepee there. So there were three tepees of them.

Kingfisher was having a hard time getting his fish. He could get little fishes, but not enough. They didn't suit Coyote, who expected Kingfisher to do his fishing for him.

The four brothers could get all the meat they wanted because they could kill a deer any time they wanted to. They had plenty of meat, and they gave Coyote plenty of meat. The four brothers, the Wolves, were Coyote's nephews. But Kingfisher ate no meat. He was having a hard time getting his fish.

Down at Celilo on the Columbia, four sisters had a fish trap. They wouldn't let any big fish come up the river.

Finally Coyote said, "That won't do. I've got to get busy and see into that, so that everybody can have fish. Not just the sisters. I'll have to take a trip down there and see what I can do."

It took him a long time to walk down to Celilo. Before he came to the house where the fish trap was, he tried to think how he would break the dam and bring the fish up without hurting the girls any and without fighting with them. How was he going to fool them? Then he made [called upon] his powers.

He asked his powers, "What can I do to get the fish up the river?"

His powers said to him, "Well, that's too much work. You can't do it."

"I can work all right," said Coyote, "if you will tell me what to do."

One of his powers said to him, "Go down a ways and get in the water and float down. You'll be a little wooden bowl. Go down on the trap. Then the sisters will see you and pick you up and take you back to the house."

So he went down to the water and turned into a little wooden

bowl. When he got to the trap, he couldn't float any longer. So he stopped right there. When the sisters came down from the hills where they had been picking service berries, they went to look at the trap and to get some water. They got down there and saw the little wooden bowl on the trap.

One of them said, "O sisters, see this little wooden bowl! Now we can have a nice little dish to put our salmon in."

Two of her sisters ran up and said, "Isn't it pretty? Isn't it lovely!"

But the youngest sister stood off at one side and said, "I don't think that wooden bowl is good for us. Better leave it alone. It might be something that will harm us."

"Oh, you're always suspicious," said one of her sisters. "What is the little bowl going to do? Someone must have tipped over in a canoe up above, and this is part of their stuff. It can't harm anyone. Let's take the wooden bowl to the house."

That's what they did. So they cooked their salmon, ate all they wanted, and after supper put what was left into the little wooden bowl for breakfast. Then they put it behind their little pantry and went to bed.

The next morning when they got up, the wooden bowl was empty. There wasn't a thing in it.

"I wonder what's happened to our salmon?" asked one of the sisters. "There isn't a thing in here."

The youngest sister said, "I told you that wooden bowl isn't good for us. You wouldn't listen. We'd better throw it away."

But the others said, "There must have been a rat or something that came and ate all the salmon. I don't think the dish had anything to do with it."

The youngest couldn't do anything with her sisters. There were three against one. So they cooked some more salmon, ate their fill, put what was left into the wooden bowl, and put it behind the pantry. Then they went up into the hills after more berries.

When they came back about one o'clock, they went to their house and looked at the little wooden bowl. But there wasn't anything in it.

The youngest said, "I told you that bowl is no good for us."

The others began to believe her and walked out of the house. The youngest had the bowl in her hand. She threw it against a big rock. Celilo was pretty rocky. The girl found a big rock and threw the bowl against it, to break it. When the bowl hit the rock, it dropped down on the ground and sat up as a little baby. One of the sisters ran over and picked it up. A little baby was staring at her.

"Oh, it's a little boy baby. Sisters, we'll have a brother now. We'll take care of him, and he'll grow up, and then he can get all the salmon for us. We won't have to get the salmon. All we'll have to do is to dry it and take care of it."

But the youngest sister said, "You'd better leave him alone. We don't want him in the house at all."

But they were three against one. They took the baby up to the house. It was a cute little baby, full of smiles. It was always smiling.

"Isn't he a cute little baby!" said the sisters. "Now we have a little brother."

So they fed it, put it in the bed in the tepee, and went back into the hills to pick berries. As soon as they were out of sight, Coyote changed himself from the little wooden bowl into a man. The man went down and began digging and digging, to break the dam that they had worked so hard to make. When it was about time for the sisters to come back, he would go into the tepee, get into bed, and change himself into a baby.

Well, that went on for quite a few days. Every day he went on digging and digging. One day he said to himself, "Today I think I'll be able to break through this dam." He was working as hard as he could. "It's about time for them to come home, but I'll stay here and finish breaking the dam. They can't harm me."

He had a wooden bowl which he put on top of his head. He kept on digging away and digging away. The sisters got back and went down after water. They saw him there, digging.

"Oh, he's a great big man, and he's breaking our trap!" cried one of the sisters.

The youngest sister said, "You think you know it all. I told you that baby was no good for us."

They picked up a stick and ran over to him. They tried to hit him over the head. But he had on that wooden bowl, so they couldn't hurt him. He gave the dam a few more licks and it was broken through. Then he started running away from the girls.

He laughed at them. "You women never will put it over us men. Men always will put it over you."

When he walked away from them, the salmon followed him. When the dam was broken, the salmon went through the hole he had made. Coyote walked along the shore. Whenever he got hungry or tired, he would stop and call to some of the salmon in the river. A big salmon would jump out. He would catch it, roast it, eat it, and rest a while. Whenever he stopped, the salmon stopped. So he kept coming up the river that way.

On the way down, he had stopped at the place where Dry Falls are now. At the time, the Columbia River flowed there. He had seen a family camping there and catching little fish to eat. They had two nice-looking girls. They looked good to him. He made up his mind that he would camp there and see what he could do.

He came there that evening and went to their tepee. The girls were out picking berries, so he talked to the old folks a while. He said to the old man, "You'd better come down to the river with me. I saw a couple of salmon down there that you can have."

So they went down there and caught one and brought it back and cooked it. The girls came home. They all had a big feed on the salmon. He talked with them and then stayed over night. Next morning he went down and caught two more and brought them up to the old man.

After breakfast Coyote asked the old folks if he could have the girls, to marry them.

"Well, I'll have to ask the girls," the old man said. So he asked them.

"No," the girls said, "we don't want to be married yet. We want to be free for a while."

That made Coyote so angry that he broke up the river.

"All right. If you girls won't have me, you can go hungry the rest of your days. I'll just take the river away from you."

So he changed the channel and made the river run down this other way, where it's running now.

He said to the old man, "Some day there'll be some smart man who will run the river through here again. Years from now there will be one man who will make the water run this way again."

Then he came on up the river. He kept coming up, coming up, coming up the river till he reached the mouth of the Sanpoil River. A girl there looked good to him. He put in Hell Gate dam to hold the salmon back for her people. The salmon couldn't get over Hell Gate dam. It was too high; they couldn't get over it, the way he had it fixed.

But that girl wouldn't have him.

So Coyote said, "Four or five kinds of salmon will come up the big river. King salmon will go up the big river, but no big ones will come up the Sanpoil River. Steelheads first, chinooks, then silver salmon, those little salmon smaller than the silver and red on the outside—those four kinds will go up the Sanpoil. But no king salmon—no big ones."

Then he broke up the dam he had made at Hell Gate. Ever since then there have been rocks and rapids at Hell Gate. He went on up the river and took his salmon with him. He went and went and went and went. He got as far as Kettle Falls. Of course there were no falls there, but people were living on both sides of the river. And he saw a nice-looking girl there. She was one of the Beaver family, and she looked good to him in spite of her big teeth.

"I'm going to see what I can do here," Coyote said to himself.

He caught salmon for the old folks and was good to them. Next morning he asked the old man for his daughter. The old man said, "Yes, you can have her. Then I can have all the salmon I want to eat as long as I'm alive."

So that's where Coyote got his woman—at Kettle Falls. He made the falls there. That's as far as the salmon could go. He would not break those falls. He left them there. So all these years that is as far as the salmon would go up the river.

Coyote was very good to Beaver's daughter. He gave her a beautiful fur coat, the softest and most priceless of furs. He gave

her the right to live under the falls. "Whenever you see people or hear them coming," he told her, "you can hide under the falls. There you will be safe."

Coyote piled rocks across the river and cut them, so that there would always be a waterfall. He made three levels of rocks, so that there would be a waterfall whether the river was high or low. When the salmon tried to jump the falls, they could be easily caught by people fishing from the rocks.

Coyote broke down all the dams from the mouth of the river all the way to Kettle Falls. Soon the salmon were so thick that Beaver could not throw a stick into the water without hitting the back of a fish.

Then Coyote made Beaver the salmon chief. "The people of many tribes will come here to fish," Coyote said to Beaver. "You will be chief over all of them. You must share the salmon with everyone who comes. There will always be enough for everyone. You must never be greedy with it, and you must see to it that no one else is greedy."

WHY THE
COLUMBIA SPARKLES

Five stars once came down from the sky and slept beside the river, near The Dalles. Next morning four of them rose into the air and took four sisters back to the sky with them. When the sisters got to the place where the stars live, they saw that the sky world is just like this one, with grass and flowers.

The oldest of the five stars did not go back with the others, because he was still tired from the long journey. He remained lying there on the ground by the river, but he changed himself into a white flint rock, very large and thick and round and bright. It shone so brilliantly that it could be seen from a long distance.

It became a good-luck rock for the Wishram people who lived near it. The star rock brought many salmon up the river, enough for the Wishram to dry for their own use and also to trade with the people who came to the narrows and to the big falls of the river. The place where the rock lay was a great gathering place for many tribes. Everyone knew the star. The Wishram became known as the Star people.

Across the river on the south side lived the Wasco people. They did not have a star, but they did have a big cup. *Wasco* means "those that have the cup." Near their main village was a rock in the shape of a big cup. Into it bubbled a spring of pure, cold water. The Wasco people prized the cup very highly.

The Wasco, who were always quarreling and fighting with their neighbors, became jealous of the good luck the bright star was bringing the Wishram. One night when the Wishram people were away, some of the Wasco people crossed the river and stole the star. They wrapped it in an elkskin and threw it into the river.

When the Wishram returned from picking berries, they could not find the star. Months later, when the water of the river was low, some people of the Wishram village saw it shining on the bottom. They got it and put it back on the shore. Always thereafter, someone guarded the star. But three summers later, when the Wishram were again in the Mount Adams country picking berries, Wasco men found the guard asleep one day and stole the star once more. This time they broke it into pieces and threw it into the river.

When the Wishram came back to their winter village, the star rock was gone. Angrily they crossed the river and made war on the Wasco. Some of the young men pounded the big cup until they almost destroyed it. It had been very large and deep. It is now very small.

After the star was stolen and broken, the Wishram lost the name Star people and became very common people. But the broken star rock is still in the river. That is why the water sparkles in the sunshine.

THE ORIGIN OF
THE SPOKANE RIVER

The Spokane Indians once lived in terror because of a huge monster that lived both on land and in the water. He swallowed all the fish and birds and animals that came near him. His claws were so strong that with one pull he could uproot the largest pine trees. His breath was so bad that it killed people. No weapons would stick in his skin, and no hunter had been able to capture him. All people were afraid of him.

One day a girl was picking berries near where the Spokane River now flows into the Columbia River. At that time there was no Spokane River. The girl looked up from the berries and saw the monster. He was lying on a hillside, asleep in the sunshine.

The girl slipped quietly away and ran to her village as fast as she could.

"I have seen the monster!" she gasped. "And he is asleep."

The headman of the village called his men together and said to them, "Gather up every cord and rope and every leather thong in all the tepees."

After this was done, the men walked noiselessly to the hillside where the monster still lay sleeping. There they tied him to trees and to rocks. Still he slept, they moved so quietly. Then all the people began to beat him with their weapons of war and their weapons of hunting.

When the monster awoke, he made one big jump. All the cords and all the leather thongs broke, as if they were made of grass. The monster turned and ran eastward like the wind. He ran and ran until he reached Lake Coeur d'Alene. As he went, he tore a deep channel. When he reached the lake, the waters of Lake Coeur d'Alene rushed into the new channel and made a new river.

Ever since then, the Spokane River has flowed from Lake Coeur d'Alene into Big River, and so its waters have reached the sea.

Inducements to the Liking of the Voyage Intended towards Virginia in 40 and 42 Degrees of Latitude

Richard Hakluyt the Elder

Richard Hakluyt the Elder (?–1591), a lawyer, geographer, and economic essayist, hoped that his writings would encourage the English to colonize North America. Along with his cousin, Richard Hakluyt the Younger (1552?–1616), the elder Hakluyt tried to convince policymakers in Elizabethan England that America contained all the natural resources anyone could want, and that labor for developing colonies could be found among the unemployed people, most of them young men, wandering the English countryside looking for work. For Hakluyt and other promoters, gaining control of American rivers was a necessary step in any plans to plant colonies.

16. The great broad rivers of that main that we are to enter into, so many leagues navigable or portable into the mainland, lying so long a tract with so excellent and so fertile a soil on both sides, do seem to promise all things that the life of man doth require and whatsoever men may wish that are to plant upon the same or to traffic in the same.

17. And whatsoever notable commodity the soil within or without doth yield in so long a tract, that is to be carried out from thence to England, the same rivers so great and deep do yield no small benefit for the sure, safe, easy, and cheap carriage of the same to shipboard, be it of great bulk or of great weight.

18. And in like sort whatsoever commodity of England the

John Farrar, *The Sea of China and the Indies*, c. 1667.
Library of Congress, Geography and Map Division.

inland people there shall need, the same rivers do work the like effect in benefit for the incarriage of the same aptly, easily, and cheaply.

19. If we find the country populous and desirous to expel us and injuriously to offend us, that seek but just and lawful traffic, then, by reason that we are lords of navigation and they not so, we are the better able to defend ourselves by reason of those great rivers and to annoy them in many places.

20. Where there be many petty kings or lords planted on the rivers' sides, and [who] by all likelihood maintain the frontiers of their several territories by wars, we may by the aid of this river join with this king here, or with that king there, at our pleasure, and may so with a few men be revenged of any wrong offered by any of them; or may, if we will proceed with extremity, conquer, fortify, and plant in soils most sweet, most pleasant, most strong, and most fertile, and in the end bring them all in subjection and to civility.

21. The known abundance of fresh fish in the rivers, and the known plenty of fish on the sea-coast there, may assure us of sufficient victual in spite of the people, if we will use salt and industry.

Voyages of Samuel de Champlain

Samuel de Champlain

Translated from the French by Charles Pomeroy Otis

During the early seventeenth century, European explorers traveled to North America to record their impressions of the land and its peoples. Among the most famous of these travelers was Samuel de Champlain (1567?–1635), who is best known today for his explorations of New France (modern-day Canada) and his founding, in 1608, of the town of Québec. Champlain traveled much of the coast of the northeast during the first decade of the century; in the process he became the first European to describe Mount Desert Island, as well as the Kennebec, Androscoggin, and Saco rivers. In this passage Champlain recounts his experiences along the Kennebec River in 1605.

Discovery of the coast of the Almouchiquois as far as the forty-second degree of latitude, and details of this voyage.

On the 18th of June, 1605, Sieur de Monts set out from the Island of St. Croix with some gentlemen, twenty sailors, and a savage named Panounias, together with his wife, whom he was unwilling to leave behind. These we took, in order to serve us as guides to the country of the Almouchiquois, in the hope of exploring and learning more particularly by their aid what the character of this country was, especially since she was a native of it.

Coasting along inside of Manan, an island three leagues from the main land, we came to the Ranges on the seaward side, at one of which we anchored, where there was a large number of crows, of which our men captured a great many, and we called it the Isle aux Corneilles. Thence we went to the Island of Monts Déserts, at the entrance of the river Norumbegue, as I have before stated,

and sailed five or six leagues among many islands. Here there came to us three savages in a canoe from Bedabedec Point, where their captain was; and, after we had some conversation with them, they returned the same day.

On Friday, the 1st of July, we set out from one of the islands at the mouth of the river, where there is a very good harbor for vessels of a hundred or a hundred and fifty tons. This day we made some twenty-five leagues between Bedabedec Point and many islands and rocks, which we observed as far as the river Quinibequy, at the mouth of which is a very high island, which we called the Tortoise. Between the latter and the main land there are some scattering rocks which are covered at full tide, although the sea is then seen to break over them. Tortoise Island and the river lie south-south-east and north-north-west. As you enter, there are two medium-sized islands forming the entrance, one on one side, the other on the other; and some three hundred paces farther in are two rocks, where there is no wood, but some little grass. We anchored three hundred paces from the entrance in five and six fathoms of water. While in this place, we were overtaken by fogs, on account of which we resolved to enter, in order to see the upper part of the river and the savages who live there; and we set out for this purpose on the 5th of the month. Having made some leagues, our barque came near being lost on a rock which we grazed in passing. Further on, we met two canoes which had come to hunt birds, which for the most part are moulting at this season, and cannot fly. We addressed these savages by aid of our own, who went to them with his wife, who made them understand the reason of our coming. We made friends with them and with the savages of this river, who served us as guides. Proceeding farther, in order to see their captain, named Manthoumermer, we passed, after we had gone seven or eight leagues, by some islands, straits, and brooks, which extend along the river, where we saw some fine meadows. After we had coasted along an island some four leagues in length, they conducted us to where their chief was with twenty-five or thirty savages, who, as soon as we had anchored, came to us in a canoe, separated a short distance from ten others, in which were

those who accompanied him. Coming near our barque, he made an harangue, in which he expressed the pleasure it gave him to see us, and said that he desired to form an alliance with us and to make peace with his enemies through our mediation. He said that, on the next day, he would send to two other captains of savages, who were in the interior, one called Marchin, and the other Sasinou, chief of the river Quinibequy. Sieur de Monts gave them some cakes and peas, with which they were greatly pleased. The next day they guided us down the river another way than that by which we had come, in order to go to a lake, and, passing by some islands, they left, each one of them, an arrow near a cape where all the savages pass, and they believe that if they should not do this some misfortune would befall them, according to the persuasions of the devil. They live in such superstitions, and practice many others of the same sort. Beyond this cape we passed a very narrow waterfall, but only with great difficulty; for, although we had a favorable and fresh wind, and trimmed our sails to receive it as well as possible, in order to see whether we could not pass it in that way, we were obliged to attach a hawser to some trees on shore and all pull on it. In this way, by means of our arms together with the help of the wind, which was favorable to us, we succeeded in passing it. The savages accompanying us carried their canoes by land, being unable to row them. After going over this fall, we saw some fine meadows. I was greatly surprised by this fall, since as we descended with the tide we found it in our favor, but contrary to us when we came to the fall. But, after we had passed it, it descended as before, which gave us great satisfaction. Pursuing our route, we came to the lake, which is from three to four leagues in length. Here are some islands, and two rivers enter it, the Quinibequy coming from the north-north-east, and the other from the north-west, whence were to come Marchin and Sasinou. Having awaited them all this day, and as they did not come, we resolved to improve our time. We weighed anchor accordingly, and there accompanied us two savages from this lake to serve as guides. The same day we anchored at the mouth of the river, where we caught a large number of excellent fish of various sorts. Meanwhile, our savages went hunt-

ing, but did not return. The route by which we descended this river is much safer and better than that by which we had gone. Tortoise Island before the mouth of this river is in latitude 44°; and 19°12′ of the deflection of the magnetic needle. They go by this river across the country to Quebec some fifty leagues, making only one portage of two leagues. After the portage, you enter another little stream which flows into the great river St. Lawrence. This river Quinibequy is very dangerous for vessels half a league from its mouth, on account of the small amount of water, great tides, rocks and shoals outside as well as within. But it has a good channel, if it were well marked out. The land, so far as I have seen it along the shores of the river, is very poor, for there are only rocks on all sides. There are a great many small oaks, and very little arable land. Fish abound here, as in the other rivers which I have mentioned. The people live like those in the neighborhood of our settlement; and they told us that the savages, who plant the Indian corn, dwelt very far in the interior, and that they had given up planting it on the coasts on account of the war they had with others, who came and took it away. This is what I have been able to learn about this region, which I think is no better than the others.

XIII.

Their manner of fishynge in Virginia.

Hey haue likewife a notable way to catche fishe in their Riuers. for whear as they lacke both yron, and steele, they faste vnto their Reedes or longe Rodds, the hollowe tayle of a certaine fishe like to a sea crabb in steede of a poynte, wehr with by nighte or day they stricke fishes, and take them opp into their boates. They also know how to vfe the prickles, and pricks of other fishes. They also make weares, with fettinge opp reedes or twigges in the water, which they foe plant one within a nother, that they growe still narrower, and narrower, as appeareth by this figure. Ther was neuer feene amonge vs foe cunninge a way to take fish withall, wherof fondrie fortes as they fownde in their Riuers vnlike vnto ours. which are alfo of a verye good tafte. Dowbtlefs yt is a pleafant fighte to fee the people, fomtymes wadinge, and goinge fomtymes failinge in thofe Riuers, which are shallowe and not deepe, free from all care of heapinge opp Richers for their posterite, content with their state, and liuinge frendly together of thofe thinges which god of his bountye hath giuen vnto them, yet without giuinge hym any thankes according to his defarte. So fauage is this people, and depriued of the true knowledge of god. For they haue none other then is mentionned before in this worke.

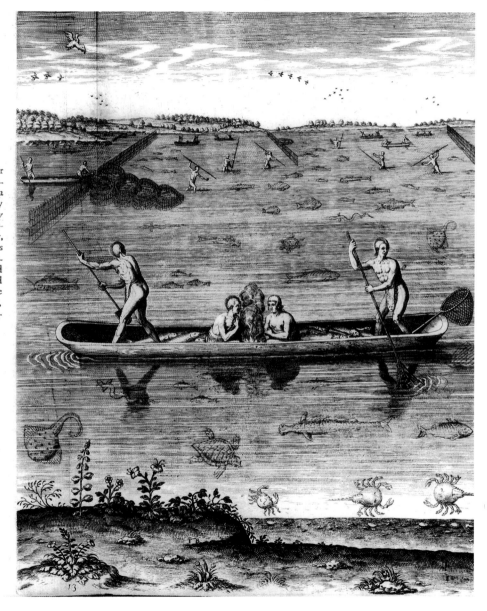

Theodor de Bry, *Their manner of fishynge in Virginia.* From Thomas Harriot, *A Briefe and True Report of the New Found Land of Virginia,* 1590.
Library of Congress, Geography and Map Division.

"Good News from Virginia"

Alexander Whitaker

The Anglican minister Alexander Whitaker (1585–1616/1617) was among the earliest English migrants to the straggling settlement at Jamestown, founded in 1607. The town's location along the James River made it one of the least healthy places imaginable, especially during summer. Yet even though many colonists succumbed after their arrival there, Whitaker delivered a sermon in 1613 extolling the natural resources of the region. Like Richard Hakluyt the Elder, Whitaker saw the benefit of controlling the rivers of the region.

The whole continent of Virginia, situate within the degrees of 34 and 47, is a place beautified by God with all the ornaments of nature and enriched with His earthly treasures. That part of it which we already possess, beginning at the Bay of Chesapeake and stretching itself in northerly latitude to the degrees of 39 and 40, is interlined with seven most goodly rivers, the least whereof is equal to our river of Thames; and all these rivers are so nearly joined as that there is not very much distance of dry ground between either of them, and those several mainlands are everywhere watered with many veins or creeks of water, which sundry ways do overthwart the land and make it almost navigable from one river to the other.

THE MEANS FOR OUR PEOPLE to live and subsist here of themselves are many and most certain, both for beasts, birds, fish, and herbs. The beasts of the country are for the most part wild: as lions, bears, wolves, and deer; foxes, black and red; raccoons; beavers; possums; squirrels; wildcats, whose skins are of great price; and muskrats, which yield musk as the musk-cats do. There be two

kinds of beasts among these most strange: one of them is the female possum, which will let forth her young out of her belly and take them up into her belly again at her pleasure without hurt to herself; neither think this to be a traveller's tale but the very truth, for Nature hath framed her fit for that service: my eyes have been witness unto it and we have sent of them and their young ones into England. The other strange-conditioned creature is the flying squirrel, which, through the help of certain broad flaps of skin growing on each side of her forelegs, will fly from tree to tree twenty or thirty paces at one flight and more, if she have the benefit of a small breath of wind. Besides these, since our coming hither we have brought both kind, goats, and hogs, which prosper well and would multiply exceedingly if they might be provided for.

This country besides is replenished with birds of all sorts, which have been the best sustenance of flesh which our men have had since they came; also eagles and hawks of all sorts, amongst whom are osprey, fishing hawk, and the cormorant. The woods be everywhere full of wild turkeys, which abound and will run as swift as a greyhound. In winter our fields be full of cranes, herons, pigeons, partridges, and blackbirds; the rivers and creeks be overspread everywhere with water-fowl of the greatest and least sort, as swans, flocks of geese and brants, duck and mallard, sheldrakes, divers, etc., besides many other kinds of rare and delectable birds whose names and natures I cannot yet recite; but we want the means to take them.

The rivers abound with fish both great and small. The sea-fish come into our rivers in March and continue until the end of September; great schools of herrings come in first; shads, of a great bigness, and rock fish, follow them. Trouts, bass, flounders, and other dainty fish come in before the other be gone; then come multitudes of great sturgeons, whereof we catch many and should do more but that we want good nets answerable to the breadth and depth of our rivers: besides our channels are so foul in the bottom with great logs and trees that we often break our nets upon them. I cannot reckon nor give proper names to the divers kinds of fresh fish in our rivers. I have caught with mine angle pike, carp, eel, perches of six several kinds, crayfish, and the torope or little turtle, besides many smaller kinds.

Wherefore, since God hath filled the elements of earth, air, and waters with His creatures, good for our food and nourishment, let not the fear of starving hereafter, or of any great want, dishearten your valiant minds from coming to a place of so great plenty. If the country were ours and means for the taking of them (which shortly I hope shall be brought to pass), then all of these should be ours; we have them now but we are fain to fight for them; then should we have them without that trouble. Fear not, then, to want food, but only provide means to get it here. We have store of wild-fowl in England, but what are they better for them that cannot come by them, wanting means to catch them? Even such is and hath been our case heretofore.

"*Contemplations*"

Anne Bradstreet

Anne Bradstreet (1612?–1672) migrated with her husband Simon to Massachusetts Bay in 1630 aboard the Arabella, *the ship that carried John Winthrop, first governor of the new colony. Since she was the daughter of a prominent Puritan and the spouse of the secretary of the colony, perhaps she heard Winthrop deliver his sermon "A Modell of Christian Charity," in which he contended that the Puritans "must consider that we shall be as a city upon a hill." Once arrived in America, she distinguished herself by being a poet among Puritans who were more interested in determining God's will than in trying to determine if verses scanned correctly. Bradstreet's poems were first published in London in 1650. Although perhaps acclaimed at the time, her poetry has not pleased everyone. As Charles Eliot Norton, the nineteenth-century literary scholar and a founder of* The Nation, *noted in 1897, her poetry was derivative and lacked real literary merit: "Of all those things about which we should be curious and interested to hear there is not a word."*

21

Under the cooling shadow of a stately Elm
Close sate I by a goodly Rivers side,
Where gliding streams the Rocks did overwhelm;
A lonely place, with pleasures dignifi'd.
I once that lov'd the shady woods so well,
Now thought the rivers did the trees excel,
And if the sun would ever shine, there would I dwell.

22

While on the stealing stream I fixt mine eye,
Which to the long'd for Ocean held its course,
I markt, nor crooks, nor rubs that there did lye
Could hinder ought, but still augment its force:
O happy Flood, quoth I, that holds thy race
Till thou arrive at thy beloved place,
Nor is it rocks or shoals that can obstruct thy pace.

23

Nor is't enough, that thou alone may'st slide,
But hundreds brooks in thy cleer waves do meet,
So hand in hand along with thee they glide
To *Thetis* house, where all imbrace and greet:
Thou Emblem true, of what I count the best,
O could I lead my Rivolets to rest,
So may we press to that vast mansion, ever blest.

24

Ye Fish which in this liquid Region 'bide,
That for each season, have your habitation,
Now salt, now fresh where you think best to glide
To unknown coasts to give a visitation,
In Lakes and ponds, you leave your numerous fry,
So nature taught, and yet you know not why,
You watry folk that know not your felicity.

25

Look how the wantons frisk to tast the air,
Then to the colder bottome streight they dive,
Eftsoon to *Neptun's* glassie Hall repair
To see what trade they great ones there do drive,
Who forrage o're the spacious sea-green field,
And take the trembling prey before it yield,
Whose armour is their scales, their spreading fins their shield.

26

While musing thus with contemplation fed,
And thousand fancies buzzing in my brain,
The sweet-tongu'd Philomel percht ore my head,
And chanted forth a most melodious strain
Which rapt me so with wonder and delight,
I judg'd my hearing better then my fight,
And wisht me wings with her a while to take my flight.

27

O merry Bird (said I) that fears no snares,
That neither toyles nor hoards up in thy barn,
Feels no sad thoughts, nor cruciating cares
To gain more good, or shun what might thee harm
Thy cloaths ne're wear, thy meat is every where,
Thy bed a bough, thy drink the water cleer,
Reminds not what is past, nor whats to come dost fear.

28

The dawning morn with songs thou dost prevent,
Sets hundred notes unto thy feathered crew,
So each one tunes his pretty instrument,
And warbling out the old, begin anew,
And thus they pass their youth in summer season,
Then follow thee into a better Region,
where winter's never felt by that sweet airy legion.

29

Man at the best a creature frail and vain,
In knowledg ignorant, in strength but weak,
Subject to sorrows, losses, sickness, pain,
Each storm his state, his mind, his body break,
From some of these he never finds cessation,
But day or night, within, without, vexation,
Troubles from foes, from friends, from dearest, near'st Relation.

30

And yet this sinfull creature, frail and vain,
This lump of wretchedness, of sin and sorrow,
This weather-beaten vessel wrackt with pain,
Joyes not in hope of an eternal morrow;
Nor all his losses, crosses and vexation,
In weight, in frequency and long duration
Can make him deeply groan for that divine Translation.

Rural Pastime, mid nineteenth century.
Spencer Museum of Art / University of Kansas, The Thayer Collection.

31

The Mariner that on smooth waves doth glide,
Sings merrily, and steers his Barque with ease,
As if he had command of wind and tide,
And now become great Master of the seas;
But suddenly a storm spoiles all the sport,
And makes him long for a more quiet port,
Which 'gainst all adverse winds may serve for fort.

32

So he that faileth in this world of pleasure,
Feeding on sweets, that never bit of th'sowre,
That's full of friends, of honour and of treasure,
Fond fool, he takes this earth ev'n for heav'ns bower.
But sad affliction comes & makes him see
Here's neither honour, wealth, nor safety;
Only above is found all with security.

33

O Time the fatal wrack of mortal things,
That draws oblivions curtains over kings,
Their sumptuous monuments, men know them not,
Their names without a Record are forgot,
Their parts, their ports, their pomp's all laid in th' dust
Nor wit nor gold, nor buildings scape times rust;
But he whose name is grav'd in the white stone
Shall last and shine when all of these are gone.

French Explorers on the Mississippi

"We were not long in preparing our outfit, although we were embarking on a voyage the duration of which we could not foresee," *the French missionary and explorer Jacques Marquette (1637–1675) wrote in 1673. "Indian corn, with some dried meat, was our whole stock of provisions. With this we set out in two bark canoes, M. Jollyet, myself, and five men, firmly resolved to do all and suffer all for so glorious an enterprise." That glorious enterprise was not, in the seventeenth century, a lost cause. Until the British defeated the French in the Seven Years' War (1756–1763), the French laid claim to much of the interior of North America. To do so, the French sent explorers, including the Jesuit priest Father Marquette, down inland rivers to assess the resources and peoples of North America. Henri de Tonty was perhaps an unlikely ally in that task. As he wrote in his memoir, he had served "eight years in the French service, by land and by sea, and having had a hand shot off in Sicily by a grenade, I resolved to return to France to solicit employment."*

Shortly after his return to his homeland in 1678, he became an assistant to René-Robert, Cavelier de La Salle (1643–1687), traveled to America with his new patron, and was present when La Salle claimed the Louisiana Territory for France on April 9, 1682.

EXCERPT *from "Voyages and Discoveries of Father James Marquette in the Mississippi Valley"* [1673]

Here, then, we are on this renowned river, of which I have endeavored to remark attentively all the peculiarities. The Mississippi river has its source in several lakes in the country of the nations to the north; it is narrow at the mouth of the Miskousing; its current, which runs south, is slow and gentle; on the right is a considerable chain of very high mountains, and on the left fine lands; it is in many places studded with islands. On sounding, we have found ten fathoms of water. Its breadth is very unequal; it is sometimes three-quarters of a league, and sometimes narrows in to three arpents [220 yards]. We gently follow its course, which bears south and southeast till the forty-second degree. Here we perceive that the whole face is changed; there is now almost no wood or mountain, the islands are more beautiful and covered with finer trees; we see nothing but deer and moose, bustards and wing-less swans, for they shed their plumes in this country. From time

to time we meet monstrous fish, one of which struck so violently against our canoe, that I took it for a large tree about to knock us to pieces. Another time we perceived on the water a monster with the head of a tiger, a pointed snout like a wild-cat's, a beard, and ears erect, a grayish head and neck all black. We saw no more of them. On casting out nets, we have taken sturgeon and a very extraordinary kind of fish [the "spoon bill"]; it resembles a trout with this difference, that it has a larger mouth, but smaller eyes and snout. Near the latter is a large bone, like a woman's busk, three fingers wide, and a cubit long; the end is circular and as wide as the hand. In leaping out of the water the weight of this often throws it back.

Having descended as far as 41 degrees 28 minutes, following the same direction, we find that turkeys have taken the place of game, and the pisikious [the Algonquin for Buffalo], or wild cattle, that of other beasts. We call them wild cattle, because they are like our domestic cattle; they are no longer, but almost as big again, and more corpulent; our men having killed one, three of us had considerable trouble in moving it. The head is very large, the forehead flat and a foot and a half broad between the horns, which are exactly like those of our cattle, except that they are black and much larger. Under the neck there is a kind of large crop hanging down, and on the back a pretty high hump. The whole head, the neck, and part of the shoulders, are covered with a great mane like a horse's; it is a crest a foot long, which renders them hideous, and falling over their eyes, prevents their seeing before them. The rest of the body is covered with a coarse curly hair like the wool of our sheep, but much stronger and thicker. It falls in summer, and the skin is then as soft as velvet. At this time the Indians employ the skins to make beautiful robes, which they paint of various colors; the flesh and fat of the pisikious are excellent, and constitute the best dish in banquets. They are very fierce, and not a year passes without their killing some Indian. When attacked, they take a man with their horns, if they can, lift him up, and then dash him to the ground, trample on him, and kill him. When you fire at them from a distance with gun or bow, you must throw yourself on the ground as soon as you fire, and hide in the grass; for, if they perceive the one who fired, they rush on him and attack him. As their feet are large and rather short, they do not generally go very fast, except when they are irritated. They are scattered over the prairies like herds of cattle. I have seen a band of four hundred.

We advanced constantly, but as we did not know where we were going, having already made more than a hundred leagues without having discovered anything but beasts and birds, we kept well on our guard. Accordingly we make only a little fire on the shore at night to prepare our meal, and after supper keep as far from it as possible, passing the night in our canoes, which we anchor in the river pretty far from the bank. Even this did not prevent one of us being always as a sentinel, for fear of a surprise.

Proceeding south and south-southwest, we find ourselves at 41 degrees north; then at 40 degrees and some minutes, partly by southeast and partly by southwest, after having advanced more than sixty leagues since entering the river, without discovering anything.

At last on the 25th of June, we perceived footprints of men by the water-side, and a beaten path entering a beautiful prairie. We stopped to examine it, and concluding that it was a path leading to some Indian village, we resolved to go and reconnoitre; we accordingly left our two canoes in charge of our people, cautioning them strictly to beware of a surprise; then M. Jollyet and I undertook this rather hazardous discovery for two single men, who thus put themselves at the discretion of an unknown and barbarous people. We followed the little path in silence, and having advanced about two leagues, we discovered a village on the banks of the river, and two others on a hill, half a league from the former.

Then, indeed, we recommended ourselves to God, with all our hearts; and, having implored His help, we passed on undiscovered.

EXCERPT *from "Memoir of Henry de Tonty"* [1693]

I cannot describe the beauty of all the countries I have mentioned. If I had a better knowledge of them, I should be better able to say what special advantages might be derived from them.

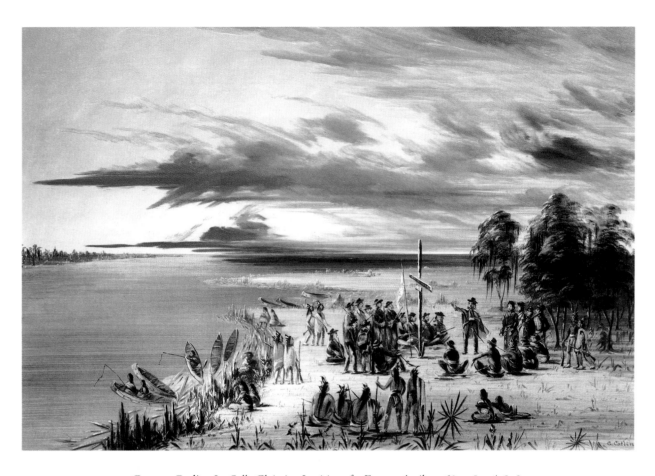

George Catlin, *La Salle Claiming Louisiana for France, April 9, 1682*, 1847/1848.
Paul Mellon Collection, National Gallery of Art, Washington, D.C.

As for the Mississippi, it could produce every year 20,000 ecu's worth of peltries, an abundance of lead, and wood for ship-building. A silk trade might be established there, and a port for the protection of vessels and the maintenance of a communication with the Gulf of Mexico. Pearls might be found there. If wheat will not grow at the lower part of the river, the upper country would furnish it; and the islands might be supplied with everything they need, such as planks, vegetables, grain, and salt beef. If I had not been hurried in making this narrative, I should have stated many circumstances which would have gratified the reader, but the loss of my notes during my travels is the reason why this relation is not such as I could have wished.

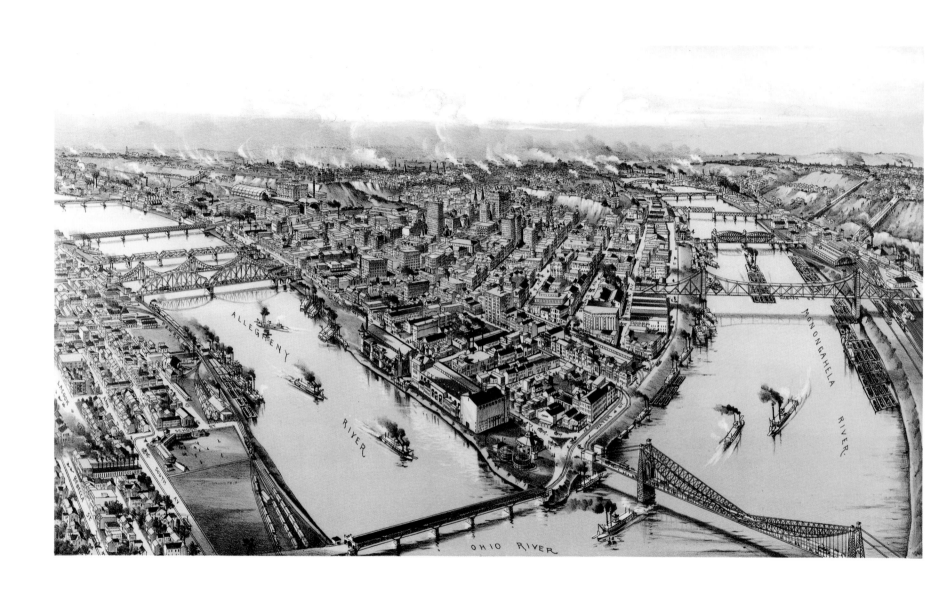

Pittsburgh, Pennsylvania, 1902.
Library of Congress, Geography and Map Division.

"Some Proposals for a Second Settlement in the Province of Pennsylvania"

William Penn

William Penn (1644–1718) is perhaps best known today for the policies of religious toleration he supported in Pennsylvania, the colony he founded in 1681. But Penn was well aware of the need to develop the natural resources of the colony, and to do so he put his capital city, Philadelphia, at the

juncture of the two principal rivers of the eastern portion of the colony, the Schuylkill and the Delaware; he planned to locate the colony's second major city along the Susquehanna. Although the development of the Susquehanna Valley took place after Penn's death, his proposal revealed that European colonizers recognized the importance of channeling people and goods along the interior waterways of the continent.

Whereas, I did about nine years past, propound the selling of several parts or shares of land, upon that side of the Province of Pennsylvania, next Delaware river, and setting out of a place upon it for the building of a city, by the name of Philadelphia; and that divers persons closed with those proposals, who, by their ingenuity, industry and charge, have advanced that city, from a wood, to a good forwardness of building (there being above one thousand houses finished in it) and that the several plantations and towns begun upon the land, bought by those first undertakers, are also in a prosperous way of improvement and enlargement (insomuch as last year ten sail of ships were freighted there, with the growth of the Province for Barbados, Jamaica, &c. besides what came directly for this kingdom). It is now my purpose to make another settlement, upon the river of Susquehannagh, that runs into the Bay of Chesapeake, and bears about fifty miles west from the river Delaware, as appears by the Common Maps of the English

Dominion in America. There I design to lay out a Plan for the building of another City, in the most convenient place for communication with the former plantations on the East: which by land, is as good as done already, a way being laid out between the two rivers very exactly and conveniently, at least three years ago; and which will not be hard to do by water, by the benefit of the river Scoulkill; for a Branch of that river lies near a Branch that runs into Susquehannagh River, and is the Common Course of the Indians with their Skins and Furr's into our Parts, and to the Provinces of East and West Jersey, and New York, from the West and Northwest parts of the continent from whence they bring them.

And I do also intend that every one who shall be a Purchaser in this proposed settlement, shall have a proportional Lot in the said City to build a House or Houses upon; which Town-Ground, and the Shares of Land that shall be bought of me, shall be delivered clear of all Indian Pretentions; for it has been my way from the first, to purchase their title from them, and so settle with their consent.

The Shares I dispose of, contain each, Three Thousand Acres for £100, and for greater or lesser quantities after that rate: The acre of that Province is according to the Statute of the 33th of Edw. 1. And no acknowledgement or Quit Rent shall be paid by the Purchasers till five years after a settlement be made upon their lands, and that only according to the quantity of acres so taken up and seated; and not otherwise; and only then to pay but one shilling for every hundred acres for ever. And further I do promise to agree with every Purchaser that shall be willing to treat with me between this and next spring, upon all such reasonable conditions as shall be thought necessary for their accommodation, intending, if God please, to return with what speed I can, and my Family with me, in order to our future Residence.

To conclude, that which particularly recommends this Settlement, is the known goodness of the soyll and scituation of the Land, which is high and not mountainous, also the Pleasantness, and Largeness of the River being clean and not rapid, and broader than the Thames at London bridge, many miles above the Place intended for this Settlement; and runs (as we are told by the Indians) quite through the Province, into which many fair rivers empty themselves. The sorts of Timber that grow there are chiefly oak, ash, chesnut, walnut, cedar, and poplar. The native Fruits are pawpaws, grapes, mulbery's, chesnuts, and several sorts of walnuts. There are likewise great quantities of Deer, and especially Elks, which are much bigger than our Red Deer, and use that River in Herds. And Fish there is of divers sorts, and very large and good, and in great plenty.

But that which recommends both this Settlement in particular, and the Province in general, is a late Pattent obtained by divers Eminent Lords and Gentlemen for that Land that lies north of Pennsylvania up to the 46th Degree and an half, because their Traffick and Intercourse will be chiefly through Pennsylvania, which lies between that Province and the Sea. We have also the comfort of being the Center of all the English colonies upon the Continent of America, as they lie from the North East Ports of New England to the most Southern parts of Carolina, being above 1000 miles upon the Coast.

If any Persons please to apply themselves to me by letter in relation to this affair, they may direct them to Robert Ness Scrivener in Lumber street in London for Philip Ford, and suitable answers will be returned by the first opportunity. There are also Instructions printed for information of such as intend to go, or send servants or families thither, which way they may proceed with most ease and advantage, both here and there, in reference to Passage, Goods, Utensels, Building, Husbandry, Stock, Subsistence, Traffick, &c. being the effect of their expence and experiance that have seen the Fruit of their labours.

OPPOSITE: Emanuel Leutze, *Washington Crossing the Delaware*, 1851. Metropolitan Museum of Art, gift of John Stewart Kennedy.

The Eighteenth Century

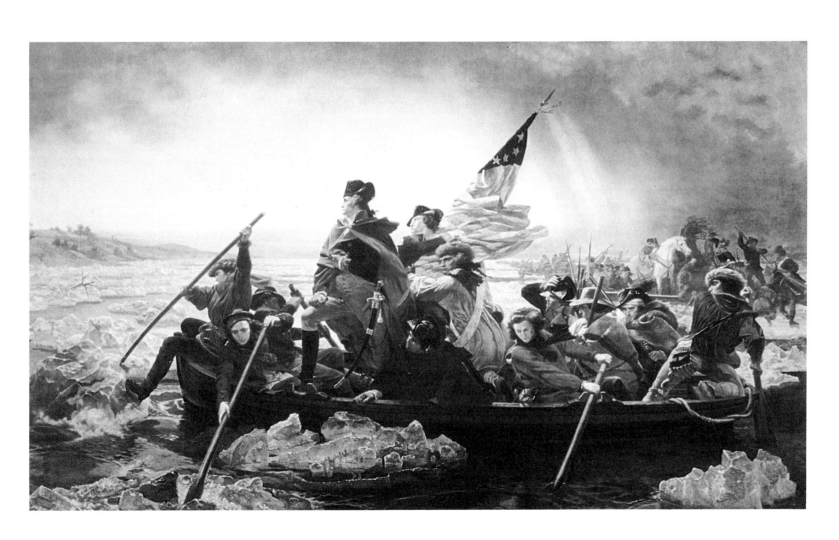

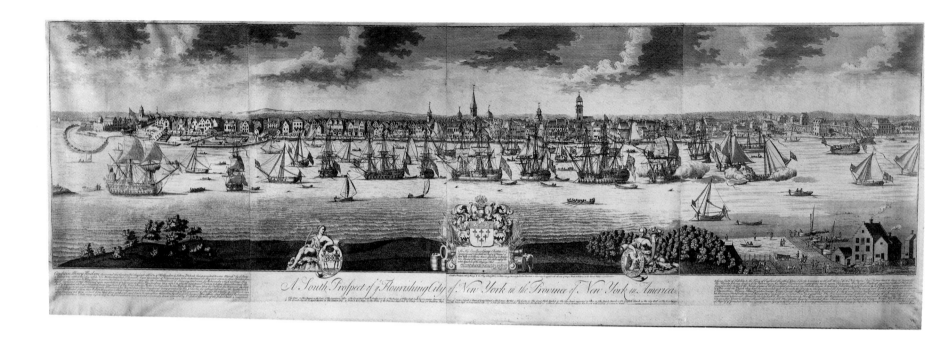

A South Prospect of ye Flourishing City of New York in the Province of New York in America.

William Burgis with later additions by Thomas Bakewell, *The Bakewell View of New York, 1716–1745.*
Museum of the City of New York, gift of Mrs. William Sloane.

"*Upon the Drying Up that Ancient River, The River Merrymak*"

Samuel Sewall

The Boston-based jurist Samuel Sewall (1652–1730) made some mistakes in his life. As he publicly noted in 1697, he had erred when he presided at the witchcraft trials at Salem five years earlier and sent nineteen accused witches to their deaths. But Sewall is known today less for his legal judgments than for his extensive diary which covered his life in Boston from 1674 to 1677 and from 1685 until 1729. Published originally in three volumes in the late nineteenth century, the diary sheds remarkable light on the people and culture of Puritan Massachusetts.

*L*ong did *Euphrates* make us glad,
Such pleasant, steady Course he had;
Eight *White*, fight *Chesnut*; all was one,
In Peace profound our River Run
From his remote and lofty Head,
Until he with the Ocean Wed.
Thousands of Years ran parallel,
View'd it throughout, and lik'd it well.
Herbs, Trees, Fowls, Fishes, Beasts, and Men,
Refresh'd were by this goodly Stream.
Dutiful *Salmon*, once a Year,
Still visited their Parent dear:
And royal *Sturgeon* saw it good
To Sport in the renowned Flood.

All sorts of *Geese*, and *Ducks*, and *Teal*,
In their Allotments fared well.
Many a *Moose*, and Thirsty *Dear*,
Drank to full Satisfaction here.
The *Fox*, the *Wolf*, the angry *Bear*,
Of Drink were not deny'd their share.
The Strangers, late Arrived here,
Were Entertain'd with Welcom chear;
The *Horse*, and *Ox*, at their own will,
Might taste, and drink, and drink their fill.
Thus *Merrymak* kept House secure,
And hop'd for Ages to endure;
Living in Love, and Union,
With every Tributary Son.
At length, an Ambushment was laid
Near *Pawwow* Hill, when none afraid;
And unawares, at one Huge Sup,
Hydropick *Hampshire* Drunk it Up!
Look to thy Self! *Wadchuset* Hill;
And Bold *Menadnuck*, Fear some Ill!
Envy'd *Earth* knows no certain Bound;
In HEAV'N alone, CONTENT is found.

Correspondence of Benjamin Franklin and Mary Stevenson

Benjamin Franklin (1706–1790) ran away from his home in Boston to Philadelphia in 1723. He was seventeen at the time, and no one could have predicted that he would become the most prominent resident in the most important city in colonial British America. Yet over the course of his life, this brilliant polymath excelled in seemingly everything from printing to statecraft to science. Along the way, he corresponded regularly with Mary Stevenson (1739–1795); approximately 170 of the letters survive. Franklin at one point had hoped that Stevenson, the daughter of his landlady in London, would become his daughter-in-law, but she found a better prospect. The correspondence between the two was remarkable. Of the scores of letters he wrote to her, he included eight of them in his Experiments and Observations on Electricity *(1769). Looking back on their relationship in 1783, Franklin noted that in the previous twenty-five years "we have never had among us the smallest Misunderstanding. Our Friendship has been all clear Sunshine, without any the least Cloud in its Hemisphere." Stevenson was at Franklin's bedside when he died in 1790.*

Mary Stevenson to Benjamin Franklin

August 1760

I remember you told me in your last obliging Conversation that the rising of Tides in Rivers was not owing to a greater quantity of Water in them but to the Moon's attraction. Now my dear Sir it appears to me that the Rivers are augmented by the water flowing into them from the Sea, because they begin to rise first at the part nearest it whether there Course is contrary or the same with the Moon, and are reckon'd saltiest at high Water. Whether my last assertion may not be a false one I will not presume to determine, but it is the common opinion, tho I don't comprehend why there should not retire an equal quantity of fresh as salt Water. I offer my sentiments to you without reserve, trusting to your Candour, and hoping to have my Errors corrected. I hope you know my Heart well enough to believe I do it with becoming Diffidence.

Benjamin Franklin to Mary Stevenson

September 13, 1760

But I shall now endeavour to explain what I said to you about the Tide in Rivers, and to that End shall make a Figure, which tho' not very like a River, may serve to convey my Meaning. Suppose a Canal 140 Miles long communicating at one End with the Sea, and fill'd therefore with Sea Water. I chuse a Canal at first, rather than a River, to throw out of Consideration the Effects produc'd by the Streams of Fresh Water from the Land,

the Inequality in Breadth, and the Crookedness of Courses. Let A, C, be the Head of the Canal, C D the Bottom of it; D F the open Mouth of it next the Sea. Let the strait prick'd Line B G represent Low Water Mark the whole Length of the Canal, A F High Water Mark: Now if a Person standing at E, and observing at the time of High water there that the Canal is quite full at that Place up to the Line E, should conclude that the Canal is equally full to the same Height from End to End, and therefore there was as much more Water come into the Canal since it was down at Low Water Mark, as could be included in the oblong Space A. B. G. F. he would be greatly mistaken. For the Tide is *a Wave*, and the Top of the Wave, which makes High Water, as well as every other lower Part, is progressive; and it is High Water successively, but not at the same time, in all the several Points between G, F. and A, B.— and in such a Length as I have mention'd it is Low Water at F G and also at A B, at or near the same time with its being High Water at E; so that the Surface of the Water in the Canal, during that Situation, is properly represented by the Curve prick'd Line B E G. And on the other hand, when it is Low Water at E H, it is High

Water both at F G and at A B at or near the same time; and the Surface would then be describ'd by the inverted Curve Line A H F.

In this View of the Case, you will easily see, that there must be very little more Water in the Canal at what we call High Water than there is at Low Water, those Terms not relating to the whole Canal at the same time, but successively to its Parts. And if you suppose the Canal six times as long, the Case would not vary as to the Quantity of Water at different times of the Tide; there would only be six Waves in the Canal at the same time, instead of one, and the Hollows in the Water would be equal to the Hills.

That this is not mere Theory, but conformable to Fact, we know by our long Rivers in America. The Delaware, on which Phila-delphia stands, is in this particular similar to the Canal I have supposed of one Wave: For when it is High Water at the Capes or Mouth of the River, it is also High Water at Philadelphia, which stands about 140 Miles from the Sea; and there is at the same time a Low Water in the Middle between the two High Waters; where, when it comes to be High Water, it is at the same time Low Water at the Capes and at Philadelphia. And the longer Rivers have, some a Wave and Half, some two, three, or four Waves, according to their Length. In the shorter Rivers of this Island, one may see the same thing in Part: for Instance; it is High Water at Gravesend an Hour before it is High Water at London Bridge; and 20 Miles below Gravesend an Hour before it is High Water at Gravesend. Therefore at the Time of High Water at Gravesend the Top of the Wave is there, and the Water is then not so high by some feet where the Top of the Wave was an Hour before, or where it will be an Hour after, as it is just then at Gravesend.

Now we are not to suppose, that because the Swell or Top of the Wave runs at the Rate of 20 Miles an Hour, that therefore the Current or Water itself of which the Wave is compos'd, runs at that rate. Far from it. To conceive this Motion of a Wave, make a small Experiment or two. Fasten one End of a Cord in a Window near the Top of a House, and let the other End come down to the Ground; take this End in your Hand, and you may, by a sudden

I. Carwitham, *A View of Fort George with the City of New York from the S.W.*, 1731–1736.
Museum of the City of New York, gift of Mrs. J. Insley Blair.

Motion occasion a Wave in the Cord that will run quite up to the Window; but tho' the Wave is progressive from your Hand to the Window, the Parts of the Rope do not proceed with the Wave, but remain where they were, except only that kind of Motion that produces the Wave. So if you throw a Stone into a Pond of Water when the Surface is still and smooth, you will see a circular Wave proceed from the Stone as its Center, quite to the Sides of the Pond; but the Water does not proceed with the Wave, it only rises and falls to form it in the different Parts of its Course; and the Waves that follow the first, all make use of the same Water with their Predecessors.

But a Wave in Water is not indeed in all Circumstances exactly like that in a Cord; for Water being a Fluid, and gravitating to the Earth, it naturally runs from a higher Place to a lower; therefore the Parts of the Wave in Water do actually run a little both ways from its Top towards its lower Sides, which the Parts of the Wave in the Cord cannot do. Thus when it is high and standing Water at Gravesend, the Water 20 Miles below has been running Ebb, or towards the Sea for an Hour, or ever since it was High Water there; but the Water at London Bridge will run Flood, or from the Sea yet another Hour, till it is High Water or the Top of the Wave arrives at that Bridge, and then it will have run Ebb an Hour at Gravesend, &c. &c. Now this Motion of the Water, occasion'd only by its Gravity, or Tendency to run from a higher Place to a lower, is by no means so swift as the Motion of the Wave. It scarce exceeds perhaps two Miles in an Hour. If it went as the Wave does 20 Miles an Hour, no Ships could ride at Anchor in such a Stream, nor Boats row against it.

In common Speech, indeed, this Current of the Water both ways from the Top of the Wave is call'd *the Tide*; thus we say, *the Tide runs strong, the Tide runs at the rate of 1, 2, or 3 Miles an hour, &c.* and when we are at a Part of the River behind the Top of the Wave, and find the Water lower than High-water Mark, and running towards the Sea, we say, *the Tide runs Ebb*; and when we are before the Top of the Wave, and find the Water higher than Low-water Mark, and running from the Sea, we say, *the Tide runs Flood*: But these Expressions are only locally proper; for a Tide strictly speaking is *one whole Wave*, including all its Parts higher and lower, and these Waves succeed one another about twice in twenty four Hours.

This Motion of the Water, occasion'd by its Gravity, will explain to you why the Water near the Mouths of Rivers may be salter at Highwater than at Low. Some of the Salt Water, as the Tide Wave enters the River, runs from its Top and fore Side, and mixes with the fresh, and also pushes it back up the River.

Supposing that the Water commonly runs during the Flood at the Rate of two Miles in an Hour, and that the Flood runs 5 Hours, you see that it can bring at most into our Canal only a Quantity of Water equal to the Space included in the Breadth of the Canal, ten Miles of its Length, and the Depth between Low and High-water Mark. Which is but a fourteenth Part of what would be necessary to fill all the Space between Low and Highwater Mark, for 140 Miles, the whole Length of the Canal.

And indeed such a Quantity of Water as would fill that whole Space, to run in and out every Tide, must create so outrageous a Current, as would do infinite Damage to the Shores, Shipping, &c. and make the Navigation of a River almost impracticable.

I have made this Letter longer than I intended, and therefore reserve for another what I have farther to say on the Subject of Tides and Rivers. I shall now only add, that I have not been exact in the Numbers, because I would avoid perplexing you with minute Calculations, my Design at present being chiefly to give you distinct and clear Ideas of the first Principles.

Benjamin Franklin to Mary Stevenson

[November? 1760]

My dear Friend

It is, as you observed in our late Conversation, a very general opinion, that *all Rivers run into the Sea*, or deposite their Waters there. 'Tis a kind of Audacity to call such general Opinions in question, and may subject one to Censure: But we must hazard

something in what we think the Cause of Truth: And if we propose our Objections modestly, we shall, tho' mistaken, deserve a Censure less severe, than when we are both mistaken and insolent.

That some Rivers run into the Sea is beyond a doubt: Such, for Instance, are the Amazones, and I think the Oranoko and the Mississippi. The Proof is, that their Waters are fresh quite to the Sea, and out to some Distance from the Land. Our Question is, whether the fresh Waters of those Rivers whose Beds are filled with Salt Water to a considerable Distance up from the Sea (as the Thames, the Delaware, and the Rivers that communicate with Chesapeak Bay in Virginia) do ever arrive at the Sea? and as I suspect they do not, I am now to acquaint you with my Reasons; or, if they are not allow'd to be Reasons, my Conceptions, at least of this Matter.

The common Supply of Rivers is from Springs, which draw their Origin from Rain that has soak'd into the Earth. The Union of a Number of Springs forms a River. The Waters as they run, expos'd to the Sun, Air and Wind, are continually evaporating. Hence in Travelling one may often see where a River runs, by a long blueish Mist over it, tho' we are at such a Distance as not to see the River itself. The Quantity of this Evaporation is greater or less in proportion to the Surface exposed by the same Quantity of Water to those Causes of Evaporation. While the River runs in a narrow confined Channel in the upper hilly Country, only a small Surface is exposed; a greater as the River widens. Now if a River ends in a Lake, as some do, whereby its Waters are spread so wide as that the Evaporation is equal to the Sum of all its Springs, that Lake will never overflow: And if instead of ending in a Lake, it was drawn into greater Length as a River, so as to expose a Surface equal, in the whole to that Lake, the Evaporation would be equal, and such River would end as a Canal; when the Ignorant might suppose, as they actually do in such cases, that the River loses itself by running under ground, whereas in truth it has run up into the Air.

Now many Rivers that are open to the Sea, widen much before they arrive at it, not merely by the additional Waters they receive, but by having their Course stopt by the opposing Flood Tide; by being turned back twice in twenty-four Hours, and by finding broader Beds in the low flat Countries to dilate themselves in; hence the Evaporation of the fresh Water is proportionably increas'd, so that in some Rivers it may equal the Springs of Supply. In such cases, the Salt Water comes up the River, and meets the fresh in that part where, if there were a Wall or Bank of Earth across from Side to Side, the River would form a Lake, fuller indeed at some times than at others according to the Seasons, but whose Evaporation would, one time with another, be equal to its Supply.

When the Communication between the two kinds of Water is open, this supposed Wall of Separation may be conceived as a moveable one, which is not only pushed some Miles higher up the River by every Flood Tide from the Sea, and carried down again as far by every Tide of Ebb, but which has even this Space of Vibration removed nearer to the Sea in wet Seasons, when the Springs and Brooks in the upper Country are augmented by the falling Rains so as to swell the River, and farther from the Sea in dry Seasons.

Within a few Miles above and below this moveable Line of Separation, the different Waters mix a little, partly by their Motion to and fro, and partly from the greater specific Gravity of the Salt Water, which inclines it to run under the Fresh, while the fresh Water being lighter runs over the Salt.

Cast your Eye on the Map of North America, and observe the Bay of Chesapeak in Virginia, mentioned above; you will see, communicating with it by their Mouths, the great Rivers Sasquehanah, Potowmack, Rappahanock, York and James, besides a Number of smaller Streams each as big as the Thames. It has been propos'd by philosophical Writers, that to compute how much Water any River discharges into the Sea, in a given time, we should measure its Depth and Swiftness at any Part above the Tide, as, for the Thames, at Kingston or Windsor. But can one imagine, that if all the Water of those vast Rivers went to the Sea, it would not first have pushed the Salt Water out of that narrow-mouthed Bay, and filled it with fresh? The Sasquehanah alone would seem to be sufficient for this, if it were not for the Loss by Evaporation. And yet that Bay is salt quite up to Annapolis.

Frederic Edwin Church, *New England Scenery*, 1851.
George Walter Vincent Smith Art Museum, Springfield, Massachusetts.

Travels in North America

Peter Kalm

The Swedish botanist Peter Kalm (1716–1779) left London for Philadelphia on August 5, 1748, arriving six weeks later. He went, the translator of his account wrote in 1770, hoping to identify American plants that "promised to be very useful in husbandry and physic." Whatever his original intent, Kalm's initial reaction to America was awe. "I found that I had now come into a new world," he wrote in his Travels. "Whenever I looked to the ground, I every where found such plants as I had never seen before. When I saw a tree, I was forced to stop, and ask those who accompanied me, how it was called. . . . I was seized with terror at the thought of ranging so many new and unknown parts of natural history."

June the 21st (P.M.)

Leaving Albany. About five o'clock in the afternoon we left Albany, and proceeded toward Canada. We had two men with us, who were to accompany us to the first French place, which is Fort St. Frédéric, or as the English call it, Crown Point. For this service each of them was to receive five pounds of New York currency, in addition to food and drink. This is the common price here, and he that does not choose to conform to it, is obliged to travel alone. We were forced to use a canoe, as we could get neither battoes, nor boats of bark; and as there was a good road along the west side of the Hudson, we left the men to follow in the canoe, and we went along on the shore, that we might be able to examine it and its natural characteristics with greater accuracy. It is very inconvenient forwards. They commonly keep close to the shore, that they may be able to reach the ground easily. The rowers [or paddlers] are forced to stand upright while they row in a canoe. We kept along the shore all evening. It consisted of large hills, and next to the water grew the trees, which I have mentioned above,

and which likewise are to be seen on the shores of the isle, in the river, situated below Albany. The easterly shore of the river is uncultivated, woody, and hilly; but the western is flat, cultivated, and chiefly turned into plowed fields, which have no drains, though they need them in some places. It appears very plainly here that the river has formerly been broader, for there is a sloping bank on the grain fields, at about thirty yards distance from the river, which always runs parallel. From this it sufficiently appears that the rising ground formerly was the shore of the river, and the fields its bed. As a further proof, it may be added that the same shells which abound on the present shore of the river, and are not applied to any use by the inhabitants, lie plentifully scattered on these fields. I cannot say whether this change was occasioned by the diminishing of the water in the river, or by its washing some earth down the river and carrying it to its sides, or by the river's cutting deeper in on the sides.

Agriculture. All land was plowed very even as is usual in the Swedish province of Uppland. Some fields were sown with yellow and others with white wheat. Now and then we saw great fields of flax, which was now beginning to flower. In some parts it grew very well, and in others it was poor. The excessive drought which had continued throughout this spring had parched all the grass and plants on hills and higher grounds, leaving no other green plant than the common mullein (*Verbascum thapsus* L.) which I saw in several places, on the driest and highest hills, growing in spite of the parching heat of the sun, and though the pastures and meadows were excessively poor and afforded scarcely any food at all; yet the cattle never touched the mullein. Now and then I found fields with peas, but the charlock (wild mustard) (*Sinapis arvensis* L.) kept them quite under. The soil in most of these fields is a fine black mould, which goes down pretty deep.

The wild vines cover all the hills along the rivers, on which no other plants grow, and on those which are covered with trees they climb to the tops and wholly cover them, making them bend down with their weight. They had already large grapes; we saw them in abundance all day, and during all the time that we kept to the

Hudson, on the hills, along the shores, and on some little islands in the river.

The white-beaked corn thieves (*blackbirds*) appeared now and then, flying amongst the bushes; their note is pleasant and they are not so large as the black corn thieves (*Oriolus Phœnicus*). We saw them near New York, for the first time.

We found a water beech tree (*Platanus occidentalis*) cut down near the road, measuring about five feet in diameter.

This day and for some days afterwards we met islands in the river. The large ones were cultivated and turned into grain fields and meadows. We walked about five English miles along the river today, and found the ground, during that time, very uniform and consisting of pure earth. I did not see a single stone on the fields. The red maple, the water beech, the water aspen, the wild plum tree, the sumach, the elm, the wild grape-vines, and some species of willows were the trees which we found on the rising shores of the river, where some asparagus (*Asparagus officinalis*) grew wild.

North of Albany. We passed the night about six miles from Albany in a countryman's cottage. On the west side of the river we saw several houses, one after another, inhabited by the descendants of the first Dutch settlers, who lived by cultivating their grounds. About an English mile beyond our lodgings was a place where the tide stops in the Hudson, there being only small and shallow streams above it. At that place they catch a good many kinds of fish in the river.

The barns were generally built in the Dutch way, as I have before described them; for in the middle was the threshing floor, above it a place for the hay and straw, and on each side stables for horses, cows, and other animals. The barn itself was very large. Sometimes the buildings of a farm consisted only of a small cottage with a garret above it, together with a barn upon the above plan.

June the 22nd

This morning I followed one of our guides to the waterfall near Cohoes, in the Mohawk River, before it empties into the Hudson River. These falls are about three English miles from the place

where I passed the night. The country as far as the falls is a plain, and is hilly only about the fall itself. The wood is cleared in most places, and the ground cultivated and interspersed with pretty farmhouses.

The *Cohoes Falls* are among the greatest in this locality. They are in the Mohawk, before it unites with the Hudson. Above and below the falls both sides and the bottom are of rock, and there is a cliff at the fall itself, running everywhere equally high, and crossing the river in a straight line with the side which forms the fall. It represents, as it were, a wall towards the lower side, which is not quite perpendicular, wanting about four yards. The height of this wall, over which the water rolls, appeared to me about twenty or twenty-four yards. I had noted this height in my diary, and afterwards found it agreed pretty well with the account which that ingenious engineer, Mr. Lewis Evans, gave me at Philadelphia. He said that he had geometrically measured the breadth and height of the falls, and found it nine hundred English feet broad and seventy-five feet high. There was very little water in the river and it only ran over the falls in a few places. In some spots where the water had rolled down before, it had cut deep holes below into the rock, sometimes to the depth of two or three fathoms. The bed of the river, below the falls, was quite dry, there being only a channel in the middle fourteen feet broad, and a fathom or somewhat more deep, through which the water passed which came over the falls. We saw a number of holes in the rock below the falls, which bore a perfect resemblance to those in Sweden which we call giants' pots, or mountain kettles. They differed in size, there being large deep ones, and small shallow ones. We had clear uninterrupted sunshine, not a cloud above the horizon, and no wind at all. However, close to this fall, where the water was in such a small quantity, there was a continual drizzling rain, occasioned by the vapors which rose from the water during its fall, and were carried about by the wind. Therefore, in coming within a musketshot of the falls, against the wind, our clothes became wet at once, as from rain. The whirlpools, which were in the water below the falls, contained several kinds of fish; and they were caught by some people, who amused themselves with angling. The rocks hereabouts consist of the same black stone which forms the hills about Albany. When exposed to the air, it is apt to split into horizontal flakes, as slate does.

I here saw a kind of fence which we had not seen before, but which was used all along the Hudson where there was a quantity of woods. It can be called a timber fence, for it consisted of long, thick logs, and was about four feet high. It was made by placing the long logs at right angles to and upon short ones and fitting them together by having suitable crescent-shaped hollows in the short logs [in the manner of building log cabins]. Such a fence is possible only where there is plenty of trees.

En Route for Canada. At noon we continued our journey to Canada in the canoe, which was pretty long and made of a white pine. Somewhat beyond the farm where we lay at night, the river became so shallow that the men could reach bottom everywhere with their oars, it being in some parts not above two feet, and sometimes but one foot deep. The shore and bed of the river consisted of sand and pebbles. The river was very rapid, and against us, so that our men found it hard work to propel themselves forward against the stream. The hills along the shore consisted merely of earth, and were very high and steep in places. The breadth of the river was generally near two musketshots.

Sturgeons abound in the Hudson River. We saw them all day long leaping high up into the air, especially in the evening. Our guides, and the people who lived hereabouts, asserted that they never see any sturgeons in winter time, because these fish go into the sea late in autumn, but come up again in spring and stay in the river all summer. They are said to prefer the shallowest places in the river, which agreed pretty well with our observations, for we never saw them leap out of the water except in shallow spots. Their food is said to be several kinds of *confervæ*, which grow plentifully in some places on the bottom of the river, for these weeds are found in their bellies when they are opened. The Dutch who settled here, and the Indians, fish for sturgeon, and every night of our voyage upon this river we observed several boats with people who speared them with harpoons. The torches which they employed were made

of that kind of pine which they call the black pine here. The nights were exceedingly dark, though they were now the shortest, and though we were in a country so much to the south of Sweden. The shores of the river lay covered with dead sturgeons, which had been wounded with the harpoon, but escaped, and died afterwards; they occasioned an insupportable stench during the excessive heat of the day.

Indians. As we went further up the river we saw an Indian woman and her boy sitting in a boat of bark, and an Indian wading through the river, with a great cap of bark on his head. Near them was an island which was temporarily inhabited by a number of Indians who had gone there for sturgeon fishing. We went to their huts to learn if we could get one of them to accompany us to St. Anne and help us make a bark canoe to get to Fort St. Frédéric. On our arrival we found that all the men had gone into the woods hunting this morning, and we persuaded their boys to go and look for them. They demanded bread for payment, and we gave them twenty little round loaves; for as they found that it was of great importance to us to speak with the Indians, they raised difficulties and would not go till we gave them what they wanted. The island belonged to the Dutch, who had cultivated it. But they had now leased it to the Indians who planted their corn and several kinds of melons on it. The latter built their huts or wigwams on this island, on a very simple plan. Four posts were put into the ground perpendicularly, over which they had placed poles, and made a roof of bark upon them. The huts had either no walls at all, or they consisted of branches with leaves, which were fixed to the poles. The beds consisted of deerskins which were spread to the ground. The utensils were a couple of small kettles, two ladles, and a bucket or two, of bark, made tight enough to hold water. The sturgeons were cut into long slices, and hung up in the sunshine to dry, to be ready to serve as food in winter. The Indian women were sitting at their work on the hill, upon deer-skins.—They never use chairs, but sit on the ground. However, they do not sit crosslegged, as the Turks do, but between their feet, which though they be turned backwards, are not crossed, but bent outwards. The women wear no headdress, and have black hair. They have a short blue petticoat which reaches to their knees, the edge of which is bordered with red or other-colored ribbons. They wear their blouses over their petticoats. They have large ear-rings, and their hair is tied behind and wrapped in ribbons. Their wampum, or pearls, and their money, which is made of shells, are tied round the neck and hang down on the breast. This is their whole dress. They were now making several articles of skins, to which they sewed the quills of the American porcupine, having dyed them black or red or left them in their original color.

Towards evening we went from there to a farm close to the river where we found only one man looking after the corn and the fields, the inhabitants not having yet returned from [King George's] war.

The little brooks here contain crawfish, which are exactly the same as ours, with this difference only that they are somewhat smaller; however, the Dutch settlers will not eat them.

Notes on the State of Virginia

Thomas Jefferson

The most important works of Thomas Jefferson (1743–1826)—the Declaration of Independence (1776) and the Statute for Religious Freedom for Virginia (1777)—were among the great state papers of the revolutionary age. Each expressed, in language that reaches across the centuries, fundamental values of American society as it emerged from the thrall of ancien régime Europe. Jefferson's other major work, far longer than the two state papers, was his Notes on the State of Virginia. *Written in the 1780s, the* Notes *reveal Jefferson's views of his home state, as well as his vision for the future. It was in the* Notes *that Jefferson offered a paean to American farmers and dreaded the possibility of an American economy increasingly dominated by factories. And in those pages he offered testimony as well to the benefits that all Virginians could gain from the many rivers flowing through the state. Though Jefferson lived almost forty years after writing the* Notes*—he died on July 4, 1826, the same day as John Adams and the date marking the fiftieth anniversary of the signing of the Declaration—he never again wrote at such length about his homeland or its resources.*

QUERY II.

A notice of its rivers, rivulets, and how far they are navigable? An inspection of a map of *Virginia*, will give a better idea of the geography of its rivers, than any description in writing. Their navigation may be imperfectly noted.

Roanoke, so far as it lies within this state, is no where navigable, but for canoes or light batteaux; and, even for these, in such detached parcels as to have prevented the inhabitants from availing themselves of it at all.

James River, and its waters, afford navigation as follows.

The whole of *Elizabeth River*, the lowest of those which run into James River, is a harbour, and would contain upwards of 300 ships. The channel is from 150 to 200 fathom wide, and at common flood tide, affords 18 feet water to Norfolk. The Stafford, a 60 gun ship, went there, lightening herself to cross the bar at Sowel's Point. The

Fier Rodrigue, pierced for 64 guns, and carrying 50, went there without lightening. Craney island, at the mouth of this river, commands its channel tolerably well.

Nansemond River, is navigable to Sleepy Hole, for vessels of 350 tons; to Suffolk, for those of 100 tons; and to Milner's, for those of 25.

Pagan Creek affords 8 or 10 feet water to Smithfield, which admits vessels of 20 tons.

Chickahominy has at its mouth a bar, on which is only 12 feet water at common flood tide. Vessels passing that, may go 8 miles up the river; those of 10 feet draught may go four miles further, and those of six tons burthen, 20 miles further.

Appamattox may be navigated as far as Broadways, by any vessel which has crossed Harrison's Bar in James River; it keeps 8 or 10 feet water a mile or two higher up to Fisher's bar, and 4 feet on that and upwards to Petersburg, where all navigation ceases.

James River itself affords harbour for vessels of any size in Hampton Road, but not in safety through the whole winter; and there is navigable water for them as far as Mulberry Island. A 40 gun ship goes to James town, and lightening herself, may pass to Harrison's bar; on which there is only 15 feet water. Vessels of 250 tons may go to Warwick; those of 125 go to Rocket's, a mile below Richmond; for thence is about 7 feet water to Richmond; and about the centre of the town, four feet and a half, where the navigation is interrupted by falls, which in a course of six miles, descended about 80 feet perpendicular: above these it is resumed in canoes, and batteaux, and is prosecuted safely and advantageously within 10 miles of the Blue Ridge; and even through the Blue Ridge a ton weight has been brought; and the expense would not be great, when compared with its object, to open a tolerable navigation up Jackson's River and Carpenter's creek, to within 29 miles of Howard's creek of Green Briar, both of which have then water enough to float vessels into the Great Kanhaway. In some future state of population, I think it possible, that its navigation may also be made to interlock with that of the Potowmac, and through that to communicate by a short portage with the Ohio. It is to be noted, that this river is called in the maps *James River*, only to its confluence

with the Rivanna: thence to the Blue Ridge it is called the Fluvanna: and thence to its source, Jackson's river. But in common speech, it is called James river to its source.

The Rivanna, a Branch of James River, is navigable for canoes and batteaux to its intersection with the South West mountains, which is about 22 miles; and may easily be opened to navigation through these mountains to its fork above Charlottesville.

York River, at York town, affords the best harbour in the state for vessels of the largest size. The river there narrows to the width of a mile, and is contained within very high banks, close under which the vessels may ride. It holds 4 fathom water at high tide for 25 miles above York to the mouth of Poropotank, where the river is a mile and a half wide, and the channel only 75 fathom, and passing under a high bank. At the confluence of *Pamunkey* and *Mattapony*, it is reduced to 3 fathom depth, which continues up Pamunkey to Cumberland, where the width is 100 yards, and up Mattapony to within two miles of Frazer's ferry, where it becomes 2 fathom deep, and holds that about 5 miles. Pamunkey is then capable of navigation for loaded flats to Brockman's bridge, fifty miles above Hanover town, and Mattapony to Downer's bridge, 70 miles above its mouth.

Puankatank, the little rivers making out of *Mobjack Bay* and those of the *Eastern Shore*, receive only very small vessels, and these can but enter them.

Rappahannock affords 4 fathom water to Hobb's hole, and 2 fathom from thence to Fredericksburg.

Patowmac is 7½ miles wide at the mouth; 4½ at Nomony bay; 3 at Aquia; 1½ at Hallowing point; 1¼ at Alexandria. Its soundings are, 7 fathom at the mouth; 5 at St. George's island; 4½ at Lower Mathodic; 3 at Swan's point, and thence up to Alexandria; thence 10 feet water to the falls, which are 13 miles above Alexandria. These falls are 15 miles in length, and of very great descent, and the navigation above them for batteaux and canoes, is so much interrupted as to be little used. It is, however, used in a small degree up the Cohongoronta branch as far as fort Cumberland, which was at the mouth of Willis's creek; and is capable, at no great expense, of being rendered very practicable. The Shenandoah branch in-

terlocks with James river about the Blue Ridge, and may perhaps in future be opened.

The *Mississippi* will be one of the principal channels of future commerce for the country westward of the Alleghaney. From the mouth of this river to where it receives the Ohio, is 1000 miles by water, but only 500 by land passing through the Chickasaw country. From the mouth of the Ohio to that of the Missouri, is 230 miles by water, and 140 by land, from thence to the mouth of Illinois river, is about 25 miles. The Mississippi, below the mouth of the Missouri, is always muddy, and abounding with sand bars, which frequently change their places. However, it carries 15 feet water to the mouth of the Ohio, to which place it is from one and a half to two miles wide, and thence to Kaskaskia from one mile to a mile and a quarter wide. Its current is so rapid, that it never can be stemmed by the force of the wind alone, acting on sales. Any vessel, however, navigated with oars, may come up at any time, and receive much aid from the wind. A batteaux passes from the mouth of Ohio to the mouth of Mississippi in three weeks, and is two to three months getting up again. During its floods, which are periodical as those of the Nile, the largest vessels may pass down it, if their steerage can be insured. These floods begin in April, and the river returns into its banks early in August. The inundation extends further on the western than eastern side, covering the lands in some places for 50 miles from its bands. Above the mouth of the Missouri it becomes much such a river as the Ohio, like it clear, and gentle in its current, not quite so wide, the period of its floods nearly the same, but not rising to so great a height. The streets of the village at Cohoes are not more than 10 feet above the ordinary level of the water, and yet were never overflowed. Its bed deepens every year. Cohoes, in the memory of many people now living, was insulated by every flood of the river. What was the eastern channel has now become a lake, 9 miles in length and one in width, into which the river at this day never flows. This river yields turtle of a peculiar kind, perch, trout, gar, pike, mullets, herrings, carps, spatula-fish of 50 lb. weight, catfish of 100 lb. weight, buffalo fish, and sturgeon. Aligators or crocodiles have been seen as high up as the Acansas. It also abounds

The President's House, n.d.
Spencer Museum of Art/University of Kansas.

in herons, cranes, ducks, brant, geese and swans. Its passage is commanded by a fort established by this state, five miles below the mouth of Ohio, and ten miles above the Carolina boundary.

The Missouri, since the treaty of Paris, the Illinois and Northern Branches of the Ohio, since the cession to Congress, are no longer within our limits. Yet having been so heretofore, and still opening to us channels of extensive communication with the western and northwestern country, they shall be noted in their order.

The *Missouri* is, in fact, the principal river, contributing more to the common stream than does the Mississippi, even after its junction with the Illinois. It is remarkably cold, muddy and rapid. Its overflowings are considerable. They happen during the months of June and July. Their commencement being so much later than those of the Mississippi, would induce a belief that the sources of the Missouri, are northward of those of the Mississippi, unless we suppose that the cold increases again with the ascent of the land from the Mississippi westwardly. That this ascent is great, is proved

by the rapidity of the river. Six miles above the mouth it is brought within the compass of a quarter of a mile's width: yet the Spanish merchants at Pancore, or St. Louis, say they go two thousand miles up it. It heads far westward of the Rio Norte, or North River. There is in the villages of Kaskaskia, Cohoes, and St. Vincennes, no inconsiderable quantity of plate, said to have been plundered during the last war by the Indians from the churches and private houses of Santa Fé, on the North river, and brought to the villages for sale. From the mouth of Ohio to Santa Fé are forty days journey, or about 1000 miles. What is the shortest distance between the navigable waters of the Missouri, and those of the North river, or how far this is navigable above Santa Fé, I could never learn. From Santa Fé to its mouth in the Gulph of Mexico is about 1200 miles. The road from New Orleans to Mexico crosses this river at the post of Rio Norte, 800 miles below Santa Fé: and from this post to New Orleans is about 1200 miles: thus making 2000 miles between Santa Fé and New Orleans, passing down the North river, Red river and Mississippi; whereas it is 2230 through the Missouri and Mississippi. From the same post of Rio Norte, passing near the mines of La Sierra and Laiguana, which are between the North River and the river Salina to Sartilla, is 375 miles; and from thence, passing the mines of Charcas, Zaccatecas and Potosi, to the city of Mexico is 375 miles; in all, 1550 miles from Santa Fé to the city of Mexico. From New Orleans to the city of Mexico is about 1950 miles; the roads after setting out from the Red river, near Natchitoches, keeping generally parallel with the coast, and about two hundred miles from it, till it enters the city of Mexico.

The *Illinois* is a fine river, clear, gentle, and without rapids; insomuch that it is navigable for batteaux to its source. From thence is a portage of two miles only to the Chickago, which affords a batteaux navigation of 16 miles to its entrance into lake Michigan. The Illinois, about 10 miles above its mouth, is 300 yards wide.

The *Kaskaskia* is one hundred yards wide at its entrance into the Mississippi and preserves that breadth to the Buffalo plains, 70 miles above. So far also it is navigable for loaded batteaux, and perhaps much further. It is not rapid.

The *Ohio* is the most beautiful river on earth. Its current gentle, waters clear, and bosom smooth and unbroken by rocks and rapids, a single instance only excepted.

It is ¼ of a mile wide at fort Pitt:

500 yards at the mouth of the Great Kanhaway:

1 mile and 25 poles at Louisville:

¼ of a mile on the rapids, three or four miles below Louisville.

½ a mile where the low country begins which is 20 miles above Green river:

1¼ at the receipt of the Tanissee:

And a mile wide at the mouth.

Its length, as measured according to its meanders by Capt. Hutchins, is as follows:

FROM FORT PITT

To Log's town	18½	Little Kanhaway	12¼
Big Beaver Creek	10¾	Hockhocking	16
Little Beaver Creek	13½	Great Kanhaway	82½
Yellow creek	11¾	Guiandot	43¾
Two creeks	21¾	Sandy Creek	14½
Long reach	53¾	Sioto	48¼
End Long reach	16½	Little Miami	126¼
Muskingum	25½	Licking Creek	8
Great Miami	26¾	Wabash	97¼
Big Bones	32½	Big Cave	42¾
Kentucky	44¼	Shawanee river	52½
Rapids	77¼	Cherokee river	13
Low country	155¾	Massac	11
Buffalo river	64½	Mississippi	46
			1187

In common winter and spring tides it affords 15 feet water to Louisville, 10 feet to Le Tarre's rapids, 40 miles above the mouth of the Great Kanhaway, and a sufficiency at all times for light batteaux, and canoes to Fort Pitt. The rapids are in latitude 38°8'. The inundations of this river begin about the last of March and

subside in July. During these, a first rate man of war may be carried from Louisville to New Orleans, if the sudden turns of the river and the strength of its current will admit a safe steerage. The rapids at Louisville descend about 30 feet in a length of a mile and a half. The bed of the river there is a solid rock, and is divided by an island into two branches, the southern of which is about 200 yards wide, and is dry four months in the year. The bed of the northern branch is worn into channels by the constant course of the water, and attrition of the pebble stones carried on with that, so as to be passable for batteaux through the greater part of the year. Yet it is thought that the southern arm may be the most easily opened for constant navigation. The rise of the waters in these rapids does not exceed 10 or 12 feet. A part of this island is so high as to have been never overflowed, and to command the settlement at Louisville, which is opposite to it. The fort, however, is situated at the head of the falls. The ground on the south side rises very gradually.

The *Tanissee*, Cherokee or Hogohege river is 600 yards wide at its mouth, ¼ of a mile at the mouth of Holston, and 200 yards at Chotee, which is 20 miles above Holston, and 300 miles above the mouth of the Tanissee. This river crosses the southern boundary of Virginia, 58 miles from the Mississippi. Its current is moderate. It is navigable for loaded boats of any burden to the Muscle shoals, where the river passes through the Cumberland mountain. These shoals are 6 or 8 miles long, passable downwards for loaded canoes, but not upwards, unless there be a swell in the river. Above these the navigation for loaded canoes and batteaux continues to the Long Island. This river has its inundations also. Above the Chickamogga towns is a whirlpool called the sucking pot, which takes in trunks of trees or boats, and throws them out again half a mile below. It is avoided by keeping very close to the bank, on the south side. There are but a few miles portage between a branch of this river and the navigable waters of the river Mobile, which runs into the Gulph of Mexico.

Cumberland, or Shawanee river, intersects the boundary between Virginia and north Carolina 67 miles from the Mississippi, and again 198 miles from the same river, a little above the entrance of Obey's river, into the Cumberland. Its clear fork crosses the same boundary about 300 miles from the Mississippi. Cumberland is a very gentle stream, navigable for loaded batteaux 800 miles, without interruption; then intervenes some rapids of 15 miles in length, after which it is again navigable 70 miles upwards, which brings you within 10 miles of the Cumberland mountains. It is about 120 yards wide through its whole course, from the head of its navigation to its mouth.

The *Wabash* is a very beautiful river, 400 yards wide at the mouth, and 300 at St. Vincennes, which is a post 100 miles above the mouth, in a direct line. Within this space there are two small rapids, which give very little obstruction to the navigation. It is 400 yards wide at the mouth, and navigable 30 leagues upwards for canoes and small boats. From the mouth of Maple river to that of Eel river is about 80 miles in a direct line, the river continuing navigable, and from one to two hundred yards in width. The Eel river is 150 yards wide, and affords at all times navigation for periaguas, to within 18 miles of the Miami of the Lake. The Wabash, from the mouth of Eel river to Little river, a distance of 50 miles direct, is interrupted with frequent rapids and shoals, which obstruct the navigation except in a swell. Little river affords navigation, during a swell to within 3 miles of the Miami, which thence affords a similar navigation into Lake Erie, 100 miles distant in a direct line. The Wabash overflows periodically in correspondence with the Ohio, and in some places two leagues from its banks.

Green River is navigable for loaded batteaux at all times 50 miles upwards; but it is then interrupted by impassable rapids, above which the navigation again commences, and continues good 30 or 40 miles to the mouth of Barren river.

Kentucky River is 90 yards wide at the mouth, and also at Boonsborough, 80 miles above. It affords a navigation for loaded batteaux 180 miles in a direct line, in the winter tides.

The *Great Miami* of the Ohio, is 200 yards wide at the mouth. At the Piccawee towns, 75 miles above, it is reduced to 30 yards; it is, nevertheless, navigable for loaded canoes 50 miles above these towns. The portage from its western branch into the Miami of

Lake Erie, is 5 miles; that from its eastern branch into Sandusky river, is of 9 miles.

Salt river is at all times navigable for loaded batteaux 70 or 80 miles. It is 80 yards wide at its mouth, and keeps that width to its fork, 25 miles above.

The *Little Miami* of the Ohio, is 60 or 70 yards wide at its mouth, 60 miles to its source, and affords no navigation.

The *Sioto* is 250 yards wide at its mouth, which is in latitude 38°22′, and at the Saltlick towns, 200 miles above the mouth, it is yet 100 yards wide. To these towns it is navigable for loaded batteaux, and its eastern branch affords navigation almost to its source.

Great Sandy River is about 60 yards wide, and navigable 60 miles for loaded batteaux.

Guiandot is about the width of the river last mentioned, but is more rapid. It may be navigated by canoes 60 miles.

The *Great Kanhaway* is a river of considerable note for the fertility of its lands, and still more, as leading towards the head waters of James river. Nevertheless, it is doubtful whether its great and numerous rapids will admit a navigation, but at an expense to which it will require ages to render its inhabitants equal. The great obstacles begin at what are called the Great Falls, 90 miles above the mouth, below which are only 5 or 6 rapids, and these passable, with some difficulty, even at low water. From the falls to the mouth of Greenbriar is 100 miles, and thence to the lead mines 120. It is 280 yards wide at its mouth.

Hockhocking is 80 yards wide at its mouth, and yields navigation for loaded batteaux to the Pressplace, 60 miles above its mouth.

The *Little Kanhaway* is 150 yards wide at the mouth. It yields a navigation of 10 miles only. Perhaps its northern branch called Junius's creek, which interlocks with the western of Monongahela, may one day admit a shorter passage from the latter into the Ohio.

The *Miskingum* is 280 yards wide at its mouth, and 200 yards at the lower Indian towns, 150 miles upwards. It is navigable for small batteaux to within one mile of a navigable part of Cayahoga river, which runs into Lake Erie.

At Fort Pitt the river Ohio loses its name, branching into the Monongahela and Alleghaney.

The *Monongahela* is 400 yards wide at its mouth. From thence is 12 or 15 miles to the mouth of Yohogany, where it is 300 yards wide. Thence to Redstone by water is 50 miles, by land 30. Then to the mouth of Cheat river by water 40 miles, by land 28, the width continuing at 300 yards, and the navigation good for boats. Thence the width is about 200 yards to the western fork, 50 miles higher, and the navigation frequently interrupted by rapids, which however with a swell of two or three feet become very passable for boats. It then admits light boats, except in dry seasons, 65 miles further to the head of Tygart's valley, presenting only some small rapids and falls of one or two feet perpendicular, and lessening in its width to 20 yards. The *Western fork* is navigable in the winter 10 or 15 miles towards the northern of the Little Kanhaway, and will admit a good wagon road to it. The *Yahoganey* is the principal branch of this river. It passes through the Laurel mountain, about 30 miles from its mouth; is so far from 300 to 150 yards wide, and the navigation much obstructed in dry weather by rapids and shoals. In its passage through the mountain it makes very great falls, admitting no navigation for 10 miles to the Turkey Foot. Thence to the Great Crossing, about 20 miles, it is again navigable, except in dry seasons, and at this place is 200 yards wide. The sources of this river are divided from those of the Patowmac by the Alleghaney mountain. From the falls, where it intersects the Laurel mountain, to Fort Cumberland, the head of the navigation on the Patowmac, is 40 miles of very mountainous road. Wills's creek, at the mouth of which was Fort Cumberland, is 30 or 40 yards wide, but affords no navigation as yet. *Cheat* river, another considerable branch of the Monongahela, is 200 yards wide at its mouth, and 100 yards at the *Dunkard's* settlement, 50 miles higher. It is navigable for boats, except in dry seasons. The boundary between Virginia and Pennsylvania crosses it about 3 or 4 miles above its mouth.

The *Alleghaney* river, with a slight swell, affords navigation for light batteaux to Venango, at the mouth of French creek, where it is 200 yards wide, and is practised even to Le Bœuf, from whence there is a portage of 15 miles to Presque Isle on the Lake Erie.

The country watered by the Mississippi and its eastern branches constitutes five-eighths of the United States, two of which five-

eighths are occupied by the Ohio and its waters: the residuary streams which run into the Gulph of Mexico, the Atlantic, and the St. Laurence, water the remaining three-eighths.

Before we quit the subject of the western waters, we will take a view of their principal connections with the Atlantic. These are three; the Hudson's river, the Patowmac, and the Mississippi itself. Down the last will pass all heavy commodities. But the navigation through the Gulph of Mexico is so dangerous, and that up the Mississippi so difficult and tedious, that it is thought probable that European merchandise will not return through that channel. It is most likely that flour, timber, and other heavy articles will be floated on rafts, which will themselves be an article for sale as well as their loading, the navigators returning by land or in light batteaux. There will therefore be a competition between the Hudson and Patowmac rivers for the residue of the commerce of all the country westward of Lake Erie, on the waters of the lakes, of the Ohio, and upper parts of the Mississippi. To go to New-York, that part of the trade which comes from the lakes or their waters must first be brought into Lake Erie. Between Lake Superior and its waters and Huron are the rapids of St. Mary, which will permit boats to pass, but not larger vessels. Lakes Huron and Michigan afford communication with Lake Erie by vessels of 8 feet draught. That part of the trade which comes from the waters of the Mississippi must pass from them through some portage into the waters of the lakes. The portage from the Illinois river into a water of Michigan is of one mile only. From the Wabash, Miami, Muskingum, or Alleghaney, are portages into the waters of Lake Erie, there is between that and Ontario an interruption by the falls of Niagara, where the portage is of 8 miles; and between Ontario and the Hudson's river are portages at the falls of Onondago, a little above Oswego, of a quarter of a mile; from Wood creek to the Mohawks river two miles; at the little falls of the Mohawks river half a mile, and from Schenectady to Albany 16 miles. Besides the increase of expense occasioned by frequent change of carriage, there is an increased risk of pillage produced by committing merchandise to a greater number of hands successively. The Patowmac offers itself under the following circumstances. For the trade of the lakes and their waters westward of Lake Erie, when it shall have entered that lake, it must coast along its southern shore, on account of the number and excellence of its harbours; the northern, though shortest, having few harbours, and these unsafe. Having reached Cayahoga, to proceed on to New-York it will have 825 miles and five portages; whereas it is but 425 miles to Alexandria, its emporium on the Patowmac, if it turns into the Cayahoga, and passes through that, Big-beaver, Ohio, Yohoganey, (or Monongahela and Cheat) and Patowmac, and there are but two portages; the first of which between Cayahoga and Beaver may be removed by uniting the sources of these waters, which are lakes in the neighbourhood of each other, and in a champaign country; the other from the waters of Ohio to Patowmac will be from 15 to 40 miles, according to the trouble which shall be taken to approach the two navigations. For the trade of the Ohio, or that which shall come into it from its own waters or the Mississippi, it is nearer through the Patowmac to Alexandria than to New-York by 580 miles, and it is interrupted by one portage only. There is another circumstance of difference too. The lakes themselves never freeze, but the communications between them freeze, and the Hudson's river is itself shut up by the ice three months in the year; whereas the channel to the Chesapeake leads directly into a warmer climate. The southern parts of it very rarely freeze at all, and whenever the northern do, it is so near the sources of the rivers, that the frequent floods to which they are there liable, break up the ice immediately, so that vessels may pass through the whole winter, subject only to accidental and short delays. Add to all this, that in case of a war with our neighbours, the Anglo-Americans or the Indians, the route to New-York becomes a frontier through almost its whole length, and all commerce through it ceases from that moment. But the channel to New-York is already known to practice; whereas the upper waters of the Ohio and the Patowmac, and the great falls of the latter, are yet to be cleared of their fixed obstructions.

Travels

William Bartram

The eighteenth century was the great age of natural historians. The Swedish botonist Carl von Linné (Linnaeus) (1707–1778) developed a system for the classification of species that allowed observers to catalog nature as never before; the English clergyman Gilbert White (1720–1793) wrote The Natural History and Antiquities of Selborne *(1789), a volume so cherished that the English public purchased it more than any other work except the Bible. In America, John Bartram (1699–1777), botanist to the king of England, entertained the most famous Americans of his day— Benjamin Franklin and George Washington among them—at his garden on the outskirts of Philadelphia. His son William (1739–1823) followed in his father's path, and became in the process arguably the greatest American naturalist of the century. It is difficult for us to know what audiences made of the encounter between Bartram and a Florida alligator recounted in this excerpt from his* Travels, *first published in 1791. However fanciful it might appear, there seems little question that the story introduced many Americans to one of the more bizarre creatures inhabiting the continent. And that was exactly Bartram's intent. "This world," he informed his readers, "as a glorious apartment of the boundless palace of the sovereign Creator, is furnished with an infinite variety of animated scenes, inexpressibly beautiful and pleasing, equally free to the inspection and enjoyment of all his creatures."*

The little lake, which is an expansion of the river, now appeared in view; on the East side are extensive marshes, and on the other high forests and Orange groves, and then a bay, lined with vast Cypress swamps, both coasts gradually approaching each other, to the opening of the river again, which is in this place about three hundred yards wide; evening now drawing on, I was anxious to reach some high bank of the river, where I intended to lodge, and agreeably to my wishes, I soon after discovered on the West shore, a little promontory, at the turning of the river, contracting it here to about one hundred and fifty yards in width. This promontory is a peninsula, containing about three acres of high ground, and is one entire Orange grove, with a few Live Oaks, Magnolias and Palms. Upon doubling the point, I arrived at the landing, which is a circular harbour, at the foot of the bluff, the top of which is about twelve feet high; and back of it is a large Cypress swamp, that spreads each way, the right wing forming the West coast of the little lake, and the left stretching up the river many miles, and encompassing a vast space of low grassy marshes. From this promontory, looking Eastward across the river, we behold a landscape of low country, unparalleled as I think; on the left is the East coast of the little lake, which I had just passed, and from the Orange bluff at the lower end, the high forests begin, and increase in breadth from the shore of the lake, making a circular sweep to the right, and contain many hundred thousand acres of meadow, and this grand sweep of high forests encircles, as I apprehend, at least twenty miles of these green fields, interspersed with hommocks or islets or evergreen trees, where the sovereign Magnolia and lordly Palm stand conspicuous. The islets are high shelly knolls, on the sides of creeks or branches of the river, which wind about and drain off the superabundant waters that cover these meadows, during the winter season.

The evening was temperately cool and calm. The crocodiles began to roar and appear in uncommon numbers along the shores and in the river. I fixed my camp in an open plain, near the utmost projection of the promontory, under the shelter of a large Live Oak, which stood on the highest part of the ground and but a few yards from my boat. From this open, high situation, I had a free prospect of the river, which was a matter of no trivial consideration to me, having good reason to dread the subtle attacks of the alligators, who were crouding about my harbour. Having collected a good quantity of wood for the purpose of keeping up a light and smoke during the night, I began to think of preparing my supper, when, upon examining my stores, I found but a scanty provision. I thereupon determined, as the most expeditious way of supplying my necessities, to take my bob and try for some trout. About one hundred yards above my harbour, began a cove or bay of the river, out of which opened a large lagoon. The mouth or entrance from the river to it was narrow, but the waters soon after spread and

formed a little lake, extending into the marshes, its entrance and shores within I observed to be verged with floating lawns of the Pistia and Nymphea and other aquatic plants; these I knew were excellent haunts for trout.

The verges and islets of the lagoon were elegantly embellished with flowering plants and shrubs; the laughing coots with wings half spread were tripping over the little coves and hiding themselves in the tufts of grass; young broods of the painted summer teal, skimming the still surface of the waters, and following the watchful parent unconscious of danger, were frequently surprised by the voracious trout, and he in turn, as often by the subtle, greedy alligator. Behold him rushing forth from the flags and reeds. His enormous body swells. His plaited tail brandished high, floats upon the lake. The waters like a cataract descend from his opening jaws. Clouds of smoke issue from his dilated nostrils. The earth trembles with his thunder. When immediately from the opposite coast of the lagoon, emerges from the deep his rival champion. They suddenly dart upon each other. The boiling surface of the lake marks their rapid course, and a terrific conflict commences. They now sink to the bottom folded together in horrid wreaths. The water becomes thick and discoloured. Again they rise, their jaws clap together, re-echoing through the deep surrounding forests. Again they sink, when the contest ends at the muddy bottom of the lake, and the vanquished makes a hazardous escape, hiding himself in the muddy turbulent waters and sedge on a distant shore. The proud victor exulting returns to the place of action. The shores and forests resound his dreadful roar, together with the triumphing shouts of the plaited tribes around, witnesses of the horrid combat.

My apprehensions were highly alarmed after being a spectator of so dreadful a battle; it was obvious that every delay would but tend to encrease my dangers and difficulties, as the sun was near setting, and the alligators gathered around my harbour from all quarters; from these considerations I concluded to be expeditious in my trip to the lagoon, in order to take some fish. Not thinking it prudent to take my fusee with me, lest I might lose it overboard in case of a battle, which I had every reason to dread before my return, I therefore furnished myself with a club for my defence, went on board, and penetrating the first line of those which surrounded my harbour, they gave way; but being pursued by several very large ones, I kept strictly on the watch, and paddled with all my might towards the entrance of the lagoon, hoping to be sheltered there from the multitude of my assailants; but ere I had halfway reached the place, I was attacked on all sides, several endeavouring to overset the canoe. My situation now became precarious to the last degree: two very large ones attacked me closely, at the same instant, rushing up with their heads and part of their bodies above the water, roaring terribly and belching floods of water over me. They struck their jaws together so close to my ears, as almost to stun me, and I expected every moment to be dragged out of the boat and instantly devoured, but I applied my weapons so effectually about me, though at random, that I was so successful as to beat them off a little; when, finding that they designed to renew the battle, I made for the shore, as the only means left me for my preservation, for, by keeping close to it, I should have my enemies on one side of me only, whereas I was before surrounded by them, and there was a probability, if pushed to the last extremity, of saving myself, by jumping out of the canoe on shore, as it is easy to outwalk them on land, although comparatively as swift as lightning in the water. I found this last expedient alone could fully answer my expectations, for as soon as I gained the shore they drew off and kept aloof. This was a happy relief, as my confidence was, in some degree, recovered by it. On recollecting myself, I discovered that I had almost reached the entrance of the lagoon, and determined to venture in, if possible to take a few fish and then return to my harbour, while day-light continued; for I could now, with caution and resolution, make my way with safety along shore, and indeed there was no other way to regain my camp, without leaving my boat and making my retreat through the marshes and reeds, which, if I could even effect, would have been in a manner throwing myself away, for then there would have been no hopes of ever recovering my bark, and returning in safety to any settlements of men. I accordingly proceeded and made good my entrance into

Currier and Ives, *Brook Trout,—Just Caught*, n.d.
Library of Congress, Geography and Map Division.

the lagoon, though not without opposition from the alligators, who formed a line across the entrance, but did not pursue me into it, nor was I molested by any there, though there were some very large ones in a cove at the upper end. I soon caught more trout than I had present occasion for, and the air was too hot and sultry to admit of their being kept for many hours, even though salted or barbecued. I now prepared for my return to camp, which I succeeded in with but little trouble, by keeping close to the shore, yet I was opposed upon re-entering the river out of the lagoon, and pursued near to my landing (though not closely attacked) particularly by an old daring one, about twelve feet in length, who kept close after me, and when I stepped on shore and turned about, in order to draw up my canoe, he rushed up near my feet and lay there for some time, looking me in the face, his head and shoulders out of water; I resolved he should pay for his temerity, and having a heavy load in my fusee, I ran to my camp, and returning with my piece, found him with his foot on the gunwale of the boat, in search of fish, on my coming up he withdrew sullenly and slowly into the water, but soon returned and placed himself in his former position, looking at me and seeming neither fearful or any way disturbed. I soon dispatched him by lodging the contents of my gun in his head, and then proceeded to cleanse and prepare my fish for supper, and accordingly took them out of the boat, laid them down on the sand close to the water, and began to scale them, when, raising my head, I saw before me, through the clear water, the head and shoulders of a very large alligator, moving slowly towards me; I instantly stepped back, when, with a sweep of his tail, he brushed off several of my fish. It was certainly most providential that I looked up at that instant, as the monster would probably, in less than a minute, have seized and dragged me into the river. This incredible boldness of the animal disturbed me greatly, supposing there could now be no reasonable safety for me during the night, but by keeping continually on the watch; I therefore, as soon as I had prepared the fish, proceeded to secure myself and effects in the best manner I could: in the first place, I hauled my bark upon the shore, almost clear out of the water, to prevent their oversetting or sinking her,

after this every moveable was taken out and carried to my camp, which was but a few yards off; then ranging some dry wood in such order as was the most convenient, cleared the ground round about it, that there might be no impediment in my way, in case of an attack in the night, either from the water or the land; for I discovered by this time, that this small isthmus, from its remote situation and fruitfulness, was resorted to by bears and wolves. Having prepared myself in the best manner I could, I charged my gun and proceeded to reconnoitre my camp and the adjacent grounds; when I discovered that the peninsula and grove, at the distance of about two hundred yards from my encampment, on the land side, were invested by a Cypress swamp, covered with water, which below was joined to the shore of the little lake, and above to the marshes surrounding the lagoon, so that I was confined to an islet exceedingly circumscribed, and I found there was no other retreat for me, in case of an attack, but by either ascending one of the large Oaks, or pushing off with my boat.

It was by this time dusk, and the alligators had nearly ceased their roar, when I was again alarmed by a tumultuous noise that seemed to be in my harbour, and therefore engaged my immediate attention. Returning to my camp I found it undisturbed, and then continued on to the extreme point of the promontory, where I saw a scene, new and surprising, which at first threw my senses into such a tumult, that it was some time before I could comprehend what was the matter; however, I soon accounted for the prodigious assemblage of crocodiles at this place, which exceeded every thing of the kind I had ever heard of.

How shall I express myself so as to convey an adequate idea of it to the reader, and at the same time avoid raising suspicions of my want of veracity. Should I say, that the river (in this place) from shore to shore, and perhaps near half a mile above and below me, appeared to be one solid bank of fish, of various kinds, pushing through this narrow pass of St. Juans into the little lake, on their return down the river, and that the alligators were in such incredible numbers, and so close together from shore to shore, that it would have been easy to have walked across on their heads, had

the animals been harmless. What expressions can sufficiently declare the shocking scene that for some minutes continued, whilst this mighty army of fish were forcing the pass? During this attempt, thousands, I may say hundreds of thousands of them were caught and swallowed by the devouring alligators. I have seen an alligator take up out of the water several great fish at a time, and just squeeze them betwixt his jaws, while the tails of the great trout flapped about his eyes and lips, ere he had swallowed them. The horrid noise of their closing jaws, their plunging amidst the broken banks of fish, and rising with their prey some feet upright above the water, the floods of water and blood rushing out of their mouths, and the clouds of vapour issuing from their wide nostrils, were truly frightful. This scene continued at intervals during the night, as the fish came to the pass. After this sight, shocking and tremendous as it was, I found myself somewhat easier and more reconciled to my situation, being convinced that their extraordinary assemblage here was owing to this annual feast of fish, and that they were so well employed in their own element, that I had little occasion to fear their paying me a visit.

It being now almost night, I returned to my camp, where I had left my fish broiling and my kettle of rice stewing, and having with me, oil, pepper and salt, and excellent oranges hanging in abundance over my head (a valuable substitute for vinegar) I sat down and regaled myself chearfully; having finished my repast, I rekindled my fire for light, and whilst I was revising the notes of my past day's journey, I was suddenly roused with a noise behind me toward the main land; I sprang up on my feet, and listening, I distinctly heard some creature wading in the water of the isthmus; I seized my gun and went cautiously from my camp, directing my steps towards the noise; when I had advanced about thirty yards, I halted behind a coppice of Orange trees, and soon perceived two very large bears, which had made their way through the water, and had landed in the grove, about one hundred yards distance from me, and were advancing towards me. I waited until they were within thirty yards of me, they there began to snuff and look towards my camp, I snapped my piece, but it flashed, on which they both turned about and galloped off, plunging through the water and swamp, never halting as I suppose, until they reached fast land, as I could hear them leaping and plunging a long time; they did not presume to return again, nor was I molested by any other creature, except being occasionally awakened by the whooping of owls, screaming of bitterns, or the wood-rats running amongst the leaves.

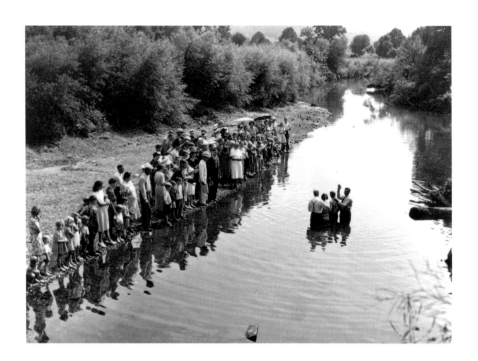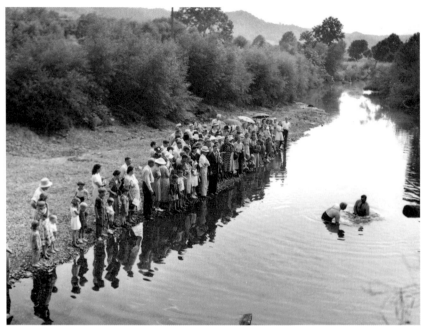

Marion Post Wolcott, *Baptism of Members of Primitive Baptist Church in Triplett Creek*, 1940.
Left: Spencer Museum of Art/University of Kansas, the Peter T. Bohan Fund.
Right: Library of Congress, Geography and Map Division.

"On Jordan's Stormy Banks"

Samuel Stennett

Samuel Stennett (1728–1795) did not publish much in his lifetime: his edition of John Owen's The Nature, Power, Deceit, and Prevalency of Indwelling Sin in Believers *appeared in 1793; and his own work,* The Bird of Paradise, *was published posthumously in 1800.*

Given the relative lack of attention the public gave his work during his life, no one could have predicted that this religious dissenter's hymn would become so popular in the generations following his death in England in 1795.

On Jordan's stormy banks I stand,
And cast a wishful eye
To Canaan's fair and happy land,
Where my possessions lie.

We will rest in the fair and happy land, by and by
Just across on the evergreen shore
Sing the song of Moses and the Lamb, by and by,
And dwell with Jesus evermore.

O the transporting rapturous scene
That rises to my sight!
Sweet fields arrayed in living green,
And rivers of delight.

Filled with delight, my raptured soul
Would here no longer stay;
Tho' Jordan's waves around me roll,
Fearless I'd launch away.

A View of the United States of America

A Plan for Encouraging Agriculture, and Increasing the Value of Farms in the Midland and More Western Counties of Pennsylvania, Applicable to Several Other Parts of that State, and to Many Parts of the United States.

Tench Coxe

Tench Coxe (1755–1824) served under Alexander Hamilton in the Treasury Department during the administration of George Washington. While there, Coxe became one of the most influential economic theorists of his generation; his plans to create an American economy free from Europe, written when the French Revolution threatened to undermine the stability of the European economy, were among the earliest calls for the economic independence of the nation. Searching for ways to develop America's resources, Coxe believed that economic success could come from harnessing the powers of the great rivers flowing through the interior. Like William Penn, Coxe saw particular value in the Susquehanna River, although the plan he proposed here was intended as a model for development across the nation, not just in Pennsylvania. As is evident here, Coxe's call for government support for the development of the river signaled a vital turning point in Americans' relationship to their rivers: from that point onward, many Americans believed that the government should play a leading role in the development of riparian resources.

Columbia Bridge [over the Susquehanna River], mid nineteenth century.
Spencer Museum of Art/University of Kansas.

*I*n a country, the people, the soil, and the climate of which are well suited to agriculture, and which has immense natural treasures in the bowels and on the surface of the earth, *the creation of a ready, near, and stable market for its spontaneous and agricultural productions, by the introduction and increase of internal trade and manu-factures, is the most effectual method to promote husbandry, and to advance the interests of the proprietors and cultivators of the earth.* This position has been assumed, with the firmest confidence, by *one* [David Hume], and maintained and relied upon afterwards by others, of the most informed and sound minds in Great-Britain, in relation to the internal trade, manufactures, and landed interest of that kingdom, although it is an island possessing uncommon advantages in its artificial roads, canals, rivers, and bays, which, altogether, afford the inhabitants a *peculiar* facility in transporting their surplus produce with very little expense to foreign markets.

To a nation inhabiting a great continent, not yet traversed by artificial roads and canals, the rivers of which, above their natural navigation, have been hitherto very little improved, many of whose people are at this moment closely settled upon lands, which actually sink from one fifth to one half the value of their crops, in the mere charges of transporting them to the sea-port towns, and others, of whose inhabitants cannot at present send their produce to a sea-port for its *whole* value, a *thorough sense of the truth of the position* is a matter of *unequalled* magnitude and importance.

The state of things in most of the counties of Pennsylvania, which are contiguous to, or in the vicinity of the river Susquehan-nah and its extensive branches, is considered to be really and pre-cisely that, which has been described; and the object of this paper is to suggest hints for a plan of relief from the great expence and inconveniencies they at present sustain, by creating a market town for their produce on *the main body of that river*, at some proper place between the confluence of its eastern and western branches, and the lower end of its present navigation.

It is proposed that the sum of five hundred thousand dollars, to be applied as is herein after mentioned, be raised in either of the three following methods—that is to say, *either* by five thousand subscriptions, of one hundred dollars each, to the capital stock of a company to be temporarily associated for the purpose, without any exclusive privileges—*Or*, by the sale of one hundred thousand lottery tickets, at five dollars each; or fifty thousand tickets, at ten dollars each, the whole enhanced amount of which is to be redrawn in prizes agreeably to a scheme, which will be herein after exhib-ited—*Or*, by the application of five hundred thousand dollars, of the monies in the treasury (or otherwise in the command) of the state of Pennsylvania.—The inducements to the operation, either to the state, to the adventurers in the lottery, or to the subscribers of the stock of the associated company, will appear in the sequel to be an augmentation of about one hundred percent in the value of the property to be embraced—that is, in a profit of about one hundred per cent. on the monies to be raised or advanced for the purchase of the lands, and the erection of the buildings.

The application of the above sum of five hundred thousand dollars, might be as follows:

1st. In the purchase of two thousand acres of land on the *western* bank of Susquehannah, as a town seat to be regularly laid off in a *town or city for inland trade and manufactures*, with streets sixty feet wide, in oblongs of five hundred feet, fronting the south western or *prevalent summer winds*, by two hundred and twenty feet; each oblong to be intersected by a twenty foot alley, running lengthwise, or from north-west to south-east, so as to give all the lots *south-west* front exposures, or *south-west* back exposures, and outlets in the rear.

	Dollars		Dollars
The purchase of the land, including the farm buildings which may be on it, and water rights, &c. would probably be at fifteen dollars per acre, for two thousand acres,	30,000	One paper mill,	1,500
		One flaxseed, hempseed, and rapeseed oil mill,	1,500
		One grist mill,	2,000
The contents will be a little more than three square miles. The shape might be two miles on the river, by a little more than one mile and one half running from the river.—The number of lots of twenty feet front, and one hundred feet deep, would be about twenty-six thousand.		Two bake houses, five hundred dollars each,	1,000
		Two slitting and rolling mills, five thousand dollars each,	10,000
		One steel furnace,	3,000
		One soap boiler's and tallow chandler's shop,	500
		One malt house,	2,000
2dly. In the erection of five hundred and ten stone and brick houses, of the value of three hundred dollars each (inclusive of the value of the lots,)	153,000	One brewery,	4,000
		Ten grain and fruit distilleries, of various sizes, averaging in value one thousand two hundred and fifty dollars, each,	12,500
Two hundred and twenty stone and brick houses, of the value of five hundred dollars each,	110,000	One printer's office for the English language,	500
		One printer's office for the German language,	300
Fifty stone and brick houses, of the value of eight hundred dollars each,	40,000	Six blacksmith's shops, and naileries of various sizes, averaging five hundred dollars each,	3,000
Ten stone and brick houses, of the value of two thousand dollars each,	20,000	Two cooper's shops, one three hundred, the other two hundred dollars,	500
Four stone and brick houses, of the value of six hundred and fifty dollars each,	2,600	One cedar cooper's shop,	200
Two mills for preparing hemp, which would often come down in boats, and on rafts from the rich new lands on the upper waters of Susquehannah and its branches, one thousand two hundred and fifty dollars each,	2,500	Four hatter's shops, two at five hundred, and two at three hundred dollars,	1,600
		One bleach yard and house,	1,000
		Two fulling mills, one a thousand, the other one thousand five hundred dollars,	2,500
One mill for preparing flax,	800	Two potteries, five hundred dollars each,	1,000
One mill of about five hundred spindles, for spinning flax, hemp, and combed wool, to be divided into fifty shares, of one hundred dollars each, to increase the number of prizes,	5,000	Four wheelwright's and chairmaker's shops, two at five hundred, and two at four hundred dollars,	1,800
		Two coppersmith's shops, one five hundred, the other four hundred dollars,	900
One rope walk,	2,000	Two pot-ash works, one three hundred, the other two hundred dollars,	500
Two smaller ditto one thousand dollars each,	2,000	One brass founder's shop,	600
Two tan yards, one thousand five hundred dollars each,	3,000	Two painter's shops, one five hundred, the other three hundred dollars,	800
Two smaller ditto,	1,500		

	Dollars
Two turner's shops, one five hundred, the other three hundred dollars,	800
Two water forges, one thousand five hundred dollars each,	3,000
Four tilt hammer forges, one thousand dollars each,	4,000
One tobacco and snuff manufactory,	800
Two boring and grinding mills for guns, scythes, sickles, &c. at one thousand dollars each,	2,000
Two skin-dresser's shops, five hundred dollars each,	1,000
Four lumber yards on the river, fenced, twenty-five dollars each,	100
Two gun smith's shops, one five hundred, the other three hundred dollars,	800
Two boat builder's yards and sheds, one four hundred, the other three hundred dollars,	700
Four school houses, two for each sex, (part to be German) at three hundred dollars (twelve hundred) and four houses for the tutors, five hundred (two thousand) dollars,	3,200
One church for all denominations, to be used in rotation by every society, until any one shall have a place of worship of its own, when that society shall lose its right,	4,000
Two taverns, one four thousand, the other three thousand dollars,	7,000
Two stables, one in the vicinity of each tavern, for thirty horses and ten carriages, one thousand dollars each,	2,000
One hundred buildings, of the value of two hundred and fifty dollars each, half with, and half without	

	Dollars
cellars, for tradesmen's and manufacturer's shops, stables, &c. as occasion may require,	25,000
One large scale house to weigh loaded waggons, to be erected on the market square,	500
One scale house to weigh hogsheads and other things, of less than one ton weight,	100
One sail-cloth manufactory,	5,000
One plumber's shop,	300
Two brick kilns, yards and houses, eight hundred dollars each,	1,600
Two twine and cord factories, five hundred dollars each,	1,000
Four slaughter houses and yards,	1,600
One starch work and dwelling house,	800
One library of three hundred shares, of ten dollars each, to increase the number of prizes, to be composed of books relative to the useful arts and manufactures,	3,000
One parchment manufactory,	500
One glue manufactory,	500
One pump maker's shed and yard,	100
Charges of the superintendence of the execution, at one percent.	5,000
	500,000

The buildings above mentioned will form a town of one thousand houses, useful work shops and factories by water, fire or hand, all of stone or brick, which is larger by near one half than the borough of Lancaster.

The Nineteenth Century

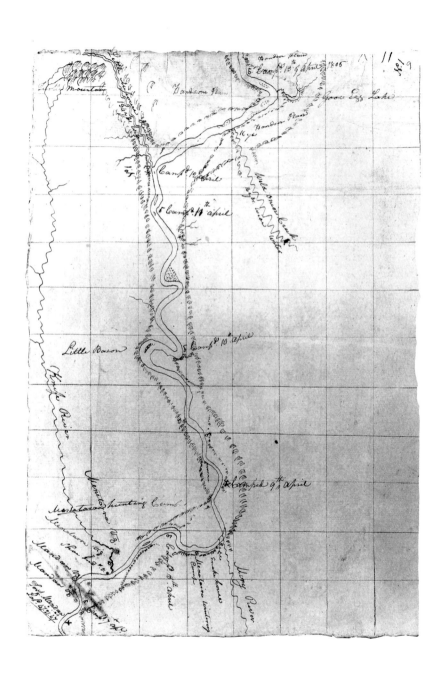

Route about April 7–14, 1805, from the *Atlas of the Lewis and Clark Expedition.*
Beinecke Rare Book and Manuscript Library, Yale University.

Original Journals of the Lewis and Clark Expedition

Meriwether Lewis and William Clark

No explorers of America, with the exception of Christopher Columbus, captured the public imagination and our historical consciousness like Meriwether Lewis (1774–1809) and William Clark (1770–1838). President Thomas Jefferson sent them to explore the Louisiana Territory and to find a water route from the heart of the nation to the Pacific, and they pursued the task with great energy. Their travels took them up the Missouri River from St. Louis, across the Great Divide and toward the Columbia River, a round-trip journey that began in 1804 and ended in 1806. The journals from their trips are filled with the mundane matters that took up much of their time: finding necessary supplies, describing what they had seen and the peoples they encountered. There is little sense in these pages that the two men had embarked on a mission that had enormous importance for the nation. Traveling up the Missouri on the orders of the federal government less than a decade after Tench Coxe had revealed his plans, the expedition further established the notion that the government would play a central role in the development of American rivers. While each man went on to hold public office in the west after the trip concluded—Lewis was governor of the Louisiana Territory from 1807 to 1809; Clark was governor of the Missouri Territory from 1813 to 1821— their later achievements never became part of American folklore. That status clung only to their inland journey.

Fort Mandan April 7th. 1805.

. . .

Our vessels consisted of six small canoes, and two large perogues. This little fleet altho' not quite so respectable as those of Columbus or Capt. Cook, were still viewed by us with as much pleasure as those deservedly famed adventurers ever beheld theirs; and I dare say with quite as much anxiety for their safety and preservation. We were now about to penetrate a country at least two thousand miles in width, on which the foot of civilized man had never trodden; the good or evil it had in store for us was for experiment yet to determine, and these little vessels contained every article by which we were to expect to subsist or defend ourselves. However, as the state of mind in which we are, generally gives the colouring to events, when the imagination is suffered to wander into futurity, the picture which now presented itself to me was a most pleasing one. Enterta[in]ing as I do, the most confident hope of succeeding in a voyage which had formed a da[r]ling project of mine for the last ten years, I could but esteem this moment of my departure as among the most happy of my life. The party are in excellent health and spirits, zealously attached to the enterprise, and anxious to proceed; not a whisper or murmur of discontent to be heard among them, but all act in unison, and with the most perfect harmony. I took an early supper this evening and went to bed. Capt. Clark myself the two Interpreters and the woman and child sleep in a tent of dressed skins.

Saturday April 13th

Being disappointed in my observations of yesterday for Longitude, I was unwilling to remain at the entrance of the river another day for that purpose, and therefore determined to set out early this morning; which we did accordingly; the wind was in our favour after 9 A.M. and continued favourable until three 3 P.M. We therefore hoisted both the sails in the White Perogue, consisting of a small squar sail, and spritsail, which carried her at a pretty good

gate, until about 2 in the afternoon when a sudden squall of wind struck us and turned the perogue so much on the side as to alarm Sharbono who was steering at the time, in this state of alarm he threw the perogue with her side to the wind, when the spritsail gibing was as near overseting the perogue as it was possible to have missed. The wind however abating for an instant I ordered Drewyer to the helm and the sails to be taken in, which was instant[ly] executed and the perogue being steered before the wind was again placed in a state of security. This accident was very near costing us dearly. Believing this vessel to be the most steady and safe, we had embarked on board of it our instruments, Papers, medicine and the most valuable part of the merchandize which we had still in reserve as presents for the Indians. We had also embarked on board ourselves, with three men who could not swim and the squaw with the young child, all of whom, had the perogue overset, would most probably have perished, as the waves were high, and the perogue upwards of 200 yards from the nearest shore; however we fortunately escaped and pursued our journey under the square sail, which shortly after the accident I directed to be again hoisted. Our party caught three beaver last evening; and the French hunters 7. As there was much appearance of beaver just above the entrance of the little Missouri these hunters concluded to remain some days, we therefore left them without the expectation of seeing them again. Just above the entrance of the little Missouri the great Missouri is upwards of a mile in width, tho' immediately at the entrance of the former it is not more than 200 yards wide and so shallow that the canoes passed it with seting poles. At the distance of nine miles passed the mouth of a creek on the Stard. side which we called onion creek from the quantity of wild onions which grow in the plains on its borders. Capt. Clark who was on shore informed me that this creek was 16 yards wide a mile & a half above its entrance, discharges more water than creeks of its size usually do in this open country, and that there was not a stick of timber of any discription to be seen on its borders, or the level plain country through which it passes. At the distance of 10 Miles further we passed the mouth of a large creek, discharging itself in the center of a deep bend. Of

this creek and the neighbouring country, Capt. Clark who was on shore gave me the following description. "This creek I took to be a small river from its size, and the quantity of water which it discharged; I ascended it 1½ miles, and found it the discharge of a pond or small lake, which had the appearance of having formerly been the bed of the Missouri. Several small streams discharge themselves into this lake. The country on both sides consists of beautiful level and elevated plains; ascending as they recede from the Missouri; there were a great number of Swan and geese in this lake and near its borders I saw the remains of 43 temporary Indian lodges, which I presume were those of the Assinniboins who are now in the neighbourhood of the British establishments on the Assinniboin river[.]" This lake and its discharge we call *goose* Egg from the circumstance of Capt. Clark shooting a goose while on her nest in the top of a lofty cotton wood tree, from which we afterwards took one egg. The wild geese frequently build their nests in this manner, at least we have already found several in trees, nor have we as yet seen any on the ground, or sand bars where I had supposed from previous information that they most commonly deposited their eggs. Saw some Buffaloe and Elk at a distance to-day but killed none of them. We found a number of carcases of the Buffaloe lying along shore, which had been drowned by falling through the ice in winter and lodged on shore by the high water when the river broke up about the first of this month. We saw also many tracks of the white bear of enormous size, along the river shore and about the carcases of the Buffaloe, on which I presume they feed. We have not as yet seen one of these animals, tho' their tracks are so abundant and recent. The men as well as ourselves are anxious to meet with some of these bear. The Indians give a very formidable account of the streng[t]h and ferocity of this animal, which they never dare to attack but in parties of six eight or ten persons; and are even then frequently defeated with the loss of one or more of their party. The savages attack this animal with their bows and arrows and the indifferent guns with which the traders furnish them, with these they shoot with such uncertainty and at so short a distance, that (*unless shot thro' head or heart wound not mortal*) they frequently miss their aim & fall a sacrifice to the bear. Two Minetaries were killed during the last winter in an attack on a white bear. This anamall is said more frequently to attack a man on meeting with him, than to flee from him. When the Indians are about to go in quest of the white bear, previous to their departure, they paint themselves and perform all those supersticious rights commonly observed when they are about to make war upon a neighbouring nation. O[b]served more bald eagles on this part of the Missouri than we have previously seen. Saw the small hawk, frequently called the sparrow hawk, which is common to most parts of the U. States. Great quantities of geese are seen feeding in the prairies. Saw a large flock of white brant or geese with black wings pass up the river; there were a number of gray brant with them; from their flight I presume they proceed much further still to the N.W. We have never been enabled yet to shoot one of these birds, and cannot therefore determine whether the gray brant found with the white, are their brude of the last year or whether they are the same with the grey brant common to the Mississippi and lower part of the Missouri. We killed 2 antelopes to-day which we found swiming from the S. to the N. side of the river; they were very poor. We encamped this evening on the Stard. shore in a beautifull plain, elevated about 30 feet above the river.

"Morning on the Wissahiccon"

Edgar Allan Poe

Known best for his tales of gothic horror, the Boston-born poet and story writer Edgar Allan Poe (1809–1849) lived a turbulent life. He dropped out of the University of Virginia after one term in 1826, and was dismissed from West Point for neglecting his duties and disregarding orders in 1831. Poe supported himself mostly through editorial positions along the east coast, including stints as the associate editor of Burton's Gentleman's Magazine *in Philadelphia from 1839 to 1840 and editor of the* Broadway Journal *in New York from 1845 to 1846. At some point while he was thrilling a nation with his tales of horror and suspense, especially after the wide-ranging fame of "The Raven" in 1845, Poe sat down and wrote this quiet elegy to the Wissahickon, a stream that runs through the northwest portion of Philadelphia before it drains into the Schuylkill River. In a society obsessed with traveling the great rivers that captured the imagination of other writers, Poe recognized that smaller waterways also offered much to anyone who would pay attention to them.*

The natural scenery of America has often been contrasted, in its general features as well as in detail, with the landscape of the Old World—more especially of Europe—and not deeper has been the enthusiasm, than wide the dissension, of the supporters of each region. The discussion is one not likely to be soon closed, for, although much has been said on both sides, a world more yet remains to be said.

The most conspicuous of the British tourists who have attempted a comparison, seem to regard our northern and eastern seaboard, comparatively speaking, as all of America, at least as all of the United States, worthy consideration. They say little, because they have seen less, of the gorgeous interior scenery of some of our western and southern districts—of the vast valley of Louisiana, for example,—a realization of the wildest dreams of paradise. For the most part, these travellers content themselves with a hasty inspection of the natural *lions* of the land—the Hudson, Niagara, the Catskills, Harper's Ferry, the lakes of New York, the Ohio, the prairies, and the Mississippi. These, indeed, are objects well worthy

the contemplation even of him who has just clambered by the castellated Rhine, or roamed

By the blue rushing of the arrowy Rhone;

but these are not *all* of which we can boast; and, indeed, I will be so hardy as to assert that there are innumerable quiet, obscure, and scarcely explored nooks, within the limits of the United States, that, by the true artist, or cultivated lover of the grand and beautiful amid the works of God, will be perfected to each *and to all* of the chronicled and better accredited scenes to which I have referred.

In fact, the real Edens of the land lie far away from the track of our own most deliberate tourists—how very far, then, beyond the reach of the foreigner, who, having made with his publisher at home arrangements for a certain amount of comment upon America, to be furnished in a stipulated period, can hope to fulfil his agreement in no other manner than by steaming it, memorandum-book in hand, through only the most beaten thoroughfares of the country!

I mentioned, just above, the valley of Louisiana. Of all extensive areas of natural loveliness, this is perhaps the most lovely. No fiction has approached it. The most gorgeous imagination might derive suggestions from its exuberant beauty. And *beauty* is, indeed, its sole character. It has little, or rather nothing, of the sublime. Gentle undulations of soil, interwreathed with fantastic crystallic streams, banked by flowery slopes, and backed by a forest vegetation, gigantic, glossy, multicoloured, sparkling with gay birds and burthened with perfume—these features make up, in the vale of Louisiana, the most voluptuous natural scenery upon earth.

But, even of this delicious region, the sweeter portions are reached only by bypaths. Indeed, in America generally, the traveller who would behold the finest landscapes, must seek them not by the railroad, nor by the steamboat, nor by the stage-coach, nor in his private carriage, nor yet even on horseback—but on foot. He must *walk*, he must leap ravines, he must risk his neck among precipices, or he must leave unseen the truest, the richest, and most unspeakable glories of the land.

Now in the greater portion of Europe no such necessity exists.

In England it exists not at all. The merest dandy of a tourist may there visit every nook worth visiting without detriment to his silk stockings; so thoroughly known are all points of interest, and so well-arranged are the means of attaining them. This consideration has never been allowed its due weight, in comparisons of the natural scenery of the Old and New Worlds. The entire loveliness of the former is collated with only the most noted, and with by no means the most eminent items in the general loveliness of the latter.

River scenery has, unquestionably, within itself, all the main elements of beauty, and, time out of mind, has been the favourite theme of the poet. But much of this fame is attributable to the predominance of travel in fluvial over that in mountainous districts. In the same way, large rivers, because usually highways, have, in all countries, absorbed an undue share of admiration. They are more observed, and, consequently, made more the subject of discourse, than less important, but often more interesting streams.

A singular exemplification of my remarks upon this head may be found in the Wissahiccon, a brook, (for more it can scarcely be called,) which empties itself into the Schuylkill, about six miles westward of Philadelphia. Now the Wissahiccon is of so remarkable a loveliness that, were it flowing in England, it would be the theme of every bard, and the common topic of every tongue, if, indeed, its banks were not parcelled off in lots, at an exorbitant price as building-sites for the villas of the opulent. Yet it is only within a very few years that any one has more than heard of the Wissahiccon, while the broader and more navigable water into which it flows, has been long celebrated as one of the finest specimens of American river scenery. The Schuylkill, whose beauties have been much exaggerated, and whose banks, at least in the neighbourhood of Philadelphia, are marshy like those of the Delaware, is not at all comparable, as an object of picturesque interest, with the more humble and less notorious rivulet of which we speak.

It was not until Fanny Kemble, in her droll book about the United States, pointed out to the Philadelphians the rare loveliness of a stream which lay at their own doors, that this loveliness was more than suspected by a few adventurous pedestrians of the vicinity. But, the "Journal" having opened all eyes, the Wissahiccon,

Wissahickon Polka, mid nineteenth century.
The Library Company of Philadelphia.

to a certain extent, rolled at once into notoriety. I say "to a certain
extent," for, in fact, the true beauty of the stream lies far above the
route of the Philadelphian picturesque-hunters, who rarely proceed
farther than a mile or two above the mouth of the rivulet—for the
very excellent reason that here the carriage-road stops. I would
advise the adventurer who would behold its finest points to take
the Ridge Road, running westwardly from the city, and, having
reached the second lane beyond the sixth mile-stone, to follow this
lane to its termination. He will thus strike the Wissahiccon, at one
of its best reaches, and, in a skiff, or by clambering along its banks,
he can go up or down the stream, as best suits his fancy, and in
either direction will meet his reward.

I have already said, or should have said, that the brook is narrow.
Its banks are generally, indeed almost universally, precipitous, and
consist of high hills, clothed with noble shrubbery near the water,
and crowned at a greater elevation, with some of the most mag-
nificent forest trees of America, among which stands conspicuous
the *liriodendron tulipiferum*. The immediate shores, however, are of
granite, sharply-defined or moss-covered, against which the pel-
lucid water lolls in its gentle flow, as the blue waves of the Medi-
terranean upon the steps of her palaces of marble. Occasionally in
front of the cliffs, extends a small definite *plateau* of richly herbaged
land, affording the most picturesque position for a cottage and
garden which the richest imagination could conceive. The wind-
ings of the stream are many and abrupt, as is usually the case where
banks are precipitous, and thus the impression conveyed to the
voyager's eye, as he proceeds, is that of an endless succession of
infinitely varied small lakes, or, more properly speaking, tarns. The
Wissahiccon, however, should be visited, not like "fair Melrose,"
by moonlight, or even in cloudy weather, but amid the brightest
glare of a noonday sun; for the narrowness of the gorge through
which it flows, the height of the hills on either hand, and the density
of the foliage, conspire to produce a gloominess, if not an absolute
dreariness of effect, which, unless relieved by a bright general light,
detracts from the mere beauty of the scene.

Not long ago I visited the stream by the route described, and
spent the better part of a sultry day in floating in a skiff upon its

bosom. The heat gradually overcame me, and, resigning myself to the influence of the scenes and of the weather, and of the gently moving current, I sank into a half slumber, during which my imagination revelled in visions of the Wissahiccon of ancient days—of the "good old days" when the Demon of the Engine was not, when pic-nics were undreamed of, when "water privileges" were neither bought nor sold, and when the red man trod alone, with the elk, upon the ridges that now towered above. And, while gradually these conceits took possession of my mind, the lazy brook had borne me, inch by inch, around one promontory and within full view of another that bounded the prospect at the distance of forty or fifty yards. It was a steep rocky cliff, abutting far into the stream, and presenting much more of the Salvator character than any portion of the shore hitherto passed. What I saw upon this cliff, although surely an object of very extraordinary nature, the place and season considered, at first neither startled nor amazed me—so thoroughly and appropriately did it chime in with the half-slumberous fancies that enwrapped me. I saw, or dreamed that I saw, standing upon the extreme verge of the precipice, with neck outstretched, with ears erect, and the whole attitude indicative of profound and melancholy inquisitiveness, one of the oldest and boldest of those identical elks which had been coupled with the red men of my vision.

I say that, for a few moments, this apparition neither startled nor amazed me. During this interval my whole soul was bound up in intense sympathy alone. I fancied the elk repining, not less than wondering, at the manifest alterations for the worse, wrought upon the brook and its vicinage, even within the last few years, by the stern hand of the utilitarian. But a slight movement of the animal's head at once dispelled the dreaminess which invested me, and aroused me to a full sense of the novelty of the adventure. I arose upon one knee within the skiff, and, while I hesitated whether to stop my career, or let myself float nearer to the object of my wonder, I heard the words "hist! hist!" ejaculated quickly but cautiously, from the shrubbery overhead. In an instant afterwords, a negro emerged from the thicket, putting aside the bushes with care, and treading stealthily. He bore in one hand a quantity of salt, and,

John Moran, *Wissahickon Creek*, late nineteenth century.
The Library Company of Philadelphia.

holding it towards the elk, gently yet steadily approached. The noble animal, although a little fluttered, made no attempt at escape. The negro advanced; offered the salt; and spoke a few words of encouragement or conciliation. Presently, the elk bowed and stamped, and then lay quietly down and was secured with a halter.

Thus ended my romance of the elk. It was a *pet* of great age and very domestic habits, and belonged to an English family occupying a villa in the vicinity.

EXCERPT *from*

Delineations of
American Scenery and Character

John James Audubon

John James Audubon (1785–1851) is perhaps the most famous painter of birds in the history of the world. His paintings are so lifelike that it is difficult to believe that he could be so precise because he posed dead birds in naturalistic settings. His greatest work, Birds of America *(1827–1838), remains both a monument to ornithological knowledge and a stunning work of art. Known to the world as an observer of birds, Audubon shared an obsession of many naturalists: he wanted to describe his entire world. To do so, he wrote a series of sketches which were posthumously published in 1926 under the title* Delineations of American Scenery and Character. *The selection here provides us with remarkable insight into one of the more important human uses of rivers in nineteenth-century America: logging.*

The men who are employed in cutting down the trees, and conveying the logs to the saw-mills or the places for shipping, are, in the State of Maine, called "Lumberers." Their labours may be said to be continual. Before winter has commenced, and while the ground is yet uncovered with a great depth of snow, they leave their homes to proceed to the interior of the pine forests, which in that part of the country are truly magnificent; and betake themselves to certain places already well known to them. Their provisions, axes, saws, and other necessary articles, together with provender for their cattle, are conveyed by oxen in heavy sledges. Almost at the commencement of their march, they are obliged to enter the woods, and they have frequently to cut a way for themselves, for considerable spaces, as the ground is often covered with the decaying trunks of immense trees, which have fallen either from age, or in consequence of accidental burnings. These trunks, and the un-

dergrowth which lies entangled in their tops, render many places almost impassable even to men on foot. Over miry ponds they are sometimes forced to form causeways, this being, under all circumstances, the easiest mode of reaching the opposite side. Then, reader, is the time for witnessing the exertions of their fine large cattle. No rods do their drivers use to pain their flanks; no oaths or imprecations are ever heard to fall from the lips of these most industrious and temperate men, for in them, as indeed in most of the inhabitants of our Eastern States, education and habit have tempered the passions and reduced the moral constitution to a state of harmony. Nay, the sobriety that exists in many of the villages of Maine, I acknowledge I have often considered as carried to excess, for on asking for brandy, rum or whisky, not a drop could I obtain, and it is probable there was an equal lack of spirituous liquors of every other kind. Now and then I saw some good old wines, but they were always drunk in careful moderation. But to return to the management of the oxen. Why, reader, the lumberers speak to them as if they were rational beings. Few words seem to suffice, and their whole strength is applied to the labour, as if in gratitude to those who treat them with so much gentleness and humanity.

While present on more than one occasion at what Americans call "ploughing matches," which they have annually in many of the States, I have been highly gratified, and in particular at one, of which I still have a strong recollection, and which took place a few miles from the fair and hospitable city of Boston. There I saw fifty or more ploughs drawn by as many pairs of oxen, which performed their work with so much accuracy and regularity, without the infliction of whip or rod, but merely guided by the verbal mandates of the ploughmen, that I was perfectly astonished.

After surmounting all obstacles, the lumberers with their stock arrive at the spot which they have had in view, and immediately commence building a camp. The trees around soon fall under the blows of their axes, and before many days have elapsed a low habitation is reared and fitted within for the accommodation of their cattle, while their provender is secured on a kind of loft covered with broad shingles or boards. Then their own cabin is put

White River, Vermont.
United States Department of Agriculture.

up; rough bedsteads, manufactured on the spot, are fixed in the corners; a chimney, composed of a frame of sticks plastered with mud, leads away the smoke; the skins of bears or deer, with some blankets, form their bedding, and around the walls are hung their changes of home-spun clothing, guns, and various necessities of life. Many prefer spending the night on the sweet-scented hay and corn-blades of their cattle, which are laid on the ground. All arranged within, the lumberers set their "dead-falls," large "steel-traps," and "spring guns," in suitable places around their camp, to procure some of the bears that ever prowl round such establishments.

Now the heavy clouds of November, driven by the northern blasts, pour down the snow in feathery flakes. The winter has fairly set in, and seldom do the sun's gladdening rays fall on the wood-cutter's hut. In warm flannels his body is enveloped, the skin of a raccoon covers his head and brow, his moose-skin leggings reach the girdle that secures them around his waist, while on broad moccasins, or snowshoes, he stands from the earliest dawn until night, hacking the majestic pines that for a century past have embellished the forest. The fall of these valuable trees no longer resounds on the ground; and, as they tumble here and there, nothing is heard but the rustling and crackling of their branches, their heavy trunks sinking into the deep snows. Thousands of large pines thus cut down every winter afford room for the younger trees, which spring up profusely to supply the wants of man.

Weeks and weeks have elapsed; the earth's pure white covering has become thickly and firmly crusted by the increasing intensity of the cold, the fallen trees have all been sawn into measured logs, and the long repose of the oxen has fitted them for hauling them to the nearest frozen streams. The ice gradually becomes covered with the accumulating mass of timber, and, their task completed, the lumberers wait impatiently for the breaking up of the winter.

At this period, they pass the time in hunting the moose, the deer, and the bear, for the benefit of their wives and children; and as these men are most excellent woodsmen, great havoc is made among the game.

Many skins of sables, martins, and musk-rats they have procured during the intervals of their labour, or under night. The snows are now giving way, as the rains descend in torrents, and the lumberers collect their utensils, harness their cattle, and prepare for their return. This they accomplish in safety.

From being lumberers they now become millers, and with pleasure each applies the grating file to the saws. Many logs have already reached the dams on the swollen waters of the rushing streams, and the task commences, which is carried on through the summer, of cutting them up into boards.

The great heats of the dog-days have parched the ground; every creek has become a shallow, except here and there, where in a deep hole the salmon and the trout have found a retreat; the sharp slimy angles of multitudes of rocks project, as if to afford resting places to the wood-ducks and herons that breed on the borders of these streams. Thousands of "saw-logs" remain in every pool, beneath and above each rapid or fall. The miller's dam has been emptied of its timber, and he must now resort to some expedient to procure a fresh supply.

It was my good fortune to witness the method employed for the purpose of collecting the logs that had not reached their destination, and I had the more pleasure that it was seen in company with my little family. I wish for your sake, reader, that I could describe in an adequate manner the scene which I viewed; but, although not so well qualified as I wish to be, rely upon it, that the desire which I feel to gratify you, will induce me to use all my endeavours to give you an idea of it.

It was the month of September. At the upper extremity of Dennisville, which is itself a pretty village, are the sawmills and ponds of the hospitable Judge Lincoln and other persons. The creek that conveys the logs to these ponds, and which bears the name of the village, is interrupted in its course by many rapids and narrow embanked gorges. One of the latter is situated about half a mile above the mill-dams, and is so rocky and rugged in its bottom and sides, as to preclude the possibility of the trees passing along it at low water, while, as I conceived, it would have given no slight

labour to an army of woodmen or millers, to move the thousands of large logs that had accumulated in it. They lay piled in confused heaps to a great height along an extent of several hundred yards, and were in some places so close as to have formed a kind of dam. Above the gorge there is a large natural reservoir, in which the head waters of the creek settle, while only a small portion of them ripples through the gorge below, during the latter weeks of summer and in early autumn, when the streams are at their lowest.

At the *neck* of this basin, the lumberers raise a temporary barrier with the refuse of their sawn logs. The boards were planted nearly upright, and supported at their tops by a strong tree extended from side to side of the creek, which might be about forty feet in breadth. It was prevented from giving way under the pressure of the rising waters, by having strong abutments of wood laid against its centre, while the ends of these abutments were secured by wedges, which could be knocked off when necessary.

The temporary dam was now finished. Little or no water escaped through the barrier, and that in the creek above it rose in the course of three weeks to its top, which was about ten feet high, forming a sheet that extended upwards fully a mile from the dam. My family was invited, early one morning, to go and witness the extraordinary effect which would be produced by the breaking down of the barrier, and we all accompanied the lumberers to the place. Two of the men, on reaching it, threw off jackets, tied handkerchiefs round their heads, and fastened to their bodies a long rope, the end of which was held by three or four others, who stood ready to drag their companions ashore, in case of danger or accident. The two operators, each bearing an axe, walked along the abutments, and at a given signal, knocked out the wedges. A second blow from each sent off the abutments themselves, and the men, leaping with extreme dexterity from one cross log to another, sprung to the shore with almost the quickness of thought.

Scarcely had they effected their escape from the frightful peril that threatened them, when the mass of waters burst forth with a horrible uproar. All eyes were bent towards the huge heaps of logs in the gorge below. The tumultuous burst of the waters instantly swept away every object that opposed their progress, and rushed in foaming waves among the timber that every where blocked up the passage. Presently a slow, heaving motion was perceived in the mass of logs; one might have imagined that some mighty monster lay convulsively writhing beneath them, struggling with a fearful energy to extricate himself from the crushing weight. As the waters rose, this movement increased; the mass of timber extended in all directions, appearing to become more and more entangled each moment; the logs bounced against each other, thrusting aside, demerging, or raising into the air those with which they came in contact:—it seemed as if they were waging a war of destruction, such as ancient authors describe the efforts of the Titans, the foamings of whose wrath might to the eye of the painter have been represented by the angry curlings of the waters, while the tremulous and rapid motions of the logs, which at times reared themselves almost perpendicularly, might by the poet have been taken for the shakings of the confounded and discomfited giants.

Now the rushing element filled up the gorge to its brim. The logs, once under way, rolled, reared, tossed and tumbled amid the foam, as they were carried along. Many of the smaller trees broke across, from others great splinters were sent up, and all were in some degree seamed and scarred. Then in tumultuous majesty swept along the mingled wreck, the current being now increased to such a pitch, that the logs, as they were dashed against the rocky shores, resounded like the report of distant artillery, or the angry rumblings of the thunder. Onward it rolls, the emblem of wreck and ruin, destruction and chaotic strife. It seemed to me as if I witnessed the rout of a vast army, surprised, overwhelmed, and overthrown. The roar of the cannon, the groans of the dying, and the shouts of the avengers, were thundering through my brain; and amid the frightful confusion of the scene, there came over my spirit a melancholy feeling, which had not entirely vanished at the end of many days.

In a few hours, almost all the timber that had lain heaped in the rocky gorge, was floating in the great pond of the millers; and as we walked homewards, we talked of the Force of the Waters.

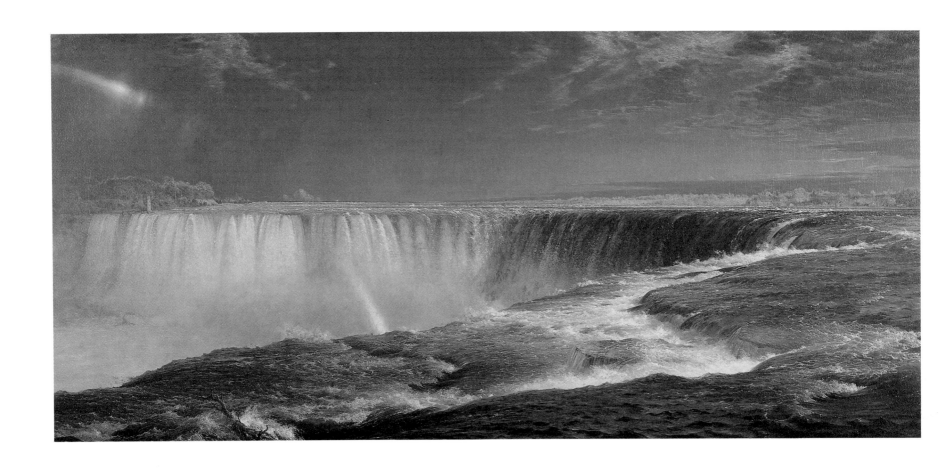

Frederic Edwin Church, *Niagara*, 1857.
The Corcoran Gallery of Art, Museum Purchase.

"My Visit to Niagara"

Nathaniel Hawthorne

*Nathaniel Hawthorne (1804–1864), author of two of the classic novels of the mid nineteenth century—*The Scarlet Letter *(1850) and* The House of the Seven Gables *(1851)— led a varied life. In addition to his writing, he lived for a time at the experimental settlement at Brook Farm in Massachusetts, worked at the custom house in Boston, served as a surveyor of the port at Salem, and was the United States consul in Liverpool, England. At some point in an otherwise hectic life, he traveled, as generations of Americans have, to Niagara Falls. Written long before the "Maid of the Mist" began its hourly trek with its raincoated passengers under the falls, Hawthorne's description of Niagara conveys the wonder of one of the continent's most remarkable natural resources.*

Never did a pilgrim approach Niagara with deeper enthusiasm, than mine. I had lingered away from it, and wandered to other scenes, because my treasury of anticipated enjoyments, comprising all the wonders of the world, had nothing else so magnificent, and I was loth to exchange the pleasures of hope for those of memory so soon. At length, the day came. The stage-coach, with a Frenchman and myself on the back seat, had already left Lewiston, and in less than an hour would set us down in Manchester. I began to listen for the roar of the cataract, and trembled with a sensation like dread, as the moment drew nigh, when its voice of ages must roll, for the first time, on my ear. The French gentleman stretched himself from the window, and expressed loud admiration, while, by a sudden impulse, I threw myself back and closed my eyes. When the scene shut in, I was glad to think, that for me the whole burst of Niagara was yet in futurity. We rolled on, and entered the village of Manchester, bordering on the falls.

I am quite ashamed of myself here. Not that I ran, like a madman, to the falls, and plunged into the thickest of the spray—never

stopping to breathe, till breathing was impossible; not that I committed this, or any other suitable extravagance. On the contrary, I alighted with perfect decency and composure, gave my cloak to the black waiter, pointed out my baggage, and inquired, not the nearest way to the cataract, but about the dinner-hour. The interval was spent in arranging my dress. Within the last fifteen minutes, my mind had grown strangely benumbed, and my spirits apathetic, with a slight depression, not decided enough to be termed sadness. My enthusiasm was in a deathlike slumber. Without aspiring to immortality, as he did, I could have imitated that English traveller, who turned back from the point where he first heard the thunder of Niagara, after crossing the ocean to behold it. Many a western trader, by-the-by, has performed a similar act of heroism with more heroic simplicity, deeming it no such wonderful feat to dine at the hotel and resume his route to Buffalo or Lewiston, while the cataract was roaring unseen.

Such has often been my apathy, when objects, long sought, and earnestly desired, were placed within my reach. After dinner—at which, an unwonted and perverse epicurism detained me longer than usual—I lighted a cigar and paced the piazza, minutely attentive to the aspect and business of a very ordinary village. Finally, with reluctant step, and the feeling of an intruder, I walked towards Goat Island. At the tollhouse, there were further excuses for delaying the inevitable moment. My signature was required in a huge ledger, containing similar records innumerable, many of which I read. The skin of a great sturgeon, and other fishes, beasts, and reptiles; a collection of minerals, such as lie in heaps near the falls; some Indian moccasins, and other trifles, made of deer-skin and embroidered with beads; several newspapers from Montreal, New-York, and Boston; all attracted me in turn. Out of a number of twisted sticks, the manufacture of a Tuscarora Indian, I selected one of curled maple, curiously convoluted, and adorned with the carved images of a snake and a fish. Using this as my pilgrim's staff, I crossed the bridge. Above and below me were the rapids, a river of impetuous snow, with here and there a dark rock amid its whiteness, resisting all the physical fury, as any cold spirit did the moral influences of the scene. On reaching Goat Island, which

separates the two great segments of the falls, I chose the right-hand path, and followed it to the edge of the American cascade. There, while the falling sheet was yet invisible, I saw the vapor that never vanishes, and the Eternal Rainbow of Niagara.

It was an afternoon of glorious sunshine, without a cloud, save those of the cataracts. I gained an insulated rock, and beheld a broad sheet of brilliant and unbroken foam, not shooting in a curved line from the top of the precipice, but falling headlong down from height to depth. A narrow stream diverged from the main branch, and hurried over the crag by a channel of its own, leaving a little pineclad island and a streak of precipice, between itself and the larger sheet. Below arose the mist, on which was painted a dazzling sun-bow, with two concentric shadows—one, almost as perfect as the original brightness; and the other, drawn faintly round the broken edge of the cloud.

Still, I had not half seen Niagara. Following the verge of the island, the path led me to the Horse-shoe, where the real, broad St. Lawrence, rushing along on a level with its banks, pours its whole breadth over a concave line of precipice, and thence pursues its course between lofty crags towards Ontario. A sort of bridge, two or three feet wide, stretches out along the edge of the descending sheet, and hangs upon the rising mist, as if that were the foundation of the frail structure. Here I stationed myself, in the blast of wind, which the rushing river bore along with it. The bridge was tremulous beneath me, and marked the tremor of the solid earth. I looked along the whitening rapids, and endeavored to distinguish a mass of water far above the falls, to follow it to their verge, and go down with it, in fancy, to the abyss of clouds and storm. Casting my eyes across the river, and every side, I took in the whole scene at a glance, and tried to comprehend it in one vast idea. After an hour thus spent, I left the bridge, and, by a staircase, winding almost interminably round a post, descended to the base of the precipice. From that point, my path lay over slippery stones, and among great fragments of the cliff, to the edge of the cataract, where the wind at once enveloped me in spray, and perhaps dashed the rainbow round me. Were my long desires fulfilled? And had I seen Niagara?

Oh, that I had never heard of Niagara till I beheld it! Blessed

were the wanderers of old, who heard its deep roar, sounding through the woods, as the summons to an unknown wonder, and approached its awful brink, in all the freshness of native feeling. Had its own mysterious voice been the first to warn me of its existence, then, indeed, I might have knelt down and worshipped. But I had come thither, haunted with a vision of foam and fury, and dizzy cliffs, and an ocean tumbling down out of the sky—a scene, in short, which Nature had too much good taste and calm simplicity to realize. My mind had struggled to adapt these false conceptions to the reality, and finding the effort vain, a wretched sense of disappointment weighed me down. I climbed the precipice, and threw myself on the earth—feeling that I was unworthy to look at the Great Falls, and careless about beholding them again.

All that night, as there has been and will be, for ages past and to come, a rushing sound was heard, as if a great tempest were sweeping through the air. It mingled with my dreams, and made them full of storm and whirlwind. Whenever I awoke, and heard this dread sound in the air, and the windows rattling as with a mighty blast, I could not rest again, till, looking forth, I saw how bright the stars were, and that every leaf in the garden was motionless. Never was a summer-night more calm to the eye, nor a gale of autumn louder to the ear. The rushing sound proceeds from the rapids, and the rattling of the casements is but an effect of the vibration of the whole house, shaken by the jar of the cataract. The noise of the rapids draws the attention from the true voice of Niagara, which is a dull, muffled thunder, resounding between the cliffs. I spent a wakeful hour at midnight, in distinguishing its reverberations, and rejoiced to find that my former awe and enthusiasm were reviving.

Gradually, and after much contemplation, I came to know, by my own feelings, that Niagara is indeed a wonder of the world, and not the less wonderful, because time and thought must be employed in comprehending it. Casting aside all preconceived notions, and preparation to be dire-struck or delighted, the beholder must stand beside it in the simplicity of his heart, suffering the mighty scene to work its own impression. Night after night, I dreamed of it, and was gladdened every morning by the conscious-ness of a growing capacity to enjoy it. Yet I will not pretend to the all-absorbing enthusiasm of some more fortunate spectators, nor deny, that very trifling causes would draw my eyes and thoughts from the cataract.

The last day that I was to spend at Niagara, before my departure for the far west, I sat upon the Table Rock. This celebrated station did not now, as of old, project fifty feet beyond the line of the precipice, but was shattered by the fall of an immense fragment, which lay distant on the shore below. Still, on the utmost verge of the rock, with my feet hanging over it, I felt as if suspended in the open air. Never before had my mind been in such perfect unison with the scene. There were intervals, when I was conscious of nothing but the great river, rolling calmly into the abyss, rather descending than precipitating itself, and acquiring tenfold majesty from its unhurried motion. It came like the march of Destiny. It was not taken by surprise, but seemed to have anticipated, in all its course through the broad lakes, that it must pour their collected waters down this height. The perfect foam of the river, after its descent, and the ever-varying shapes of mist, rising up, to become clouds in the sky, would be the very picture of confusion, were it merely transient, like the rage of a tempest. But when the beholder has stood awhile, and perceives no lull in the storm, and considers that the vapor and the foam are as everlasting as the rocks which produce them, all this turmoil assumes a sort of calmness. It soothes, while it awes the mind.

Leaning over the cliff, I saw the guide conducting two adventurers behind the falls. It was pleasant, from that high seat in the sunshine, to observe them struggling against the eternal storm of the lower regions, with heads bent down, now faltering, now pressing forward, and finally swallowed up in their victory. After their disappearance, a blast rushed out with an old hat, which it had swept from one of their heads. The rock, to which they were directing their unseen course, is marked, at a fearful distance on the exterior of the sheet, by a jet of foam. The attempt to reach it, appears both poetical and perilous, to a looker-on, but may be accomplished without much more difficulty or hazard, than in stemming a violent northeaster. In a few moments, forth came the

children of the mist. Dripping and breathless, they crept along the base of the cliff, ascended to the guide's cottage, and received, I presume, a certificate of their achievement, with three verses of sublime poetry on the back.

My contemplations were often interrupted by strangers, who came down from Forsyth's to take their first view of the falls. A short, ruddy, middle-aged gentleman, fresh from old England, peeped over the rock, and evinced his approbation by a broad grin. His spouse, a very robust lady, afforded a sweet example of maternal solicitude, being so intent on the safety of her little boy that she did not even glance at Niagara. As for the child, he gave himself wholly to the enjoyment of a stick of candy. Another traveller, a native American, and no rare character among us, produced a volume of Captain Hall's tour, and labored earnestly to adjust Niagara to the captain's description, departing, at last, without one new idea or sensation of his own. The next comer was provided, not with a printed book, but with a blank sheet of foolscap, from top to bottom of which, by means of an ever-pointed pencil, the cataract was made to thunder. In a little talk, which we had together, he awarded his approbation to the general view, but censured the position of Goat Island, observing that it should have been thrown farther to the right, so as to widen the American falls, and contract those of the Horse-shoe. Next appeared two traders of Michigan, who declared, that, upon the whole, the sight was worth looking at; there certainly was an immense waterpower here; but that, after all, they would go twice as far to see the noble stone-works of Lockport, where the Grand Canal is locked down a descent of sixty feet. They were succeeded by a young fellow, in a home-spun cotton dress, with a staff in his hand, and a pack over his shoulders. He advanced close to the edge of the rock, where his attention, at first wavering among the different components of the scene, finally became fixed in the angle of the Horse-shoe falls,

which is, indeed, the central point of interest. His whole soul seemed to go forth, and be transported thither, till the staff slipped from his relaxed grasp, and falling down—down—down—struck upon the fragment of the Table Rock.

In this manner, I spent some hours, watching the varied impression, made by the cataract, on those who disturbed me, and returning to unwearied contemplation, when left alone. At length, my time came to depart. There is a grassy footpath, through the woods, along the summit of the bank, to a point whence a causeway, hewn in the side of the precipice, goes winding down to the ferry, about half a mile below the Table Rock. The sun was near setting, when I emerged from the shadow of the trees, and began the descent. The indirectness of my downward road continually changed the point of view, and shewed me, in rich and repeated succession—now, the whitening rapids and the majestic leap of the main river, which appeared more deeply massive as the light departed; now, the lovelier picture, yet still sublime, of Goat Island, with its rocks and grove, and the lesser falls, tumbling over the right bank of the St. Lawrence, like a tributary stream; now, the long vista of the river, as it eddied and whirled between the cliffs, to pass through Ontario towards the sea, and everywhere to be wondered at, for this one unrivalled scene. The golden sunshine tinged the sheet of the American cascade, and painted on its heaving spray the broken semicircle of a rainbow, Heaven's own beauty crowning earth's sublimity. My steps were slow, and I paused long at every turn of the descent, as one lingers and pauses, who discerns a brighter and brightening excellence in what he must soon behold no more. The solitude of the old wilderness now reigned over the whole vicinity of the falls. My enjoyment became the more rapturous, because no poet shared it—nor wretch, devoid of poetry, profaned it: but the spot, so famous through the world, was all my own!

A Week on the Concord and Merrimack Rivers

Henry David Thoreau

Henry David Thoreau (1817–1862) was among the most influential writers in nineteenth-century America. Along with other New Englanders, notably Ralph Waldo Emerson (1803–1882) and Harriet Beecher Stowe (1811–1896), Thoreau sought to alter the course of American society. His most notable work, Walden, or Life in the Woods *(1854), extolled the virtues of pre-industrial life in a language that came to define much of American nature writing in the mid nineteenth century. So too did his writings about Massachusetts rivers, including* A Week on the Concord and Merrimack Rivers.

CONCORD RIVER.

Beneath low hills, in the broad interval
Through which at will our Indian rivulet
Winds mindful still of sannup and of squaw,
Whose pipe and arrow oft the plough unburies,
Here, in pine houses, built of new-fallen trees,
Supplanters of the tribe, the farmers dwell.

EMERSON.

The Musketaquid, or Grass-ground River, though probably as old as the Nile or Euphrates, did not begin to have a place in civilized history, until the fame of its grassy meadows and its fish attracted settlers out of England in 1635, when it received the other but kindred name of Concord from the first plantation on its banks, which appears to have been commenced in a spirit of peace and harmony. It will be Grass-ground River as long as grass grows and water runs here; it will be Concord River only while men lead peaceable lives on its banks. To an extinct race it was grass-ground, where they hunted and fished, and it is still perennial grass-ground to Concord farmers who own the Great Meadows, and get the hay from year to year. "One branch of it," according to the historian of Concord, for I love to quote so good authority, "rises in the south part of Hopkinton, and another from a pond and a large cedar-swamp in Westborough," and flowing between Hopkinton and Southborough, through Framingham, and between Sudbury and Wayland, where it is sometimes called Sudbury River, it enters Concord at the south part of the town, and after receiving the

North or Assabeth River, which has its source a little farther to the north and west, goes out at the northeast angle, and flowing between Bedford and Carlisle, and through Billerica, empties into the Merrimack at Lowell. In Concord it is, in summer, from four to fifteen feet deep, and from one hundred to three hundred feet wide, but in the spring freshets, when it overflows its banks, it is in some places nearly a mile wide. Between Sudbury and Wayland the meadows acquire their greatest breadth, and when covered with water, they form a handsome chain of shallow vernal lakes, resorted to by numerous gulls and ducks. Just above Sherman's Bridge, between these towns, is the largest expanse, and when the wind blows freshly in a raw March day, heaving up the surface into dark and sober billows or regular swells, skirted as it is in the distance with alder-swamps and smoke-like maples, it looks like a smaller Lake Huron, and is very pleasant and exciting for a landsman to row or sail over. The farm-houses along the Sudbury shore, which rises gently to a considerable height, command fine water prospects at this season. The shore is more flat on the Wayland side, and this town is the greatest loser by the flood. Its farmers tell me that thousands of acres are flooded now, since the dams have been erected, where they remember to have seen the white honeysuckle or clover growing once, and they could go dry with shoes only in summer. Now there is nothing but blue-joint and sedge and cut-grass there, standing in water all the year round. For a long time, they made the most of the driest season to get their hay, working sometimes till nine o'clock at night, sedulously paring with their scythes in the twilight round the hummocks left by the ice; but now it is not worth the getting when they can come at it, and they look sadly round to their wood-lots and upland as a last resource.

It is worth the while to make a voyage up this stream, if you go no farther than Sudbury, only to see how much country there is in the rear of us; great hills, and a hundred brooks, and farm-houses, and barns, and haystacks, you never saw before, and men everywhere, Sudbury, that is *Southborough* men, and Wayland, and Nine-Acre-Corner men, and Bound Rock, where four towns bound on a rock in the river, Lincoln, Wayland, Sudbury, Concord. Many

waves are there agitated by the wind, keeping nature fresh, the spray blowing in your face, reeds and rushes waving; ducks by the hundred, all uneasy in the surf, in the raw wind, just ready to rise, and now going off with a clatter and a whistling like riggers straight for Labrador, flying against the stiff gale with reefed wings, or else circling round first, with all their paddles briskly moving, just over the surf, to reconnoitre you before they leave these parts; gulls wheeling overhead, muskrats swimming for dear life, wet and cold, with no fire to warm them by that you know of; their labored homes rising here and there like haystacks; and countless mice and moles and winged titmice along the sunny windy shore; cranberries tossed on the waves and heaving up on the beach, their little red skiffs beating about among the alders;—such healthy natural tumult as proves the last day is not yet at hand. And there stand all around the alders, and birches, and oaks, and maples full of glee and sap, holding in their buds until the waters subside. You shall perhaps run aground on Cranberry Island, only some spires of last year's pipegrass above water, to show where the danger is, and get as good a freezing there as anywhere on the Northwest Coast. I never voyaged so far in all my life. You shall see men you never heard of before, whose names you don't know, going away down through the meadows with long ducking-guns, with water-tight boots wading through the fowl-meadow grass, on bleak, wintry, distant shores, with guns of half-cock, and they shall see teal, blue-winged, green-winged, shelldrakes, whistlers, black ducks, ospreys, and many other wild and noble sights before night, such as they who sit in parlors never dream of. You shall see rude and sturdy, experienced and wise men, keeping their castles, or teaming up their summer's wood, or chopping alone in the woods, men fuller of talk and rare adventure in the sun and wind and rain, than a chestnut is of meat; who were out not only in '75 and 1812, but have been out every day of their lives; greater men than Homer, or Chaucer, or Shakespeare, only they never got time to say so; they never took to the way of writing. Look at their fields, and imagine what they might write, if ever they should put pen to paper. Or what have they not written on the face of the earth already, clearing, and

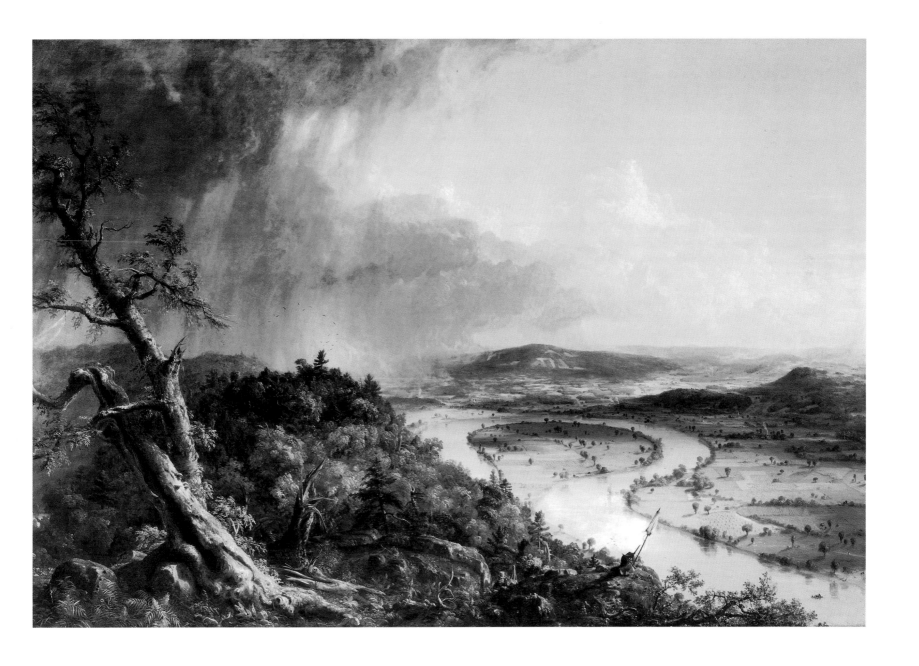

Thomas Cole, *Oxbow (The Connecticut River near Northampton)*, 1836.
The Metropolitan Museum of Art, gift of Mrs. Russell Sage.

burning, and scratching, and harrowing, and ploughing, and sub-soiling, in and in, and out and out, and over and over, again and again, erasing what they had already written for want of parchment.

As yesterday and the historical ages are past, as the work of to-day is present, so some flitting perspectives, salmon and dace cannot come up, by reason of the rocky falls, which causeth their meadows to lie much covered with water, the which these people, together with their neighbor town, have several times essayed to cut through but cannot, yet it may be turned another way with an hundred pound charge as it appeared." As to their farming he says: "Having laid out their estate upon cattle at 5 to 20 pound a cow, when they came to winter them with inland hay, and feed upon such wild fother as was never cut before, they could not hold out the winter, but, ordinarily the first or second year after their coming up to a new plantation, many of their cattle died." And this from the same author "Of the Planting of the 19th Church in the Mattachusets' Government, called Sudbury": "This year [does he mean 1654] the town and church of Christ at Sudbury began to have the first foundation stones laid, taking up her station in the inland country, as her elder sister Concord had formerly done, lying further up the same river, being furnished with great plenty of fresh marsh, but, it lying very low is much indamaged with land floods, insomuch that when the summer proves wet they lose part of their hay; yet are they so sufficiently provided that they take in cattle of other towns to winter."

The sluggish artery of the Concord meadows steals thus unobserved through the town, without a murmur or a pulse-beat, its general course from southwest to northeast, and its length about fifty miles; a huge volume of matter, ceaselessly rolling through the plains and valleys of the substantial earth with the moccasoned tread of an Indian warrior, making haste from the high places of the earth to its ancient reservoir. The murmurs of many a famous river on the other side of the globe reach even to us here, as to more distant dwellers on its banks; many a poet's stream floating the helms and shields of heroes on its bosom. The Xanthus or Scamander is not a mere dry channel and bed of a mountain torrent, but fed by the everflowing springs of fame;—

"And thou Simois, that as an arrowe, clere
 Through Troy rennest, aie downward to the sea";—

And I trust that I may be allowed to associate our muddy but much abused Concord River with the most famous in history.

"Sure there are poets which did never dream
 Upon Parnassus, nor did taste the stream
 Of Helicon; we therefore may suppose
 Those made not poets, but the poets those."

The Mississippi, the Ganges, and the Nile, those journeying atoms from the Rocky Mountains, the Himmaleh, and Mountains of the Moon, have a kind of personal importance in the annals of the world. The heavens are not yet drained over their sources, but the Mountains of the Moon still send their annual tribute to the Pasha without fail, as they did to the Pharaohs, though he must collect the rest of his revenue at the point of the sword. Rivers must have been the guides which conducted the footsteps of the first travellers. They are the constant lure, when they flow by our doors, to distant enterprise and adventure, and, by a natural impulse, the dwellers on their banks will at length accompany their currents to the lowlands of the globe, or explore at their invitation the interior of continents. They are the natural highways of all nations, not only levelling the ground and removing obstacles from the path of the traveller, quenching his thirst and bearing him on their bosoms, but conducting him through the most interesting scenery, the most populous portions of the globe, and where the animal and vegetable kingdoms attain their greatest perfection.

I had often stood on the banks of the Concord, watching the lapse of the current, an emblem of all progress, following the same law with the system, with time, and all that is made; the weeds at the bottom gently bending down the stream, shaken by the watery wind, still planted where their seeds had sunk, but erelong to die and go down likewise; the shining pebbles, not yet anxious to better their condition, the chips and weeds, and occasional logs and stems of trees that floated past, fulfilling their fate, were objects of singular interest to me, and at last I resolved to launch myself on its bosom and float whither it would bear me.

A Pioneer's Search for an Ideal Home

Phoebe Goodell Judson

Phoebe Goodell Judson (1823–?) had a good memory. Late in her life she sat down to write an account of her travails, all of which stemmed from a momentous decision in 1853 to abandon the familiar world of Vermilion, Ohio, and set out for a new home in Oregon Territory. She was one of perhaps 27,500 overland migrants who trekked westward that year, across the Mississippi and into territory only recently opened to settlement. But it was not until she was ninety-five that her story was published. Why did she finally undertake the task of writing the account? She provided her own answer: "It is the oft repeated inquiry of my friends as to what induced me to bury myself more than fifty years ago in this far-off corner of the world, that has determined me to take my pen in hand at this late day." The excerpt here recounts her experiences crossing the Big Blue River. Once across, she made her way to the promised land of the Nooksack Valley, not far from modern-day Seattle, and found her ideal home.

Monday morning we were up bright and early, our men much refreshed by their day of rest, and all were in fine spirits. After camp duties were performed and the oxen yoked and attached to the wagons, we were ready to jog along on our journey.

By the departure of our Missouri family our train was reduced to five wagons, and each took its turn in leading the train, like an old fashioned spelling class—the one that was head at night took its place at the foot next morning.

In a few hours we reached the Big Blue river and were somewhat crestfallen when we found there were several large trains ahead of us awaiting their turn to be ferried over. The facilities for crossing were so inadequate that we were detained five days, awaiting our turn to be ferried over.

The time seemed long to wait, and I, for one, was quite impatient at the delay, but not a murmur was heard censuring "our Moses," who, no doubt, had he known the situation, would have made another day's travel and not allowed so many trains to pass us. There was nothing for us to do but "possess our souls in patience" and wait.

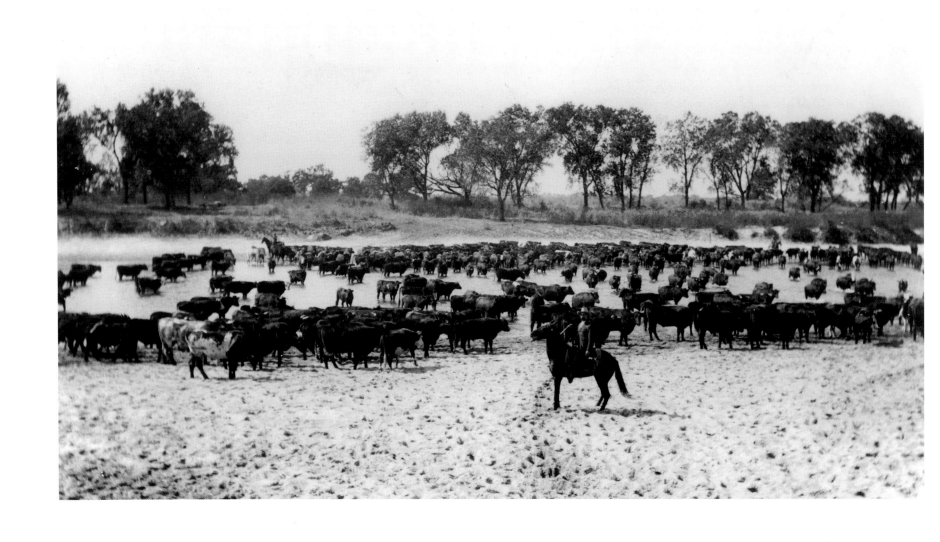

Watering the herd on the Big V Ranch, near Ponca City, Oklahoma, c. 1910.
Kansas Collection, University of Kansas Libraries.

One would naturally suppose that traveling after the slow, plod-ding cattle would have been sufficient to thoroughly inculcate that Christ-like quality, but it was evident, at least in our case, that additional lessons were required. So here we were, mixed up with other trains in the greatest confusion on the sandy banks of the Blue, where a perfect bedlam reigned. Men hallooing from one side of the river to the other, cattle bellowing, calves bawling, and a woman on the opposite side of the river screaming at the top of her voice, "Oh, papa, mam says them cows can't swim with their bags full of milk." The poor woman was nearly frantic for fear the cows would drown. The prolonged sound of the "O" indicated that they were western people, or at least were not Yankees.

Many trains were distinguished by having the names of their states painted on the covers of their wagons, and some were loaded with "a right smart chance of truck," with many of the belongings of its inmates dangling from the outside.

The women and children of each train were ferried over on the flatboat with the wagons, where they anxiously awaited the swim-ming of the stock. The river was much swollen from the melting snow, and it seemed utterly impossible to drive the poor, dumb brutes into the cold water of the rapid stream.

Our captain finally devised a successful plan which proved a solution of the difficulty. Placing three young calves on the stern of the ferry boat, he huddled the cattle together on the bank, and when the boat started the calves bawled for their mothers, who lunged into the river after them—the other cattle following. They were all soon over on the opposite bank of the river, when a shout of victory went up for the shrewd "Yankee" captain.

One of the Missourians was so pleased with this successful scheme of the captain that he gave utterance to this encouraging prophecy, "You ones will git to Oregon," which implied that he had some lingering doubts that the others would attain the goal of their ambition.

The expense of the ferriage was three dollars per wagon, but we did not stop to parley—we were only too glad to take up our line of march again at any price.

"Crossing Brooklyn Ferry"

Walt Whitman

Walt Whitman (1819–1892) was perhaps the most important poet in nineteenth-century America. Ever since the publication of Leaves of Grass *in 1855, Whitman influenced the shape of poetry in the nation. His writings about the Civil War—in which he attended to the wounded in battle hospitals—sear the conscience of any reader. Though he claimed that "the real war will never get in the books," his evocations of the horrors of that conflict remain among the most poignant of any testimonial to the personal sacrifice and catastrophe of war. As became evident after the war, the conflict forever changed the way Whitman looked at America. "Crossing Brooklyn Ferry," written five years before the attack on Fort Sumter, reveals a poet at the height of his power. The poem remains an ode to an optimistic spirit that, we now realize, could not survive the Civil War.*

1

Flood-tide below me! I see you face to face!
 Clouds of the west—sun there half an hour high—I see you also face to face.

Crowds of men and women attired in the usual costumes, how curious you are to me!
On the ferry-boats the hundreds and hundreds that cross, returning home, are more curious to me than you suppose,
And you that shall cross from shore to shore years hence are more to me, and more in my meditations, than you might suppose.

2

The impalpable sustenance of me from all things at all hours of the day,
The simple, compact, well-join'd scheme, myself disintegrated, every one disintegrated yet part of the scheme,
The similitudes of the past and those of the future,

OPPOSITE: Alvin Langdon Coburn, *The Ferry, New York*, 1910. Spencer Museum of Art/University of Kansas.

101

The glories strung like beads on my smallest sights and hearings,
 on the walk in the street and the passage over the river,
The current rushing so swiftly and swimming with me far away,
The others that are to follow me, the ties between me and them,
The certainty of others, the life, love, sight, hearing of others.

Others will enter the gates of the ferry and cross from shore
 to shore,
Others will watch the run of the flood-tide,
Others will see the shipping of Manhattan north and west, and
 the heights of Brooklyn to the south and east,
Others will see the islands large and small;
Fifty years hence, others will see them as they cross, the sun half
 an hour high,
A hundred years hence, or ever so many hundred years hence,
 others will see them,
Will enjoy the sunset, the pouring-in of the flood-tide, the
 falling-back to the sea of the ebb-tide.

3

It avails not, time nor place—distance avails not,
I am with you, you men and women of a generation, or ever so
 many generations hence,
Just as you feel when you look on the river and sky, so I felt,
Just as any of you is one of a living crowd, I was one of a crowd,
Just as you are refresh'd by the gladness of the river and the bright
 flow, I was refresh'd,
Just as you stand and lean on the rail, yet hurry with the swift
 current, I stood yet was hurried,
Just as you look on the numberless masts of ships and the thick-
 stemm'd pipes of steamboats, I look'd.

I too many and many a time cross'd the river of old,
Watched the Twelfth-month sea-gulls, saw them high in the air
 floating with motionless wings, oscillating their bodies,
Saw how the glistening yellow lit up parts of their bodies and left
 the rest in strong shadow,

Saw the slow-wheeling circles and the gradual edging toward
 the south,
Saw the reflection of the summer sky in the water,
Had my eyes dazzled by the shimmering track of beams,
Look'd at the fine centrifugal spokes of light round the shape of
 my head in the sunlit water,
Look'd on the haze on the hills southward and south-westward,
Look'd on the vapor as it flew in fleeces tinged with violet,
Look'd toward the lower bay to notice the vessels arriving,
Saw their approach, saw aboard those that were near me,
Saw the white sails of schooners and sloops, saw the ships
 at anchor,
The sailors at work in the rigging or out astride the spars,
The round masts, the swinging motion of the hulls, the slender
 serpentine pennants,
The large and small steamers in motion, the pilots in their
 pilot-houses,
The white wake left by the passage, the quick tremulous whirl of
 the wheels,
The flags of all nations, the falling of them at sunset,
The scallop-edged waves in the twilight, the ladled cups, the
 frolicsome crests and glistening,
The stretch afar growing dimmer and dimmer, the gray walls of
 the granite storehouses by the docks,
On the river the shadowy group, the big steam-tug closely
 flank'd on each side by the barges, the hay-boat,
 the belated lighter,
On the neighboring shore the fires from the foundry chimneys
 burning high and glaringly into the night,
Casting their flicker of black contrasted with wild red and
 yellow light over the tops of houses, and down into the clefts
 of streets.

4

These and all else were to me the same as they are to you,
I loved well those cities, loved well the stately and rapid river,
The men and women I saw were all near to me,

Others the same—others who look back on me because I look'd
 forward to them,
(The time will come, though I stop here to-day and to-night.)

5

What is it then between us?
What is the count of the scores or hundreds of years between us?

Whatever it is, it avails not—distance avails not, and place
 avails not,
I too lived, Brooklyn of ample hills was mine,
I too walk'd the streets of Manhattan island, and bathed in the
 waters around it,
I too felt the curious abrupt questionings stir within me.
In the day among crowds of people sometimes they came
 upon me,
In my walks home late at night or as I lay in my bed they came
 upon me,
I too had been struck from the float forever held in solution,
I too had receiv'd identity by my body,
That I was I knew was of my body, and what I should be I knew
 I should be of my body.

6

It is not upon you alone the dark patches fall,
The dark threw its patches down upon me also,
The best I had done seem'd to me blank and suspicious,
My great thoughts as I supposed them, were they not in
 reality meagre?
Nor is it you alone who know what it is to be evil,
I am he who knew what it was to be evil,
I too knitted the old knot of contrariety,
Blabb'd, blush'd, resented, lied, stole, grudg'd,
Had guile, anger, lust, hot wishes I dared not speak,
Was wayward, vain, greedy, shallow, sly, cowardly, malignant,
The wolf, the snake, the hog, not wanting in me,

The cheating look, the frivolous word, the adulterous wish,
 not wanting,
Refusals, hates, postponements, meanness, laziness, none of these
 wanting,
Was one with the rest, the days and haps of the rest,
Was call'd by my nighest name by clear loud voices of young
 men as they saw me approaching or passing,
Felt their arms on my neck as I stood, or the negligent leaning of
 their flesh against me as I sat,
Saw many I loved in the street or ferry-boat or public assembly,
 yet never told them a word,
Lived the same life with the rest, the same old laughing, gnawing,
 sleeping,
Play'd the part that still looks back on the actor or actress,
The same old role, the role that is what we make it, as great as
 we like,
Or as small as we like, or both great and small.

7

Closer yet I approach you,
What thought you have of me now, I had as much of you—I laid
 in my stores in advance,
I consider'd long and seriously of you before you were born.

Who was to know what should come home to me?
Who knows but I am enjoying this?
Who knows, for all the distance, but I am as good as looking at
 you now, for all you cannot see me?

8

Ah, what can ever be more stately and admirable to me than
 mast-hemm'd Manhattan?
River and sunset and scallop-edg'd waves of flood-tide?
The sea-gulls oscillating their bodies, the hay-boat in the
 twilight, and the belated lighter?

What gods can exceed these that clasp me by the hand, and with
 voices I love call me promptly and loudly by my nighest name
 as I approach?
What is more subtle than this which ties me to the woman or
 man that looks in my face?
Which fuses me into you now, and pours my meaning into you?

We understand then do we not?
What I promis'd without mentioning it, have you not accepted?
What the study could not teach—what the preaching could not
 accomplish is accomplish'd, is it not?

 9
Flow on, river! flow with the flood-tide, and ebb with the
 ebb-tide!
Frolic on, crested and scallop-edg'd waves!
Gorgeous clouds of the sunet! drench with your splendor me,
 or the men and women generations after me!
Cross from shore to shore, countless crowds of passengers!
Stand up, tall masts of Mannahatta! stand up, beautiful hills of
 Brooklyn!
Throb, baffled and curious brain! throw out questions and
 answers!
Suspend here and everywhere, eternal float of solution!
Gaze, loving and thirsting eyes, in the house or street or public
 assembly!
Sound out, voices of young men! loudly and musically call me by
 my nighest name!
Live, old life! play the part that looks back on the actor or actress!
Play the old role, the role that is great or small according as one
 makes it!
Consider, you who peruse me, whether I may not in unknown
 ways be looking upon you;

Be firm, rail over the river, to support those who lean idly, yet
 haste with the hasting current;
Fly on, sea-birds! fly sideways, or wheel in large circles high in
 the air;
Receive the summer sky, you water, and faithfully hold it till all
 downcast eyes have time to take it from you!
Diverge, fine spokes of light, from the shape of my head, or any
 one's head, in the sunlit water!
Come on, ships from the lower bay! pass up or down, white-
 sail'd schooners, sloops, lighters!
Flaunt away, flags of all nations! be duly lower'd at sunset!
Burn high your fires, foundry chimneys! cast black shadows at
 nightfall! cast red and yellow light over the tops of the houses!
Appearances, now or henceforth, indicate what you are,
You necessary film, continue to envelop the soul,
About my body for me, and your body for you, be hung our
 divinest aromas,
Thrive, cities—bring your freight, bring your shows, ample and
 sufficient rivers,
Expand, being than which none else is perhaps more spiritual,
Keep your places, objects than which none else is more lasting.

You have waited, you always wait, you dumb, beautiful
 ministers,
We receive you with free sense at last, and are insatiate
 henceforward,
Not you any more shall be able to foil us, or withhold yourselves
 from us,
We use you, and do not cast you aside—we plant you
 permanently within us,
We fathom you not—we love you—there is perfection in
 you also,
You furnish your parts toward eternity,
Great or small, you furnish your parts toward the soul.

The Company of Adventurers

Isaac Cowie

"Listening to many a splendid story of adventure in the wilderness, around camp fires, and during the long winter nights before a blazing open chimney of the quarters in an inland post, I have often urged the narrators to preserve in writing such interesting and valuable materials." So wrote Isaac Cowie (1848–1917), who was born in Lerwick in the Shetland Islands and who followed his father, a physician for an 1847 Hudson's Bay Company expedition, into the service of the Company. Once enlisted, Cowie traveled deep into the Canadian interior, stationed at Fort Qu'Appelle, where he spent time with the local Indians. His memory of those peoples was so distinct that Franz Boas, the great American ethnologist, hired Cowie to prepare material on Plains Cree culture for the Chicago Exposition of 1892. Although he did not intend to sit down and write a "comprehensive, ancient, and modern history" of the Company, Cowie did inform his readers that The Company of Adventurers *contained "an attempt to give some data of the history of the Hudson's Bay Company from the fur-trader's point of view."*

We pushed off into the stream and set our square dipping lug sail to a fair breeze which carried us slowly along till evening, when we camped near Ten Shilling Creek, on the bare stones and boulders of the beach, in a downpour of rain, which lasted all night, and rendered our first night under canvas, unprepared as we were, very uncomfortable. The campfire was a miserable little one of driftwood, and we were glad to accept the invitation of the doctor to his tent to have supper. As a campaigner of three years' experience, the doctor had everything comfortably arranged in his tent, and had had a fine ham and some delicious cured buffalo tongues cooked before leaving the Factory. After disposing of these and fortifying ourselves with wine, Lang brought forth a concertina, upon which he was no mean performer, and we all joined in a sing-song till about ten o'clock, when we were surprised by Chief Trader Fortescue suddenly arriving in a canoe with papers to be placed in the packet box for Red River. We sat at the feet of Mr. Fortescue for hours there-after listening to his clever and entertaining descriptions of life in the interior.

Yelling "'Leve, 'Leve."

At an unearthly hour next morning, Sandison rattled the cold, wet tent down about our ears, and startled us from rosy sleep to the shivering realities of getting up and dressing in the open air of a chill, damp dawn. We scrambled aboard, where we found in a sternsheets a steaming kettle of tea and some biscuits which he had provided for our early breakfast. The boats started under oars, but the crews soon commenced the long and laborious job of tracking up the Hayes. The river was about half a mile wide, with a current too strong to make headway rowing against it. The banks were of clay and got steeper and higher as we advanced, with sometimes a wet, muddy beach and often none, when the poor fellows were obliged to scramble as best they could along the steep slopes in mud and through brush, driftwood, and landslips, while we on board took our ease as the boat slipped smoothly along.

The Scenery Improves.

The tamarack, spruce, poplar and willows growing along the bank became of larger growth as we proceeded up stream. The scenery changed to beauty and variety. All vegetation had begun to put on the glorious hues of autumn. The weather, improving day by day and continuing delightful, with scarcely a break throughout the journey, rendered the travelling to us as mere passengers most enjoyable. The Steel River is three hundred yards wide where we left the Hayes, and its banks are, though higher, less steep than those of the latter, rendering the tracking ground easier, but the stream is more obstructed by rapids and shoals.

Absence of Game.

The Steel winds its serpentine course through a lovely valley, then adorned with the varying shades of the season of the fall of the leaf in North America. The novel experience of this new country and mode of travel, and the ease and comfort we had now attained afloat and ashore in camp fulfilled all our fond anticipations of life in the wilderness. But to our intense disappointment there appeared to be a total absence of the game, the pursuit of which had been our chief lure into exile. The noise of the boatmen shouting and laughing as they went along tracking, and the rattling of our oars in the tholes and their splashing in the water, scared all game away. Ducks in the river ahead would take flight as the string of noisy boatmen marching in advance of the boats approached, and other game in the woods were equally alarmed by the unwonted noise of our intrusion; so it was only that mass of nothing but feathers and impudence, the ubiquitous "Whiskey Jack," which, presuming on its being no good and unworthy of powder and shot, ever gave us a chance to shoot, while under way.

Armit was a very ardent sportsman, however, and kept keen watch and ward for a shot in spite of continual disappointment. So he succeeded in bagging about four ducks and one mink between York and Norway House. We both missed a red fox, and were successful in trolling for pike, which furnished a welcome and much appreciated addition to our usual bill of fare. As we passed through the narrow grassy channels of the Echemamis, near the watershed at Painted Stone, the rabbits were numerous and in good condition too, and we had some satisfactory sport there.

Picturesque Hill River.

We made good progress, reaching the mouth of the Steel on the second day from York, and entering the Hill River two days afterwards. The Hill was shallow and rapid, the men often having to jump out and lift and push the boat over the shallows, and pole and warp up the rapids. The banks are higher than those of the Steel and more broken in outline, the clay cliffs some ninety feet high, surmounted by hills two hundred feet higher, but the woods were too thick to give any view further back. At Rock Portage the river is pent up by islands, between which it rushes down in many

cascades of rare beauty. On the 8th we arrived at the site of the old depot for the Selkirk Settlement, Rock House, long since abandoned, which was in charge of Mr. Bunn, the ancestor of the well-known Red River family, in 1819, when Franklin passed it and stored some of his supplies there.

The "Tracking Grounds" being now passed, we entered into the fight with the rushing river by poling, warping and portaging up and over the many rapids and cascades formed by the rocky nature of the country. At Morgan's Portage the Hill River expands to three-quarters of a mile, and its low, flat, rocky banks permit of a wide and extensive view for the first time since leaving the sea coast. Among a multitude of conical hills scattered about, one of six hundred feet towers over the rest, and has given name to the river. From its summit over thirty lakes can be seen. The low-lying islands covered with spruce, birch, poplar and willow right to the water's edge, in their green, yellow and russet foliage, with babbling brooks and dancing cascades between, entranced the eye. We landed for dinner on one of these islet gems of the wilderness. Under an azure sky we lounged luxuriously on velvety couches of emerald moss, and I fain would have had the friends we had left behind in Scotland there to admire the perfect picture and partake of our picnic.

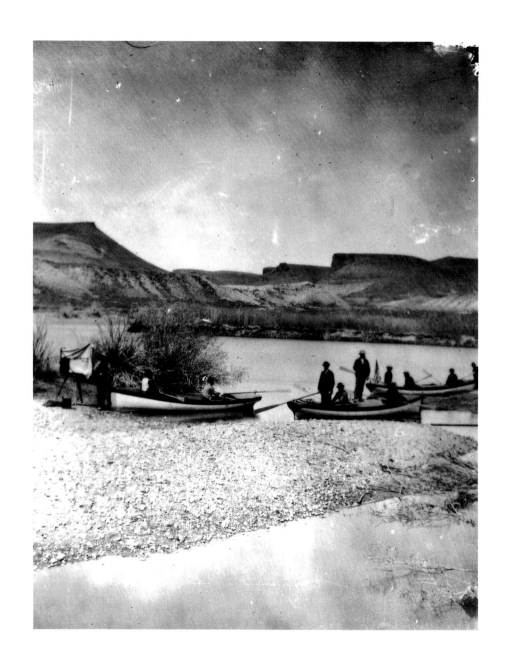

John Wesley Powell and his party on the Colorado River, 1871.
John K. Hillers, United States Geological Survey.

The Exploration of the Colorado River

John Wesley Powell

John Wesley Powell (1834–1902) lost his right arm at the battle of Shiloh, but it had little effect on his place in American history. Lashing his chair to his boat, he and his party explored the Colorado and Green rivers from 1869 to 1875, traveling through treacherous stretches of whitewater that could have killed them at any moment. When the journey ended he joined the staff of the United States Geological Survey and he succeeded Clarence King (1842–1901) as its director in 1881. While at the Geological Society Powell inaugurated the publication of its bulletins (in 1883), monographs (in 1890), and folio atlases (in 1894); near the end of his career he also became director of the Smithsonian Institution's Bureau of Ethnology.

August 13.

We are now ready to start on our way down the Great Unknown. Our boats, tied to a common stake, are chafing each other, as they are tossed by the fretful river. They ride high and buoyant, for their loads are lighter than we could desire. We have but a month's rations remaining. The flour has been sifted through the mosquito-net sieve; the spoiled bacon has been dried, and the worst of it boiled; the few pounds of dried apples have been spread in the sun, and reshrunken to their normal bulk; the sugar has all melted, and gone on its way down the river; but we have a large sack of coffee. The lighting of the boats has this advantage; they will ride the waves better, and we shall have but little to carry when we make a portage.

We are three quarters of a mile in the depths of the earth, and the great river shrinks into insignificance, as it dashes its angry waves against the walls and cliffs, that rise to the world above; they are but puny ripples, and we but pigmies, running up and down the sands, or lost among the boulders.

We have an unknown distance yet to run; an unknown river yet to explore. What falls there are, we know not; what rocks beset the channel, we know not; what walls rise over the river we know not. Ah, well! we may conjecture many things. The men talk as cheerfully as ever; jests are bandied about freely this morning; but to me the cheer is somber and the jests are ghastly.

With some eagerness, and some anxiety, and some misgiving, we enter the canyon below, and are carried along by the swift water through walls which rise from its very edge. They have the same structure as we noticed yesterday—tiers of irregular shelves below, and, above these, steep slopes to the foot of marble cliffs. We run six miles in a little more than half an hour, and emerge into a more open portion of the canyon, where high hills and ledges of rock intervene between the river and the distant walls. Just at the head of this open place the river runs across a dike; that is, a fissure in the rocks, open to depths below, has been filled with eruptive matter, and this, on cooling, was harder than the rocks through which the crevice was made, and, when these were washed away, the harder volcanic matter remained as a wall, and the river has cut a gateway through it several hundred feet high, and as many wide. As it crosses the wall, there is a fall below, and a bad rapid, filled with boulders of trap; so we stop to make a portage. Then we go, gliding by hills and ledges, with distant walls in view; sweeping past sharp angles of rock; stopping at a few points to examine rapids, which we find can be run, until we have made another five miles, when we land for dinner.

Then we let down with lines, over a long rapid, and start again. Once more the walls close in, and we find ourselves in a narrow gorge, the water again filling the channel, and very swift. With great care, and constant watchfulness, we proceed, making about four miles this afternoon, and camp in a cave.

August 14.

—At daybreak we walk down the bank of the river, on a little sandy beach, to take a view of a new feature in the canyon. Heretofore, hard rocks have given us bad river; soft rocks, smooth water; and a series of rocks harder than any we have experienced sets in. The river enters the granite!

We can see but a little way into the granite gorge, but it looks threatening.

After breakfast we enter on the waves. At the very introduction, it inspires awe. The canyon is narrower than we have ever before seen it; the water is swifter; there are but few broken rocks in the channel; but the walls are set, on either side, with pinnacles and crags; and sharp, angular buttresses, bristling with wind and wave-polished spires, extend far out into the river.

Ledges of rocks jut into the stream, their tops sometimes just below the surface, sometimes rising few or many feet above; and island ledges, and island pinnacles, and island towers break the swift course of the stream into chutes, and eddies, and whirlpools. We soon reach a place where a creek comes in from the left, and just below, the channel is choked with boulders, which have washed down this lateral canyon and formed a dam, over which there is a fall of thirty or forty feet; but on the boulders we can get foothold, and we make a portage.

Three more such dams are found. Over one we make a portage; at the other two we find chutes, through which we can run.

As we proceed, the granite rises higher, until nearly a thousand feet of the lower part of the walls are composed of this rock.

About eleven o'clock we hear a great roar ahead, and approach it very cautiously. The sound grows louder and louder as we run, and at last we find ourselves above a long, broken fall, with ledges and pinnacles of rock obstructing the river. There is a descent of, perhaps, seventy-five or eighty feet in a third of a mile, and the rushing waters break into great waves on the rocks, and lash themselves into a mad, white foam. We can land just above, but there is no foothold on either side by which we can make a portage. It is nearly a thousand feet to the top of the granite, so it will be impossible to carry our boats around, though we can climb to the summit up a side gulch, and, passing along a mile or two, can descend to the river. This we find on examination; but such a portage would be impracticable for us, and we must run the rapid, or abandon the river. There is no hesitation. We step into our

boats, push off and away we go, first on smooth but swift water, then we strike a glassy wave, and ride to its top, down again into the trough, up again on a higher wave, and down and up on waves higher and still higher, until we strike one just as it curls back, and a breaker rolls over our little boat. Still, on we speed, shooting past projecting rocks, till the little boat is caught in a whirlpool, and spun around several times. At last we pull out again into the stream, and now the other boats have passed us. The open compartment of the "Emma Dean" is filled with water, and every breaker rolls over us. Hurled back from a rock, now on this side, now on that, we are carried into an eddy, in which we struggle for a few minutes, and are then out again, the breakers still rolling over us. Our boat is unmanageable, but she cannot sink, and we drift down another hundred yards, through breakers; how, we scarcely know. We find the other boats have turned into an eddy at the foot of the fall, and are waiting to catch us as we come, for the men have seen that our boat is swamped. They push out as we come near, and pull us in against the wall. We bail our boat, and on we go again.

The walls, now, are more than a mile in height—a vertical distance difficult to appreciate. Stand on the south steps of the Treasury building, in Washington, and look down Pennsylvania Avenue to the Capitol Park, and measure this distance overhead, and imagine cliffs to extend to that altitude, and you will understand what I mean or, stand at Canal Street, in New York, and look up Broadway to Grace Church, and you have about the distance; or, stand at Lake Street bridge in Chicago, and look down to the Central Depot, and you have it again.

A thousand feet of this is up through granite crags, then steep slopes and perpendicular cliffs rise, one above another, to the summit. The gorge is black and narrow below, red and gray and flaring above, with crags and angular projections on the walls, which, cut in many places by side canyons, seem to be a vast wilderness of rocks. Down in these grand, gloomy depths we glide, ever listening, for the mad waters keep up their roar; ever watching, ever peering ahead, for the narrow canyon is winding, and the river is closed in so that we can see but a few hundred yards, and what there may be below we know not; but we listen for falls, and watch for rocks, or stop now and then, in the bay of a recess, to admire the gigantic scenery. And ever, as we go, there is some new pinnacle or tower, some crag or peak, some distant view of the upper plateau, some strange shaped rock, or some deep, narrow side canyon. Then we come to another broken fall, which appears more difficult than the one we ran this morning.

A small creek comes in on the right, and the first fall of the water is over boulders, which have been carried down by this lateral stream. We land at its mouth, and stop for an hour or two to examine the fall. It seems possible to let down with lines, at least a part of the way, from point to point, along the right-hand wall. So we make a portage over the first rocks, and find footing on some boulders below. Then we let down one of the boats to the end of her line, when she reaches a corner of the projecting rock, to which one of the men clings, and steadies her, while I examine an eddy below. I think we can pass the other boats down by us, and catch them in the eddy. This is soon done and the men in the boats in the eddy pull us to their side. On the shore of this little eddy there is about two feet of gravel beach above the water. Standing on this beach, some of the men take the line of the little boat and let it drift down against another projecting angle. Here is a little shelf, on which a man from my boat climbs, and a shorter line is passed to him, and he fastens the boat to the side of the cliff. Then the second one is let down, bringing the line of the third. When the second boat is tied up, the two men standing on the beach above spring into the last boat, which is pulled up alongside of ours. Then we let down the boats, for twenty-five or thirty yards, by walking along the shelf, landing them again in the mouth of a side canyon. Just below this there is another pile of boulders, over which we make another portage. From the foot of these rocks we can climb to another shelf, forty or fifty feet above the water.

On this bench, we camp for the night. We find a few sticks, which have lodged in the rocks. It is raining hard, and we have no shelter, but kindle a fire and have our supper. We sit on the rocks all night, wrapped in our ponchos, getting what sleep we can.

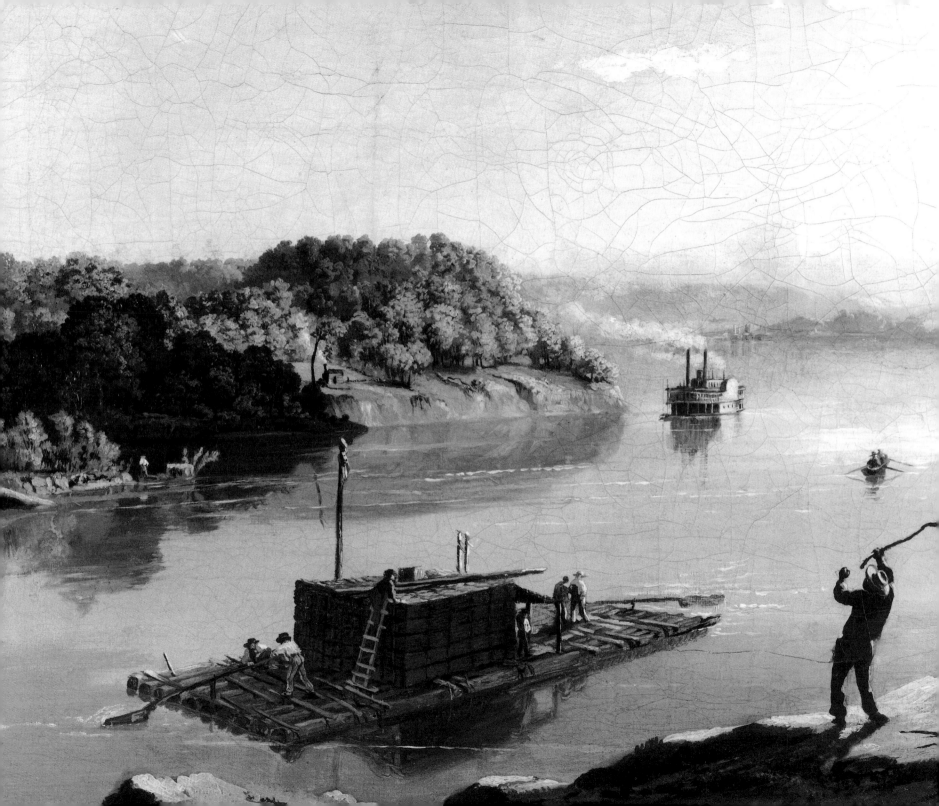

Life on the Mississippi and The Adventures of Huckleberry Finn

Mark Twain

The Adventures of Huckleberry Finn *by Mark Twain, the pen name of Samuel Clemens (1835–1910), remains lodged in the canon of classic American novels. Somewhere further down in American literature lies* Life on the Mississippi, *which appeared in serial form in* The Atlantic Monthly *in the 1870s.* Huck *reveals Twain at his most creative, with his evocation of speech patterns so clear that the reader can almost hear the way people spoke to each other.* Life on the Mississippi *reveals another vital part of Twain: the man who learned to navigate a steamboat along the nation's most important river. Taken together, they show two sides of a literary genius shaped, at least in part, by his experiences along American rivers.*

EXCERPT *from* Life on the Mississippi

There was no use in arguing with a person like this. I promptly put such a strain on my memory that by and by even the shoal water and the countless crossing-marks began to stay with me. But the result was just the same. I never could more than get one knotty thing learned before another presented itself. Now I had often seen pilots gazing at the water and pretending to read it as if it were a book; but it was a book that told me nothing. A time came at last, however, when Mr. Bixby seemed to think me far enough advanced to bear a lesson on water-reading. So he began:

"Do you see that long, slanting line on the face of the water? Now, that's a reef. Moreover, it's a bluff reef. There is a solid sandbar under it that is nearly as straight up and down as the side of a house.

OPPOSITE: Anonymous, *Rafting Downstream*, c. 1840–1850. Indiana University Art Museum, Bloomington, Indiana.

There is plenty of water close up to it, but mighty little on top of it. If you were to hit it you would knock the boat's brains out. Do you see where the line fringes out at the upper end and begins to fade away?"

"Yes, sir."

"Well, that is a low place; that is the head of the reef. You can climb over there, and not hurt anything. Cross over, now, and follow along close under the reef—easy water there—not much current."

I followed the reef along till I approached the fringed end. Then Mr. Bixby said:

"Now get ready. Wait till I give the word. She won't want to mount the reef; a boat hates shoal water. Stand by—wait—wait—keep her well in hand. Now cramp her down! Snatch her! snatch her!"

He seized the other side of the wheel and helped to spin it around until it was hard down, and then we held it so. The boat resisted, and refused to answer for a while, and next she came surging to starboard, mounted the reef, and sent a long, angry ridge of water foaming away from her bows.

"Now watch her; watch her like a cat, or she'll get away from you. When she fights strong and the tiller slips a little, in a jerky, greasy sort of way, let up on her a trifle; it is the way she tells you at night that the water is too shoal; but keep edging her up, little by little, toward the point. You are well up on the bar now; there is a bar under every point, because the water that comes down around it forms an eddy and allows the sediment to sink. Do you see those fine lines on the face of the water that branch out like the ribs of a fan? Well, those are little reefs; you want to just miss the ends of them, but run them pretty close. Now look out—look out! Don't you crowd that slick, greasy-looking place; there ain't nine feet there; she won't stand it. She begins to smell it; look sharp, I tell you! Oh, blazes, there you go! Stop the starboard wheel! Quick! Ship up to back! Set her back!"

The engine bells jingled and the engines answered promptly, shooting white columns of steam far aloft out of the 'scapepipes,

but it was too late. The boat had "smelt" the bar in good earnest; the foamy ridges that radiated from her bows suddenly disappeared, a great dead swell came rolling forward, and swept ahead of her, she careened far over to larboard, and went tearing away toward the other shore as if she were about scared to death. We were a good mile from where we ought to have been when we finally got the upper hand of her again.

During the afternoon watch the next day, Mr. Bixby asked me if I knew how to run the next few miles. I said:

"Go inside the first snag above the point, outside the next one, start out from the lower end of Higgin's woodyard, make a square crossing, and—"

"That's all right. I'll be back before you close up on the next point."

But he wasn't. He was still below when I rounded it and entered upon a piece of river which I had some misgivings about. I did not know that he was hiding behind a chimney to see how I would perform. I went gaily along, getting prouder and prouder, for he had never left the boat in my sole charge such a length of time before. I even got to "setting" her and letting the wheel go entirely, while I vaingloriously turned my back and inspected the stem marks and hummed a tune, a sort of easy indifference which I had prodigiously admired in Bixby and other great pilots. Once I inspected rather long, and when I faced to the front again my heart flew into my mouth so suddenly that if I hadn't clapped my teeth together I should have lost it. One of those frightful bluff reefs was stretching its deadly length right across our bows! My head was gone in a moment; I did not know which end I stood on; I gasped and could not get my breath; I spun the wheel down with such rapidity that it wove itself together like a spider's web; the boat answered and turned square away from the reef, but the reef followed her! I fled, and still it followed—still it kept right across my bows! I never looked to see where I was going, I only fled. The awful crash was imminent—why didn't that villain come! If I committed the crime of ringing a bell I might get thrown overboard. But better that than kill the boat. So in blind desperation, I started such a rattling

"shivaree" down below as never had astounded an engineer in this world before, I fancy. Amidst the frenzy of the bells the engines began to back and fill in a furious way, and my reason forsook its throne—we were about to crash into the woods on the other side of the river. Just then Mr. Bixby stepped calmly into view on the hurricane-deck. My soul went out to him in gratitude. My distress vanished; I would have felt safe on the brink of Niagara, with Mr. Bixby on the hurricane-deck. He blandly and sweetly took his toothpick out of his mouth between his fingers, as if it were a cigar—we were just in the act of climbing an overhanging big tree, and the passengers were scudding astern like rats—and lifted up these commands to me ever so gently:

"Stop the starboard! Stop the larboard! Set her back on both!"

The boat hesitated, halted, pressed her nose among the boughs a critical instant, then reluctantly began to back away.

"Stop the larboard! Come ahead on it! Stop the starboard! Come ahead on it! Point her for the bar!"

I sailed away as serenely as a summer's morning. Mr. Bixby came in and said, with mock simplicity:

"When you have a hail, my boy, you ought to tap the big bell three times before you land, so that the engineers can get ready."

I blushed under the sarcasm, and said I hadn't had any hail.

"Ah! Then it was for wood, I suppose. The officer of the watch will tell you when he wants to wood up."

I went on consuming, and said I wasn't after wood.

"Indeed? Why, what could you want over here in the bend, then? Did you ever know of a boat following a bend up-stream at this stage of the river?"

"No, sir—and I wasn't trying to follow it. I was getting away from a bluff reef."

"No, it wasn't a bluff reef; there isn't one within three miles of where you were."

"But I saw it. It was as bluff as that one yonder."

"Just about. Run over it!"

"Do you give it as an order?"

"Yes. Run over it!"

"If I don't, I wish I may die."

"All right; I am taking the responsibility."

I was just as anxious to kill the boat, now, as I had been to save her before. I impressed my orders upon my memory, to be used at the inquest, and made a straight break for the reef. As it disappeared under our bows I held my breath; but we slid over it like oil.

"Now, don't you see the difference? It wasn't anything but a *wind* reef. The wind does that."

"So I see. But it is exactly like a bluff reef. How am I ever going to tell them apart?"

"I can't tell you. It is an instinct. By and by you will just naturally *know* one from the other, but you never will be able to explain why or how you know them apart."

It turned out to be true. The face of the water, in time, became a wonderful book—a book that was a dead language to the uneducated passenger, but which told its mind to me without reserve, delivering its most cherished secrets as clearly as if it uttered them with a voice. And it was not a book to be read once and thrown aside, for it had a new story to tell every day. Throughout the long twelve hundred miles there was never a page that was void of interest, never one that you could leave unread without loss, never one that you would want to skip, thinking you could find higher enjoyment in some other thing. There never was so wonderful a book written by man; never one whose interest was so absorbing, so unflagging, so sparklingly renewed with every re-perusal. The passenger who could not read it was charmed with a peculiar sort of faint dimple on its surface (on the rare occasions when he did not overlook it altogether); but to the pilot that was an *italicized* passage; indeed, it was more than that, it was legend of the largest capitals, with a string of shouting exclamation-points at the end of it, for it meant that a wreck or a rock was buried there that could tear the life out of the strongest vessel that ever floated. It is the faintest and simplest expression the water ever makes, and the most hideous to a pilot's eye. In truth, the passenger who could not read this book saw nothing but all manner of pretty pictures in it, painted by the sun and shaded by the clouds, whereas to the trained eye

these were not pictures at all, but the grimmest and most dead-earnest of reading-matter.

Now when I had mastered the language of this water, and had come to know every trifling feature that bordered the great river as familiarly as I knew the letters of the alphabet, I had made a valuable acquisition. But I had lost something, too. I had lost something which could never be restored to me while I lived. All the grace, the beauty, the poetry, had gone out of the majestic river! I still keep in mind a certain wonderful sunset which I witnessed when steamboating was new to me. A broad expanse of the river was turned to blood; in the middle distance the red hue brightened into gold, through which a solitary log came floating, black and conspicuous; in one place a long, slanting mark lay sparkling upon the water; in another the surface was broken by boiling, tumbling rings, that were as many-tinted as an opal; where the ruddy flush was faintest, was a smooth spot that was covered with graceful circles and radiating lines, ever so delicately traced; the shore on our left was densely wooded, and the somber shadow that fell from this forest was broken in one place by a long, ruffled trail that shone like silver; and high above the forest wall a clean-stemmed dead tree waved a single leafy bough that glowed like a flame in the unobstructed splendor that was flowing from the sun. There were graceful curves, reflected images, woody heights, soft distances; and over the whole scene, far and near, the dissolving lights drifted steadily, enriching it every passing moment with new marvels of coloring.

I stood like one bewitched. I drank it in, in a speechless rapture. The world was new to me, and I had never seen anything like this at home. But as I have said, a day came when I began to cease from noting the glories and the charms which the moon and the sun and the twilight wrought upon the river's face; another day came when I ceased altogether to note them. Then, if that sunset scene had been repeated, I should have looked upon it without rapture, and should have commented upon it, inwardly, after this fashion: "This sun means that we are going to have wind to-morrow; that floating log means that the river is rising, small thanks to it; that slanting mark on the water refers to a bluff reef which is going to kill somebody's steamboat one of these nights, if it keeps on stretching out like that; those tumbling 'boils' show a dissolving bar and a changing channel there; the lines and circles in the slick water over yonder are a warning that that troublesome place is shoaling up dangerously; that silver streak in the shadow of the forest is the 'break' from a new snag, and he has located himself in the very best place he could have found to fish for steamboats; that tall dead tree, with a single living branch, is not going to last long, and then how is a body ever going to get through this blind place at night without the friendly old landmark?"

No, the romance and beauty were all gone from the river. All the value any feature of it had for me now was the amount of usefulness it could furnish toward compassing the safe piloting of a steamboat. Since those days, I have pitied doctors from my heart. What does the lovely flush in a beauty's cheek mean to a doctor but a "break" that ripples above some deadly disease? Are not all her visible charms sown thick with what are to him the signs and symbols of hidden decay? Does he ever see her beauty at all, or doesn't he simply view her professionally, and comment upon her unwholesome condition all to himself? And doesn't he sometimes wonder whether he has gained most or lost most by learning his trade?

EXCERPT *from*

The Adventures of Huckleberry Finn

*T*wo or three days and nights went by; I reckon I might say they swum by, they slid along so quiet and smooth and lovely. Here is the way we put in the time. It was a monstrous big river down there—sometimes a mile and a half wide; we run nights, and laid up and hid day-times; soon as night was most gone, we stopped navigating and tied up—nearly always in the dead water under a

towhead; and then cut young cottonwoods and willows and hid the raft with them. Then we set out the lines. Next we slid into the river and had a swim, so as to freshen up and cool off; then we set down on the sandy bottom where the water was about knee deep, and watched the daylight come. Not a sound, anywheres—perfectly still—just like the whole world was asleep, only sometimes the bullfrogs a-cluttering, maybe. The first thing to see, looking away over the water, was a kind of dull line—that was the woods on t'other side—you couldn't make nothing else out; then a pale place in the sky; then more paleness, spreading around; then the river softened up, away off, and warn't black any more, but gray; you could see little dark spots drifting along, ever so far away—trading-scows, and such things; and long black streaks—rafts; sometimes you could hear a sweep screaking; or jumbled-up voices, it was so still, and sounds come so far; and by and by you could see a streak on the water which you know by the look of the streak that there's a snag there in a swift current which breaks on it and makes that streak look that way; and you see the mist curl up off of the water, and the east reddens up, and the river, and you make out a log cabin in the edge of the woods, away on the bank on t'other side of the river, being a wood-yard, likely, and piled by them cheats so you can throw a dog through it anywheres; then the nice breeze springs up, and comes fanning you from over there, so cool and fresh, and sweet to smell, on account of the woods and the flowers; but sometimes not that way, because they've left dead fish laying around, gars, and such, and they do get pretty rank; and next you've got the full day, and everything smiling in the sun, and the song-birds just going it!

A little smoke couldn't be noticed, now, so we would take some fish off of the lines, and cook up a hot breakfast. And afterwards we would watch the lonesomeness of the river, and kind of lazy along, and by and by lazy off to sleep. Wake up, by and by, and look to see what done it, and maybe see a steamboat, coughing along up stream, so far off towards the other side you couldn't tell nothing about her only whether she was stern-wheel or side-wheel; then for about an hour there wouldn't be nothing to hear nor

Leah Balcham, *Boating*, n.d.
Spencer Museum of Art / University of Kansas, WPA gift.

nothing to see—just solid lonesomeness. Next you'd see a raft sliding by, away off yonder, and maybe a galoot on it chopping, because they're most always doing it on a raft; you'd see the ax flash, and come down—you don't hear nothing; you see that ax go up again, and by the time it's above the man's head, then you hear the *k'chunk!*—it had took all that time to come over the water. So we would put in the day, lazying around, listening to the stillness. Once there was a thick fog, and the rafts and things that went by was beating tin pans so the steamboats wouldn't run over them. A scow or a raft went by so close we could hear them talking and cussing and laughing—heard them plain; but we couldn't see no sign of them; it made you feel crawly; it was like spirits carrying on that way in the air. Jim said he believed it was spirits; but I says:

"No; spirits wouldn't say, 'Dern the dern fog.'"

Soon as it was night, out we shoved; when we got her out to about the middle, we let her alone, and let her float wherever the current wanted her to; then we lit the pipes, and dangled our legs in the water and talked about all kinds of things—we was always naked, day and night, whenever the mosquitoes would let us—the new clothes Buck's folks made for me was too good to be comfortable, and besides I didn't go much on clothes, nohow.

Sometimes we'd have that whole river all to ourselves for the longest time. Yonder was the banks and the islands, across the water; and maybe a spark—which was a candle in a cabin window—and sometimes on the water you could see a spark or two—on a raft or a scow, you know; and maybe you could hear a fiddle or a song coming over from one of them crafts. It's lovely to live on a raft. We had the sky, up there, all speckled with stars, and we used to lay on our backs and look up at them, and discuss about whether they was made, or only just happened—Jim he allowed they was made, but I allowed they happened; I judged it would have took too long to *make* so many. Jim said the moon could 'a' *laid* them; well, that looked kind of reasonable, so I didn't say nothing against it, because I've seen a frog lay most as many, so of course it could be done. We used to watch the stars that fell, too, and see them streak down. Jim allowed they'd got spoiled and was hove out of the nest.

Once or twice of a night we would see a steamboat slipping along in the dark, and now and then she would belch a whole world of sparks up out of her chimbleys, and they would rain down in the river and look awful pretty; then she would turn a corner and her lights would wink out and her pow-wow shut off and leave the river still again; and by and by her waves would get to us, a long time after she was gone, and joggle the raft a bit, and after that you wouldn't hear nothing for you couldn't tell how long, except maybe frogs or something.

[1889] EXCERPT *from*

History of the Johnstown Flood

Willis Fletcher Johnson

The Johnstown Flood of 1889 remains, with the great fire of Chicago and the earthquake that leveled San Francisco, one of the most remembered tragedies in American history. Yet while the flood was caused by higher than average rainfall that year, it was no natural occurrence: the torrent that overwhelmed the town took place because an earthen dam built to create a recreational lake for an exclusive club could not contain the water in the Conemaugh Lake Reservoir. When the dam broke, and the rush of waters transformed Johnstown in minutes into a sodden graveyard with fires burning out of control from exploding gas tanks, the destruction was unimaginable.

As one of the surviving lithographs reveals, at one moment houses—some with their occupants inside—washed downstream, piled up against a bridge, and the entire mass caught fire even as the water swirled around the conflagration. Willis Fletcher Johnson (1857–1931) was not a famous American author. But he wrote perhaps the first "history" of the event, telling it with an immediacy that only witnesses could grasp. His work is testimony to the folly of trying to control watersheds with inadequate resources and indifference to downstream residents.

The course of the torrent from the broken dam at the foot of the lake to Johnstown is almost eighteen miles, and with the exception of one point, the water passed through a narrow V-shaped valley. Four miles below the dam lay the town of South Fork, where the South Fork itself empties into the Conemaugh river. The town contained about 2000 inhabitants. About four-fifths of it has been swept away. Four miles further down on the Conemaugh river, which runs parallel with the main line of the Pennsylvania Railroad, was the town of Mineral Point. It had 800 inhabitants, 90 per cent of the houses being on a flat and close to the river. Terrible as it may seem, very few of them have escaped. Six miles further down was the town of Conemaugh, and here alone there was a topographical possibility—the spreading of the flood and the breaking of its force. It contained 2500 inhabitants, and has been almost wholly devastated. Woodvale, with 2000

people, lay a mile below Conemaugh in the flat, and one mile further down were Johnstown and its suburbs—Cambria City and Conemaugh borough, with a population of 30,000. On made ground, and stretched along right at the river's verge, were the immense iron works of the Cambria Iron and Steel Company, who have $5,000,000 invested in their plant. Besides this there are many other large industrial establishments on the bank of the river.

The stream of human beings that was swept before the angry floods was something most pitiful to behold. Men, women and children were carried along frantically shrieking for help, but their cries availed them nothing. Rescue was impossible. Husbands were swept past their wives, and children were borne along, at a terrible speed, to certain death, before the eyes of their terrorized and frantic parents. Houses, outbuildings, trees and barns were carried on the angry flood of waters as so much chaff. Cattle standing in the field were overwhelmed, and their carcasses strewed the tide. The railroad tracks converging on the town were washed out, and wires in all directions were prostrated.

Down through the Packsaddle came the rushing waters. Clinging to improvised rafts, constructed in the death battle from floating boards and timbers, were agonized men, women and children, their heartrending shrieks for help striking horror to the breasts of the onlookers. Their cries were of no avail. Carried along at a railway speed on the breast of this rushing torrent, no human ingenuity could devise a means of rescue.

It is impossible to describe briefly the suddenness with which the disaster came. A warning sound was heard at Conemaugh a few minutes before the rush of water came, but it was attributed to some meteorological disturbance, and no trouble was borrowed because of the thing unseen. As the low, rumbling noise increased in volume, however, and came nearer, a suspicion of danger began to force itself even upon the bravest, which was increased to a certainty a few minutes later, when, with a rush, the mighty stream spread out in width, and when there was no time to do anything to save themselves. Many of the unfortunates were whirled into the middle of the stream before they could turn around; men,

women and children were struggling in the streets, and it is thought that many of them never reached Johnstown, only a mile or two below.

At Johnstown a similar scene was enacted, only on a much larger scale. The population is greater and the sweeping whirlpool rushed into a denser mass of humanity. The imagination of the reader can better depict the spectacle than the pen of the writer can give it. It was a twilight of terror, and the gathering shades of evening closed in on a panorama of horrors that has few parallels in the history of casualties.

When the great wave from Conemaugh lake, behind the dam, came down the Conemaugh Valley, the first obstacle it struck was the great viaduct over the South Fork. This viaduct was a State work, built to carry the old Portage road across the Fork. The Pennsylvania Railroad parallels the Portage road for a long distance, and runs over the Fork. Besides sweeping the viaduct down, the bore, or smaller bores on its wings, washed out the Portage road for miles. One of the small bores went down the bed of a brook which comes into the Conemaugh at the village of South Fork, which is some distance above the viaduct. The big bore backed the river above the village. The small bore was thus checked in its course and flowed into the village.

The obstruction below removed, the backed-up water swept the village of South Fork away. The flood came down. It moved steadily, but with a velocity never yet attained by an engine moved by power controllable by man. It accommodated itself to the character of the breaks in the hill. It filled every one, whether narrow or broad. Its thrust was sideways and downward as well as forward. By side thrusts it scoured every cave and bend in the line of the mountains, lessening its direct force to exert power laterally, but at the same time moving its centre straight on Johnstown. It is well to state that the Conemaugh river is tortuous, like most streams of its kind. Wherever the mountains retreat, flats make out from them to the channel of the stream. It was on such flats that South Fork and Mineral Point villages and the boroughs of Conemaugh, Franklin, Woodvale, East Conemaugh and Johnstown were built.

OPPOSITE: Artist's rendition of the Johnstown Flood, 1889. The Johnstown Area Heritage Association.

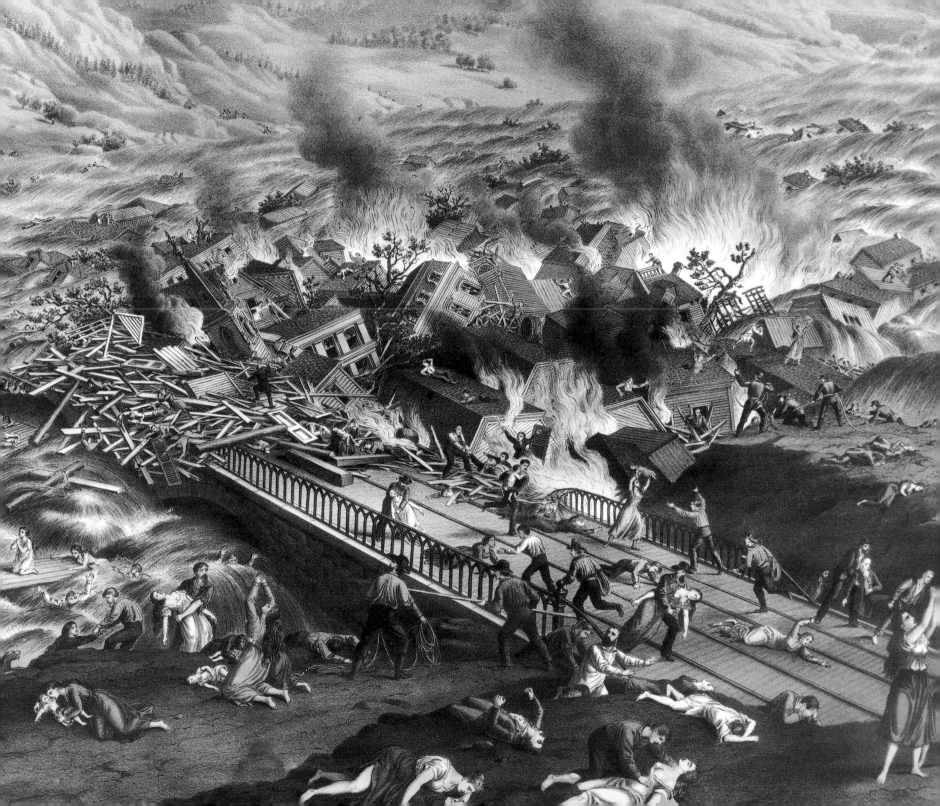

After emerging from the South Fork, with the ruins of the great viaduct in its maw, it swept down a narrow valley until just above the village of Mineral Point. There it widened, and, thrusting its right wing into the hollow where the village nestled, it swept away every house on the flat. These were soon welded into a compact mass, with trees and logs and general drift stuff. This mass followed the bore. What the bore could not budge, its follower took up and carried.

The first great feat at carrying and lifting was done at East Conemaugh. It tore up every building in the yard of the Pennsylvania Railroad. It took locomotives and carried them down and dug holes for their burials. It has been said that the flood had a downward thrust. There was proof of this on the banks of the river, where there was a sort of breakwater of concreted cinders, slag, and other things, making a combination harder than stone. Unable to get a grip directly on these banks, the flood jumped over them, threw the whole weight of the mass of logs and broken buildings down on the sand behind them, scooped this sand out, and then, by backward blows, knocked the concrete to pieces. In this it displayed almost the uttermost skill of human malice.

After crossing the flat of East Conemaugh and scooping out of their situations sixty-five houses in two streets, as well as tearing passenger trains to pieces, drowning an unknown number of persons, and picking up others to dash against whatever obstacles it encountered, it sent a force to the left, which cut across the flat of Franklin borough, ripped thirty-two houses to pieces, and cut a second channel for the Conemaugh river, leaving an island to mark the place of division of the forces of the flood. The strength of the eastern wing can be estimated from the fact that the iron bars piled in heaps in the stock yard of the Cambria Iron Company were swept away, and that some of them may be found all along the river as far as Johnstown.

After this came the utter wiping out of the borough of Woodvale, on the flat to the northeast of Johnstown and diagonally opposite it. Woodvale had a population of nearly 3000 people. It requires a large number of houses to shelter so many. Estimating 10 to a family, which is a big estimate, there were 300 houses in Woodvale. There were also a woolen mill, a flour mill, the Gautier Barb Wire Mills of the Cambria Iron Company, and the tannery of W. H. Rosenthal & Co. Only the flour mill and the middle section of the bridge remain. The flat is bare otherwise. The stables of the Woodvale Horse Railroad Company went out with the water; every horse and car in them went also.

The change was wrought in five minutes. Robert Miller, who lost two of his children and his mother-in-law, thus describes the scene: "I was standing near the Woodvale Bridge, between Maple avenue and Portage street, in Johnstown. The river was high, and David Lucas and I were speculating about the bridges, whether they would go down or not. Lucas said, 'I guess this bridge will stand; it does not seem to be weakened.' Just then we saw a dark object up the river. Over it was a white mist. It was high and somehow dreadful, though we could not make it out. Dark smoke seemed to form a background for the mist. We did not wait for more. By instinct we knew the big dam had burst and its water was coming upon us. Lucas jumped on a car horse, rode across the bridge, and went yelling into Johnstown. The flood overtook him, and he had to abandon his horse and climb a high hill.

"I went straight to my house in Woodvale, warning everybody as I ran. My wife and mother-in-law were ready to move, with my five children, so we went for the hillside, but we were not speedy enough. The water had come over the flat at its base and cut us off. I and my wife climbed into a coal car with one of the children, to get out of the water. I put two more children into the car and looked around for my other children and my mother-in-law. My mother-in-law was a stout woman, weighing about two hundred and twelve pounds. She could not climb into a car. The train was too long for her to go around it, so she tried to crawl under, leading the children.

"The train was suddenly pushed forward by the flood, and she was knocked down and crushed, so were my children, by the same

shock. My wife and children in the car were thrown down and covered with coal. I was taken off by the water, but I swam to the car and pulled them from under a lot of coal. A second blow to the train threw our car against the hillside and us out of it to firm earth. I never saw my two children and mother-in-law after the flood first struck the train of coal cars. I have often heard it said that the dam might break, but I never paid any attention to it before. It was common talk whenever there was a freshet or a big pack of ice."

The principal street of Woodvale was Maple avenue. The Conemaugh river now rushes through it from one side of the flat to the other. Its pavement is beautifully clean. It is doubtful that it will ever be cleared by mortal agency again.

Breaking down the barbed steel wire mill and the tannery at the bridge, the flood went across the regular channel of the river and struck the Gautier Steel Works, made up of numerous stanch brick buildings and one immense structure of iron, filled with enormous boilers, fly wheels, and machinery generally. The buildings are strewn through Johnstown. Near their sites are some bricks, twisted iron beams, boilers, wheels and engine bodies, bound together with logs, driftwood, tree branches, and various other things, woven in and out of one another marvelously. These aggregations are of enormous size and weight. They were not too strong for the immense power of the destroying agent, for a twenty-ton locomotive, taken from the Gautier Works, now lies in Main street, three-quarters of a mile away. It did not simply take a good grip upon them; it was spreading out its line for a force by its left wing, and hit simultaneously upon Johnstown flat, its people and houses, while its right wing did whatever it could in the way of helping the destructive work. The left wing scoured the flat to the base of the mountain. With a portion of the centre it then rushed across Stony creek. The remainder of the central force cleared several paths in diverging directions through the town.

While the left and centre were tearing houses to pieces and drowning untold lives, the right had been hurrying along the base of the northern hills, in the channel of the Conemaugh river,

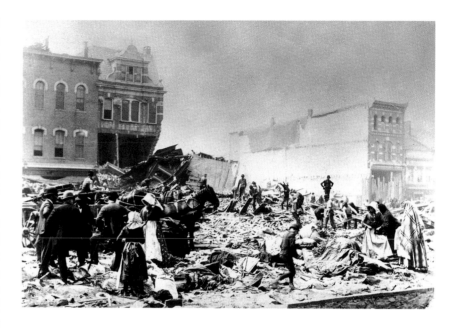

Cleaning up after the Johnstown Flood of 1889.
The Johnstown Area Heritage Association.

carrying down the houses, bridges, human beings and other drift that had been picked up on the way from South Fork.

Thus far the destruction at Johnstown had not been one-quarter what it is now. But the bed of the Conemaugh beyond Johnstown is between high hills that come close together. The cut is bridged by a viaduct. The right wing, with its plunder, was stopped by the bridge and the bend. The left and centre came tearing down Stony creek. There was a collision of forces. The men, women, children, horses, other domestic animals, houses, bridges, railroad cars, logs and tree branches were jammed together in a solid mass, which only dynamite can break up. The outlet of Stony creek was almost completely closed and the channel of the Conemaugh was also choked. The water in both surged back. In Stony creek it went along the curve of the base of the hill in front of which Kernville is built. Dividing its strength, one part of the flood went up Stony creek a short distance and moved around again into Johnstown. It swept before it many more houses than before and carried them around in a circle, until they met and crashed against other houses, torn from the point of Johnstown flat by a similar wave moving in a circle from the Conemaugh.

The two waves and their burdens went around and around in slowly-diminishing circles, until most of the houses had been ground to pieces. There are living men, women and children who circled in these frightful vortices for an hour. Lawyer Rose, his wife, his two brothers and his two sisters are among those. They were drawn out of their house by the suction of the retreating water, and thus were started on a frightful journey. Three times they went from the Kernville side of the creek to the centre of the Johnstown flat and past their own dwelling. They were dropped at last on the Kernville shore. Mr. Rose had his collar bone broken, but the others were hurt only by fright, wetting and some bruises.

Some of the back water went up the creek and did damage at Grubtown and Hornerstown. More of it, following the line of the mountain, rushed in at the back of Kernville. It cut a clear path for itself from the lower end of the village to the upper end, diagonally opposite, passing through the centre. It sent little streams to topple homes over in side places and went on a round trip into the higher part of Johnstown, between the creek and the hill. It carried houses from Kernville to the Johnstown bank of the creek, and left them there. Then it coursed down the bank, overturning trains of the Baltimore and Ohio railroad, and also houses, and keeping on until it had made the journey several times.

How so marvelous a force was exerted is illustrated in the following statement from Jacob Reese, of Pittsburg, the inventor of the basic process for manufacturing steel. Mr. Reese says:—

"When the South Fork dam gave way, 16,000,000 tons of water rushed down the mountain side, carrying thousands of tons of rocks, logs and trees with it. When the flood reached the Conemaugh Valley it struck the Pennsylvania Railroad at a point where they make up the trains for ascending the Allegheny Mountains. Several trains with their locomotives and loaded cars were swept down the valley before the flood wave, which is said to have been fifty feet high. Cars loaded with iron, cattle, and freight of all kinds, with those mighty locomotives, weighing from seventy to one hundred tons each, were pushed ahead of the flood, trucks and engines rolling over and over like mere toys.

"Sixteen million tons of water gathering fences, barns, houses, mills and shops into its maw. Down the valley for three miles or more rushed this mighty avalanche of death, sweeping everything before it, and leaving nothing but death and destruction behind it. When it struck the railroad bridge at Johnstown, and not being able to force its way through that stone structure, the debris was gorged and the water dammed up fifty feet in ten minutes.

"This avalanche was composed of more than 100,000 tons of rocks, locomotives, freight cars, car trucks, iron, logs, trees and other material pushed forward by 16,000,000 tons of water falling 500 feet, and it was this that, sliding over the ground, mowed down the houses, mills, and factories as a mowing machine does a field of grain. It swept down with a roaring, crushing sound, at the rate of a mile a minute, and hurled 10,000 people into the jaws of death in less than half an hour. And so the people called it the avalanche of death."

The Conquest of Arid America

William E. Smythe

The American West does not get much rain. Or, to put that more precisely, vast stretches of the West get far less rain than the East, and fewer rivers cross the terrain. Yet the trans-Mississippi West beckoned Americans in the nineteenth century, and many rushed there seeking land when it was available. To succeed, those settlers needed water to irrigate their fields. They found their spokesman in William E. Smythe (1861–1922), arguably the greatest proponent of irrigation in American history. His faith that the West could be transformed from desert into farmland was evident in the arrogant title of his book, and the power of his vision was apparent in the ongoing attempts to siphon off the water of western rivers to support agribusiness.

The beauty of Damascus is the theme of poets. Speaking of this ancient capital an anonymous writer remarks that "the cause of its importance as a city in all the ages is easily seen as you approach it from the south. Miles before you see the mosques of the modern city the fountains of a copious and perennial stream spring from among the rocks and brushwood at the base of the Anti-Lebanon, creating a wide area about them, rich with prolific vegetation." He continues:

"These are the 'streams of Lebanon,' which are poetically spoken of in the Songs of Solomon, and the 'rivers of Damascus,' which Naaman, not unnaturally, preferred to all the 'waters of Israel.' This stream, with its many branches, is the inestimable treasure of Damascus. While the desert is a fortification round Damascus, the river, where the habitations of men must always have been gathered, as along the Nile, is its life.

"The city, which is situated in a wilderness of gardens of flowers and fruits, has rushing through its streets the limpid and refreshing current; nearly every dwelling has its fountain, and at night the lights are seen flashing on the waters that dash along from their mountain home. As you first view the city from one of the overhanging ridges you are prepared to excuse the Mohammedans for calling it the earthly paradise. Around the marble minarets, the glittering domes, and the white buildings, shining with ivory softness, a maze of bloom and fruitage—where olive and pomegranate, orange and apricot, plum and walnut, mingle their varied tints of green—is presented to the sight, in striking contrast to the miles of barren desert over which you have just ridden."

This is the miracle of irrigation in the Syrian desert. It is no more miraculous in that far-eastern country than in our own West. Nor is Damascus more beautiful than Denver, Salt Lake City, or

than any one of a score of modern towns in California. But because Damascus is ancient and historic, and looks down on mankind from the biblical past, it possesses a degree of interest with which it is difficult to invest much better and more important places of our own country and our own time. It is well, then, to remember that not only the beauty of Damascus, but the glories of the Garden of Eden itself, were products of irrigation. "A river went out of Eden to water the Garden," says the Bible story.

No consideration of the subject can be appreciative when it starts with the narrow view that irrigation is merely an adjunct to agriculture. It is a social and industrial factor, in a much broader sense. It not only makes it possible for a civilization to rise and flourish in the midst of desolate wastes; it shapes and colors that civilization after its own peculiar design. It is not merely the life-blood of the field, but the source of institutions. These wider and more subtle influences are difficult to define in abstract terms, but we may trace them clearly through the history of various communities which have grown up in conformity with these conditions.

The essence of the industrial life which springs from irrigation is its democracy. The first great law which irrigation lays down is this: There shall be no monopoly of land. This edict it enforces by the remorseless operation of its own economy. Canals must be built before water can be conducted upon the land. This entails expense, either of money or of labor. What is expensive cannot be had for naught. Where water is the foundation of prosperity it becomes a precious thing, to be neither cheaply acquired not wantonly wasted. Like a city's provisions in a siege, it is a thing to be carefully husbanded, to be fairly distributed according to men's needs, to be wisely expended by those who receive it. For these reasons men cannot acquire as much irrigated land, even from the public domain, as they could acquire where irrigation was unnecessary. It is not only more difficult to acquire in large bodies, but yet more difficult to retain. A large farm under irrigation is a misfortune; a great farm, a calamity. Only the small farm pays. But this small farm blesses its proprietor with industrial independence and crowns him with social equality. That is democracy.

Industrial independence is, in simplest terms, the guarantee of subsistence from one's own labors. It is the ability to earn a living under conditions which admit of the smallest possible element of doubt with the least possible dependence upon others. Irrigation fully satisfies this definition.

The canal is an insurance policy against loss of crops by drought, while aridity is a substantial guarantee against injury by flood. Of all the advantages of irrigation, this is the most obvious. Scarcely less so, however, is its compelling power in the matter of production. Probably there is no spot of land in the United States where the average crop raised by dependence upon rainfall might not be doubled by intelligent irrigation. The rich soils of the arid region produce from four to ten times as largely with irrigation as the soil of the humid region without it. As the measure of value is not area, but productive capacity, twenty acres in the Far West should equal one hundred acres elsewhere. Such is the actual fact.

A little further on we shall see that not merely the quantity of crops, but their quality as well, responds to the influence of irrigation. We shall see how this art favors the production of the wide diversity of products required for a generous living. Certainty, abundance, variety—all this upon an area so small as to be within the control of a single family through its own labor—are the elements which compose industrial independence under irrigation. The conditions which prevail where irrigation is not necessary— large farms, hired labor, a strong tendency to the single crop—are here reversed. Intensive cultivation and diversified production are inseparably related to irrigation. These constitute a system of industry the fruit of which is a class of small landed proprietors resting upon a foundation of economic independence.

This is the miracle of irrigation on its industrial side.

As a factor in the social life of the civilization it creates, irrigation is no less influential and beneficent. Compared with the familiar conditions of country life which we have known in the East and central West, the change which irrigation brings amounts to a revolution. The bane of rural life is its loneliness. Even food, shelter, and provision for old age do not furnish protection against social discontent where the conditions deny the advantages which flow

LEFT: William Henry Jackson, *Moraines on Clear Creek, Valley of the Arkansas, Colorado*, 1873.
RIGHT: Mark Klett and JoAnn Verburg, *Clear Creek Reservoir, Colorado*, 1977.
Left: Spencer Museum of Art / University of Kansas, gift of Sam and Terry Evans.
Right: Spencer Museum of Art / University of Kansas, with permission of Mark Klett for the Rephotographic Survey Project.

from human association. Better a servant in the town than a proprietor in the country!—such has been the verdict of recent generations who have grown up on the farm and left it to seek satisfaction for their social instincts in the life of the town. The starvation of the soul is almost as real as the starvation of the body.

Irrigation compels the adoption of the small-farm unit. This is the germ of new social possibilities, and we shall see to what extent they have already been realized as we proceed. During the first and second eras of colonization in this country the favorite size for a farm was about four hundred acres, of which from a fourth to a half was gradually cleared and the rest retained in woodland. The Mississippi Valley was settled mostly in quarter-sections, containing one hundred and sixty acres each. The productive capacity of

land is so largely increased by irrigation, and the amount which one family can cultivate by its own labor consequently so much reduced, that the small-farm unit is a practical necessity in the arid region.

Where settlement has been carried out upon the most enlightened lines irrigated farms range from five to twenty acres upon the average, rarely exceeding forty acres at the maximum. It is perfectly obvious, of course, that a twenty-acre unit means that neighbors will be eight times as numerous as in a country settled up in quarter-sections—that where farms are ten acres in size neighbors will be multiplied by sixteen. Thus in its most elementary aspect the society of the arid region differs materially from that of a country of large farms. Eight or sixteen families upon a quarter-section are

much better than no neighbors at all, but irrigation goes further than this in revolutionizing the social side of rural life.

A very-small-farm unit makes it possible for those who till the soil to live in the town. The farm village, or home centre, is a well-established feature of life in Arid America, and a feature which is destined to enjoy wide and rapid extension. Each four or five thousand acres of cultivated land will sustain a thrifty and beautiful hamlet, where all the people may live close together and enjoy most of the social and educational advantages within the reach of the best eastern town. Their children will have kindergartens as well as schools, and public libraries and reading-rooms as well as churches. The farm village, lighted by electricity, furnished with domestic water through pipes, served with free postal delivery, and supplied with its own daily newspapers at morning and evening, has already been realized in Arid America. The great cities of the western valleys will not be cities in the old sense, but a long series of beautiful villages, connected by lines of electric motors, which will move their products and people from place to place. In this scene of intensely cultivated land, rich with its bloom and fruitage, with its spires and roofs, and with its carpets of green and gold stretching away to the mountains, it will be difficult for the beholder to say where the town ends and the country begins.

This is the miracle of irrigation upon its social side.

Irrigation is the foundation of truly scientific agriculture. Tilling the soil by dependence upon rainfall is, by comparison, like a stage-coach to the railroad, like the tallow dip to the electric light. The perfect conditions for scientific agriculture would be presented by a place where it never rained, but where a system of irrigation furnished a never-failing water supply which could be adjusted to the varying needs of different plants. It is difficult for those who have been in the habit of thinking of irrigation as merely a substitute for rain to grasp the truth that precisely the contrary is the case. Rain is the poor dependence of those who cannot obtain the advantages of irrigation. The western farmer who has learned to irrigate thinks it would be quite as illogical for him to leave the watering of his potato-patch to the caprice of the clouds as for the housewife to defer her wash-day until she could catch rain-water in her tubs.

The supreme advantage of irrigation consists not more in the fact that it assures moisture regardless of the weather than in the fact that it makes it possible to apply that moisture just when and just where it is needed. For instance, on some cloudless day the strawberry-patch looks thirsty and cries for water through the unmistakable language of its leaves. In the Atlantic States it probably would not rain that day, such is the perversity of nature, but if it did it would rain alike on the just and unjust—on the strawberries, which would be benefited by it, and on the sugar-beets, which crave only the uninterrupted sunshine that they may pack their tiny cells with saccharine matter. In the arid region there is practically no rain during the growing season. Thus the scientific farmer sends the water from his canal through the little furrows which divide the lines of strawberry plants, but permits the water to go singing past his field of beets.

Plants and trees require moisture as well as sunshine and soil, and for three reasons: first, that the tiny roots may extract the chemical qualities from the soil; then, that there may be sap and juice; finally, that there may be moisture to evaporate or transpire from the leaves. But while all plant-life requires moisture, all kinds of it do not require the same amount, nor do they desire to receive it at the same time and in the same manner. Just as the skilful teacher studies the individualities of fifty different boys, endeavoring to discover how he may most wisely vary his methods to obtain the best results from each, so the scientific farmer studies his fifty different plants or trees and adjusts his artificial "rainfall" in the way which will produce the highest outcome. With the aid of colleges, experimental farms, and country institutes, wonderful progress has been made along these lines in recent years. This progress will continue until the agriculture and horticulture practiced on the little farms of Arid America shall match the marvelous results won by research and inventive genius in every other field of human endeavor.

This is the miracle of irrigation upon its scientific side.

OPPOSITE: William Sanger, *Bridge from Brooklyn*, n.d. Spencer Museum of Art/University of Kansas, WPA gift.

The Twentieth Century

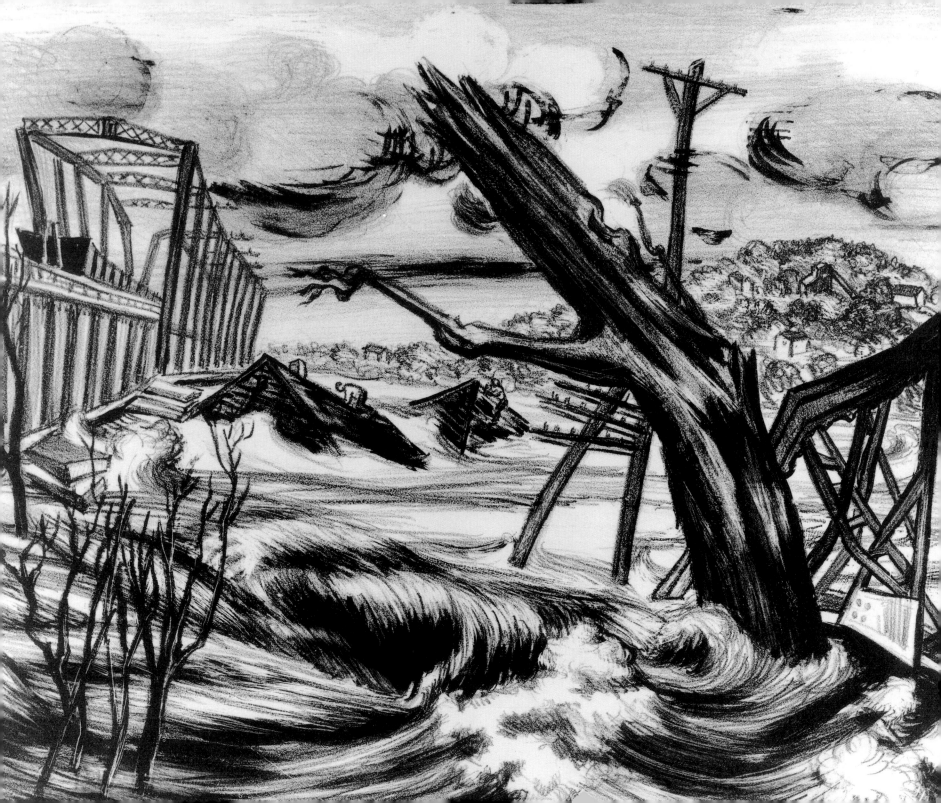

[1910] EXCERPT *from*

The River and I

John G. Neihardt

John Neihardt (1881–1973) grew up along the shores of the Missouri River. That fact hardly makes him distinct. But unlike many Americans who grow up near rivers, Neihardt used his literary skills to write one of the most personal accounts of any individual's relationship to a particular river. Neihardt was certainly wide-ranging; during his life he was both Poet Laureate of the state of Nebraska and an adopted Oglala Sioux. He is best known today for Black Elk Speaks *(1932), his account of an Oglala medicine man's life story. In this passage entitled "The River of an Unwritten Epic," Neihardt demonstrates the links between the life of an individual and that of a river.*

The River of an Unwritten Epic

It was Carlyle—was it not?—who said that all great works pro–duce an unpleasant impression, on first acquaintance. It is so with the Missouri River. Carlyle was not, I think, speaking of rivers; but he was speaking of masterpieces—and so am I.

It makes little difference to me whether or not an epic goes at a hexameter gallop through the ages, or whether it chooses to be a flood of muddy water, ripping out a channel from the mountains to the sea. It is merely a matter of how the great dynamic force shall express itself.

I have seen trout streams that I thought were better lyrics than I or any of my fellows can ever hope to create. I have heard the moaning of rain winds among mountain pines that struck me as being equal, at least, to *Adonais*. I have seen the solemn rearing of a mountain peak into the pale dawn that gave me a deep religious appreciation of my significance in the Grand Scheme, as though I had heard and understood a parable from the holy lips of an Avatar.

OPPOSITE: Jacob Kainen, *Flood*, n.d. Spencer Museum of Art/University of Kansas, WPA gift.

And the vast plains of my native country are as a mystic scroll unrolled, scrawled with a cabalistic writ of infinite things.

In the same sense, I have come to look upon the Missouri as more than a river. To me, it is an epic. And it gave me my first big boy dreams. It was my ocean. I remember well the first time I looked upon my turbulent friend, who has since become as a brother to me. It was from a bluff at Kansas City. I know I must have been a very little boy, for the terror I felt made me reach up to the saving forefinger of my father, lest this insane devil-thing before me should suddenly develop an unreasoning hunger for little boys. My father seemed as tall as Alexander—and quite as courageous. He seemed to fear it almost not at all. And I should have felt little surprise had he taken me in his arms and stepped easily over that mile or so of liquid madness. He talked calmly about it—quite calmly. He explained at what angle one should hold one's body in the current, and how one should conduct one's legs and arms in the whirlpools, providing one should swim across.

Swim across! Why, it took a giant even to talk that way! For the summer had smitten the distant mountains, and the June floods ran. Far across the yellow swirl that spread out into the wooded bottom-lands, we watched the demolition of a little town. The siege had reached the proper stage for a sally, and the attacking forces were howling over the walls. The sacking was in progress. Shacks, stores, outhouses, suddenly developed a frantic desire to go to St. Louis. It was a weird retreat in very bad order. A cottage with a garret window that glared like the eye of a Cyclops, trembled, rocked with the athletic lift of the flood, made a panicky plunge into a convenient tree; groaned, dodged, and took off through the brush like a scared cottontail. I felt a boy's pity and sympathy for those houses that got up and took to their legs across the yellow waste. It did not seem fair. I have since experienced the same feeling for a jack-rabbit with the hounds a-yelp at its heels.

But—to *swim* this thing! To fight this cruel, invulnerable, restless giant that went roaring down the world with a huge uprooted oak tree in its mouth for a toothpick! This yellow, sinuous beast with hellbroth slavering from its jaws! This daredevil-boy-god that saun-

tered along with a town in its pocket, and a steepled church under its arm for a moment's toy! Swim this?

For days I marvelled at the magnificence of being a fullgrown man, unafraid of big rivers.

But the first sight of the Missouri River was not enough for me. There was a dreadful fascination about it—the fascination of all huge and irresistible things. I had caught my first wee glimpse into the infinite; I was six years old.

Many a lazy Sunday stroll took us back to the river; and little by little the dread became less, and the wonder grew—and a little love crept in. In my boy heart I condoned its treachery and its giant sins. For, after all, it sinned through excess of strength, not through weakness. And that is the eternal way of virile things. We watched the steamboats loading for what seemed to me far distant ports. (How the world shrinks!) A double stream of "roosters" coming and going at a dog-trot rushed the freight aboard; and at the foot of the gang-plank the mate swore masterfully while the perspiration dripped from the point of his nose.

And then—the raucous whistles blew. They reminded me of the lions roaring at the circus. The gang-plank went up, the hawsers went in. The snub nose of the steamer swung out with a quiet majesty. Now she feels the urge of the flood, and yields herself to it, already dwindled to half her size. The pilot turns his wheel—he looks very big and quiet and masterful up there. The boat veers round; bells jangle. And now the engine wakens in earnest. She breathes with spurts of vapor!

Breathed? No, it was sighing; for about it all clung an inexplicable sadness for me—the sadness that clings about all strong and beautiful things that must leave their moorings and go very, very far away. (I have since heard it said that river boats are not beautiful!) My throat felt as though it had smoke in it. I felt that this queenly thing really wanted to stay; for far down the muddy swirl where she dwindled, dwindled, I heard her sobbing hoarsely.

Off on the perilous flood for "faerie lands forlorn"! It made the world seem almost empty and very lonesome.

And then the dog-days came, and I saw my river tawny, sinewy,

gaunt—a half-starved lion. The long dry bars were like the protruding ribs of the beast when the prey is scarce, and the ropy main current was like the lean, terrible muscles of its back.

In the spring it had roared; now it only purred. But all the while I felt in it a dreadful economy of force, just as I have since felt it in the presence of a great lean jungle-cat at the zoo. Here was a thing that crouched and purred—a mewing but terrific thing. Give it an obstacle to overcome—fling it something to devour; and lo! the crushing impact of its leap!

And then again I saw it lying very quietly in the clutch of a bitter winter—an awful hush upon it, and the white cerement of the snow flung across its face. And yet, this did not seem like death; for still one felt in it the subtle influence of a tremendous personality. It slept, but sleeping it was still a giant. It seemed that at any moment the sleeper might turn over, toss the white cover aside and, yawning, saunter down the valley with its thunderous seven-league boots. And still, back and forth across this heavy sleeper went the pigmy wagons of the farmers taking corn to market!

But one day in March the far-flung arrows of the geese went over. Honk! honk! A vague, prophetic sense crept into the world out of nowhere—part sound, part scent, and yet too vague for either. Sap seeped from the maples. Weird mist-things went moaning through the night. And then, for the first time, I saw my big brother win a fight!

For days, strange premonitory noises had run across the shivering surface of the ice. Through the foggy nights, a muffled intermittent booming went on under the wild scurrying stars. Now and then a staccato crackling ran up the icy reaches of the river, like the sequent bickering of Krags down a firing line. Long seams opened in the disturbed surface, and from them came a harsh sibilance as of a line of cavalry unsheathing sabres.

But all the while, no show of violence—only the awful quietness with deluge potential in it. The lion was crouching for the leap.

Then one day under the warm sun a booming as of distant big guns began. Faster and louder came the dull shaking thunders, and passed swiftly up and down, drawling into the distance. Fissures

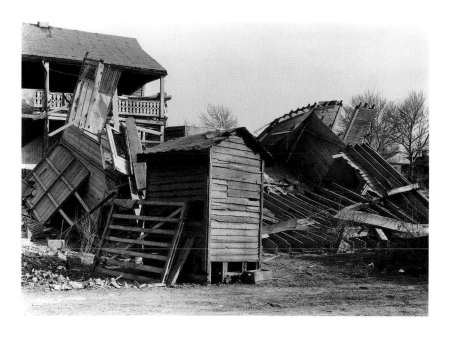

Flood damage at Shawneetown, Illinois, April 1937.
Library of Congress.

yawned, and the sound of the grumbling black water beneath came up. Here and there the surface lifted—bent—broke with shriekings, groanings, thunderings. And then—

The giant turned over, yawned and got to his feet, flinging his arms about him! Barriers formed before him. Confidently he set his massive shoulders against them—smashed them into little blocks, and went on singing, shouting, toward the sea. It was a glorious victory. It made me very proud of my big brother. And yet all the while I dreaded him—just as I dread the caged tiger that I long to caress because he is so strong and so beautiful.

Since then I have changed somewhat, though I am hardly as tall, and certainly not so courageous as Alexander. But I have felt the sinews of the old yellow giant tighten about my naked body. I have been bent upon his hip. I have presumed to throw against his Titan strength the craft of man. I have often swum in what seemed liquid madness to my boyhood. And we have become acquainted through battle. No friends like fair foes reconciled!

And I have lain panting on his bars, while all about me went the lisping laughter of my brother. For he has the strength of a god, the headlong temper of a comet; but along with these he has the glad, mad, irresponsible spirit of a boy. Thus ever are the epic things.

The Missouri is unique among rivers. I think God wished to teach the beauty of a virile soul fighting its way toward peace—and His precept was the Missouri. To me, the Amazon is a basking alligator; the Tiber is a dream of dead glory; the Rhine is a fantastic fairy-tale; the Nile a mummy, periodically resurrected; the Missis-sippi, a convenient geographical boundary line; the Hudson, an epicurean philosopher.

But the Missouri—my brother—is the eternal Fighting Man!

I love all things that yearn toward far seas: the singing Tenny-sonian brooks that flow by "Philip's farm" but "go on forever"; the little Ik Walton rivers, where one may "study to be quiet and go a-fishing"! the Babylonian streams by which we have all pined in captivity; the sentimental Danubes which we can never forget because of "that night in June"; and at a very early age I had already developed a decent respect for the verbose manner in which the "waters come down at Lodore."

But the Missouri is more than a sentiment—even more than an epic. It is the symbol of my own soul, which is, I surmise, not unlike other souls. In it I see flung before me all the stern world-old struggle become materialized. Here is the concrete represen-tation of the earnest desire, the momentarily frustrate purpose, the beating at the bars, the breathless fighting of the half-whipped but never-to-be-conquered spirit, the sobbing of the wind-broken runner, the anger, the madness, the laughter. And in it all the unwearying urge of a purpose, the unswerving belief in the peace of a far away ocean.

If in a moment of despair I should reel for a breathing space away from the fight, with no heart for battle-cries, and with only a desire to pray, I could do it in no better manner than to lift my arms above the river and cry out into the big spaces: "You who somehow understand—behold this river! It expresses what is voice-less in me. It prays for me!"

The Owens Valley—
Los Angeles Controversy

The explosive growth of the population of southern California in the early twentieth century, particularly around Los Angeles, led to one of the bitterest disputes over river water in American history. The issue was clear to those at the time: in a region that did not get sufficient rainfall to support the booming agribusinesses developing in California's Central Valley, where should water come from to irrigate fields and to support the people of Los Angeles? As these articles from newspapers in 1924 reveal, the crisis demonstrated the problems caused when there is insufficient water to meet the demands of everyone who needs it.

From the Los Angeles Times, *November 18, 1924*

THE AQUEDUCT CRISIS

A crisis was reached in the Owens River Valley water dispute on Sunday when 100 residents of the valley forcibly opened the Alabama waste gates of the Los Angeles Aqueduct five miles north of Lone Pine and turned practically the entire flow of the aqueduct into the bed of the Owens River, of water, while not imperiling the city's supply, is serious.

This illegal act was the climax of a conflict that started years ago, and in the last twelve months has assumed a more serious aspect. The ranchers of the Owens Valley declare that their farms and homes are being gradually destroyed by the various steps taken by Los Angeles in connection with the maintenance of an adequate water supply for the city. They bitterly resent the manner—to them harsh and confiscatory—in which this end has been attained.

On May 21 of this year the feeling culminated in the first overt

protest of violence when the ranchers dynamited a section of the aqueduct near Lone Pine, apparently not with the intention of inflicting serious damage on the city's property but to call public attention forcibly to the situation. A second lawless act, following further legal delays, was the kidnapping of a Los Angeles attorney, sent to Bishop to represent the city. He was sent away with a warning that he had better not return.

A commission of city officials and citizens visited the valley and listened to the farmers. They looked the situation over from a more or less neutral standpoint and made recommendations as a result of which the city formulated an offer to the ranchers. This proposition was fair enough from the city's standpoint, but was not acceptable to the ranchers. The next move was the "seizure" of the big ditch by the Owens Valley farmers on Sunday and an appeal by the sheriff of Inyo County to Governor Richardson for troops. This the Governor has wisely refused, pending developments to show that troops are actually necessary.

It is to be remembered that these farmers are not anarchists nor bomb-throwers but, in the main, honest, earnest hardworking American citizens who look upon Los Angeles as an octopus about to strangle out their lives. They have put themselves hopelessly in the wrong by taking the law into their own hands but that is not to say that there has not been a measure of justice on their side of the argument—so long as it remained an argument and not an appeal to dynamite and force.

It is to the hard work of such men as the ranchers of Owens River Valley that California largely owes its present wealth. It was such pioneers who by settling up the back country laid the foundation for rich and prosperous cities. Many of them were in the valley before the aqueduct was built. *Without water their homes are ruined*, their towns must be abandoned, their valley return to the desert. They must move elsewhere and start again. Under such conditions they are hardly to be blamed for seeking as high as possible a price for their lands and for resenting methods of acquisition by the city which, under other circumstances, would be merely businesslike.

The conflict between the city of Los Angeles and the ranchers of the Owens River Valley must be one between right and right, not between might and might. It must be settled on the principle of the greatest good to the greatest number with the proper safeguarding of the poorest as well as the wealthiest contestant. *For the city to use its immense power to gain an unfair advantage over the settlers in the Owens River Valley is as intolerable as for the settlers to resort to violence.*

If the city of Los Angeles needs all the water that flows from the melted snows of Mt. Whitney it is rich enough to compensate amply, *even generously, every rancher who will suffer by the transaction.* It is not a time to drive the hardest possible bargain. *The city can afford to be liberal in its settlement with these pioneers whose work of half a century it will undo.*

The present tactics of the ranchers are, from their own standpoint, the worst they could adopt. Lawless violence has never yet accomplished an enduring right and never will. The farmers complain with justice of the law's interminable delay in handing down equitable decisions on the legal points involved, declaring that in the meantime Los Angeles is draining the lifeblood of the valley. Yet it is only through disinterested adjudication of the issues, either by the courts or by a commission alike acceptable to the farmers and the city, that justice can be done.

The Times believes that the situation is susceptible to such a solution and that both sides would consent to such disinterested arbitration, agreeing to abide by the result.

In the meantime, The Times counsels moderation on both sides—a spirit of restraint on the part of the ranchers and one of generosity on that of the city. One more hot-headed mistake may precipitate a situation that will be a blot on our record for the rest of time. There are few differences which reasonable human beings can not compromise.

There must be no civil war in southern California.

From the Inyo Register, *December 4, 1924*

HOW A CITY'S MIGHT HAS PREVAILED FOR RUIN OF FARMING COMMUNITIES

Nearly Twenty Years Marked with Injustice— Even Government Functions Perverted for Los Angeles

A Summary of History of Noted Aqueduct. During Nearly Twenty Years City's Record Shows Bad Faith, Duplicity, to Win, Regardless of Right.

While a large number of extra copies of last week's issue were printed, they were not enough to meet the demand. The review of aqueduct history is therefore reprinted, and copies can be supplied while the extra supply of papers lasts.

Owens Valley has been in the limelight of publicity of late, because of the seizure of the Los Angeles Aqueduct spillway by citizens, a step designed to secure some sort of settlement of issues which have lasted nearly twenty years. Before entering into an explanation of the situation, it is well to have a view of the valley.

Bordered on the west by the highest of the Sierras, Owens Valley is roughly 100 miles long and of widths varying from eight to fifteen or more miles. It is watered by a score or so of mountain creeks, and by Owens River, which runs along its eastern side. The visitor entering from the south first reaches Lone Pine, surrounded by lands most of which have been bought by Los Angeles and which are reverting to primitive wastes. Next to the north is Manzanar, a large body of fine level land on which many orchards were thriving before Los Angeles bought the streams used for irrigation, but now doomed to destruction. A two-teacher school will next year have but seven pupils. Independence, the county seat, is no longer the central point for many fine farms; the ground is there, but from beneath it, the water is being forced by power pumps and from the surface the streams are being taken to pour into the Los Angeles Aqueduct. Camp Independence and Aberdeen are two or three miles and a dozen miles, respectively, beyond; Aberdeen is defending itself against ruinous subdrainage; the other is already in transition from productive acreage to the waste that ownership by Los Angeles has come to mean. Here and there along the way through the valley are other abandoned farms, decaying and neglected houses. Big Pine is next, its business men facing loss of all they have built because the city has bought the surrounding farms. Once fine orchards and splendid fields bordered the roadside, the trees dying, the fields destroyed for usefulness by the taking of their irrigation supply for the aqueduct. Across the valley spreads the blight of Los Angeles, until gradually the Bishop area is entered. Here many other farms and homes are doomed as elsewhere, but here also is the only section in which the city's influence is not predominant. And even here it is in one way predominant, for values and credit have largely been destroyed by the uncertainty of the future. In Bishop is found a thoroughly modern town of 1500 or more population, a $200,000 high school, said to be one of the three best in details west of Salt Lake City, and every advantage of many much larger places. And here is the center and strength of the antagonism to the course of Los Angeles domination.

This is but the merest sketch, omitting columns which might be told to give a right idea of the section which has been driven to defense of its rights. It is a valley of high productiveness, and which but for its plundering by Los Angeles would be supporting several times its present population. The population is American; no foreign element has colonized or invaded here. Intelligent, sound citizenship is the rule; education high in average. Fine school buildings are found from one end of the valley to the other—some of them, alas, doomed to be almost unused in the future. It has been said by observers that in Bishop more collegians are to be found than in nearly any other California town of equal size. Inyo has a

reading, studying people. Churches, fraternities and clubs are many. This is the class of people who lately seized the Los Angeles aqueduct; and appreciating these facts of population, a reasonable conclusion must be that "there's a reason."

One more fact is to be understood in considering the controversy between Los Angeles and Owens Valley, to wit: The city is not after more water for meeting its own corporate needs, but for irrigating lands nearer to its own borders, or taken within them in order to give the color of municipal use to such irrigation. It has water enough for every use that is legitimately a part of city government. Let that not be forgotten.

. . .

PATIENCE WAS NEARING ITS END. Promise after promise by the city has been broken and there has been no belief that a different policy would prevail so long as the present dynasty rules there. Thus came about the seizure of the Alabama Hills spillway. How many did it is unimportant—there were enough. They were but the representatives about whom immediately rallied a practically unanimous public sentiment. During the time of holding the gates, from 300 to 1000 persons were there daily, the men to watch if need be, the women to provide for them. The town of Bishop was practically closed for business purposes for three days while its business and professional men shared in the vigil with their farmer neighbors. When the Clearing House Association of Los Angeles promised to use its best effort for an immediate adjustment, the gates were closed, and the aqueduct current went on its way to Haiwee reservoir. But the concession to the promise was not made without argument; and it is more than probable that if the untruthful report printed in the Los Angeles Examiner of November 21st had been foreseen, the water would still be wasting into Owens River and lake.

The Inyo grand jury made an extended inquiry into the situation this fall, having before it statements from practically all the civic organizations of the valley. Its report condemned the methods of the city of Los Angeles, attributing the mental and financial evils existing to the "unfair acts and dealings of the Public Service Commission of the city of Los Angeles," and demanded a definite statement of policy of further actions toward Inyo County.

The city of Los Angeles has shrewdly done its work under color of lawful proceedings. It is horrified at the actions of men who invoke a law higher than the statutes, and its officials feel duty bound to mouth threats as to consequences to the disturbers. That is all sound and fury, signifying nothing. They knew better than to add fuel to the flame. They must talk to save their faces.

The same city, so shocked at a demonstration outside of written law, did not hesitate, or its agents did not, to dynamite an irrigation dam, nor did it hesitate, until rifles commanded a different course, to try to ruin a valley irrigation system as has already been mentioned. It drilled many wells to pump water from beneath and drain and ruin the lands of farmers whom it has not bought out. A sample of its regard for law and justice: The daughter of a pioneer Indian fighter lived on a tract she had inherited from her father, located over fifty years ago. It was watered from two creeks. There she and her husband spent most of their lives, and they and ten children won a living. The husband died. The city came along and bought adjoining places, but the widow did not wish to sell. Soon she found that she could not obtain water for irrigation; when the streams were turned upon her land, as for years, they were interfered with. The last year she remained there she could not get irrigation water enough to raise feed for one cow. Could she fight the city of Los Angeles? She sold, under this compulsion. "We have dealt fairly," say Mulholland and others. Just such samples of the city's fairness can be matched in many cases, differing only in details of meanness or pettiness of the paid agents.

"The Negro Speaks of Rivers"

Langston Hughes

Langston Hughes (1902–1967) was only twenty-four when he wrote "The Negro Speaks of Rivers." Born in Joplin, Missouri, Hughes worked at various jobs, including a stint as an assistant cook in Paris in 1924, before he became known as one of America's most gifted poets. Influenced by an eclectic group of writers—including Theodore Dreiser (1871–1945), Paul Laurence Dunbar (1872–1906), and Carl Sandburg (1878–1967)—Hughes's work, which included The Ways of White Folks *(1934) and the autobiographical* The Big Sea *(1940), had an enduring influence on American culture. Hughes began to reach a large audience when his poem "The Weary Blues" won a prize in 1926; thereafter he commented on the absurdities of racial prejudice in America more astutely than virtually any other writer of his generation.*

I've known rivers:
I've known rivers ancient as the world and older than the
 flow of human blood in human veins.

My soul has grown deep like the rivers.

I bathed in the Euphrates when dawns were young.
I built my hut near the Congo and it lulled me to sleep.
I looked upon the Nile and raised the pyramids above it.
I heard the singing of the Mississippi when Abe Lincoln went
 down to New Orleans, and I've seen its muddy bosom turn all
 golden in the sunset.

I've known rivers.
Ancient, dusky rivers.

My soul has grown deep like the rivers.

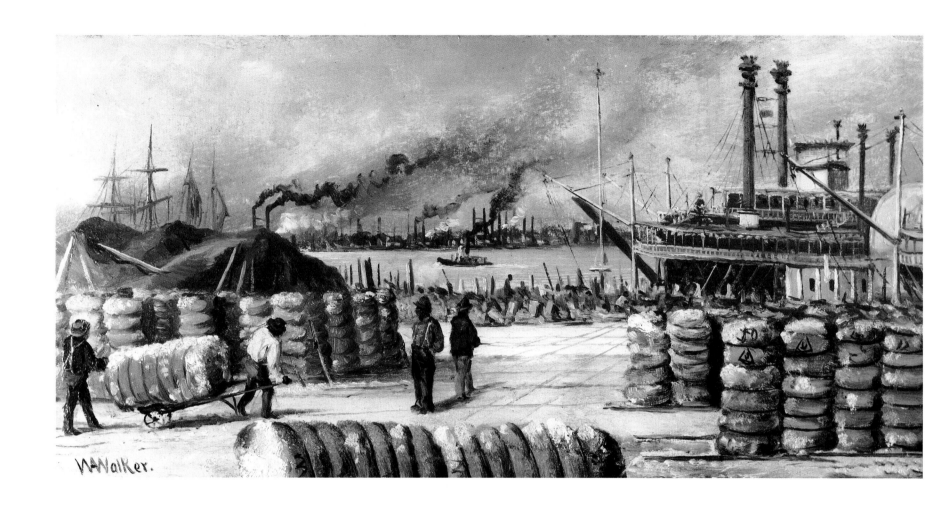

William Aiken Walker, *Loading Cotton, New Orleans*, n.d.
The Historic New Orleans Collection.

"Ol' Man River"

Oscar Hammerstein II

Oscar Hammerstein II (1895–1960), the playwright, wrote the libretto for Show Boat *(1927), one of the most compelling American musicals of the twentieth century. The grandson of the theatre- and opera-builder Oscar Hammerstein (1846–1919), the younger Hammerstein used the songs in* Show Boat, *particularly "Ol' Man River," to reveal the painful legacy of slavery in the American south.*

Colored folks work on de Mississippi,
Colored folks work while de white folks play,
Pullin' dose boats from de dawn to sunset,
Gittin' no rest till de judgment day.

Don't look up an' don't look down,
You don't dast make de white boss frown;
Bend yo' knees an' bow yo' head,
an' pull dat rope until yo're dead.

Let me go 'way from de Mississippi,
Let me go 'way from de white men boss,
Show me dat stream called de river Jordan,
Dat's de ol' stream dat I long to cross.

Ol' man river, dat ol' man river,
He must know sumpin', but don't say nothin',
He jus' keeps rollin', He keeps on rollin' along.

He don't plant 'taters, he don't plant cotton,
An' dem dat plants 'em is soon forgotten;
But ol' man river, he jus' keeps rollin' along.

You an' me, we sweat an' strain,
Body all achin' an' racked wid pain.
"Tote dat barge!" "Lift dat bale,"
Git a little drunk an' you land in jail.

Ah gits weary an' sick of tryin',
Ah'm tired of livin' an' skeered of dyin',
But ol' man river, he jus' keeps rollin' along.

Frederic Edwin Church, *Twilight, "Short Arbiter 'Twixt Day and Night,"* 1850.
The Newark Museum, Purchase 1956, Wallace M. Scudder Bequest Fund.

"West-running Brook"

Robert Frost

Few poets in twentieth-century America ever received the reception offered to Robert Frost (1874–1963). Born in California, Frost moved to New England with his family after the death of his father, when he was eleven. That he spent most of his life in the northeast comes as no surprise to anyone who has read his poetry; virtually all of his work dwells on the region. By reading Frost we come into contact with a poet who possessed a brilliant sense of language and imagery. What he said of poetry in general fits his work well: a poem "begins in delight, and ends in wisdom."

'Fred, where is north?'
 'North? North is there, my love.
The brook runs west.'
 'West-running Brook then call it.'
(West-running Brook men call it to this day.)
'What does it think it's doing running west
When all the other country brooks flow east
To reach the ocean? It must be the brook
Can trust itself to go by contraries
The way I can with you—and you with me—
Because we're—we're—I don't know what we are.
What are we?'
 'Young or new?'
 'We must be something.
We've said we two. Let's change that to we three.
As you and I are married to each other,
We'll both be married to the brook. We'll build
Our bridge across it, and the bridge shall be

Our arm thrown over it asleep beside it.
Look, look, it's waving to us with a wave
To let us know it hears me.'
 'Why, my dear,
That wave's been standing off this jut of shore—'
(The black stream, catching on a sunken rock,
Flung backward on itself in one white wave,
And the white water rode the black forever,
Not gaining but not losing, like a bird
White feathers from the struggle of whose breast
Flecked the dark stream and flecked the darker pool
Below the point, and were at last driven wrinkled
In a white scarf against the far shore alders.)
'That wave's been standing off this jut of shore
Ever since rivers, I was going to say,
Were made in heaven. It wasn't waved to us.'

'It wasn't, yet it was. If not to you
It was to me—in an annunciation.'

'Oh, if you take it off to lady-land,
As't were the country of the Amazons
We men must see you to the confines of
And leave you there, ourselves forbid to enter,—
It is your brook! I have no more to say.'

'Yes, you have, too. Go on. You thought of something.'

'Speaking of contraries, see how the brook
In that white wave runs counter to itself.
It is from that in water we were from
Long, long before we were from any creature.
Here we, in our impatience of the steps,
Get back to the beginning of beginnings,

The stream of everything that runs away.
Some say existence like a Pirouot
And Pirouette, forever in one place,
Stands still and dances, but it runs away,
It seriously, sadly, runs away
To fill the abyss' void with emptiness.
It flows beside us in this water brook,
But it flows over us. It flows between us
To separate us for a panic moment.
It flows between us, over us, and *with* us.
And it is time, strength, tone, light, life and love—
And even substance lapsing unsubstantial;
The universal cataract of death
That spends to nothingness—and unresisted,
Save by some strange resistance in itself,
Not just a swerving, but a throwing back,
As if regret were in it and were sacred.
It has this throwing backward on itself
So that the fall of most of it is always
Raising a little, sending up a little.
Our life runs down in sending up the clock.
The brook runs down in sending up our life.
The sun runs down in sending up the brook.
And there is something sending up the sun.
It is this backward motion toward the source,
Against the stream, that most we see ourselves in,
The tribute of the current to the source.
It is from this in nature we are from.
It is most us.'
 'Today will be the day
You said so.'
 'No, today will be the day
You said the brook was called West-running Brook.'
'Today will be the day of what we both said.'

[1931] EXCERPT *from*

The Land of Feast and Famine

Helge Instad

"Hjalmar Dale came from the Mackenzie River, I from the forests further south. We met in Edmonton." So began a partnership that took Helge Instad (1899–) deep into the Northwest Territories where he lived for four years, from 1926 to 1930, in contact with the Caribou-Eaters, a group of Chipewyans. It was a strange journey indeed for Instad, who sold his "thriving lawyer's practice" in Norway to take his chances living as a trapper. Why did he do it? "I had decided," he recalled many years later, "to realize a dream that had always been with me: a primitive life in northern, practically uncharted wilds, in a region where the lives of the natives still largely followed their ancient traditions."

The Trail to Solitude

The month during which the Canadian, Fred, and I together did our best to conquer the Snowdrift River was in the nature of a prelude to the year I spent knocking about alone.

The Snowdrift is the most turbulent river east of Slave Lake. Between steep granite walls it races toward the lowlands in a series of rapids and cascades. It is no river for a canoe. The fact remained, however, that a party of Indians had once chosen this route into the interior of the Barren Lands, and we refused to be outdone. So, with our winter equipment and our dogs packed snugly into our canoes, we set out.

"Small lake near big river, fine for canoe," Batis Lockart had told me, drawing on a piece of bark a series of figures resembling a string of sausages. We discovered no lake; instead, we fell upon mile-long portages up over steep rugged country swarming with mosquitoes. Up the only stretch of river which could be called navigable we had to track and wade. This tracking was not always

145

so pleasant, for the current was swift enough to capsize our canoes on the slightest provocation. More than once we were prepared to say farewell to our winter equipment. After a week in the water, wading along as best we could, we heaved a sigh of relief, for it had indeed been a week of nerve-racking suspense.

To put it tersely, the Snowdrift had balked us at every turn, but this would not have been so bad, had it only provided us with something to eat. Less than a month before, its waters had been teeming with whitefish; now they were as empty as could be. The dogs were hungry and the pups, in particular, were in a most pitiful condition. We ourselves kept going on oatmeal.

Since there were no fish at the foot of the rapids, they must be up above. This thought seemed logical to us, so we agreed upon one last advance upstream. Leaving Fred to make camp and care for the dogs, I was to proceed east until I encountered still water. There I would drop in a net. If I were to catch some fish, all well and good; if not, there would be no point in our continuing, for the dogs were already too weak to carry packs.

My fishing trip up the rapids of the Snowdrift River forms one of my darkest memories. It was late evening when I finally came upon a comparatively still stretch of deep water. There I knocked together a raft, threw the net aboard, grabbed a good stout pole, and started out from shore. I whistled softly and confidently, for here I should have things going in a jiffy. The meshes of the net got caught every now and then in the bark and branch-stubs of the raft, but I did not take this too seriously; I simply picked the net loose and went on poling myself along.

I had succeeded in paying out most of the net when it suddenly struck me that my craft was not going the way it ought. It was swerving in a semicircle from the point where I had set out from shore. I now had a back-eddy to contend with! I clutched the pole, but the water had suddenly become so deep that I came within a hair's breadth of pitching head-first overboard. With that, I began paddling; I paddled for dear life, that wretched vessel of mine listing first to port and then to starboard. But the back-eddy persisted, and it was a hopeless battle I was waging. In a short time I had sailed completely round in a circle, and, buried in the folds of the net, like a spider in its web, the raft was now lapped by the ripples in the identical spot where I had first set out from shore. The only thing for me to do was to free the net—this took me some time—and to begin all over again. Thus it went hour after hour; I poled and I swore and I sweat and I swore, trying to get the net into the water. I was soaked to the skin and continually tortured by mosquitoes. The moon rose and piloted its pale disk up over the forest; still I struggled with the net. The back-eddy swirled round and round, and I swirled with it. And I didn't even have a dog to scold!

But there is an end to everything, even to a hungry trapper's patience. When the end came, I heaved the whole net overboard in a tangle and went ashore, where I lay down and fell asleep on the spot. The next morning there was *one* miserable trout in the net. I stuck it out one day longer and had somewhat better luck in a different place: there I caught *another* trout, one somewhat fatter than the first. . . .

Two weeks later:

We were sitting in front of a smoky fire as we ate our oatmeal and blinked our eyes in the rank smudge which was all that prevented the mosquitoes from doing away with us entirely. A short distance upstream roared a waterfall. Round about us lay twelve dogs who, with large pleading eyes, followed every move we made. Mechanically we brushed the layer of mosquitoes from our bowls of oatmeal and ate spoonful after spoonful. Neither of us uttered a word. There was nothing to say, for we had at last reached the point where we were obliged to turn back. All our striving had been in vain.

A spoonful of oatmeal was on its way to my mouth when it suddenly struck me that a certain black shadow in amongst a patch of whortleberries as high as a man's head on the other side of the river *was moving*. In a flash I had thrown aside my spoon and was on my feet. "A bear!" I said. Fred did not even bother to turn his head, just coolly kept on eating his oatmeal. "Devil take me if that isn't a bear!" I repeated warmly. Then Fred gave me a look as much as to say that this was hardly the time to pull a joke like that. He did not take me seriously until I stood there with my rifle in my hand. It was then that a big black bear received the surprise of his

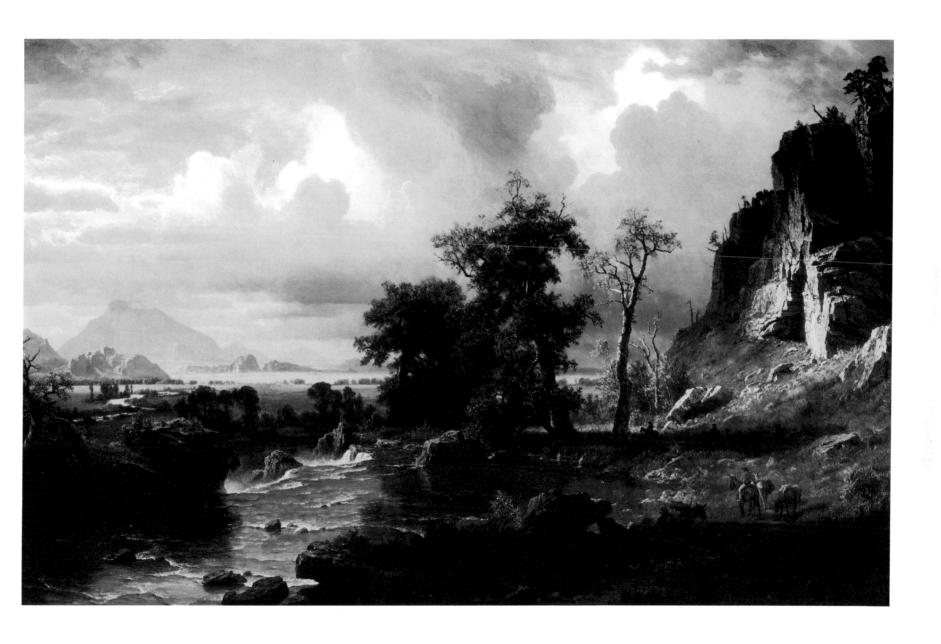

Albert Bierstadt, *Platte River, Nebraska*, 1863.
Manoogian Collection.

life. There he was, shuffling down to the river flats on his usual nocturnal rounds. Unsuspectingly he shuffled along, nibbling a few whortleberries along the way, enjoying himself immensely in this evening hour, with the music of the waterfall in his ears. And then—a series of shots! At the first shot the bear raised his head in surprise. At the second he began dancing around in a circle. At the third he stared stiffly across in our direction, shook his head, whirled about, and was off like the wind, finally disappearing behind a gravel knoll. He was gone.

In silence we laid aside our fire-arms. In silence we returned to our oatmeal. It tasted just as usual.

After a time Fred cautiously asked: "Have you ever seen a bear shake his head?"

I admitted that this was the first bear I had ever observed to behave in such a manner.

"Well," said Fred, "do you think he would have shaken his head without some good reason for it?"

"Hardly," I replied.

"There you have it," concluded Fred, with conviction. "That bear is badly wounded."

At this, I passed the jocose observation that a shake of the head might also betoken disgust for such unbelievable poor aim as we had taken.

But Fred ignored my remark and stuck to his point: "That bear is ours. One of us ought to paddle across and follow the trail of blood."

Risking life and limb, I set out across the rapids. For a half-hour or so I searched high and low for signs of blood on the ground, but without success. What I did find were the quite ordinary tracks of a quite ordinary bear which was enjoying the best of health and which had put miles between itself and the river. On my return with the report that my hunt for telltale blood stains had ended in failure, Fred was at a loss to understand the whole affair. He added that it was just as well, since it was a gruelling job to skin an autumn bear like that one!

Thus our one last opportunity had gone up in smoke. It was now merely a question of how we could best manage the return trip down the river. Were we to wade the long hard way in the water as before, or could we take a chance and shoot the rapids? The canoes would not stand much buffeting; they had no more than a hand's breadth freeboard, and that was something to be considered. But there we were, both of us in a suitably ironical mood. What, wade? Never in all this world!

A kindly fate must have kept watch over our canoes as they danced down those frothing rapids, for we succeeded in reaching still water with both boats on an even keel.

[collected in 1940]

"Flat River Girl"

American rivers have always attracted workers, many of whom took up residence on or near the waterfront. Over time, folklorists and songwriters recorded stories about the denizens of river valleys, including "Flat River Girl."

This song recounts the relationship between the daughter of a miller, "slender and neat," and a raftsman who fell in love with her, only to have his hopes dashed.

This version of the song was collected by Dan Grant in Wisconsin in 1940.

I'm a heartbroken raftsman from Gransville I came.
All joys are departed, all virtues the same,
Since the clear skies of Cupid have caused me my grief,
My heart's well nigh broken, I can ne'er find relief.

My occupation, I'm a raftsman where the Flat River flows.
I've printed my name on both rocks and the shore.
In shops, farms and households I'm very well known,
They call me Jack Haggarty, the pride of my town.

My story I'll tell you without much delay.
A neat little lassie my heart stole away.
She was a miller's daughter, close by riverside
And I always intended to make her my bride.

Her form, like a lily, was slender and neat.
Her hair hung in ringlets to her tiny white feet.
Her voice was as sweet as the wind on a leaf.
Her skin like the breast of the white smiling sea.

I took her to supper to parties and balls.
Sunday morning went riding from the first time I call.
I called her my darling, what a gem for a wife!
When I think of her treachery, I could forfeit my life.

Ferry across the Kansas River, late nineteenth century.
Kansas Collection, University of Kansas Libraries.

I dressed her in the finest of muslins and lace
And the finest of jewels that I could encase.
I gave her my wages, the same to keep safe.
I begrudged her of nothing I had on the place.

I worked on the river and saved a lot of stake.
I was steadfast and steady and ne'er played the rake.
I was buoyant and smiling on the stiff boiling stream.
Her face was before me, it haunted my dream.

One day on the river a note I received.
She said from her promise herself she released.
She'd wedded a lover she long since delayed
And the next time I'd see her she'd not be a maid.

Now getting this note sure caused some surprise.
When I think of her now it brings tears to my eyes.
For it filled me with anger and made me half mad.
I'm weary and heartsick and wish myself dead.

But it were on her mother I lay on the blame,
She'd wrecked both our lives and blackened my name.
She'd thrown off the rigging that God would soon tie
And made me a loner 'til the day that I die.

On the banks of Flat River I no more can rest,
So I told them my feeling and pulled for the west.
I will go to Muskegon, a new job to find.
I'm leaving Flat River and a false love behind.

Come all jolly raftsmen, so brave and so true.
Don't love a young girl, you'll be beat if you do.
When you see a sweet lassie with bright golden hair
Then remember Jack Haggarty and his Flat River girl.

TVA

Democracy on the March

David E. Lilienthal

David E. Lilienthal (1899–1981) held two vital positions in mid-twentieth-century America:
he was chairman of the Tennessee Valley Authority and later the first chairman of the
Atomic Energy Commission. While chairman of the TVA, Lilienthal believed that the power
of the Tennessee River had the potential for transforming the lives of rural southerners, particularly by spreading the benefits of electricity to people who had no other means to get it. As this excerpt makes clear, Lilienthal believed that river development had political as well as economic benefits.

This is an entirely different region from what it was ten years ago. You can see the change almost every where you go. You can see it in the copper lines strung along back country roads, in the fresh paint on the houses those electric lines were built to serve. You can see it in new electric water pumps in the farmyards, in the community refrigerators at the crossroads, in the feed grinders in the woodsheds. You can see the factories that stand today where there were worn-out cotton fields and rows of tenant shacks a few years ago. You can see new houses, by the thousands on the edges of the towns—new houses of the men who take away as much cash from a few trips to the payroll window as they used to earn in a year.

You can see the change best of all if you have flown down the valley from time to time, as I have done so frequently during these past ten years. From five thousand feet the great change is unmis-

takable. There it is, stretching out before your eyes, a moving and exciting picture. You can see the undulation of neatly terraced hillsides, newly contrived to make the beating rains "walk, not run, to the nearest exit"; you can see the grey bulk of the dams, stout marks across the river now deep blue, no longer red and murky with its hoard of soil washed from the eroding land. You can see the barges with their double tows of goods to be unloaded at new river terminals. And marching toward every point on the horizon you can see the steel criss-cross of electric transmission towers, a twentieth-century tower standing in a cove beside an eighteenth-century mountain cabin, a symbol and a summary of the change. These are among the things you can see as you travel through the Tennessee Valley today. And on every hand you will also see the dimensions of the job yet to be done, the problem and the promise of the valley's future.

A technical man will observe much that will interest him, for the Tennessee Valley Authority represents a substantial technical achievement, a record written over a wide area in concrete and steel, and in land revived and forests renewed. Here one can see what modern science can do in a few years to change the face of the earth and the waters. That technical story has been recorded with painstaking care and great detail and published in the many volumes of scientific reports by TVA's engineers, agronomists, town builders, chemists, biologists, foresters, public health experts, architects.

These technical reports will interest the experts. The average citizen will measure the change through reports of another kind: in the records of new private industries established in the valley, of failing enterprises revived, more money in people's hands, less tax delinquencies, increased bank deposits, a greater volume of buying at the stores—trends clearly established before the war. The citizen may read of the decade's change in records of new public library service or state parks established where none had been before, more hospitals, county health units almost doubled, less tuberculosis and malaria and other "low-income diseases." He may read of the number of miles of lines built to bring power to the farms of the area and the rapid increase in the amount of electricity used by the people—unprecedented in this country. He may reflect on the better quality of food produced and the increased yield per acre on the land, or analyze the ton-miles of traffic increase on the river. He may figure the potential value of the millions of seedlings planted in farm woodland and forest. He may see the newly created "Great Lakes of the South," the beauty of their thousands of miles of wooded shoreline unmarred, deep blue waters set among high mountains and abounding with game fish.

Such sights and such records reflect the ways in which, as this beautiful valley has changed, the lives of several million fellow Americans have also changed.

The story of the change begins with the river. On the map the river's five mountain tributaries, each a considerable stream—the French Broad, the Holston, the Hiwassee, the Little Tennessee, the Clinch—are clearly set off from the broad main stem, the Tennessee itself, a major river of great volume, fed by the heaviest rainfall in eastern America. The map shows that main stem as a deep crescent, its source and eastern tip in the Appalachian Mountains, the dip of the crescent slicing off the northern third of Alabama, the western tip arching northward through the flat red lands of western Tennessee and Kentucky. The river flows not in one general direction, but in three; it moves southward first, then its middle course is westward, and its lower reaches turn back toward the north. A river that "flows up the map," as visitors to TVA almost invariably remark, seems to be water flowing perversely uphill, making its way more than 650 miles from Knoxville in Tennessee, in sight of the virgin timber in the Great Smoky Mountains, the highest peaks in eastern North America, to Paducah in the lowlands of Kentucky where across the broad Ohio you can see the fields of Illinois.

The valley through which the river flows actually lies in seven historic states of the Old South: the western part of the seacoast states of North Carolina and Virginia; the northern parts of Georgia, Alabama, and Mississippi; the western half of Kentucky from its southern jointure with Tennessee north to the Ohio River; and almost the whole of the wide reaches of the state of Tennessee.

Hiawassee River, Tennessee.
United States Department of Agriculture.

Less exactly, the region reaches from the mountains about Asheville west to the sluggish Mississippi at Memphis, and north and south from the old steamboat whistle landings on Ohio's shores to the cotton fields of Mississippi and the flambeau of the furnaces at Birmingham—an area all told about the size of England and Scotland, with a population of about 4,500,000 persons.

This is the river system that twenty-one dams of the TVA now control and have put to work for the people. To do that job sixteen new dams, several among the largest in America, were designed and constructed. Five dams already existing have been improved and modified. One of TVA's carpenters, a veteran who worked on seven of these dams, described this to me as "one hell of a big job of work." I cannot improve on that summary. It is the largest job of engineering and construction ever carried out by any single organization in all our history.

In heat and cold, in driving rain and under the blaze of the August sun, tens of thousands of men have hewed and blasted and hauled with their teams and tractors, clearing more than 175,000 acres of land, land that the surface of the lakes now covers. They have built or relocated more than 1200 miles of highway and almost 140 miles of railroad. With thousands of tons of explosives and great electric shovels they have excavated nearly 30,000,000 cubic yards of rock and earth to prepare the foundations of these dams— an excavation large enough to bury twenty Empire State buildings. To hold the river the men of the TVA have poured and placed concrete, rock fill, and earth in a total quantity of 113 million cubic yards.

To comprehend these figures requires a few comparisons. This 113 million cubic yards of material is more than twelve times the bulk of the seven great pyramids of Egypt. Of these materials, the concrete alone poured into the TVA dams is two and a half times as much as used in all the locks and structures of the Panama Canal; is four times as much as in Boulder Dam, 1,200,000 cubic yards greater than in the Grand Coulee Dam; would build more than seven dams as large as Soviet Russia's great Dnieprostroy Dam. The Grand Coulee Dam is the largest single masonry structure yet

built, and Boulder Dam the second largest. Boulder was in the process of construction for five years and took the combined efforts of six of our largest private building contractor firms. Grand Coulee took eight years to build, and ten major private construction firms were engaged on it.

Thirty-five Boulder dams to ten Grand Coulee dams could have been built with the total materials required for completion of this valley's dams, the work of a single organization. The TVA's employees in 1947 were simultaneously designing and building a dozen dams and improving four others, were erecting the South's largest steam-electric plant, and building large chemical and munitions factories, with a total of 40,000 men and women at work.

The work of the builders has made of the river a highway that is carrying huge amounts of freight over its deep watercourses. In 1942 more than 161 million ton-miles of traffic moved through locks, designed in co-operation with the Army Corps of Engineers and operated by them, which raise the barges from one lake's level to another. But in 1928 only a little more than 46 million ton-miles of traffic moved on the river; in 1933 the figure was 32 million. This was mostly sand and gravel moving in short hauls between adjacent areas, and some forest products.

Today huge modern towboats, powered by great Diesel engines, move up and down the channel, pushing double columns of barges, and the cargo is no longer limited to raw materials. Billets of steel and cotton goods come from Birmingham headed north, grain from Minneapolis, millions of gallons of gasoline, oil, machinery, merchandise, automobiles, military ambulances and jeeps. It is estimated that in 1945, when the channel will be fully completed for all the year and for the river's total length, the savings to shippers will be about three and a half million dollars each year.

Quiet cotton towns of yesterday are now busy river ports. And, as always has been true of water transportation, new industries are rising along its course. Millions of dollars have been invested and thousands of jobs created as new grain elevators, flour mills, and oil terminals have been erected along the river's banks. At Decatur in Alabama, on land where a few years ago farmers were raising corn

OPPOSITE: George Tice, *Factories along the Passaic River, Paterson, New Jersey*, 1969. Spencer Museum of Art/University of Kansas, anonymous gift.

and cotton, now newly built ocean-going vessels go down the ways into "Wheeler Lake" and thence to their North Atlantic job.

And on these same lakes are thousands of new pleasure craft of every kind—costly yachts, sailboats, homemade skiffs. Nine thousand miles of shoreline—more than the total of the seacoast line of the United States on the Atlantic, the Pacific, and the Gulf of Mexico—are available for the recreation of the people. Thousands of acres along the shore are devoted to public parks, operated by the states, by counties, cities, and by the TVA. More than fifty boat docks serve the needs of fishermen from all parts of the United States. By patient scientific methods designed to give nature a chance, the number of fish has been increased fortyfold in the storage reservoirs. More than forty species of fish have been caught in these lakes—a variety comparable to that of the Great Lakes. Here is the basis of a thriving industry that in 1943 produced six million pounds of edible fish, and is expected to increase to twenty-five million pounds a year.

Before the men of the Tennessee Valley built these dams, flooding was a yearly threat to every farm and industry, every town and village and railroad on the river's banks, a barrier to progress. Today there is security from that annual danger in the Tennessee Valley. With the erection of local protective works at a few points this region will be completely safe, even against a flood bigger than anything in recorded history. A measure of protection resulting from the Tennessee's control extends even beyond this valley; for no longer will the Tennessee send her torrents at flood crest to add what might be fatal inches to top the levees and spread desolation on the lower Ohio and the Mississippi.

In others of the earth's thousand valleys people live under the shadow of fear that each year their river will bring upon them damage to their property, suffering, and death. Here the people are safe. In the winter of 1942 torrents came raging down this valley's two chief tributaries, in Tennessee and Virginia. Before the river was controlled this would have meant a severe flood; the machinery of vital war industries down the river at Chattanooga would have stopped, under several feet of water, with over a million dollars of direct damage resulting.

But in 1942 it was different. Orders went out from the TVA office of central control to every tributary dam. The message came flashing to the operator in the control room at Hiwassee Dam, deep in the mountains of North Carolina: "Hold back all the water of the Hiwassee River. Keep it out of the Tennessee." The operator pressed a button. Steel gates closed. The water of that tributary was held. To Cherokee Dam on the Holston went the message: "Keep back the flow of the Holston." To Chickamauga Dam just above the industrial danger spot at Chattanooga: "Release water to make room for the waters from above."

Day by day till the crisis was over the men at their control instruments at each dam in the system received their orders. The rate of water release from every tributary river was precisely controlled. The Tennessee was kept in hand. There was no destruction, no panic, no interruption of work. Most of the water, instead of wrecking the valley, actually produced a benefit in power, when later it was released through the turbines.

Back of the orders from the water dispatcher to the men who operate the dams is an elaborate system of reporting rainfall and gauging the flow of streams so the height of waters can be predicted for days in advance. To the head of the TVA forecasting division, from all over the watershed, from every tributary stream, from three hundred stations, by teletype, telephone, and shortwave radio come reports of the river's "stages," i.e., its height. Here, for example, is one of the messages that came from H. S. Barker near Mendota, in Virginia, during the critical days of the 1942 flood:

River three feet eighty-four hundredths raining rainfall one seventeen hundredths inches.

That is, river stage was 3.84 feet; it was raining at the time; the rainfall during the past twenty-four hours was 1.17 inches.

Reports come in from hundreds of remote rain-gauge stations, telephoned in by a farmer's wife, a crossroad store merchant, a woodsman. From well-nigh inaccessible mountain streams ingenious TVA-made devices send in their reports by shortwave radio without human intervention. And all the reports are combined

and interpreted by engineers, so that they know almost exactly how much water will be swelling the river the next day and the next. Yesterday's reports are checked with today's and revised tomorrow, and the best technical judgment is sent to the river control room: just how much water is being added to the river's flow in the French Broad, the Holston, the Clinch, the Hiwassee.

The operating orders go out, turning water off or on to meet the demands of the crisis along a watercourse from the headwaters of the Tennessee to the Gulf, almost as long as the Mississippi from its headwaters to New Orleans. The Tennessee River throughout its length is controlled, as water is retained at one dam, released at another. This valley has been made safe.

This is not true of other river valleys. Here, for example, is a press association dispatch of May 13, 1943:

> Swollen creeks and rivers flooded more than one million acres of low-lying farmlands in six states Thursday, burying spring crops, blocking highways and taking at least seven lives.
>
> High water left hundreds of farm families homeless as flood crests rolled downstream in Arkansas, Oklahoma, Kansas, Missouri, Indiana, and Illinois. . . .
>
> As the river crest moved downstream Army engineers retreated before it, abandoning levee after levee as the hopelessness of combating the flood became apparent.

A few days later this summary appeared in the New York *Times* (May 27, 1943):

> During May muddy waters have submerged 3,926,000 acres in Illinois, Missouri, Arkansas, Oklahoma, Kansas and Indiana, routed 160,000 persons and caused twenty-one deaths in the worst floods in the midlands since 1937, when the Ohio and Mississippi Valley disaster made more than 1,000,000 persons homeless and took 466 lives.

All over the world the story is much the same. Here, for example, is a newspaper account from New Delhi, India, dated August 7, 1943:

> Approximately 10,000 Indians were drowned in the past week by floodwaters of the Khari River which swept suddenly through nearly 100 villages. Nearly a sixth of the tiny British Province of Ajmer-Merwara was under water.

And in the fall of 1943 came that flood's horrible sequel: famine. No major river in the world is so fully controlled as the Tennessee, no other river works so hard for the people, for the force that used to spend itself so violently is today turning giant waterwheels. The turbines and generators in the TVA powerhouses have transformed it into electric energy. And this is the river's greatest yield.

A Pima Remembers

George Webb

"With my own forefathers as informants I write this narration which is part of the lives they went through." So wrote George Webb (1893?–1964) in the preface to A Pima Remembers. *Webb's book had two missions: to instruct young Pima Indians about "the customs and habits of their forefathers"; and to record Pima beliefs for mainstream American society.*

Water

In the old days, all the Pima Indians made a good living working their farms which produced a good yield. There was plenty of feed and water along the Gila River for their stock. Many lived in nice adobe homes of which a few are still in use today.

They maintained their own water system, distributing the water to anyone needing it the most. When a dam washed out by flood water, they all went out and put in another brush dam. When an irrigation ditch needed cleaning, they went out together with their shovels and cleaned it out.

There were only a few farm machines, but they had the plow, drawn by horses. Even plowing was done from farm to farm by someone who had a plow and a team. At other times the people he plowed for did something for him. Every field was put into crop. And so successful was their planting that if you climbed to the top of one of the nearby hills, as far as your eyes could see, you would see green along the river. All this was the result of helping

each other, and having plenty of water from the Gila River. That is how the Pimas farmed in the Gila Valley for hundreds of years.

Then came a time when all this was changed.

A dam was put across the Gila River, upstream from the Pimas.

The purpose of this dam was to hold the waters of the rainy season and let it out for irrigation use in the dry times.

It took a long time for that dam to fill up and when it did, the water no longer came down the Gila. The Pimas were left without any water at all, to irrigate their farms or water their stock or even to drink. They dug wells. The wells dried up. The stock began to die. The sun burned up the farms. Where everything used to be green, there were acres of desert, miles of dust, and the Pima Indians were suddenly desperately poor.

They had never worked for wages. They chose to stay on the Reservation. It was their home.

That was a time before electricity and gas were much in use, so the demand for wood was large. There was plenty of wood on the Reservation, so the Pimas became sellers of wood. The price for wood was small, but wood saved them from starving. Today there are no mesquite trees left on the Reservation that are not second growth. If you look at the base of any mesquite tree you will find a dry stump. That is where a much bigger tree once grew.

For many years the Pimas lived somehow without farming. They still had their land, but no water. It was hard. But harder when white people used to accuse us of being lazy for not working our farms.

The Pimas didn't say much about their trouble. But finally some white missionaries and other friends of the Indians spoke to someone in the Government.

What came of this was the San Carlos Dam, later called Coolidge Dam. This dam was built up in a canyon of the Gila River, and its purpose was to conserve water especially for the use of the Pima Indians.

The Pima lands, after lying idle for so many years, had been covered with brush and mesquite, so the Government came in with heavy equipment and cleared and leveled about fifty thousand acres on the Reservation. These lands were made ready for the flow of irrigation water, and the people were happy, thinking that now they would be able to farm again.

This is not all the Government did for the Pimas, they issued to them an assortment of farm machinery. Many Indians, who did not have any implements left, took advantage of this and equipped their farms with mowers, racks, wagons and teams to pull them. Some of these people are still paying for that equipment today. The issue was of course reimbursable. But at that time the Pimas were happy and confident. When the dam was completed there would be plenty of water.

And there was. For about five years. Then the water began to run short again. After another five years it stopped altogether.

What happened?

Some speculators had bought up desert land under this dam and sold it with water rights. They sold the land fast and they sold a lot of it. The irrigation water didn't go far, so the farmers began to drill wells. They drilled so many wells and ran so many hundreds of pumps day and night that the water table sank almost out of reach and they began to fight each other for the underground water.

On the Reservation the Pimas had about a dozen wells, and the white farmers criticized us for taking away their underground flow.

You can guess how much water ever got to the Reservation, and what the Pima farms began to look like.

In the old days, on hot summer nights, a low mist would spread over the river and the sloughs. Then the sun would come up and the mist would disappear. On those hot nights the cattle often gathered along the river up to their knees in the cool mud.

Soon some Pima boy would come along and dive into the big ditch and swim for awhile. Then he would get out and open the headgate and the water would come splashing into the laterals and flow out along the ditches. By this time all the Pimas were out in the fields with their shovels. They would fan out and lead the water to the alfalfa, along the corn rows, and over to the melons. The red-wing blackbirds would sing in the trees and fly down to look for bugs along the ditches. Their song always means that there is

water close by as they will not sing if there is not water splashing somewhere.

The green of those Pima fields spread along the river for many miles in the old days when there was plenty of water.

Now the river is an empty bed full of sand.

Now you can stand in that same place and see the wind tearing pieces of bark off the cottonwood trees along the dry ditches.

The dead trees stand there like white bones. The red-wing blackbirds have gone somewhere else. Mesquite and brush and tumbleweeds have begun to turn those Pima fields back into desert.

Now you can look out across the valley and see the green alfalfa and cotton spreading for miles on the farms of white people who irrigate their land with hundreds of pumps running night and day. Some of those farms take their water from big ditches dug hundreds of years ago by Pimas, or the ancestors of Pimas. Over there across the valley is where the red-wing blackbirds are singing today.

I am not criticizing our Government, or most of the men who administer its program. Only one or two who shut their eyes to justice when the pressure gets too much on them.

There are some very smart white operators coming into this desert country these days with money and influence. Not all of them can write their name. They have a string of lawyers to do that for them.

I had two years in business school, but only last year I let a white man take me on a business deal for two thousand dollars.

And he had never even been to High School.

The Pimas are a very humble people who like to farm. Perhaps they have been too humble. They are intelligent in their own way, and many of them have had a good education. But the pace of progress is a little hard on them. I have heard several white men say that the pace of what is called progress today is almost too much for *them*.

Think how it must seem to a simple Pima who remembers the Gila River when it was a running stream.

[1960] EXCERPT *from*

Goodbye to a River

John Graves

John Graves (1920–) grew up near the Brazos River in Texas. He fished along the river's banks for years, and then returned when he heard that dams to be built on the Brazos would change it forever. Goodbye to a River *stands now as a testament not only to a river before industrial development altered its flow, but to the intimate relationship that an individual can have with a favorite river.*

Usually, fall is the good time to go to the Brazos, and when you can choose, October is the best month—if, for that matter, you choose to go there at all, and most people don't. Snakes and mosquitoes and ticks are torpid then, maybe gone if frosts have come early, nights are cool and days blue and yellow and soft of air, and in the spread abundance of even a Texas autumn the shooting and the fishing overlap and are both likely to be good. Scores of kinds of birds, huntable or pleasant to see, pause there in their migrations before the later, bitterer northers push many of them farther south. Men and women are scarce.

Most autumns, the water is low from the long dry summer, and you have to get out from time to time and wade, leading or dragging your boat through trickling shallows from one pool to the long channel-twisted pool below, hanging up occasionally on shuddering bars of quicksand, making six or eight miles in a day's lazy work, but if you go to the river at all, you tend not to mind. You are not in a hurry there; you learned long since not to be.

October is the good month. . . .

I don't mean the whole Brazos, but a piece of it that has had meaning for me during a good part of my life in the way that pieces of rivers can have meaning. You can comprehend a piece of river. A whole river that is really a river is much to comprehend unless it is the Mississippi or the Danube or the Yangtze-Kiang and you spend a lifetime in its navigation; and even then what you comprehend, probably, are channels and topography and perhaps the honky-tonks in the river's towns. A whole river is mountain country and hill country and flat country and swamp and delta country, is rock bottom and sand bottom and weed bottom and mud bottom, is blue, green, red, clear, brown, wide, narrow, fast, slow, clean, and filthy water, is all the kinds of trees and grasses and all the breeds of animals and birds and men that pertain and have ever pertained to its changing shores, is a thousand differing and not compatible things in-between that point where enough of the highland drainlets have trickled together to form it, and that wide, flat, probably desolate place where it discharges itself into the salt of the sea.

It is also an entity, one of the real wholes, but to feel the whole is hard because to know it is harder still. Feelings without knowl-

edge—love, and hatred, too—seem to flow easily in any time, but they never worked well for me. . . .

The Brazos does not come from haunts of coot and hern, or even from mountains. It comes from West Texas, and in part from an equally stark stretch of New Mexico, and it runs for something over 800 miles down to the Gulf. On the high plains it is gypsum-salty intermittent creek; down toward the coast it is a rolling Southern river with levees and cotton fields and ancient hardwood bottoms. It slices across Texas history as it does across the map of the state; the Republic's first capitol stood by it, near the coast, and settlement flowed northwestward up its long trough as the water flowed down.

I have shot blue quail out by the salty trickles, and a long time ago hunted alligators at night with a jacklight on the sloughs the river makes in the swamplands near the Gulf, but I do not know those places. I don't have them in me. I like them as I have liked all kinds of country from Oahu to Castilla la Vieja, but they are a part of that whole which isn't, in the way I mean, comprehensible.

A piece, then . . . A hundred and fifty or 200 miles of the river toward its center on the fringe of West Texas, where it loops and coils snakishly from the Possum Kingdom dam down between the rough low mountains of the Palo Pinto country, into sandy peanut and post-oak land, and through the cedar-dark limestone hills above a new lake called Whitney. Not many highways cross that stretch. For scores of years no boom has brought people to its banks; booms elsewhere have sucked them thence. Old respect for the river's occasional violence makes farmers and ranchers build on high ground away from the stream itself, which runs primitive and neglected. When you paddle and pole along it, the things you see are much the same things the Comanches and the Kiowas used to see, riding lean ponies down it a hundred years ago to raid the new settlements in its valley.

Few people nowadays give much of a damn about what the Comanches and the Kiowas saw. Those who don't, have good reason. It is harsh country for the most part, and like most of West Texas accords ill with the Saxon nostalgia for cool, green, dew-wet landscapes. Even to get into it is work. If you pick your time,

the hunting and the fishing are all right, but they too are work, and the Brazos is treacherous for the sort of puttering around on water that most people like. It snubs play. Its shoals shear the propeller pins of the big new outboard motors, and quicksands and whirlpools occasionally swallow folks down, so that generally visitors go to the predictable impounded lakes, leaving the river to the hard-bitten yeomanry who live along it, and to their kinsmen who gravitate back to it on weekends away from the aircraft factories and automobile assembly plants of Dallas and Fort Worth, and to those others of us for whom, in one way or another, it has meaning which makes it worth the trouble.

. . .

To note that our present world is a strange one is tepid, and it is becoming a little untrue, for strangeness and change are so familiar to us now that they are getting to be normal. Most of us in one way or another count on them as strongly as other ages counted on the green shoots rising in the spring. We're dedicated to them; we have a hunger to believe that other sorts of beings are eyeing us from the portholes of Unidentified Flying Objects, that automobiles will glitter with yet more chromed facets next year than this, and that we shall shortly be privileged to carry our inadequacies with us to the stars. And furthermore that while all the rivers may continue to flow to the sea, those who represent us in such matters will at least slow down the process by transforming them from rivers into bead strings of placid reservoirs behind concrete dams . . .

Bitterness? No, ma'am . . . In a region like the Southwest, scorched to begin with, alternating between floods and droughts, its absorbent cities quadrupling their censuses every few years, electrical power and flood control and moisture conservation and water skiing are praiseworthy projects. More than that, they are essential. We river-minded ones can't say much against them—nor, probably, should we want to. Nor, mostly, do we. . . .

But if you are built like me, neither the certainty of change, nor the need for it, nor any wry philosophy will keep you from feeling a certain enraged awe when you hear that a river that you've known always, and that all men of that place have known always back into

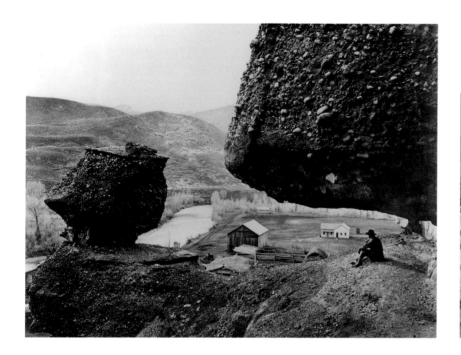

LEFT: Andrew J. Russell, *Hanging Rock, foot of Echo Canyon*, 1868. RIGHT: Rick Dingus, *Hanging Rock, foot of Echo Canyon, Utah*, 1978.
Left: Spencer Museum of Art/University of Kansas, gift of Sam and Terry Evans.
Right: Spencer Museum of Art/University of Kansas, gift of Sam and Terry Evans, with permission of Rick Dingus for the Rephotographic Survey Project.

the red dawn of men, will shortly not exist. A piece of river, any-how, my piece . . . They had not yet done more than survey the sites for the new dams, five between those two that had already risen during my life. But the squabbling had begun between their proponents and those otherwise-minded types—bottomland farm-ers and ranchers whose holdings would be inundated, competitive utility companies shrilling "Socialism!" and big irrigationists downstream—who would make a noise before they lost, but who would lose. When someone official dreams up a dam, it generally goes in. Dams are ipso facto good all by themselves, like mothers and flags. Maybe you save a Dinosaur Monument from time to time, but in between such salvations you lose ten Brazoses. . . .

It was not my fight. That was not even my part of the country any more; I had been living out of the state for years. I knew, though, that it might be years again before I got back with time enough on my hands to make the trip, and what I wanted to do was to wrap it up, the river, before what I and Hale and Satanta the White Bear and Mr. Charlie Goodnight had known ended up down yonder under all the Criss-Crafts and the tinkle of portable radios.

Or was that, maybe, an excuse for a childishness? What I wanted was to float my piece of the river again. All of it.

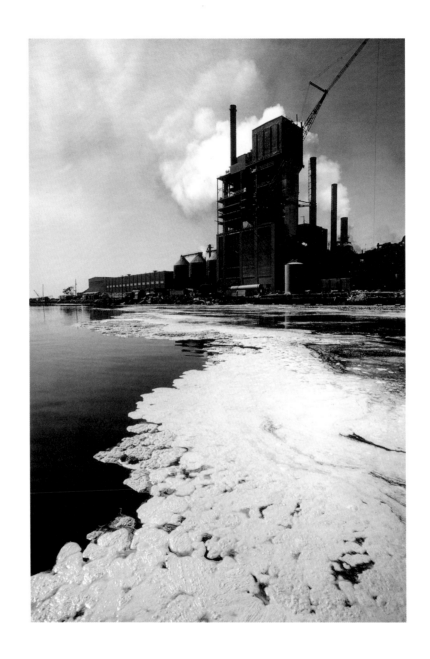

Pollution on the Shaw's River, n.d.
James P. Blair, National Geographic Collection.

[1962] EXCERPT *from*

Silent Spring

Rachel Carson

Few magazine articles have the power to alert a nation to a crisis. Rachel Carson's "Silent Spring," which ran in The New Yorker *and was then published as a book in 1962, was an exception. Perhaps no other work had such an immediate impact on industry. After Carson (1907–1964) warned of the dangers of pesticides, particularly DDT, those chemicals received more public and governmental scrutiny than ever before. By showing Americans that rivers full of life could also spread toxins, Carson became one of the century's most effective environmental writers.*

Rivers of Death

*F*rom the green depths of the offshore Atlantic many paths lead back to the coast. They are paths followed by fish; although unseen and intangible, they are linked with the outflow of waters from the coastal rivers. For thousands upon thousands of years the salmon have known and followed these threads of fresh water that lead them back to the rivers, each returning to the tributary in which it spent the first months or years of life. So, in the summer and fall of 1953, the salmon of the river called Miramichi on the coast of New Brunswick moved in from their feeding grounds in the far Atlantic and ascended their native river. In the upper reaches of the Miramichi, in streams that gather together a network of shadowed brooks, the salmon deposited their eggs that autumn in beds of gravel over which the stream water flowed swift and cold. Such places, the watersheds of the great coniferous forest of spruce and balsam, of hemlock and pine, provide the kind of spawning grounds that salmon must have in order to survive.

These events repeated a pattern that was age-old, a pattern that had made the Miramichi one of the finest salmon streams in North America. But that year the pattern was to be broken.

During the fall and winter the salmon eggs, large and thick-shelled, lay in shallow gravel-filled troughs, or redds, which the mother fish had dug in the stream bottom. In the cold of winter they developed slowly, as was their way, and only when spring at last brought thawing and release to the forest streams did the young hatch. At first they hid among the pebbles of the stream bed—tiny fish about half an inch long. They took no food, living on the large yolk sac. Not until it was absorbed would they begin to search the stream for small insects.

With the newly hatched salmon in the Miramichi that spring of 1954 were young of previous hatchings, salmon a year or two old, young fish in brilliant coats marked with bars and bright red spots. These young fed voraciously, seeking out the strange and varied insect life of the stream.

As the summer approached, all this was changed. That year the watershed of the Northwest Miramichi was included in a vast spraying program which the Canadian Government had embarked upon the previous year—a program designed to save the forests from the spruce budworm. The budworm is a native insect that attacks several kinds of evergreens. In eastern Canada it seems to become extraordinarily abundant about every 35 years. The early 1950's had seen such an upsurge in the budworm populations. To combat it, spraying with DDT was begun, first in a small way, then at a suddenly accelerated rate in 1953. Millions of acres of forests were sprayed instead of thousands as before, in an effort to save the balsams, which are the mainstay of the pulp and paper industry.

So in 1954, in the month of June, the planes visited the forests of the Northwest Miramichi and white clouds of settling mist marked the crisscross pattern of their flight. The spray—one-half pound of DDT to the acre in a solution of oil—filtered down through the balsam forests and some of it finally reached the ground and the flowing streams. The pilots, their thoughts only on their assigned task, made no effort to avoid the streams or to shut off the spray nozzles while flying over them; but because spray drifts so far in even the slightest stirrings of air, perhaps the result would have been little different if they had.

Soon after the spraying had ended there were unmistakable signs that all was not well. Within two days dead and dying fish, including many young salmon, were found along the banks of the stream. Brook trout also appeared among the dead fish, and along the roads and in the woods birds were dying. All the life of the stream was stilled. Before the spraying there had been a rich assortment of the water life that forms the food of salmon and trout—caddis fly larvae, living in loosely fitting protective cases of leaves, stems or gravel cemented together with saliva, stonefly nymphs clinging to rocks in the swirling currents, and the wormlike larvae of blackflies edging the stones under riffles or where the stream spills over steeply slanting rocks. But now the stream insects were dead, killed by the DDT, and there was nothing for a young salmon to eat.

Amid such a picture of death and destruction, the young salmon themselves could hardly have been expected to escape, and they did not. By August not one of the young salmon that had emerged from the gravel beds that spring remained. A whole year's spawning had come to nothing. The older young, those hatched a year or more earlier, fared only slightly better. For every six young of the 1953 hatch that had foraged in the stream as the planes approached, only one remained. Young salmon of the 1952 hatch, almost ready to go to sea, lost a third of their numbers.

All these facts are known because the Fisheries Research Board of Canada had been conducting a salmon study on the Northwest Miramichi since 1950. Each year it had made a census of the fish living in this stream. The records of the biologists covered the number of adult salmon ascending to spawn, the number of young of each age group present in the stream, and the normal population not only of salmon but of other species of fish inhabiting the stream. With this complete record of prespraying conditions, it was possible to measure the damage done by the spraying with an accuracy that has seldom been matched elsewhere.

The survey showed more than the loss of young fish; it revealed

a serious change in the streams themselves. Repeated sprayings have now completely altered the stream environment, and the aquatic insects that are the food of salmon and trout have been killed. A great deal of time is required, even after a single spraying, for most of these insects to build up sufficient numbers to support a normal salmon population—time measured in years rather than months.

. . .

Although the sudden death of thousands of fish or crustaceans in some stream or pond as the direct and visible effect of insect control is dramatic and alarming, these unseen and as yet largely unknown and unmeasurable effects of pesticides reaching estuaries indirectly in streams and rivers may in the end be more disastrous. The whole situation is beset with questions for which there are at present no satisfactory answers. We know that pesticides contained in runoff from farms and forests are now being carried to the sea in the waters of many and perhaps all of the major rivers. But we do not know the identity of all the chemicals or their total quantity, and we do not presently have any dependable tests for identifying them in highly diluted state once they have reached the sea. Although we know that the chemicals have almost certainly undergone change during the long period of transit, we do not know whether the altered chemical is more toxic than the original or less. Another almost unexplored area is the question of interactions between chemicals, a question that becomes especially urgent when they enter the marine environment where so many different minerals are subjected to mixing and transport. All of these questions urgently require the precise answers that only extensive research can provide, yet funds for such purposes are pitifully small.

The fisheries of fresh and salt water are a resource of great importance, involving the interests and the welfare of a very large number of people. That they are now seriously threatened by the chemicals entering our waters can no longer be doubted. If we would divert to constructive research even a small fraction of the money spent each year on the development of ever more toxic sprays, we could find ways to use less dangerous materials and to keep poisons out of our waterways. When will the public become sufficiently aware of the facts to demand such action?

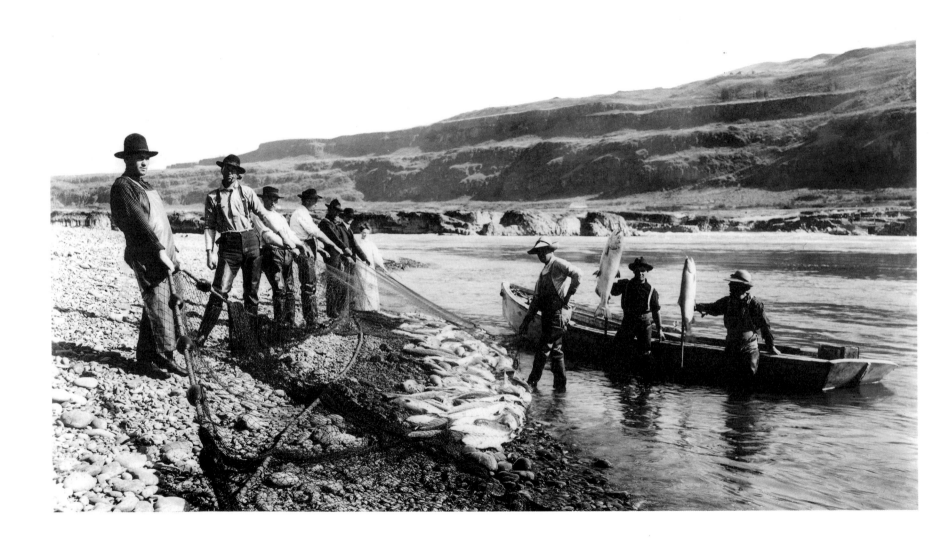

Seining on the upper Columbia, n.d.
Library of Congress, Geography and Map Division.

"*Roll On, Columbia*"

Woody Guthrie

Oklahoma-born Woody Guthrie (1912–1967) was among the nation's most popular folksingers. His lyrics often gave voice to the dispossessed, but spoke as well to the ideals of many Americans, as is evident in his memoir Bound for Glory *(1968).*

Green Douglas firs where the waters cut through,
Down her wild mountains and canyons she flew,
Canadian Northwest to the ocean so blue,
Roll on, Columbia, roll on!

Other great rivers add power to you:
Yakima, Snake, and the Klickitat, too;
Sandy Willamette and Hood River too, So
Roll on, Columbia, roll on!

At Bonneville, now, there are ships in the locks,
The waters have risen and cleared all the rocks;
Shiploads of plenty will steam past the docks,
Roll on, Columbia, roll on!©

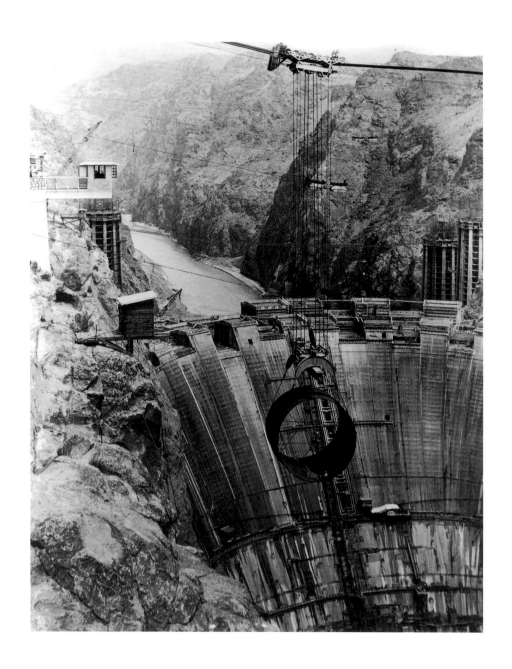

Boulder Canyon Reclamation Project, Arizona and Nevada, 1934.
Library of Congress.

[1968] EXCERPT *from*

Desert Solitaire

Edward Abbey

Edward Abbey (1927–1989) hated the United States Bureau of Reclamation. The "beavers," as he termed them, were building dams and flooding pristine valleys, all the while desecrating the wonders of the American west. In this excerpt from Desert Solitaire *Abbey bemoans the construction of the Glen Canyon Dam.*

The beavers had to go and build another goddamned dam on the Colorado. Not satisfied with the enormous silt trap and evaporation tank called Lake Mead (back of Boulder Dam) they have created another even bigger, even more destructive, in Glen Canyon. This reservoir of stagnant water will not irrigate a single square foot of land or supply water for a single village; its only justification is the generation of cash through electricity for the indirect subsidy of various real estate speculators, cottongrowers and sugarbeet magnates in Arizona, Utah and Colorado; also, of course, to keep the engineers and managers of the Reclamation Bureau off the streets and out of trouble.

The impounded waters form an artificial lake named Powell, supposedly to honor but actually to dishonor the memory, spirit and vision of Major John Wesley Powell, first American to make a systematic exploration of the Colorado River and its environs. Where he and his brave men once lined the rapids and glided through silent canyons two thousand feet deep the motorboats now smoke and whine, scumming the water with cigarette butts,

beer cans and oil, dragging the water skiers on their endless rounds, clockwise.

PLAY SAFE, read the official signboards; SKI ONLY IN CLOCKWISE DIRECTION; LET'S ALL HAVE FUN TOGETHER! with regulations enforced by water cops in government uniforms. Sold. Down the river.

Once it was different there. I know, for I was one of the lucky few (there could have been thousands more) who saw Glen Canyon before it was drowned. In fact I saw only a part of it but enough to realize that here was an Eden, a portion of the earth's original paradise. To grasp the nature of the crime that was committed imagine the Taj Mahal or Chartres Cathedral buried in mud until only the spires remain visible. With this difference: those manmade celebrations of human aspiration could conceivably be reconstructed while Glen Canyon was a living thing, irreplaceable, which can never be recovered through any human agency.

(Now, as I write these words, the very same coalition of persons and avarice which destroyed Glen Canyon is preparing a like fate for parts of the Grand Canyon.)

What follows is the record of a last voyage through a place we knew, even then, was doomed.

· · ·

We make our second river camp this evening on another sandy beach near the mouth of a small creek which enters the main canyon from the northwest. Hall's Creek? Bullfrog Creek? Sometimes I regret not having brought a decent map. Not far below are what look and sound like the most ferocious of rapids, far worse than those we'd encountered on the first day. But tomorrow we'll worry.

We eat a good, simple, sandy supper of onion soup, beef and beans, tinned fruit and coffee. With the coffee we each have a pipeful of Newcomb's Mixture—half Bull Durham and half Prince Albert, the first for flavor and the second for bulk. Good cheap workingman's tobacco.

After the meal, while Ralph washes the dishes, I take the canteens and walk up the creek to get some spring water if possible. In the sand I see the prints of deer and coyote and bobcat, also a few cattle tracks, strays perhaps, fairly fresh. I find no spring within

a reasonable distance and return to camp with empty canteens; there is water in the creek, of course, but we'd rather drink from the river than downstream from a Hereford cow.

Dark when I return, with only the light of Ralph's fire to guide me. As I brush away sticks and stones on the ground, making a place for my sleeping bag, I see a scorpion scuttle off, tail up and stinger ready. Newcomb and I meditate upon the red coals of the fire before turning in. Watching the sky I see shooting stars, blue-green and vivid, course across the narrow band of sky between the canyon walls. From downriver, as I fall asleep, comes the deep dull roar of the rapids, a sound which haunts the background of my dreams all night long.

We get up too late in the morning and have to cook breakfast in the awful heat of the sun. I burn the bacon and the wind blows sand in the pancake batter. But we're getting accustomed to sand—sand in our food and drink, in our teeth and eyes and whiskers, in our bedrolls and underwear. Sand becomes a part of our existence which, like breathing, we take for granted.

Boats loaded, we launch them into the river, still roped together side by side for the sake of comfort, conversation and safety. The rapids that worried my dreams turn out in daylight to be little more than a stretch of choppy waves and a few eroded boulders past which our boats slip without difficulty. If it were not so late in June, following a dry winter, the river consequently lower than usual, we would probably not notice these trivial ripples at all.

Down the river we drift in a kind of waking dream, gliding beneath the great curving cliffs with their tapestries of water stains, the golden alcoves, the hanging gardens, the seeps, the springs where no man will ever drink, the royal arches in high relief and the amphitheaters shaped like seashells. A sculptured landscape mostly bare of vegetation—earth in the nude.

We try the walls for echo values—

HELLO. . . .
Hello. . . .
hello. . . .

—and the sounds that come back to us, far off and fading, are so

strange and lovely, transmuted by distance, that we fall into silence, enchanted.

We pass sandbars where stands of white-plumed cane and the lacy blossoms of young tamarisk wave in the breeze among driftwood logs aged to a silver finish by sun and wind and water. In the lateral canyons we sometimes see thickets of Gambel oak and occasional cottonwoods with gray elephantine trunks and bright clear-green leaves, delicately suspended, trembling in the air.

We pass too many of these marvelous side canyons, to my everlasting regret, for most of them will never again be wholly accessible to human eyes or feet. Their living marvels must remain forever unknown, to be drowned beneath the dead water of the coming reservoir, buried for centuries under mud.

Here we become aware of the chief disadvantage of our cheap little rubber boats: far too often, when we see some place that demands unhurried exploration, the strong current will carry us past before we can paddle our awkward craft to the shore. You might think we could make a landing anyway and walk back upriver on the bank but in Glen Canyon, where the sandstone walls often rise straight up out of the water, this is sometimes impossible.

Furthermore we are lazy, indolent animals, Newcomb and I, half-mesmerized by the idyllic ease of our voyage; neither of us can seriously believe that very soon the beauty we are passing through will be lost. Instinctively we expect a miracle: the dam will never be completed, they'll run out of cement or slide rules, the engineers will all be shipped to Upper Volta. Or if these fail some unknown hero with a rucksack full of dynamite strapped to his back will descend into the bowels of the dam; there he will hide his high explosives where they'll do the most good, attach blasting caps to the lot and with angelic ingenuity link the caps to the official dam wiring system in such a way that when the time comes for the grand opening ceremony, when the President and the Secretary of the Interior and the governors of the Four-Corner states are all in full regalia assembled, the button which the President pushes will ignite the loveliest explosion ever seen by man, reducing the great dam to a heap of rubble in the path of the river. The splendid new rapids thus created we will name Floyd E. Dominy

Falls, in honor of the chief of the Reclamation Bureau; a more suitable memorial could hardly be devised for such an esteemed and loyal public servant.

Idle, foolish, futile daydreams. While we dream and drift on the magic river the busy little men with their gargantuan appliances are hard at work, day and night, racing against the time when the people of America might possibly awake to discover something precious and irreplaceable about to be destroyed.

> . . . Nature's polluted,
> There's man in every secret corner of her
> Doing damned, wicked deeds.

The ravens mock us as we float by. Unidentifiable birds call to us from the dark depths of the willow thickets—solitary calls from the wild. We see a second beaver, again like the first swimming upstream. All of our furred and feathered and hairyhided cousins who depend for their existence upon the river and the lower canyons—the deer, the beaver, the coyotes, the wildcats and cougars, most of the birds and smaller animals—will soon be compelled to find new homes. If they can. For there is no land in the canyon country not already fully occupied, to the limit of the range, by their own kind. There are no vacant lots in nature.

At four or five miles per hour—much too fast—we glide on through the golden light, the heat, the crystalline quiet. At times, almost beneath us, the river stirs with sudden odd uproars as the silty bed below alters in *its* conformations. Then comfortably readjusted, the river flows on and the only noise, aside from that of scattered birds, is the ripple of the water, the gurgling eddies off the sandspits, the sound of Newcomb puffing on his old pipe.

We are deep in the wild now, deep in the lonely, sweet, remote, primeval world, far far from anywhere familiar to men and women. The nearest town from where we are would be Blanding in southeast Utah, close to the Colorado line, or maybe Hanksville in south-central Utah, north of the Henry Mountains, either place about a hundred miles away by foot and both on the far side of an uninhabited wilderness of canyons, mesas, clay hills, slickrock domes, sand flats, pinyon and juniper forests.

Wilderness. The word itself is music.

Wilderness, wilderness. . . . We scarcely know what we mean by the term, though the sound of it draws all whose nerves and emotions have not yet been irreparably stunned, deadened, numbed by the caterwauling of commerce, the sweating scramble for profit and domination.

Why such allure in the very word? What does it really mean? Can wilderness be defined in the words of government officialdom as simply "A minimum of not less than 5000 contiguous acres of roadless area"? This much may be essential in attempting a definition but it is not sufficient; something more is involved.

Suppose we say that wilderness invokes nostalgia, a justified not merely sentimental nostalgia for the lost America our forefathers knew. The word suggests the past and the unknown, the womb of earth from which we all emerged. It means something lost and something still present, something remote and at the same time intimate, something buried in our blood and nerves, something beyond us and without limit. Romance—but not to be dismissed on that account. The romantic view, while not the whole of truth, is a necessary part of the whole truth.

But the love of wilderness is more than a hunger for what is always beyond reach; it is also an expression of loyalty to the earth, the earth which bore us and sustains us, the only home we shall ever know, the only paradise we ever need—if only we had the eyes to see. Original sin, the true original sin, is the blind destruction for the sake of greed of this natural paradise which lies all around us—if only we were worthy of it.

· · ·

We are close to the end of our journey. In the morning Ralph and I pack our gear, load the boats, and take a last lingering look at the scene which we know we will never again see as we see it now: the great Colorado River, wild and free, surging past the base of the towering cliffs, roaring through the boulders below the mouth of Forbidden Canyon; Navajo Point and the precipice of the Kaiparowits Plateau thousands of feet above, beyond the inner walls of the canyon; and in the east ranks of storm-driven cumulus clouds piled high on one another, gold-trimmed and blazing in the dawn.

Ralph takes a photograph, puts the camera back into the waterproof pouch which he hangs across his chest, and climbs into his boat. We shove off.

This is the seventh day—or is it the ninth?—of our dreamlike voyage. Late in the afternoon, waking from a deep reverie, I observe, as we glide silently by, a pair of ravens roosting on a dead tree near the shore, watching us pass. I wonder where we are. I ask Ralph; he has no idea and cares less, cares only that the journey not yet end.

I light up the last of my tobacco, and watch the blue smoke curl and twist and vanish over the swirling brown water. We are rounding a bend in the river and I see, far ahead on the left-hand shore, something white, rigid, rectangular, out of place. Our boats drift gradually closer and we see the first billboard ever erected in Glen Canyon. Planted in rocks close to the water, the sign bears a message and it is meant for us.

ATTENTION
YOU ARE APPROACHING GLEN CANYON
DAM SITE ALL BOATS MUST LEAVE
RIVER AT KANE CREEK LANDING ONE
MILE AHEAD ON RIGHT ABSOLUTELY
NO BOATS ALLOWED IN CONSTRUCTION ZONE
VIOLATORS WILL BE PROSECUTED
U.S. BUREAU OF RECLAMATION

Wild and Scenic Rivers Act

In an age when legislation intended to protect the environment is too often attacked by business interests bent on development, the passage of the Wild and Scenic Rivers Act in 1968 seems all the more remarkable. The act listed streams and parts of rivers that were to be off limits to developers "for the benefit and enjoyment of present and future generations."

PUBLIC LAW 90-542

AN ACT
TO PROVIDE FOR A NATIONAL WILD AND
SCENIC RIVERS SYSTEM, AND FOR OTHER PURPOSES.

*B*e it enacted by the Senate and House of Representatives of the United States of America in Congress assembled, That (a) this Act may be cited as the "Wild and Scenic Rivers Act."

(b) It is hereby declared to be the policy of the United States that certain selected rivers of the Nation which, with their immediate environments, possess outstandingly remarkable scenic, recreational, geologic, fish and wildlife, historic, cultural, or other similar values, shall be preserved in free-flowing condition, and that they and their immediate environments shall be protected for the benefit and enjoyment of present and future generations. The Congress declares that the established national policy of dam and other construction at appropriate sections of the rivers of the United States needs to be complemented by a policy that would

preserve other selected rivers or sections thereof in their free-flowing condition to protect the water quality of such rivers and to fulfill other vital national conservation purposes.

(c) The purpose of this Act is to implement this policy by instituting a national wild and scenic rivers system, by designating the initial components of that system, and by prescribing the methods by which and standards according to which additional components may be added to the system from time to time.

SEC. 2. (a) The national wild and scenic rivers system shall comprise rivers (i) that are authorized for inclusion therein by Act of Congress, or (ii) that are designated as wild, scenic or recreational rivers by or pursuant to an act of the legislature of the State or States through which they flow, that are to be permanently administered as wild, scenic or recreational rivers by an agency or political subdivision of the State or States concurred without expense to the United States, that are found by the Secretary of the Interior, upon application of the Governor of the State or the Governors of the States concerned, or a person or persons thereunto duly appointed by him or them, to meet the criteria established in this Act and such criteria supplementary thereto as he may prescribe, and that are approved by him for inclusion in the system, including, upon application of the Governor of the State con-cerned, the Allagash Wilderness Waterway, Maine, and that segment of the Wolf River, Wisconsin, which flows through Langlade County.

(b) A wild, scenic or recreational river area eligible to be included in the system is a free-flowing stream and the related adjacent land area that possesses one or more of the values referred to in section 1, subsection (b) of this Act. Every wild, scenic or recreational river in its free-flowing condition, or upon restoration to this condition, shall be considered eligible for inclusion in the national wild and scenic rivers system and, if included, shall be classified. designated, and administered as one of the following:

(1) Wild river areas—Those rivers or sections of rivers that are free of impoundments and generally inaccessible except by trail, with watersheds or shorelines essentially primitive and waters unpolluted. These represent vestiges of primitive America. (2) Scenic river areas—Those rivers or sections of rivers that are free of impoundments, with shorelines or watersheds still largely primitive and shorelines largely undeveloped, but accessible in places by roads. (3) Recreational river areas—Those rivers or sections of rivers that are readily accessible by road or railroad, that may have some development along their shorelines, and that may have undergone some impoundment or diversion in the past.

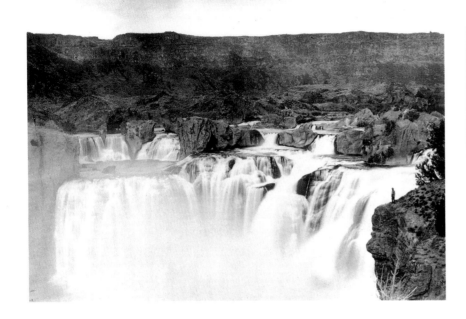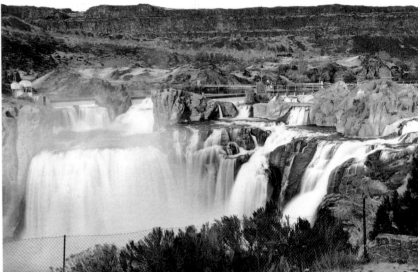

LEFT: Timothy O'Sullivan, *Shoshone Falls, full lateral view on Upper Terrace*, 1868.
RIGHT: Mark Klett, *Shoshone Falls, Snake River Canyon, Idaho*, 1978.
Spencer Museum of Art/University of Kansas, gift of Sam and Terry Evans, with permission of Mark Klett for the Rephotographic Survey Project.

[1969] EXCERPT *from*

The Sound of Mountain Water

Wallace Stegner

Wallace Stegner (1909–1993) possessed the voice of Western America. The author of the Pulitzer Prize–winning Angle of Repose *(1971) and National Book Award–winning* The Spectator Bird *(1976), Stegner gave American readers brilliant evocations of life in the trans-Mississippi west. In his "Overture" to* The Sound of Mountain Water, *Stegner captures his readers' attention with the precise description of a mountain stream: "Taste it," he implores us, "feel its chill on the teeth: it is purity absolute."*

I discovered mountain rivers late, for I was a prairie child, and knew only flatland and dryland until we toured the Yellowstone country in 1920, loaded with all the camp beds, auto tents, grub-boxes, and auxiliary water and gas cans that 1920 thought necessary. Our road between Great Falls, Montana, and Salt Lake City was the rutted track that is now Highway 89. Beside a marvelous torrent, one of the first I ever saw, we camped several days. That was Henry's Fork of the Snake.

I didn't know that it rose on the west side of Targhee Pass and flowed barely a hundred miles, through two Idaho counties, before joining the Snake near Rexburg; or that in 1810 Andrew Henry built on its bank near modern St. Anthony the first American post west of the continental divide. The divide itself meant nothing to me. My imagination was not stretched by the wonder of the parted waters, the Yellowstone rising only a few miles eastward to flow out toward the Missouri, the Mississippi, the Gulf, while this bright pounding stream was starting through its thousand miles of canyons to the Columbia and the Pacific.

All I knew was that it was pure delight to be where the land lifted in peaks and plunged in canyons, and to sniff air thin, spray-cooled, full of pine and spruce smells, and to be so close-seeming to the improbable indigo sky. I gave my heart to the mountains the minute I stood beside this river with its spray in my face and watched it thunder into foam, smooth to green glass over sunken rocks, shatter to foam again. I was fascinated by how it sped by and yet was always there; its roar shook both the earth and me.

When the sun dropped over the rim the shadows chilled sharply; evening lingered until foam on water was ghostly and luminous in the near-dark. Alders caught in the current sawed like things alive, and the noise was louder. It was rare and comforting to waken late and hear the undiminished shouting of the water in the night. And at sunup it was still there, powerful and incessant, with the slant sun tangled in its rainbow spray, the grass blue with wetness, and the air heady as ether and scented with campfire smoke.

By such a river it is impossible to believe that one will ever be tired or old. Every sense applauds it. Taste it, feel its chill on the teeth: it is purity absolute. Watch its racing current, its steady renewal of force: it is transient and eternal. And listen again to its sounds: get far enough away so that the noise of falling tons of water does not stun the ears, and hear how much is going on underneath—a whole symphony of smaller sounds, hiss and splash and gurgle, the small talk of side channels, the whisper of blown and scattered spray gathering itself and beginning to flow again, secret and irresistible, among the wet rocks.

"Burn On"

Randy Newman

In 1969 the Cuyahoga River in northern Ohio caught fire. The event signaled the environmental degradation then taking place in the United States. Songwriter Randy Newman, born in New Orleans in 1943, captured the absurdity of the event in this song.

There's a red moon rising
On the Cuyahoga River
Rolling into Cleveland to the lake

There's a red moon rising
On the Cuyahoga River
Rolling into Cleveland to the lake

There's an oil barge winding
Down the Cuyahoga River
Rolling into Cleveland to the lake

Cleveland, city of light, city of magic
Cleveland, city of light, you're calling me
Cleveland, even now I can remember
'Cause the Cuyahoga River
Goes smokin' through my dreams

Burn on, big river, burn on
Burn on, big river, burn on
Now the Lord can make you tumble
And the Lord can make you turn
And the Lord can make you overflow
But the Lord can't make you burn

Burn on, big river, burn on
Burn on, big river, burn on

White River, Vermont.
United States Department of Agriculture.

Pilgrim at Tinker Creek

Annie Dillard

"The night I stayed too late I was hunched on the log staring spellbound at spreading, reflected stains of lilac on the water." So writes Annie Dillard (1945–) in this excerpt from Pilgrim at Tinker Creek. *One of America's foremost naturalists, Dillard tells us, as Poe did a century or so before, of the life to be seen along the upstream tributaries of rivers.*

Where Tinker Creek flows under the sycamore log bridge to the tear-shaped island, it is slow and shallow, fringed thinly in cattail marsh. At this spot an astonishing bloom of life supports vast breeding populations of insects, fish, reptiles, birds, and mammals. On windless summer evenings I stalk along the creek bank or straddle the sycamore log in absolute stillness, watching for muskrats. The night I stayed too late I was hunched on the log staring spellbound at spreading, reflected stains of lilac on the water. A cloud in the sky suddenly lighted as if turned on by a switch; its reflection just as suddenly materialized on the water upstream, flat and floating, so that I couldn't see the creek bottom, or life in the water under the cloud. Downstream, away from the cloud on the water, water turtles smooth as beans were gliding down with the current in a series of easy, weightless push-offs, as men bound on the moon. I didn't know whether to trace the progress of one turtle I was sure of, risking sticking my face in one of the bridge's spider webs made invisible by the gathering dark, or take a chance on

seeing the carp, or scan the mudbank in hope of seeing a muskrat, or follow the last of the swallows who caught at my heart and trailed it after them like streamers as they appeared from directly below, under the log, flying upstream with their tails forked, so fast.

But shadows spread, and deepened, and stayed. After thousands of years we're still strangers to darkness, fearful aliens in an enemy camp with our arms crossed over our chests. I stirred. A land turtle on the bank, startled, hissed the air from its lungs and withdrew into its shell. An uneasy pink here, an unfathomable blue there, gave great suggestion of lurking beings. Things were going on. I couldn't see whether that sere rustle I heard was a distant rattlesnake, slit-eyed, or a nearby sparrow kicking in the dry flood debris slung at the foot of a willow. Tremendous action roiled the water everywhere I looked, big action, inexplicable. A tremor welled up beside a gaping muskrat burrow in the bank and I caught my breath, but no muskrat appeared. The ripples continued to fan upstream with a steady, powerful thrust. Night was knitting over my face an eyeless mask, and I still sat transfixed. A distant airplane, a delta wing out of nightmare, made a gliding shadow on the creek's bottom that looked like a stingray cruising upstream. At once a black fin slit the pink cloud on the water, shearing it in two. The two halves merged together and seemed to dissolve before my eyes. Darkness pooled in the cleft of the creek and rose, as water collects in a well. Untamed, dreaming lights flickered over the sky. I saw hints of hulking underwater shadows, two pale splashes out of the water, and round ripples rolling close together from a blackened center.

At last I stared upstream where only the deepest violet remained of the cloud, a cloud so high its underbelly still glowed feeble color reflected from a hidden sky lighted in turn by a sun halfway to China. And out of that violet, a sudden enormous black body arced over the water. I saw only a cylindrical sleekness. Head and tail, if there was a head and tail, were both submerged in cloud. I saw only one ebony fling, a headlong dive to darkness; then the waters closed, and the lights were out.

I walked home in a shivering daze, up hill and down. Later I lay open-mouthed in bed, my arms flung wide at my sides to steady the whirling darkness. At this latitude I'm spinning 836 miles an hour round the earth's axis; I often fancy I feel my sweeping fall as a breakneck arc like the dive of dolphins, and the hollow rushing of wind raises hair on my neck and the side of my face. In orbit around the sun I'm moving 64,800 miles an hour. The solar system as a whole, like a merry-go-round unhinged, spins, bobs, and blinks at the speed of 43,200 miles an hour along a course set east of Hercules. Someone has piped, and we are dancing a tarantella until the sweat pours. I open my eyes and I see dark, muscled forms curl out of water, with flapping gills and flattened eyes. I close my eyes and I see stars, deep stars giving way to deeper stars, deeper stars bowing to deepest stars at the crown of an infinite cone.

Run, River, Run

A Naturalist's Journey down One of the

Great Rivers of the American West

Ann Zwinger

"I grew up on a river," Ann Zwinger (1925–) tells us in the introduction to
Run, River, Run. *"Not a very big river, across the street and down the bank, but it was*
always there, running downhill to the Wabash and the Ohio and the Mississippi."

So begin her reflections about her experience along the Green River in the American West. "Still wild in many reaches, it is a magnificent river," she asserts. "To me, it is the most beautiful river anywhere."

Beneath the beating of the wind I can hear the river beginning. Snow rounds into water, seeps and trickles, splashes and pours and clatters, burnishing the shattered gray rock, and carols downslope, light and sound interwoven with sunlight. The high saddle upon which we stand, here in the Wind River Mountains, is labeled Knapsack Col on the map, a rim left where two opposing cirques once enlarged toward each other. It defines the head of a rock-strewn valley less than a mile wide and some two miles long. This valley, hung like a hammock between twelve- and thirteen-thousand-foot peaks, is weighted down the middle with a lead-blue line: the first vein of the Green River. High altitude, intense blue sky, fresh wind, bone-warming August sun through the

early-morning chill, panoramic view—I am bedazzled by this blazing landscape with its nascent river.

Part of my euphoria in standing here also comes, I suspect, from the fact that the only way to get here is on one's own two feet, and it has taken the three of us—Connie and Perry Binning and me—four days to do so. Connie is the only woman guide I know (and also the only woman I know to have a glacier named for her). When I am away from my family, she takes me into hers. Perry speaks to animals along the way, sometimes gravely, sometimes cheerfully, always courteously. I have long since stopped being amazed that, if they are within hearing distance, they answer in kind. Perry's walking stick is a basketless ski pole, and when Connie and I have lagged behind, we can tell we're on the right trail by the small neat perforations it makes in the dirt. We agree that this view of the headwaters of the Green River is an earned view, and the knowledge that not too many people have stood here as we do makes it all the more magnificent.

In fact, many people are not even aware of the Green River. I am abashed to admit that until a few years ago I was largely ignorant of its 730 miles of running—291 in Wyoming, 42 in Colorado, 397 in Utah—for it is a big river that has cut channels through mountain rock and canyon wilderness. It is a historic river, for it was the center of the beaver trade in the 1830s, its north-south course lay athwart westward migration, and heroic river runs were made through its canyons. In some ways, it is also a mysterious river, the derivation of its name lost in history, and its precise source, for one reason or another, until now only loosely defined.

Indians and mountain men had undoubtedly been traversing the Wind Rivers for years, but Captain Benjamin Louis Eulalie de Bonneville made the first recorded climb in 1833 and logged a vivid description, but no latitude and longitude. Major John Wesley Powell, the most famous river runner of all, did not enter the Wind River Range and only guessed at the coordinates; a party of the famous Hayden Survey of 1877 did climb the mountains, but their report also was vague. Ralf Woolley, whose definitive United States Geological Survey Water Supply Paper 618 on the Green River was printed in 1930, took refuge in saying the source lay in an "extremely rugged area" somewhere among the "glaciers and numerous small lakes on the western slope of the Wind River Range, near the Continental Divide." The U.S. Board on Geographic Names, the final authority on river sources, ruled in 1931 on the coordinates but was somewhat less specific about pinpointing the precise valley.

The U.S.G.S. topographic map—the Gannett Peak, Wyoming, quadrangle—was published just a few months ago. On my well-creased snow-dampened map we trace the stream that begins literally beneath our feet down to its first intersection, with Clark Creek, and then with Wells Creek in the valley below Stonehammer Lake; it is the master stream here and at every intersection down the line. In response to my request, final confirmation came in a letter from the U.S. Board on Geographic Names, which reviewed its 1931 decision, and

> concluded that the Green River heads in a large basin or cirque between Mount Arrowhead and Split Mountain in the Wind River Range, Wyoming . . . the geographical coordinates 43°09'N and 109°40'W for the stream's heading falls within the basin of the northwest slope of American Legion Peak. It is also the longest unnamed head water branch of the Green River, and it probably receives more water because of its location below several small glaciers.

But even without that letter I would still feel a marrow conviction that I watch and inhale the beginnings of a magnificent river.

And the sense of riverness is so strong that I follow the river the rest of the way in my mind's eye: out of the Wind Rivers it meanders south across high hay meadows and sagebrush flats, and then snakes through the dry, alkali-splotched Green River Basin. When it snubs up against the Uinta Mountains at the Utah-Wyoming border, it is deflected to run east along their northern flank through Browns Park, a wintering place for traders and trappers and, later, outlaws, and still today isolated and remote. At the eastern end of Browns Park the river angles south and enters Lodore

OPPOSITE: Along the banks of the Wakarusa River, late nineteenth century. Kansas Collection, University of Kansas Libraries.

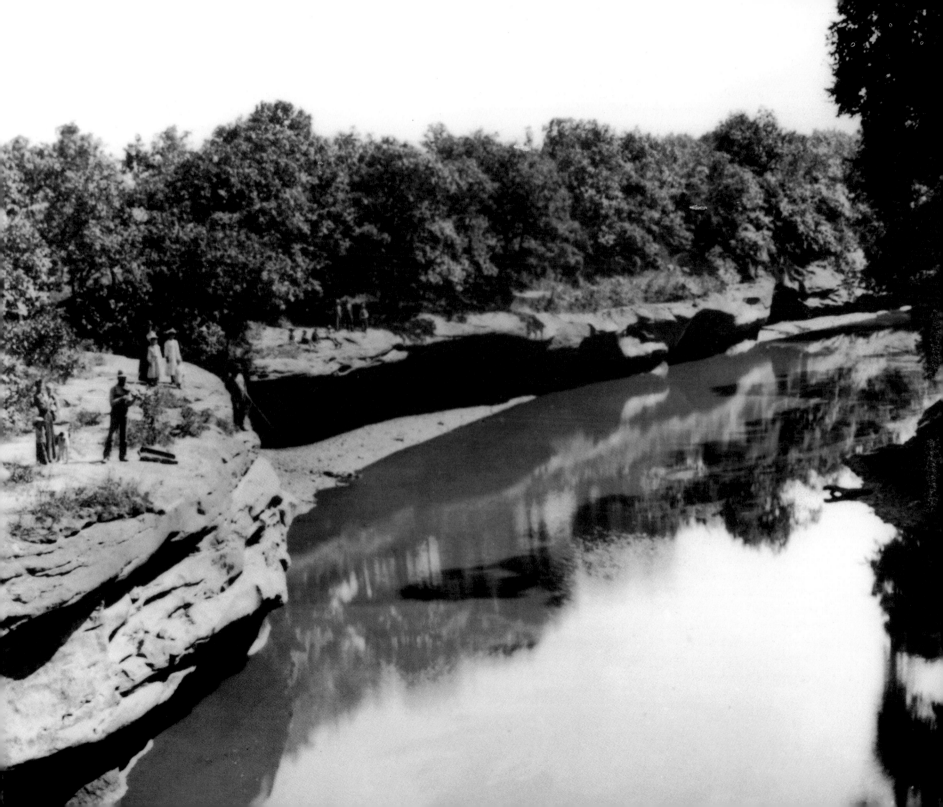

Canyon, incarcerated within its formidable red rock walls. Out of Lodore, it hooks around Steamboat Rock and charges sharp westward through Whirlpool Canyon, idles through Island Park, and dashes through Split Mountain, cleaving it nearly down the middle. It emerges and slows southward across the Uinta Basin. It begins to pare downward again as it bisects the Tavaputs Plateau, working through the pale sediments of Desolation Canyon and the craggy rock of Gray Canyon, bannered with its last white rapids. It crosses the arid Gunnison Valley, and then works its tortuous course through Labyrinth and Stillwater Canyons, through red rock and white rock, to its confluence with the Colorado River. There by Congressional proclamation, having fallen over 9,000 feet in 730 miles, the Green River ends.

. . .

The river breaks out of Three Forks Park and foams and fumes just out of sight, roaring through fallen timber and rock slides, guttering and pounding, always audible even if hidden. The path steepens downward through the woods. After a rain everything is soggy and spongy, a morass of puddles. Other hikers have made new paths to avoid the mud, creating parallel trails that infringe on the forest. Big patches of liverworts frost the ground; luxuriant mosses flourish in bouncy bolsters. Every leaf and needle has a drop or more of water. Heart-leafed arnica, that on the way up lined the trail with sunny yellow, now, after a hailstorm, is all stalks. Farther down they are untouched and blooming, a brightness in the dark woods, unusually abundant in the disturbed ground at the edge of the path.

This is my idea of the forest primeval: filled with deadfall, very still, ground soft and cushioned, a windrow of porcupine needles, big circles of dog lichen, trees festooned with old man's beard, wintergreens, bulbous yellow mushrooms like huge pats of butter, a touch of red in an already turned leaf, cinnamon-brown pine needles, streamers of twinflowers, a pale bluebell, ground pebbles grainy and lichen-spotted, scraps of bark and mats of pine needles. Although one has a sense of openness, vision is always blocked. In the quiet of the woods the river's sound is reduced to wistfulness.

The river is not so hypnotic, placed in this arboreal frame of reference.

Then the path emerges from the trees and confronts the river. Twenty feet across, the water is totally turbulent, foaming ivory, carved jade, shot with pale-turquoise depths and ice colors, scarcely relatable to the calm river less than half a mile upstream. Its fall of some 240 feet in a distance of 4,000 feet makes it churn against the canyon walls and bound back in alternating sashes of white water. There is a total continuous boom, filling my ears, echoing off the rocks, reverberating through the woods. The vibration of the river comes right up through the soles of my boots. It seems irrational, incredibly powerful, a different stream from that fine, dashing filament below Stroud Glacier, a different stream from the quiet one meandering through Three Forks Park, a stream running so crashing and full that I would not even think of wading in it.

And, in the midst of the pouring and pounding, a robin-sized gray water ouzel flits onto a rock, bobs, drops to a lower boulder nearly awash with water, bobs again, skims to another, low over the water, in perfect control of air current and wave, indifferent to the cold, holding firmly to wet rocks with long muscular toes, completely at home, the embodiment of John Muir's description in *The Mountains of California*: "Find a fall, or cascade, or rushing rapid, anywhere upon a clear stream, and there you will surely find its complementary Ouzel, flitting about in the spray, diving in foaming eddies, whirling like a leaf among beaten foam-bells; ever vigorous and enthusiastic, yet self-contained, and neither seeking nor shunning your company."

The river is on our right. To the left, a snow-slide area, depleted of trees, and now in summer an open meadow, reaches two thousand feet up the mountain flank. Trees come down the protected drainage lines and provide cover, and plentiful grass grows in the meadow. Elk feed here at dawn and dusk, lying out the day in the high grass. Two females with calves and one bull graze as we watch, working across the slope in the dimming light. Most of the Wind River slopes are timbered; only where snow slides keep trees from growing is there a chance for meadows to develop, and these open

slopes are prime summer feed grounds for elk, deer, antelope, and mountain sheep.

At the foot of this meadow slope the river quiets. Lodgepole pines dampen the upstream noise, spindly trees set in alleys of diminishing greenness, in a thick, closed stand. Old cones knot the empty branches; not until the heat of a forest fire opens them do the seeds fall out, sprouting to form again these dense stands. The needles are soft, a somber green padding on the ground; the rain-softened bark, beaded with amber pitch, is as pliable as leather.

At dusk the river turns a steely gray except for the center channel, and it retains its deep turquoise, laced with whitecaps as it bucks and pours over rocks. At the edge, tiny waves creep to the shore, lap into a little bay or slick over a rock and drop in a twelve-inch waterfall into a quiet harbor with a mica-sparkled sandy bottom. Swags of pine needles wash up on the lower edge of the bank, obscuring the shoreline; they do not decompose readily, festooning the beach until they eventually waterlog and sink to the bottom of the stream.

The main chute veers away from the shore. The current's speed is misleading; it looks much faster than it really is, and I am to remember this downstream, where the river in truth has more velocity but looks to be lazing. We throw sticks in upstream and time them between two points, trying to estimate the current's speed. If a stick comes down the slower edge of the channel it can be followed by comfortable but brisk walking. We estimate three feet per second. Although a modest velocity, it is, however, competent to move stones three inches in diameter, and the high turbulence of glacial streams makes them able to move larger materials at lower velocities than might be expected.

But, if a stick lands in the fast middle channel, I almost have to run to keep up with it. At the top of a line of rocks just downstream, the velocity of the river flips it high into the air, over the edge, and it is gone. We do it over and over again, like children, and indeed

I feel like Mole, in *Wind and the Willows*, who had never seen a river before, entranced and fascinated by this "sleek, sinuous, full-bodied animal, chasing and chuckling, gripping things with a gurgle and leaving them with a laugh, to fling itself on fresh playmates that shook themselves free, and were caught and held again. All was a-shake and a-shiver—glints and gleams and sparkles, rustle and swirl, chatter and bubble."

TOMORROW WE WILL BE BACK to civilization—no matter how long I've been out, it is always a day, a week, a month too short. Dark clouds clot the night sky, but the soft rumbling I listen to all night is not a storm coming in but cavitation from the river, created by the tremendous velocity just upstream. When water is constricted into a small channel between rocks, an increase in velocity, a rise in energy, and a decrease in pressure occur. When the pressure decreases to the vapor pressure of water, bubbles form. As water streams through the constriction and spreads out again, the opposite occurs: velocity decreases, pressure increases again, and the bubbles collapse, giving off shock waves that travel outward. Building up in series, they make the peculiar soft booming, a Stygian rhythm that I feel through the ground as well as hear. And all night long the river murmurs and hums and shudders, but always beneath the louder rushing I hear the soft little waves at the shore.

I lie awake most of the night, sensitized to the river. Peace, contentment: these are programmed cultural words; what I feel is the infinity outside of culture, and although I sleep little, I awake rested. The dawn sky is pale and pearly, like a moonstone, webbed with a few clouds the jagged skyline just beginning to pick up sunlight, that beautiful moment before full awakening when the world is fresh and clear and all is possible and good, a time of great expectations, and it is completely right, this gray rock canyon, this cold rock beginning, this beautiful river morning.

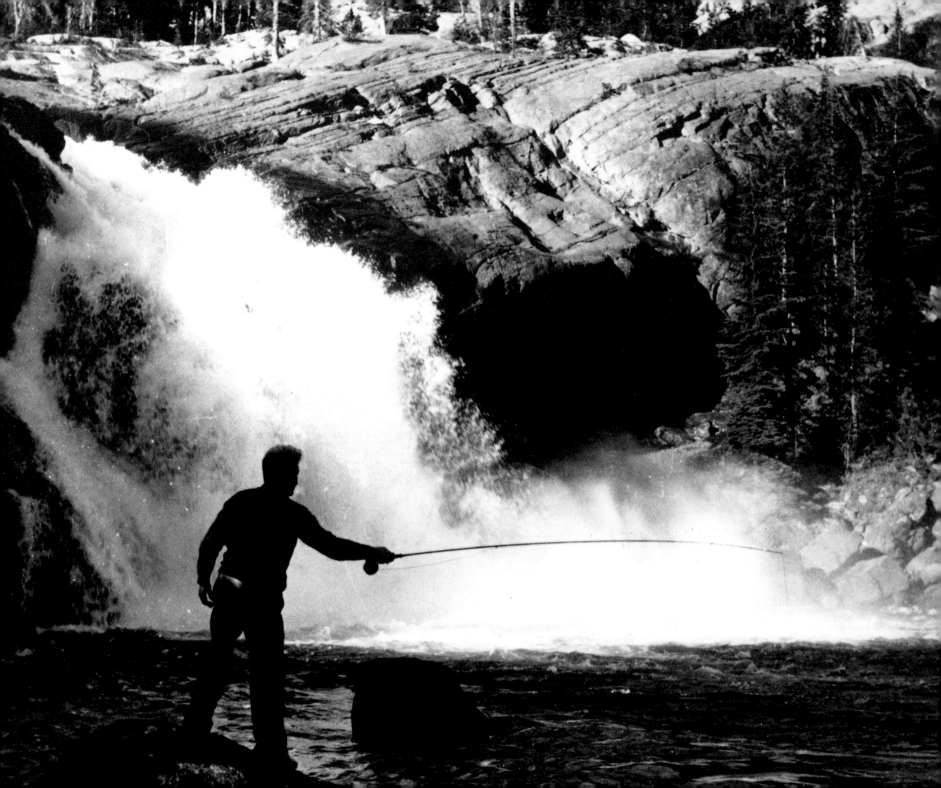

A River Runs through It

Norman Maclean

Norman Maclean (1902–1990), a longtime professor of literature at the University of Chicago, wrote perhaps the greatest American fish story. Set along the edges of rivers in Montana, the story draws out the similarity between fly fishing and religion as it tells us about the relationship between a father and his two sons.

*I*n our family, there was no clear line between religion and fly fishing. We lived at the junction of great trout rivers in western Montana, and our father was a Presbyterian minister and a fly fisherman who tied his own flies and taught others. He told us about Christ's disciples being fishermen, and we were left to assume, as my brother and I did, that all first-class fishermen on the Sea of Galilee were fly fishermen and that John, the favorite, was a dry-fly fisherman.

It is true that one day a week was given over wholly to religion. On Sunday mornings my brother, Paul, and I went to Sunday school and then to "morning services" to hear our father preach and in the evenings to Christian Endeavor and afterwards to "evening services" to hear our father preach again. In between on Sunday afternoons we had to study *The Westminster Shorter Catechism* for an hour and then recite before we could walk the hills with him while he unwound between services. But he never asked us more than the first question in the catechism, "What is the chief end of man?" And we answered together so one of us could carry

on if the other forgot, "Man's chief end is to glorify God, and to enjoy Him forever." This always seemed to satisfy him, as indeed such a beautiful answer should have, and besides he was anxious to be on the hills where he could restore his soul and be filled again to overflowing for the evening sermon. His chief way of recharging himself was to recite to us from the sermon that was coming, enriched here and there with selections from the most successful passages of his morning sermon.

Even so, in a typical week of our childhood Paul and I probably received as many hours of instruction in fly fishing as we did in all other spiritual matters.

After my brother and I became good fishermen, we realized that our father was not a great fly caster, but he was accurate and stylish and wore a glove on his casting hand. As he buttoned his glove in preparation to giving us a lesson, he would say, "It is an art that is performed on a four-count rhythm between ten and two o'clock."

As a Scot and a Presbyterian, my father believed that man by nature was a mess and had fallen from an original state of grace. Somehow, I early developed the notion that he had done this by falling from a tree. As for my father, I never knew whether he believed God was a mathematician but he certainly believed God could count and that only by picking up God's rhythms were we able to regain power and beauty. Unlike many Presbyterians, he often used the word "beautiful."

After he buttoned his glove, he would hold his rod straight out in front of him, where it trembled with the beating of his heart. Although it was eight and a half feet long, it weighed only four and a half ounces. It was made of split bamboo cane from the far-off Bay of Tonkin. It was wrapped with red and blue silk thread, and the wrappings were carefully spaced to make the delicate rod powerful but not so stiff it could not tremble.

Always it was to be called a rod. If someone called it a pole, my father looked at him as a sergeant in the United States Marines would look at a recruit who had just called a rifle a gun.

My brother and I would have preferred to start learning how to fish by going out and catching a few, omitting entirely anything difficult or technical in the way of preparation that would take away from the fun. But it wasn't by way of fun that we were introduced to our father's art. If our father had had his say, nobody who did not know how to fish would be allowed to disgrace a fish by catching him. So you too will have to approach the art Marine- and Presbyterian-style, and, if you have never picked up a fly rod before, you will soon find it factually and theologically true that man by nature is a damn mess. The four-and-a-half-ounce thing in silk wrappings that trembles with the underskin motions of the flesh becomes a stick without brains, refusing anything simple that is wanted of it. All that a rod has to do is lift the line, the leader, and the fly off the water, give them a good toss over the head, and then shoot them forward so they will land in the water without a splash in the following order: fly, transparent leader, and then the line—otherwise the fish will see the fly is a fake and be gone. Of course, there are special casts that anyone could predict would be difficult, and they require artistry—casts where the line can't go over the fisherman's head because cliffs or trees are immediately behind, sideways casts to get the fly under overhanging willows, and so on. But what's remarkable about just a straight cast—just picking up a rod with line on it and tossing the line across the river?

Well, until man is redeemed he will always take a fly rod too far back, just as natural man always overswings with an ax or golf club and loses all his power somewhere in the air; only with a rod it's worse, because the fly often comes so far back it gets caught behind in a bush or rock. When my father said it was an art that ended at two o'clock, he often added, "closer to twelve than to two," meaning that the rod should be taken back only slightly farther than overhead (straight overhead being twelve o'clock).

Then, since it is natural for man to try to attain power without recovering grace, he whips the line back and forth making it whistle each way, and sometimes even snapping off the fly from the leader, but the power that was going to transport the little fly across the river somehow gets diverted into building a bird's nest of line, leader, and fly that falls out of the air into the water about ten feet in front of the fisherman. If, though, he pictures the round trip of

the line, transparent leader, and fly from the time they leave the water until their return, they are easier to cast. They naturally come off the water heavy line first and in front, and light transparent leader and fly trailing behind. But, as they pass overhead, they have to have a little beat of time so the light, transparent leader and fly can catch up to the heavy line now starting forward and again fall behind it; otherwise, the line starting on its return trip will collide with the leader and fly still on their way up, and the mess will be the bird's nest that splashes into the water ten feet in front of the fisherman.

Almost the moment, however, that the forward order of line, leader, and fly is reestablished, it has to be reversed, because the fly and transparent leader must be ahead of the heavy line when they settle on the water. If what the fish sees is highly visible line, what the fisherman will see are departing black darts, and he might as well start for the next hole. High overhead, then, on the forward cast (at about ten o'clock) the fisherman checks again.

The four-count rhythm, of course, is functional. The one count takes the line, leader, and fly off the water; the two count tosses them seemingly straight into the sky; the three count was my father's way of saying that at the top the leader and fly have to be given a little beat of time to get behind the line as it is starting forward; the four count means put on the power and throw the line into the rod until you reach ten o'clock—then check-cast, let the fly and leader get ahead of the line, and coast to a soft and perfect landing. Power comes not from power everywhere, but from knowing where to put it on. "Remember," as my father kept saying, "it is an art that is performed on a four-count rhythm between ten and two o'clock."

My father was very sure about certain matters pertaining to the universe. To him, all good things—trout as well as eternal salvation—come by grace and grace comes by art and art does not come easy.

So my brother and I learned to cast Presbyterian-style, on a metronome. It was mother's metronome, which father had taken from the top of the piano in town. She would occasionally peer down to the dock from the front porch of the cabin, wondering nervously whether her metronome could float if it had to. When she became so overwrought that she thumped down the dock to reclaim it, my father would clap out the four-count rhythm with his cupped hands.

Eventually, he introduced us to literature on the subject. He tried always to say something stylish as he buttoned the glove on his casting hand. "Izaak Walton," he told us when my brother was thirteen or fourteen, "is not a respectable writer. He was an Episcopalian and a bait fisherman." Although Paul was three years younger than I was, he was already far ahead of me in anything relating to fishing and it was he who first found a copy of *The Compleat Angler* and reported back to me, "The bastard doesn't even know how to spell 'complete.' Besides, he has songs to sing to dairymaids." I borrowed his copy, and reported back to him, "Some of those songs are pretty good." He said, "Whoever saw a dairymaid on the Big Blackfoot River?

"I would like," he said, "to get him for a day's fishing on the Big Blackfoot—with a bet on the side."

. . .

Of course, now I am too old to be much of a fisherman, and now of course I usually fish the big waters alone, although some friends think I shouldn't. Like many fly fishermen in western Montana where the summer days are almost Arctic in length, I often do not start fishing until the cool of the evening. Then in the Arctic half-light of the canyon, all existence fades to a being with my soul and memories and the sounds of the Big Blackfoot River and a four-count rhythm and the hope that a fish will rise.

Eventually, all things merge into one, and a river runs through it. The river was cut by the world's great flood and runs over rocks from the basement of time. On some of the rocks are timeless raindrops. Under the rocks are the words, and some of the words are theirs.

I am haunted by waters.

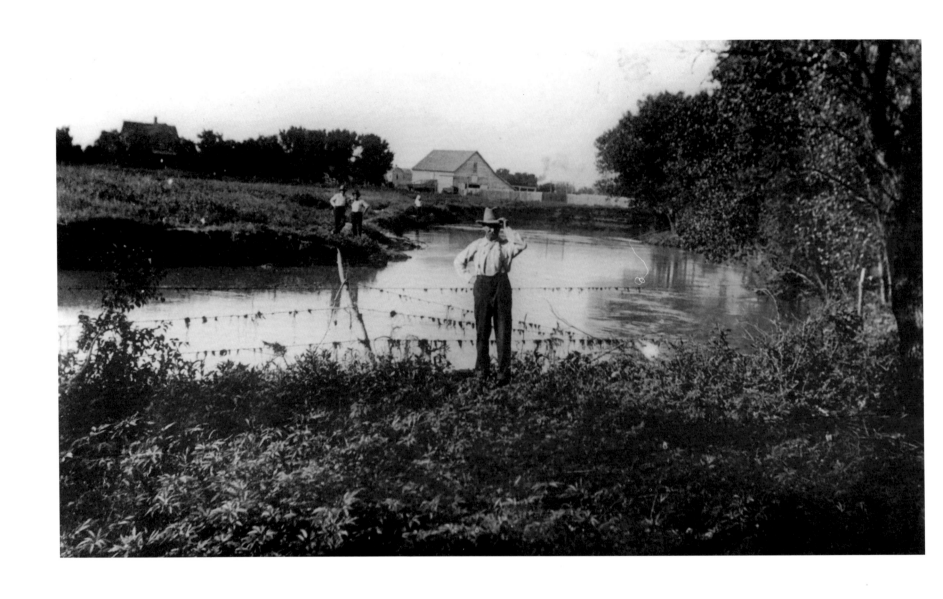

Frank H. Meckfessel on his farm, Larned, Kansas, n.d.
Kansas Collection, University of Kansas Libraries.

[1979] EXCERPT *from*

River Notes

The Dance of Herons

Barry Lopez

"When you awake, if you follow the river into the trees I will be somewhere ahead or beyond, like a flight of crows." So writes Barry Lopez (1945–) in the introduction to River Notes.
"When you are suddenly overwhelmed with a compassion that staggers you and you begin to run along the bank, at a moment when your fingers brush the soft skin of a deer-head orchid and you see sun-drenched bears stretching in an open field like young men, you will know a loss of guile and that the journey has begun."

Drought

I awoke one night and thought I heard rain—it was the dry needles of fir trees falling on the roof. Men with an intolerable air of condolence have appeared, as though drawn by the smell of death, dressed comfortably, speaking a manipulated tongue, terminally evil. They have inquired into the purchase of our homes. And reporters come and go, outraged over the absence of brown trout, which have never been here. The river like some great whale lies dying in the forest.

In the years we have been here I have trained myself to listen to the river, not in the belief that I could understand what it said, but only from one day to the next know its fate. The river's language arose principally from two facts: the slightest change in its depth brought it into contact with a different portion of the stones along

its edges and the rocks and boulders mid-stream that lay in its way, and so changed its tone; and although its movement around one object may seem uniform at any one time it is in fact changeable. Added to these major variations are the landings of innumerable insects on its surface, the breaking of its waters by fish, the falling into it of leaves and twigs, the slooshing of raccoons, the footfalls of deer; ultimately these are only commentary on the river's endless reading of the surface of the earth over which it flows.

It was in this way that I learned before anyone else of the coming drought. Day after day as the river fell by imperceptible increments its song changed, notes came that were unknown to me. I mentioned this to no one, but each morning when I awoke I went immediately to the river's edge and listened. It was as though I could hear the sound rain begins to make in a country where it is not going to come for a long time.

As the water fell, however, nothing unexpected was uncovered, although the effect of standing in areas once buried beneath the roar of the river's current was unsettling. I found only one made object, a wheel, the kind you find on the back of a child's tricycle. But I didn't look as closely as the others. The wailing of the river over its last stones was difficult to bear, yet it was this that drew me back each day, as one visits those dying hopelessly in a hospital room. During those few hours each morning I would catch stranded fish barehanded in shallow pools and release them where the river still flowed. The bleaching of algae once waving green underwater to white; river stones once cool now hot to the touch and dry; spider webs stretched where there had been salmon eggs; snakes where there had been trout—it was as though the river had been abandoned.

During those summer days, absorbed with the death of the river and irritated at the irreverent humor of weather forecasters in distant cities, I retreated into a state of isolation. I fasted and abstained as much as I felt appropriate from water. These were only gestures, of course, but even as a boy I knew a gesture might mean life or death and I believed the universe was similarly triggered.

From this point on, the song that came out of the river did not bother me as much. I sat out of the way of the pounding sun, in dark rocks shaded by the overhanging branches of alders along the bank. Their dry leaves, stirred by the breeze, fell brittle and pale around me. I slept on the bank regularly now. I would say very simple prayers in the evening, only an expression of camaraderie, stretching my fingers gently into the darkness toward the inchoate source of the river's strangulation. I did not beg. There was a power to dying, and it should be done with grace. I was only making a gesture on the shore, a speck in the steep, brutal dryness of the valley by a dying river.

In moments of great depression, of an unfathomable compassion in myself, I would make the agonized and tentative movements of a dance, like a long-legged bird. I would exhort the river.

What death we saw. Garter snake stiff as a twig in the rocks. Trees (young ones, too young) crying out in the night, shuddering, dropping all their leaves. Farther from the river, birds falling dead in thickets, animals dead on the paths, their hands stiffened in gestures of bewilderment and beseeching; the color gone out of the eyes of any creature you met, for whom, out of respect, you would step off the path to allow it to pass.

Where a trickle of water still flowed there was an atmosphere of truce, more dangerous than one might imagine. As deer and coyote sipped from the same tiny pool they abrogated their agreement, and the deer contemplated the loss of the coyote as he would the loss of a friend; for the enemy, like the friend, made you strong. I was alert for such moments, for they were augury, but I was as wary of them as of any lesson learned in death.

One moonlit evening I dreamed of a certain fish. The fish was gray-green against light-colored stones at the bottom of a deep pool, breathing a slow, unperturbed breathing, the largest fish I had ever imagined living in the river. The sparkling of the water around him and the sound of it cascading over the creek bed made me weak and I awoke suddenly, convulsed. I knew the fish. I knew the place. I set out immediately.

The dry riverbed was only a clatter of teetering stones now, ricocheting off my feet as I passed, bone weary, feeling disarmed by hunger, by the dimness of the night, and by the irrefutable wisdom and utter foolishness of what I was doing. As I drew near

the mouth of the creek the fish began to loom larger and larger and I could feel—as though my hands were extended to a piece of cloth flapping in the darkness—both the hope and the futility of such acts.

I found the spot where the creek came in and went up it. I had seen the fish once in a deep pool below a rapids where he had fed himself too well and grown too large to escape. There was a flow of night air coming down the creek bed, rattling dry leaves. In the faint moonlight a thousand harlequin beetles suddenly settled on my clothing and I knew how close I was to a loss of conviction, to rage, to hurling what beliefs I had like a handful of pebbles into the bushes.

The beetles clung to the cloth, moved through my hair, came into the cups of my hands as I walked, and as suddenly were gone, and the area I stood in was familiar, the fish before me. The rapids were gone. The pool had become a pit. In its lowest depression the huge fish lay motionless, but for the faint lifting of a gill cover. I climbed down to him and wrapped him in my shirt, soaked in the pool. I had expected, I think, a fight, to be punched in that pit by the fish who lay in my arms now like a cold lung.

Climbing out of there, stopping wherever I could to put his head under in some miserable pool, hurrying, I came to the river and the last trickle of water, where I released him without ceremony.

I knew, as I had known in the dream, the danger I was in but I knew, too, that without such an act of self-assertion no act of humility had meaning.

By now the river was only a whisper. I stood at the indistinct edge and exhorted what lay beyond the river, which now seemed more real than the river itself. With no more strength than there is in a bundle of sticks I tried to dance, to dance the dance of the long-legged birds who lived in the shallows. I danced it because I could not think of anything more beautiful.

The turning came during the first days of winter. Lynx came down from the north to what was left of the river. Deer were with him. And from some other direction Raccoon and Porcupine. And from downriver Weasel and White-footed Mouse, and from above Blue Heron and Goshawk. Badger came up out of the ground with Mole. They stood near me in staring silence and I was afraid to move. Finally Blue Heron spoke: "We were the first people here. We gave away all the ways of living. Now no one remembers how to live anymore, so the river is drying up. Before we could ask for rain there had to be someone to do something completely selfless, with no hope of success. You went after that fish, and then at the end you were trying to dance. A person cannot be afraid of being foolish. For everything, every gesture, is sacred.

"Now, stand up and learn this dance. It is going to rain."

We danced together on the bank. And the songs we danced to were the river songs I remembered from long ago. We danced until I could not understand the words but only the sounds, and the sounds were unmistakably the sound rain makes when it is getting ready to come into a country.

I awoke in harsh light one morning, moved back into the trees and fell asleep again. I awoke later to what I thought were fir needles falling on my cheeks but these were drops of rain.

It rained for weeks. Not hard, but steadily. The river came back easily. There were no floods. People said it was a blessing. They offered explanations enough. Backs were clapped, reputations lost and made, the seeds of future argument and betrayal sown, wounds suffered and allowed, pride displayed. It was no different from any other birth but for a lack of joy and, for that, stranger than anything you can imagine, inhuman and presumptuous. But people go their way, and with reason; and the hardness for some is all but unfathomable, and so begs forgiveness. Everyone has to learn how to die, that song, that dance, alone and in time.

The river has come back to fit between its banks. To stick your hands into the river is to feel the cords that bind the earth together in one piece. The sound of it at a distance is like wild horses in a canyon, going sure-footed away from the smell of a cougar come to them faintly on the wind.

[1983] EXCERPT *from*

Blue Highways

William Least Heat Moon

William Least Heat Moon (William Trogdon), born in Kansas City, Missouri, in 1939, traveled through the Pacific Northwest territory that Lewis and Clark had described in the early nineteenth century. But unlike those early explorers, Blue Highways *tells the story of a region living with the awful stench of a paper mill and the environmental consequences of dams built by the Army Corps of Engineers along the Columbia River.*

After breakfast at Lewis and Clark College, I felt like Paleolithic man. It wasn't anything I ate—it was what I heard from students. The only sensible thing for me, it seemed, was to take my ancient Black Elk and old Whitman and give up on the times. Student conversations had one theme: Grab! Time was running out on the good grabbing; you had only to look at the dollar, resources, the world, the country. The students believed in a gospel of surfeit and followed two rules: (a) anything less than more than enough was not enough; and (b) anything not taxable was of dubious use: community, insight, and so on. Goodbye, Portland.

I headed for Vancouver, Washington, once the Hudson Bay Company's major outpost in the Northwest with lines of commerce reaching to Russian Alaska and Spanish California. In spite of a head start, the old town had not been able to keep up with the new settlement across the river that got named by a coin toss. In Vancouver I lost the highway, found it again, and drove east on state 14 to follow the Columbia upriver until it made the great turn north. I could have accomplished a similar goal by taking

I-80 on the south side of the river and driving the famous Columbia Gorge Highway ("Kodak As You Go," the old slogan said, and even Meriwether Lewis wished he'd carried a camera obscura to capture the beauty); but I would have had to breathe truck fumes. Instead, on blue highway 14, I breathed a fresh odor of something like human excrement. Near Camas, I stopped where a farmer had pulled his tractor to the field edge to reload a planter. "What's that terrible smell?" I said.

"What smell?"

"Like raw sewage."

"That's the Crown-Zellerbach papermill."

"How do you stand to work in it?"

"I don't work there."

That answered my question. Running the steeply buckled land, the highway curved up and down again and again, giving horizon to horizon views of river and mountains. The strength of the Columbia shows in the deep, wide gorge it has cut through the massive uplift; river bottom here lies two hundred feet below sea level, yet the Columbia keeps out the Pacific. Although mountains stretch away north and south from the riverbanks here for hundreds of miles, nowhere else in the Cascades is there an opening like this one.

At Skamania the road climbed so far above the river valley that barns looked like Monopoly hotels and speedboats were less than whirligigs. East stood Beacon Rock, a monumental nine-hundred-foot fluted monolith of solidified lava. Lewis and Clark camped here both going and returning. In Portland, I had bought De Voto's abridged edition of their journals so I could follow that singular expedition of men and one woman, white, red, and black, upriver. Readers who see a declining literate expression in America will find further evidence in the journals. Meriwether Lewis and William Clark presented their permanently important historical and anthropological record clearly and poignantly, often writing under trying and dangerous conditions. In our time, who of the many astronauts has written anything to compare in significance or force of language?

Volcanic bluffs along the highway were flittering with cliff swallows, their sharp wings somehow keeping them airborne. High ridges came down transverse to the Columbia in long-fingered projections perforated by narrow tunnels, some with arched windows opening to the river. Above each tunnel the same date: 1936. To drive state 14 in the snow would be a terror, but on a clear day it was good to find road not so safe as to be dull; it was good to ride highway Americans wouldn't build today.

At North Bonneville, the first of the immense dams that the Corps of Engineers has built on the Columbia at about fifty-mile intervals, thereby turning one of the greatest rivers of the hemisphere into staircase lakes buzzing with outboards. Unlike the lower river, Lewis and Clark would not recognize the Columbia above Bonneville. Rapids and falls where Indians once speared fish lay under sedimented muck; sandbars and chutes, whirlpools, eddies, and sucks were gone, and the turmoil of waters—current against stone—that ancient voice of the river, silenced.

There was, of course, a new voice: the rumble of dynamos. The Columbia and its tributaries account for one-third of all hydroelectric power generated in the United States. The dams also provide other things, the Corps says: irrigation, flood control, backwash lakes for navigation and recreation. But they say nothing about turbines maiming and killing ten percent of the young salmon swimming downstream or about mature fish returning from Alaska and Russia to spawn and suffering burst blood vessels in the eyes and ulcerated blisters under the skin from a high nitrogen content spillways put into the deep pools. Dams are necessary, the Corps maintains, and you can't argue necessity; nevertheless, I don't think Lewis or Clark or the old Chinooks would care much for Bonneville. But then, like the wild river, they are dead.

[1985] EXCERPT *from*

Rivers of Empire

Water, Aridity, and the Growth of the American West

Donald Worster

Irrigation was to be the route to the salvation of the American West according to William Smythe. Yet less than a century after the publication of The Conquest of Arid America, *the reality of irrigation in the West was all too clear. As the environmental historian Donald Worster (1941–) points out in the introduction to his* Rivers of Empire, *water that had once flowed in a river system had become divorced from its natural context, with destructive consequences for the environment and for many of the people who live in the region.*

In his 1862 essay "Walking," Henry David Thoreau described a daily ritual that was characteristically American in his time. Coming out of his house on Main Street in Concord, Massachusetts, he would pause for a moment to consult his instincts. Which way should he go for his ramble into the countryside? Generally the needle of his inner compass would settle west or southwest, and he would head off in that direction, just as thousands of pioneers were doing, had done, and would go on doing for a long time to come. "The future lies that way to me," he wrote, "and the earth seems more unexhausted and richer on that side." Going west, he anticipated finding a wilder America where the trees grew taller, the sun shone brighter, and the field of action was still open to fresh heroic deeds. That way the landscape was not yet owned as private property, and the walker could still enjoy a comparative freedom. As he set off in a long, springing stride, he soon left behind him the settled parts of Concord, the constraining fences, the narrow house lots, the clamoring institutions, the dead hand of tradition, the old closed world of diminished opportunity, left them at least for an hour or two, partaking temporarily of the migratory impulse, the spirit of adventure, that had seized so many of his countrymen. "Eastward I go only by force; but westward I go free."

Had Thoreau kept on walking toward the west, traveling well beyond the outskirts of Concord clear to the Pacific shore, had he walked on and on through time into the late twentieth century, what would he have discovered? Would he have come upon a West

that had delivered on its promise to him and the nation? Would he have found there in fact a greater set for individuality, for innovation, for the creative mind, than existed in the East? A people who put less emphasis on the accumulation of property, who practiced less stratification in their society? Would he have found a more perfect democracy? A flourishing of personal freedom? A vindication of the idea of progress?

Thoreau died in the year his essay appeared in print and thus he could not have seen, could not even have anticipated, the real West as it has evolved. For that matter, many who have lived out their lives in the region during more recent times have not seen it either, or at least have not seen some of its more telling outcomes. Even now, a century and more past Thoreau's age of romantic optimism, many westerners—not to mention millions living elsewhere—remain confused by idealizing myths and ritualistic incantations of the old slogans. The West is still supposed, in popular thinking, to be a land of untrammeled freedom, and in some of its corners it may be just that. However, that is not all it is, is not even the more important part of what it is. The American West is also more consistently, and more decisively, a land of authority and restraint, of class and exploitation, and ultimately of imperial power. The time has come to brush away the obscuring mythologies and the old lost ideals and to concentrate on that achieved reality. In 1862, Thoreau was writing about a vaguely located, unrealized, unsettled West still to be experienced, to be made. We, on the other hand, have to come to terms with an established West that now has a long history. To understand that history, to probe the meaning of the region, its dynamics, its contradictions, its dreams and realizations, is to understand better some broader American aspirations and, it may be, something of the aspirations and fates of modern people everywhere.

Perhaps the best place to begin that reexamination of the West is by sauntering along one of its irrigation ditches. In it are important, neglected clues to the meaning of freedom and autonomy, of democratic self-determination and openness, in the historical as opposed to the mythical West. One might choose, for example, the Friant-Kern Canal coming down from the Sierra foothills to the desert lands around Bakersfield in the Great Central Valley of California. It is a vastly different stream of water from the Sudbury and Concord rivers on which Thoreau paddled his boat: those were, in Thoreau's time as they still are today, grass-and-tree-edged rivers moving sluggishly to the sea and required to do little work en route. After 350 years of white settlement, they remain more or less natural flows draining their natural watersheds. Friant-Kern, in contrast, is a work of advanced artifice, a piece not of nature but of technology. It has no watershed of its own but rather draws off water from a reservoir and transports it briskly to deficient areas to raise a cash crop. It means business. For long sections it runs straight as an arrow over the land, cutting across the terrain with a devastating efficiency. Engineers report that it carries, at maximum, 5,000 cubic feet of water per second. In that method of precise calculation is hinted the determination on the part of engineers, farmers, and other modern westerners to wrest every possible return from the canal and its flow. The American West literally lives today by that determination. Though its importance has seldom been well understood, more than any other single element, it has been the shaping force in the region's history. In that determination to exploit to the uttermost, there is little of Thoreau's ideal of freedom sought or expressed or possible. There is no freedom for nature itself, for natural rivers as free-flowing entities with their own integrity and order, and there is very little of the social freedom Thoreau expected humans to enjoy in the West. Friant-Kern offers a study in ecological and social regimentation.

Here then is the true West which we see reflected in the waters of the modern irrigation ditch. It is, first and most basically, a culture and society built on, and absolutely dependent on, a sharply alienating, intensely managerial relationship with nature. Were Thoreau to stroll along such a ditch today, he would find it a sterile place for living things. The modern ditch is lined along its entire length with concrete to prevent the seepage of water into the soil; consequently, nothing green can take root along its banks, no trees, no sedges and reeds, no grassy meadows, no seeds or blossoms dropping lazily into a side-eddy. Nor can one find here an egret stalking frogs and salamanders, or a redwinged blackbird swaying

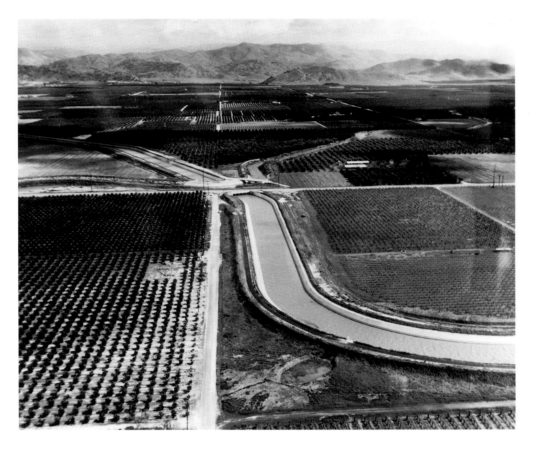

Friant-Kern Canal, California Central Valley, 1969.
United States Bureau of Reclamation.

on a stem, or a muskrat burrowing into the mud. Quite simply, the modern canal, unlike a river, is not an ecosystem. It is simplified, abstracted Water, rigidly separated from the earth and firmly directed to raise food, fill pipes, and make money. Along the Friant-Kern Canal, as along many others like it, tall chain-link fences run on either side, sealing the ditch off from stray dogs, children, fishermen (there are no fish anyway), solitary thinkers, lovers, swimmers, loping hungry coyotes, migrating turtles, indeed from all of nature and of human life except the official managerial staff of the federal Bureau of Reclamation. Where the canal passes under highways large, ominous signs are posted: "Stay alive by staying out." The intention of the signs, of course, is to promote public safety by warning the innocent of the dangers of drowning, of being sucked into siphons by the swift current. However, their

darker effect is to suggest that the contrived world of the irrigation canal is not a place where living things, including humans, are welcome.

And what of the social order, the shape of western community, which is reflected in the waters of the ditch? . . . Exploring the settlements in the vicinity of the Friant-Kern Canal yields at first a sense of social chaos, of a bewildering disorder of people and their daily lives, contrasting markedly with the rigid, clean geometry of their water system. Here, for example, sits in isolation an old black woman in the scanty shade of a peach tree, her chickens scratching in the dust, a hand-lettered advertisement, "Okra for sale," dangling from a stick. Across the road a noisy gang of white children are splashing in a galvanized horse-tank outside their mobile home. Next-door to them is a desolate brown field with rusted irrigation equipment stacked to one side, growing nothing now, as devoid of vegetation and interest as a parking lot, totally divorced from the lives of the children or the woman. Farther down the same road is a new suburban hacienda, separated from the neighbors by an ornate wrought-iron gate and brick wall. This home of a wealthy agribusinessman is resplendent in its brilliant sea of green lawn, the ignored roadside in front of it littered with empty beer cans. Beyond the house, at the end of rows of grapevines ready for harvest, are stacks and stacks of boxes piled by the road. "Malanco of Visalia" is printed on their wooden sides—they are not the property of the hacienda. The smell of oil wells rises incongruously out of alfalfa fields, and silver tanker trucks rumble along the country highways, past olive and almond groves. Intermixed are expanses of sugar beets, lying like rows of brown rocks in a field. The cacophonous sounds of machinery are everywhere in the rural air: irrigation pumps, tractors, tomato harvesters, helicopters spraying herbicides, the roar of a cotton gin, the scream of a black supercharged Chevy painted with red swirling flames, carrying migrant workers on to their next job. On every hand one finds a loose miscellany of buildings, crops, and other artifacts scattered across the landscape. The Vineyard Chapel of the Pentacostal Church of God. Our Lady of Guadaloupe. Rose of Sharon and True Light Gospel. Trinity Episcopal. Iglesia Bautista Mexicana. Corterisan Farms. Tenneco

Farms. Zaragoza Market. Safeway Incorporated. The blue-green stucco Moctezuma Cafe. The drab pink Pioneer Club. Los 3 Acres Club. Progress Road. Seventh Standard Road. Brown and Bryant Agricultural Chemicals plant. DiGiorgio Park in the town of Arvin, where old Mexican men sit and talk softly in the late afternoons. The defiant words "Fight for Socialism—Power to the Workers" painted on a new wooden stockade surrounding a housing development. A billboard touting a pesticide: "We kill to live." There is nothing harmonious, nothing picturesque about the western world that has developed beside the irrigation ditch. There is little peace or tidiness or care, little sense of a rooted community. There is no equitable sharing of prosperity. The human presence here often seems very much like the tumbleweeds that have been caught in the barbed-wire fences: impermanent, drifting, snagged for a while, drifting again, without grace or character, liable to blow away with a blast of hot desert wind.

There is, however, if one looks carefully, a kind of order underlying this jumbled, discordant West, though it is not in the main the order of nature or of landscape aesthetics or of closely integrated community life. It is a techno-economic order imposed for the purpose of mastering a difficult environment. People here have been organized and induced to run, as the water in the canal does, in a straight line toward maximum yield, maximum profit. This American West can best be described as a modern *hydraulic society*, which is to say, a social order based on the intensive, large-scale manipulation of water and its products in an arid setting. That order is not at all what Thoreau had in mind for the region. What he desired was a society of free association, of self-defining and self-managing individuals and communities, more or less equal to one another in power and authority. The hydraulic society of the West, in contrast, is increasingly a coercive, monolithic, and hierarchical system, ruled by a power elite based on the ownership of capital and expertise. Its face is reflected in every mile of the irrigation canal. One might see in that reflection the qualities of concentrated wealth, technical virtuosity, discipline, hard work, popular acquiescence, a feeling of resignation and necessity—but one cannot find in it much of what Thoreau conceived as freedom.

EXCERPT *from*

River of Traps

William deBuys

"We lived at the bottom of the village where the river squeezed between two hills and vanished in a canyon. The river was a small one, too small to be called a river in most parts of the world, but clear and cold, and we soon learned not to take its size as the measure of its power."

So writes William deBuys at the beginning of his account of life in the 1980s in northern New Mexico. As deBuys learned, the Rio de las Trampas, which began in the Sangre de Cristo Mountains and provided the water needed for irrigating fields in a small, remote village, could be transformed by a violent storm.

Days later, an unexpected storm dumped heavy snow throughout the mountains. Frost killed the apricot blossoms. The newspapers and radio reported that flood preparations were under way in towns and counties throughout the region. The cold spring had delayed the mountain runoff and kept adding to the high country's snowpack, which already was yards deeper than normal. The Indians at Taos filled hundreds of sandbags, building high the banks of Taos Creek where it ran through the pueblo. Residents of Embudo and Velarde, close beside the Rio Grande, moved their livestock and belongings to higher ground. Everyone waited with apprehension for warm weather to arrive.

THE COTTONWOODS WERE IN LEAF and all the valley decked in green, when, precisely at noon on the twentieth of May, according to my journal, the rains began. Shortly before sunset I donned a slicker and walked to the bottom of the pasture. The river was already rising.

Within a day it reached the level it had attained in April, and then held steady. Blue skies returned for two days during which Alex and Susan Norton returned from their winter in the East. We prayed for clear weather to continue, but soon, heavy clouds again rolled in. It began to pour.

The rain on our roof, usually restful, now sounded like gravel pouring from a dump truck. I ventured out once, swathed in multiple ponchos, to fetch my horse, which was grazing on the far side of the river. I figured to have him closer to hand, before the rising river put him out of reach.

But the river, already too high and fast to wade, had again swept our footbridge from its mooring. It was a continuous rapids, foaming and chocolate, roaring from every standing wave. A heap of posts and wire, tangled with clots of rubbish, tumbled past in the current. I heard a splash and saw chunks of turf fall from the bank into the swirl. And then heard a sound I could not recognize: a muted *clack*, hard and powerful like the steel-on-steel of trains coupling. I looked around and heard it again. It came from the river, from the bottom of the torrent. Then I realized it must be the sound of boulders, uprooted from the river bed, now rolling in the current and crashing, *clack*, *clack*, one against another.

A log spun by. A fencepost. Clods from the bank splashed into the current. I hurried upstream, hoping Jacobo's bridge was still in place.

Jacobo was at the crossing, maul in hand. He was pounding a stake the thickness of a fencepost into the ground. The river swirled around both ends of the bridge. Its waves splashed froth on the footboards.

"This bridge don't hold very much longer," shouted the old man. The river nearly drowned out his voice. "I got to tie him so he don't go down to Trampas."

We tethered the bridge to the stake with a pair of picket ropes. Jacobo had placed the stake so that when the bridge left its moorings, it would swing through the current and lodge in a quiet eddy against the bank.

He hid his maul and also the ax he had brought behind a cottonwood log a safe distance from the river. "No use to take them back," he said. "We gonna have plenty of work down here."

I said, "Jacobo, I better get my horse now or I won't be able to get him later."

"You better."

The bridge rocked under foot as I crossed. Jacobo waited while I caught the horse and bridled him. I rode back to the crossing, then clung to the animal's mane and fought him to try the current. Finally he lunged into the water and up the far bank. Rain fell in steady sheets as we trudged, leading the horse, up the fields.

I left Jacobo at his house and rode home as night fell, crossing the *acequia* where its waters ran through a culvert. They brimmed dangerously high. I realized that the valley's side canyons must be flooding, adding their waters to the ditch. Rain hammered on, punctuated by thunder, far into the night.

ANNE AND I AWOKE in the small hours to the sound of water gushing inside the house. We leapt from bed, afraid for the vulnerable adobes that bore the weight of the walls. Water was coursing somewhere under the raised floor of the kitchen.

We scrambled outside, and the faint beams of our flashlights showed a river of mud streaming down the road and spilling into the unfilled trench of the foundation. It surged into the house through a utility sleeve intended for future pipes. We scrambled to find rags and stuff them in the sleeve. My arm was in the water when the world blazed with lightning and thunder rocked the hill above us. The jolt ran up my arm and seemed to lift me off the ground.

"Get out of there, you fool!" Anne shouted.

I seized a shovel and tried to scrape a channel to divert the water from the house. But I could not move my arm, nor feel anything in it. Anne took the shovel from me and got the job done. Then we hurried up the road to the ditch.

We'd have made a ridiculous sight, had there been light enough

to see, clad in rubber boots and sodden long johns, me ungainly with a useless arm, thrashing about the flooding ditch. We thrust thick poles, like giant plumber's helpers, into the plugged driveway culvert, prying with all our strength against the branches and detritus the current piled up. Water spewed from the ditch. Some of it streamed toward the house, but the greater part, a river of gravel and water, swept into the hayfield.

We churned with our poles, and at last the obstruction gave way; the culvert cleared. We limped back to the house, shivering yet comical, the butts of what seemed a spiteful joke.

ALTHOUGH BY MORNING my arm was well again, the light of the new day did nothing to restore our humor. The flood from the ditch had deposited sand and gravel several inches deep over much of the hay field. Only the tips of the spring grasses showed through the sludge.

Much worse was what we saw at the river.

A quarter of the meadow no longer existed. The land was gone, dissolved. Swept down the river. The fire ring of river cobbles, where we'd barbecued the lamb, was now a swirl of coffee-colored water. The bank that had tapered to the river was a broth of standing waves. We stared dumbly at the new scene. The land fell abruptly, vertically to the water, exposing a wall of black loam protected only by dangling roots. The mild splashes I'd heard the day before were now crashes as barrow-sized loads of soil parted from the meadow and plunged into the torrent. The main channel of the river surged where we had held the wedding feast, and flotsam bobbled in the slack water where the channel used to be.

In normal times, the Rio Trampas was a mere creek that meandered through meadows and woods. It gained river status the way a Kentuckian becomes a colonel. Where the real thing is scarce, substitutes are promoted.

But now the River of Traps was a real river. Yet it lived in the body of a creek. It made room for its new size by straightening its

curves and grinding away the land. We stared at the torrent, hearing the *clack, clack* of boulders under the flow.

Upstream and downstream conditions were the same. Every bend in the river was cut raw, as the banks gave way and sod collapsed into the current. The water tore away the fence at the canyon mouth and ran in a turbulent sheet from one rocky wall to the other. But a ledge on our side remained clear, wide enough for Jacobo's cattle to wander down the canyon. Grateful for a mission, I went to tell the old man about the fence.

I found him by the river. His bridge had washed into the eddy, as he had planned, and he was securing it with extra ropes.

"Jacobo, what has happened! Did you ever see a flood like this before?"

"No. Never that I can remember." He gestured disgustedly toward [the] opposite bank where the river gouged a scar. *"Años pasados,* we had high water, but I never seen the river cut so much."

"So what is different now?"

"No sé. Too much snow. Too much rain. *Es la mano de Dios."*

Perhaps the hand of God lay behind the flood, but Jacobo was not resigned to it. Most of the damage to his land was on the far side of the river, where he could not attack it, but he came with me to see what might be done for our land by the canyon.

He surveyed the damage, then firmly but indirectly gave instructions: "If I were you," he began, "if this was my place, I would do two things. First, I don't pay attention to those cows. They got plenty of grass, and they don't bother anything for a while. Next, I put some cedars where the water is cutting, and maybe that will hold."

"Put cedars? How?"

"You need to cut plenty more stakes like the one we tie the bridge to, and drive them deep, along the bank. Then wire the cedars—or any kind of branches you can find—to the stakes and throw them in the water. The more green they got the better. You gonna see. It can help, I think."

"Branches can stop water like that?"

"They can."

"We can keep the bank from falling?"

"You can."

It took me a moment to absorb the idea, to realize we could fight the flood. Had I acted the day before when the first clods yielded to the flood, I might have saved the meadow.

Jacobo prodded, "You got a chain saw?"

"Yes."

"You got wire?"

"Yes."

"Well, go."

I collected tools: the maul, chain saw, hatchet, pliers. Jacobo left to check his own land. Alex was in Santa Fe that morning, but Anne came to help, as did Susan Norton and another friend from farther up the road. We cut a truckload of scrubby junipers from the hill behind the corral and gathered bushels of wire we'd saved from hay bales.

We cut and pounded and wired through the rest of the morning and into afternoon, spurred by the growl of the river and the dismal splashes of turf and soil plunging into the flood.

Soon our labors had an effect. As Jacobo instructed, we planted the stakes well back from the edge and bound the juniper tops to them with ropes of baling wire six or eight strands strong. One by one we threw them in. The dark water slammed the trees against the bank and sucked them down, fuming and seething through the foliage. Each new juniper stirred the water to a louder boil. Finally a forest of dwarf trees shielded the bank. The whole mass was anchored to a dozen or more stakes, each as thick as a man's arm,

and intertwined with wires that ran in every direction. Now the voice of the river changed. Its roar gave way to a constant hiss, and the bank began to hold.

Wet, muddy, and spent, we watched the brown current test the juniper and saw the juniper prevail. Jacobo had been right. The main current was deflected from the bank. The torn sod ceased its retreat.

There was little more to do. Farther downstream along the meadow the river did not charge its banks as much as roll over them. The water spread broadly over an area marked by islands of willows and cottonwoods. Trees that had once leaned above the channel now toppled into the flow, their roots undercut. Huge jams of logs and ruined fencing pressed against them.

We were carrying our tools back to the truck when again we heard the ominous plash of crumbling river banks. But it was not our land; the juniper still held. It was the other side, the Americanos' side, where the current we'd deflected now drilled the earth and sliced it away. Too bad for them, but there was nothing we could do. We'd protected our land and now we had to rest. We could not have crossed the river with our lives, let alone with saws and mauls and axes. The river, obedient to *la mano de Dios*, would do its work. Water ruled. Water would show.

That night it rained again. Hard. Anne and I speculated about how the Americanos' land would look in the morning, and the image was never far from our minds of the tall banks disintegrating into darkness. But bone-tired, we slept selfishly, without worry. We had fought. We'd not won much; perhaps we were losing, but at least we had fought.

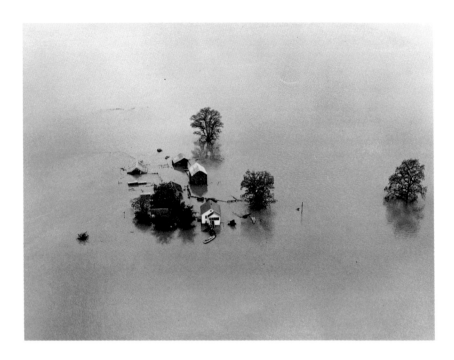

Arthur Rothstein, *Mississippi River Flood, St. Louis*, 1943.
Spencer Museum of Art/University of Kansas, gift of Mr. and Mrs. Frederick M. Myers.